AMERICAN EXPOSURES

AMERICAN EXPOSURES

PHOTOGRAPHY AND COMMUNITY IN THE TWENTIETH CENTURY

LOUIS KAPLAN

UNIVERSITY OF MINNESOTA PRESS / MINNEAPOLIS • LONDON

The University of Minnesota Press gratefully acknowledges the work of Edward Dimendberg, editorial consultant, on this project.

The author and the University of Minnesota Press gratefully acknowledge the support of the Social Sciences and Humanities Research Council of Canada for the production of this book.

Excerpts from *Land of the Free,* by Archibald MacLeish, copyright 1938, renewed 1966 by Archibald MacLeish. Reprinted by permission of Houghton Mifflin Company.

Chapter 1 originally appeared as "A Patriotic Mole: A Living Photograph," *CR: The New Centennial Review* 1, no. 1 (2001); reprinted with permission of Michigan State University Press. Chapter 4 originally appeared as "Photography and the Exposure of Community: Sharing Nan Goldin and Jean-Luc Nancy," *Angelaki: Journal of the Theoretical Humanities* 6, no. 3 (December 2001); reprinted with permission of Routledge/Taylor & Francis Ltd.

Published by the University of Minnesota Press
111 Third Avenue South, Suite 290
Minneapolis, MN 55401-2520
http://www.upress.umn.edu

Printed in the United States of America on acid-free paper

Library of Congress Cataloging-in-Publication Data

Kaplan, Louis, 1960–
 American exposures : photography and community in the twentieth century / Louis Kaplan.
 p. cm.
 Includes bibliographical references and index.
 ISBN 0-8166-4569-8 (hc : alk. paper) — ISBN 0-8166-4570-1 (pbk. : alk. paper)
 1. Photography, Artistic—United States. 2. United States—Pictorial works. I. Title: Photography and community in the twentieth century. II. Title.
 TR654.K3575 2005
 770'.973—dc22

 2005014068

The University of Minnesota is an equal-opportunity educator and employer.

12 11 10 09 08 07 06 05 10 9 8 7 6 5 4 3 2 1

To Melissa and to sharing

Contents

ILLUSTRATIONS

Acknowledgments

To the community of those who have contributed in so many different ways to this book about photography and community, I thank you for all that you have shared and all that you have sparked.

While difficult to pinpoint in space and time, the idea for *American Exposures* lies in my being exposed to a specific text—Jean-Luc Nancy's *The Inoperative Community*—and for finding in it a new way for thinking about the question of photography and community. Thanks to Scott Michaelsen for facilitating this event and for all the support and friendship that he has given me through the years that I have spent articulating what has happened—and what may happen yet—in this encounter.

Certain institutional debts have been incurred along the way. I appreciate the generous support of the Social Science and Humanities Research Council of Canada (SSHRC) for a grant that helped me to finish my research and to secure many of the images in and permissions required for this publication. I also received support from the Connaught Fund at the University of Toronto as well as an SSHRC Institutional Grant (SIG) to cover the costs of the color reproductions. I want to thank ORDA (the Office of Research and Development) at Southern Illinois University for granting me a summer research stipend so that I could work at the International Exhibition Program Archives and at the Edward Steichen Archives at the Museum of Modern Art in New York in order to do the archival digging necessary for the chapter on the Family of Man exhibition.

I am grateful to the following archives and collections: Archives of American Art in New York and in Washington, DC, the Archibald MacLeish Papers at the Library of Congress, the Prints and Photographs Collection of the Library of Congress, the Romare Bearden Foundation, the Roy E. Stryker Collection at the University of

Louisville, the Dorothea Lange Collection at the Oakland Museum, the Chicago Historical Society, the Harry Ransom Center for the Humanities at the University of Texas–Austin, and the Museum of Modern Art.

I benefited immensely from the careful reading of the manuscript and the constructive criticisms and suggestions offered by Sally Stein. Thanks also to Alexander García Düttmann and the other, anonymous, reader of an earlier draft of the project.

In the course of writing this book, I have been based at three different academic institutions. I want to thank both my colleagues and students at Tufts University, Southern Illinois University, and the University of Toronto (at the St. George and Mississauga campuses) for their support and feedback along the way. I particularly would like to mention the singular contributions of Monica Bandholz, Patrick Clancy, Heather Diack, Christina Findlayson, Sarah Miller, Shannon Petrello, Diane O'Donoghue, Will Pappenheimer, R. William Rowley, Catherine Shanahan, Rebecca Sittler, and Vagner Whitehead. Thanks to my students in the graduate seminars that I have taught on the topic of photography and community at Tufts University and the University of Toronto, where I tried out many of these ideas and approaches. I also wish to thank all those who invited me to present earlier versions of the chapters of this book: Julie Codell, Marc Gotlieb, Jeff Grossman, Andrea Noble, Barbara Jo Revelle, and John Welchman.

Thanks to the artists and gallerists for their generous cooperation in allowing me to reproduce their images: Frédéric Brenner (and the Howard Greenberg Gallery), Nan Goldin (and the Matthew Marks Gallery), Pedro Meyer, and Nikki S. Lee (and Leslie Tonkonow Artworks + Projects). Thanks especially to both Frédéric Brenner and Nikki S. Lee, who granted me extensive interviews. Thanks also to Fern Logan, Jean-Luc Nancy, Stephen Shore, and Neal Slavin for allowing me to use their images.

I appreciate the able editorial assistance of Pieter Martin at the University of Minnesota Press, who helped to steer this complex interdisciplinary project through its various phases toward completion. In addition, I want to acknowledge both Doug Armato and Ed Dimendberg for their support and for seeing the potentialities of this project. I also thank Robin Whitaker for her rigorous copyediting of the manuscript and Diana Witt for making the excellent index.

Thanks most of all to my creative and generous partner Melissa Shiff for sharing and splitting the difference(s).

INTRODUCTION

COMMUNITY-EXPOSED PHOTOGRAPHY

There is doubtless this irrepressible desire for a "community" to form but also for it to know its limit—and for its limit to be its *opening*.

—JACQUES DERRIDA, *Points: Interviews, 1974–1994*

The constellation of interlinked studies in this book revolves around issues and questions that relate to photography and community. These texts investigate a number of photographic practices that image and imagine community in the United States during the twentieth century, from the living photographs of American national icons and symbols shot by Arthur Mole at the end of World War I to the contemporary interventions into diverse subcultural communities by the Korean-American performance artist and photographer Nikki S. Lee. Some of these images have been classified as aesthetic objects and fetch high prices as art commodities (e.g., the photographs of Nan Goldin). Others are categorized as historical and sociological documents (e.g., the government-sponsored images of the Farm Security Administration photographers from the time of the Great Depression). This study is less concerned with classifying these photographs either as "art" or as "document" than it is with analyzing how all of them share certain commonalities that pose questions about our living and being with others, about community and about being-in-common. Whether classified as works of art or as documents, they are instances of "community-exposed photography."

In his discussion of the construction of national identity, Benedict Anderson states that community is "imagined because the members of even the smallest nation will never know most of their fellow-members, meet them, or even hear of them, yet in the minds of each lives the image of their communion."[1] What Anderson does not mention is that in the modern period—the period when both the nation-state and the medium of photography have been instituted and have flourished—photographic images have externalized and realized how we imagine community, so it does not exist in the mind's eye alone. This means that if we are dealing with "imagined communities," to cite Anderson's well-known phrase, then it is important to point out that

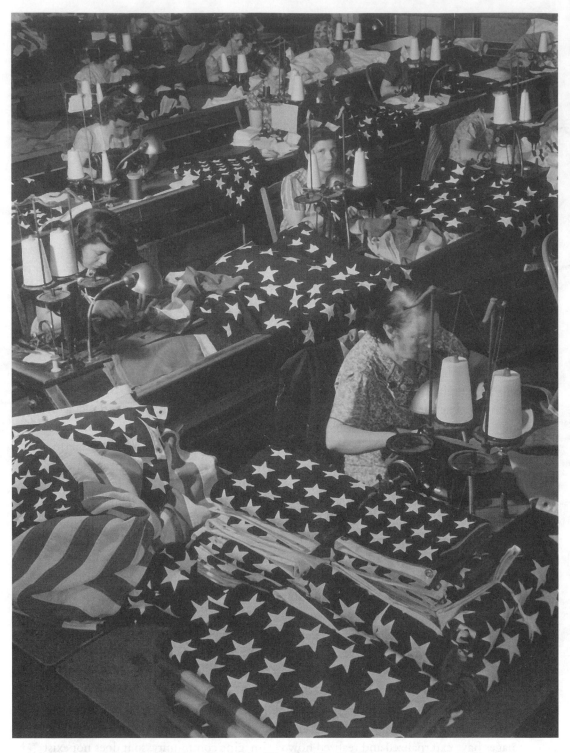

FIGURE I.1. Margaret Bourke-White, "Flag Making," Brooklyn, New York, July 24, 1940. Photograph from Northeast Region (New York) Records of Naval Districts and Shore Establishments, United States National Archives and Records Administration.

these communities have been constructed in terms and through the lens of photographic imaging. In this way, the medium of photography provides us with an image repertoire and with visual cultural artifacts that are the projections of being-in-common's imaginary. This visualizing procedure happens at the level of the nation-state (e.g., the United States) when the photographic imaging of icons and symbols mobilizes citizens into an imaginary collectivity ("us"). But this also happens at other levels of community as well. In looking to photography to ascertain how American community is imagined, we encounter issues and questions of class, race, gender, and ethnicity as photography envisions the community of those who have this or that particular characteristic in common.

Indeed, this strategy—selecting and shooting for different configurations of being-in-common—is at the heart of Neal Slavin's delightful and quirky photographic project from the mid-1970s, *When Two or More Are Gathered Together*.[2] This book of American group portraits ranges from professional wrestlers to avant-garde film types at the Cinema St. Marks in New York, from the members of the Society of Photographic Education at their annual meeting (Figure I.2) to Star Trek groupies gathered at a convention of "Trekkies." In his introductory "Memo," Slavin insists that his work affords a look into the dialectic and the conflict between individuality and belonging—between "the desire to belong in America in the mid-1970's and the conflicts caused by that wish."[3] In this way, Slavin sets up a binary opposition between the individual and the group, between the "I" and the "we." However, what I am calling community-exposed photography does not share the foundational assumption of the Cartesian cogito that individuality is somehow a separate and an independent entity that stands and thinks on its own or that the subject is in a position that somehow leaves it uncontaminated by group dynamics. Instead, this photography begins with the critique of subjectivity articulated by Jean-Luc Nancy in a reflection on our "being singular plural": "That Being is being-with, absolutely, this is what we must think. The *with* is the most basic feature of Being, the mark (*trait*) of the singular plurality of the origin or origins in it."[4] Clearly, Nancy takes his cue from Martin Heidegger's dictum in *Being and Time:* "Dasein ist wesenhaft Mitsein" (Being-in-the-world is intrinsically Being-with).[5] From this perspective, Slavin's title must be rethought in light of being singular plural—that two or more are gathered together even if and when there is only one standing alone.[6]

One of Slavin's group photographs, "The Last Man's Club, Hempstead Post 390, American Legion" of the American Legion Post 390 in Hempstead, New York (Figure I.3), illustrates in a *reducto ad absurdum* how radical individualism falters in the face of *Mitsein*. Functioning as a kind of postscript for the military photographs of Arthur Mole that constitute the first chapter of this book, Slavin's image gathers a group of veterans who fought together in World War I. The object of this ritual of male bonding and of the survival of the oldest is to be the last man left alive and to be rewarded with a vintage bottle of brandy, the coveted prize featured in the center of the photograph. Of course, the irony of the photograph is that even though this man will be

alone and bereft of the condition of sociality wherein two or more are gathered together, he will be enjoying this victory bottle of brandy only on account of this prior gift of his being-with-others.

"The Last Man's Club" also illustrates quite vividly that the etymological root of the word *community* is linked to war and to our common defense. As John D. Caputo reminds us, "After all, *communio* is a word for a military formation and a kissing cousin of the word 'munitions'; to have a *communio* is to be fortified on all sides, to build up a 'common' (*com*) 'defense' (*munis*) as when a wall is put up around the city to keep the stranger or the foreigner out."[7] Given such militaristic and closed-minded assumptions, Caputo stresses the need for a deconstructive practice to be able to transform community into something that is more open and more porous to the other. This strategy is related to the call for a "community at loose ends," sketched by Nancy and others and at the heart of this project.[8]

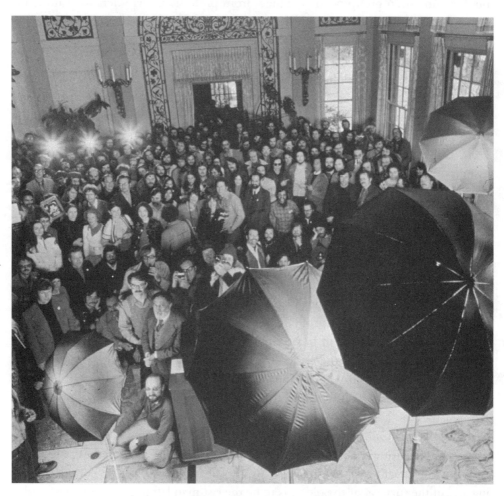

FIGURE I.2. Neal Slavin, "Society for Photographic Education (S.P.E.)," New York, New York, 1976. Reprinted from Neal Slavin, *When Two or More Are Gathered Together* (New York: Farrar, Straus, and Giroux, 1976). Courtesy of Neal Slavin.

Moreover, Slavin's "The Last Man's Club" illustrates how the thinking of community never strays far from a relationship to death. From Nancy's perspective, "The Last Man's Club" forms and performs the exemplary act of community in its photographic exposure of finitude. To recall Nancy, "A community is the presentation to its members of their mortal truth." ("Une communauté est la présentation à ses membres de leur vérité mortelle").[9] It is at this particular juncture that the thinking of community can be coupled with photographic practice as well, when we consider that the photograph also presents to each of us our own mortal truth. Photography as an experience of finitude and an exposure of being touched by death has been at the heart of recent photography theory, from Roland Barthes's *Camera Lucida* to Eduardo Cadava's *Words of Light: Theses on the Photography of History*.[10] For Cadava, "it is precisely in death that the power of the photography is revealed, and revealed to the very extent that it continues to evoke what can no longer be there."[11] Paraphrasing Nancy, Maurice Blanchot also locates the paradox of death as the groundless ground of community. "If the community is revealed by the death of the other person, it is because death is itself the true community of beings: their impossible communion."[12] Blanchot's statement offers another way to frame the irony enacted by "The Last Man's Club," in which community is revealed by the death of the others. Thinking community in relation to death also illustrates why the ideology of communal fusion and communion (inherent in the Anderson quotation above) leads to confusion and why community is always in the end a liminal or even impossible project. Enjoined to death and to its inability to be directly experienced or to be made into a work or a project, "community acknowledges and inscribes—this is its most

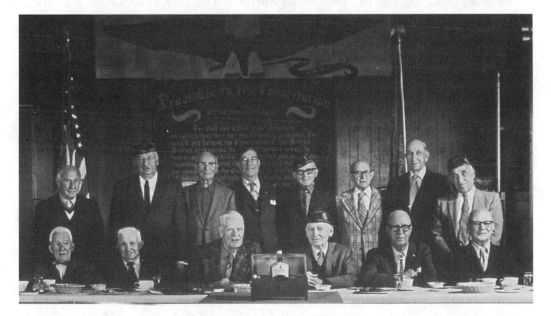

FIGURE I.3. Neal Slavin, "The Last Man's Club, Hempstead Post 390, American Legion," Hempstead, New York, 1976. Reprinted from *When Two or More Are Gathered Together*. Courtesy of Neal Slavin.

peculiar gesture—the impossibility of community."[13] To deploy another photographic metaphor in Blanchot's language, "The Last Man's Club" illuminates "the negative community" that cannot be put to work and that can be experienced only as the absence of the work.[14]

If there is one text that has served as a guide for exposing photography to community, it is Nancy's *La communauté désoeuvrée,* published in 1986 and translated into English as *The Inoperative Community* (and, more literally, as the community that cannot be put to work). This is the series of studies in which Nancy articulates a vision of community that is quite different from Benedict Anderson's romantic "image of their communion." Indeed, Nancy's postromantic articulation of "community without communion" retreats from the thinking of community in any fusional or unified way. Nancy warns against any nostalgic longing for a mythic return to a premodern "organic" community (e.g., commune, tribe, or clan). This warning is also linked to Nancy's critique of *immanence* or what Ignaas Devisch defines as "the communal desire for a closed and undivided social identity" that is "fully present . . . and closed upon" itself.[15] The sharing *and* splitting that moves the inoperative community—what Nancy marks in the French with the word *partage*—cannot be reified into a fixed entity closed in on itself or into a single totalizable body (e.g., the lure of Nazism to which Heidegger himself succumbed). Such "immanent" strategies risk losing community as the experience of finitude and as a complex of relations that are always incomplete.[16] As Nancy writes in the preface to the book, "The community that becomes a single thing (body, mind, fatherland, Leader . . .) necessarily loses the *in* of being-*in*-common. Or, it loses the *with* or the *together* that defines it. It yields its being-together to a being *of* togetherness. The truth of community, on the contrary, resides in the retreat of such a being."[17] The study of community-exposed photography can contribute to this retreat from communion, but in a manner that does not lose track of community in or as relation, in or as communication.

American Exposures: Photography and Community in the Twentieth Century stages an encounter of materials drawn from the history of twentieth-century American photography on the one hand and the theory and philosophy of Jean-Luc Nancy and other contemporary thinkers of community on the other. Rather than maintaining the status quo of disciplinary practices, this exercise in disciplinary innovation opens the fields of history of photography and American cultural studies to the fields of Continental philosophy and theory and vice versa. It is a project that crosses disciplinary borders in its attempt to make the ideas of a contemporary strand of theory dealing with questions of community speak to and about twentieth-century photographic practices and to help us to understand these philosophers of community in a different light when their theories are placed in relation to and illuminated by these photographic case studies. The approach of this book is then twofold: to forward into photography and visual studies the ideas of a community of thinkers who have approached the question of community, and to investigate the impact of confronting community theorists with these photographic exposures. In other words, *American*

Exposures seeks to position itself in a way that shares these communities of thinkers and brings them into communication with one another.

In *The Inoperative Community*, Nancy insists that community happens only in relation and that this occurs on the limit—as the passage from the one to the other, as a bringing into relation of "everyone's nonidentity to himself and to others." This mode of communication and its sharing is linked to the limits of experience *and* the experience of limits. Nancy stresses that writing and literature are critical to this exposure of community and being-in-common. "Literature inscribes being-in-common, being for others and through others." This book translates or transposes media and shifts from literature or writing to photography, or light writing. There are many passages in *The Inoperative Community* in which one can substitute photography for writing or literature quite easily. This substitution provides a better sense of how light writing flashes up at the limit where community and communication are exposed. To demonstrate: "But [photography] is the act that obeys the sole necessity of exposing the limit: not the limit of communication, *but the limit upon which communication takes place.* . . . [Photographic] communication takes place on the limit, on the common limits where we are exposed and where it exposes us."[18] In turning to these case studies of community-exposed photography, *American Exposures* articulates the varied and various limits and possibilities of photographic communication and its exposure of community.

EXPOSURES

As the citation of Nancy above indicates, the activity of exposure is at the heart of his philosophical reflections on community. This introduces another critical encounter and exchange at the crossroads of photography and community. For the concept of exposure pervades photographic discourse as well. In its standard technical sense, it refers to the action of exposing the plate or the film to light. It can also refer to the action of the photographic subjects, who expose themselves to the film when it is exposed to light, and it is in this sense that photography comes in contact with the question of community. The objective of this book is to bring photography and community into dialogue with each other in this shared interest with exposure. The ontology of the photograph and its being-in-the-world and Nancy's ontological approach to community as being-with communicate around the concept of exposure. But this is not the revelatory exposure of the exposé that guides the discourse of muckraking journalism and photography in bringing things to light and full visibility. Nancy reminds us that "'to be exposed' means to be 'posed' in exteriority,"[19] to be in a relationship with the outside. Photography in its most popular variety is exactly this type of activity—an act of sharing in which we are exposed to one another and in which we mark the insufficiency of the individual subject and an interiorized and self-contained entity. If we take a picture of another person or of a group, we pose them in a relationship with exteriority, exposing them to the gaze of others and even

to themselves as other. In this liminal way, photography opens a space for communication that is posed at the border of the sharing and splitting of singular beings. Photography exposes community to itself; it gives community the medium of its sharing and the incompleteness of its sharing. One can apply Nancy here by saying that photography lets "the singular outline of our being in common expose itself."[20]

In the recent essay entitled "Nous autres," which he composed for the Spanish Photography Festival of 2003, Nancy engages in a bilingual pun that plays at once on the word for "we" in Spanish (*nosotros*) and the phrase for "we others" in French (*nous autres*). This translinguistic maneuver forces reflection on how the space of the other always already inhabits who "we" are and on how photography exposes this relation (without relation) "by transforming everything into an alterity that is even more altered because of its nearness to us, as it sends us back to our familiar immediacy. Consequently, it always murmurs 'a we others' (*un nous autres*): we others the exposed, the irradiated of the sun, of the moon, and of the projectors."[21] Even the familial function of photography (what Nancy refers to as our familiar immediacy) undergoes estrangement when each of us is exposed as "a we others." Thus, the expository approach projects a photographic alterity that cannot be coded in terms of any logic of identity.

For Nancy, it is critical not to turn this exposition of community into something substantive (a being) or suppositional (a ground). He writes: "Exposition, precisely, is not a 'being' that one can 'sup-pose' (like a sub-stance) to be in community. . . . But community cannot be presupposed. It is only exposed. This is undoubtedly not easy to think."[22] This same logic also applies when photography is brought into the equation. We must be careful to avoid the trap of treating the exposition of community as a property or a substantive attribute of photography and its being-in-the-world. This would generate a type of photographic essentialism rather than opening photography in all its contingencies unto the other and as thinking on the limits. Both photography and community can only be exposed. While not easy to think, it is what remains to be thought in these studies that expose such contemporary discourses as photography, sociology, philosophy, American studies, art, and visual culture to one another. Therefore, the staging of the relationship between photography and community around the question of exposure calls for an interdisciplinary practice that brings conventionally isolated discourses into communication with one another and seeks affinities among them.

In mobilizing the concept of exposure as the crucial term around which phototheoretical discourse turns in order to understand photography and community, *American Exposures* moves away from semiotic theories that have dominated photography studies for the past twenty-five years.[23] First explicated in the writings of Charles Sanders Peirce, the index has pointed the way by indicating the photograph as a type of sign and as part and parcel of semiotic studies. The photograph is taken to be the direct emanation or the physical trace of its referent. Peirce differentiates photographs from likenesses or icons. "This resemblance is due to the photographs

having been produced under such circumstances that they were physically forced to correspond point by point to nature. In that aspect, then, they belong to the second class of signs, those by physical connection."[24] As smoke is to fire or as a footprint is to the foot that deposited it, so is the photograph to its referent. One finds divergent thinkers such as Rosalind Krauss and Allan Sekula agreeing implicitly on this indexical theory of photography rooted in Peirce's philosophy.[25] These assumptions are also crucial to the first half of Roland Barthes's *Camera Lucida,* with its emphasis on the *noeme* ("that has been") as what is distinctive to the photograph as the direct "emanation of the referent."[26] The indexical approach to photography as the trace of the absent referent has produced an entire discourse that stakes out photography's claims to evidence and is organized around the idea of the photograph providing proof and the immanence of meaning. Through this referential relationship and its structures of identification and signification, the photograph as indexical sign is said to represent and document community and social relationships. The indexical approach to photography advances the codes (or the *studium* in Barthes's sense) of semiotic meaning that gives photographs an identity, but it overlooks what takes photography to the limits of identity or what inclines photography toward being with others.

The indexical theory of the photograph has come under pressure from numerous directions in recent years. (This can be attributed in part to the rise of digital photography, which will be the subject of chapter 7 with a look at Pedro Meyer's "digital Chicanos.") One critical approach foregrounds the iterability of the photographic sign that generates repetition with a difference. The untimely temporality of the photograph signals its uncanny capacity to be detached from indexical reference and its refugee status. In challenging the uniqueness of the photographic event, Eduardo Cadava in his profound book *Words of Light* and his brilliant elegiac lecture "Palm Reading: Fazal Sheikh's Handbook of Death" subverts the claims of the index that binds the image to its referent and that unhinges the photograph from its own proper history and from the metaphysics of presence.[27] To recite Cadava and his affirmation of the citational structure of the photograph: "Rather the photographic event interrupts the present; it occurs between the present and itself, between the movement of time and itself."[28] Meanwhile Geoffrey Batchen's critique of the index attempts to break down the binary opposition between the real and representation. With the help of Jacques Derrida, Batchen intervenes to deconstruct Peirce and the dichotomy on which the theory of the index rests. He writes, "Peirce's work never allows us to presume that there is a real world, an ultimate foundation, that somehow precedes or exists outside of representation. Real and representation, world and sign, must, in line with Peirce's own argument, always already inhabit each other."[29]

The expository approach to photography and community that organizes these readings contributes to the critique of the index by calling into question its logic of identity, identification, and representation by foregrounding the dynamics of exposure, expropriation, and alterity. For community-exposed photography, photography poses us in exteriority in a turn toward the other. In this relationship with the outside

that is endemic to the scene of photographic exposure, "subjects" (or rather, singular beings) are put into communication with one another and in a relationship with being-in-common, in which they touch up against one another and against their limits. This is what makes the plane of the photograph the space of sharing. While both indexical and expository theories can bring photography and community into dialogue with each another, they do so in very different ways, with the indexical approach privileging the immanence of meaning that accrues to the photographic documentation of community and with the expository approach privileging the expropriation of meaning that accrues to being posed in exteriority and as communication. Photographic exposure can never provide us with the *documentation* of sharing. Instead, this non-self-identical movement only reiterates that the photograph is shared, and what this act of sharing shares is the exposure of finitude—or what constitutes the limits of our sharing.

In taking "exposure" as the basis for its photo-historical and photo-theoretical investigations of community, *American Exposures* shifts the locus of attention from the photograph as a type of legible sign (embedded in Peirce's trinity of the index, the icon, and the symbol) to the photograph as a relationship (at the limits of sharing) that exposes an aspect of ontology. Photography is understood as a way of relating to or being with others. In contrast to Peircean semiotics, community-exposed photography has its roots in the "coexistential analytic" of Martin Heidegger's *Being in Time,* in his insistence that *Dasein* necessitates *Mitsein,* not as something added on to it, but as something coappearing and compearing with it.[30] Thinking photography in terms of being-with is pivotal to the photographers of American communities addressed in this book—from Nan Goldin's emotionally charged snapshots of her subcultural family to Frédéric Brenner's elaborately staged tableau of his oddball groupings of Jews in America. While the photographic approach to subject matter may be drastically different for these two photographers, they share a commitment to photography as a mode of exposition—one that exposes community and its sharing.

In addition to Nancy, this theoretical approach to photography is indebted to a nexus of writers and texts over the course of the last two decades who have approached community in an anticommunitarian and antifoundationalist way: Giorgio Agamben's *The Coming Community* (1990), Alphonso Lingis's *The Community of Those Who Have Nothing in Common* (1994), Maurice Blanchot's *The Unavowable Community* (1983), and several texts by Jacques Derrida.[31] These writings in turn further the thinking of community articulated by those thinkers who have been of major relevance for deconstruction as a mode of reading and thinking—namely, Georges Bataille, Martin Heidegger, and Friedrich Nietzsche. One should recall that Nancy's *Inoperative Community* and Blanchot's *Unavowable Community* are written in communication with and in response to Georges Bataille. Blanchot's epigraph comes from Bataille, and it foregrounds the (im)possible idea of forging community at the limit—in relationship with death and in terms of the experience of finitude. It reads: "the community of those who do not have a community."[32] Similarly, Nancy pays

homage to Bataille as *the* thinker of community at the limit: "No doubt Bataille has gone farthest into the crucial experience of the modern destiny of community."[33]

For the philosophical investigations of most of these thinkers, photography studies have not been a major focus. But a few examples exist in the wide-ranging list of publications of Jean-Luc Nancy, including a short photographic essay with captions that is included only in the French edition of *Le poids d'une pensée*.[34] This experimental image-text narrative allows Nancy to take photographs of an elderly man named Georges as well as to reflect on photography in terms of his relationship with this man. These images show Georges performing mundane and habitual actions such as drinking, eating, and smoking at a local café. At one point in the text, Nancy maps out photographic communication in terms of a complex relationship of gazes (of the photographed subject to the photographer, of the photographed subject to his future gazing upon his own image), a complex that opens on the plane of exposition that is the photograph. "It is as if the reality of your gaze on your own image to come—but also upon me, who takes the photo—formed the same surface, spread out, brilliant and sharp."[35] "Georges" also contains Nancy's grand utterance that "photography shows the reality of thought."[36] This quotation is also the caption of a photograph that he took of Georges wearing his beret and sitting at a café table with his eyes half open and his gaze directed nowhere in particular (Figure I.4). Rather than positing "reality" as the indexical real that resides in the referent, Nancy chooses to connect photographic exposure with the reality of thought, with what is called thinking. From this perspective, community-exposed photography offers a way into philosophy—into a philosophy of finitude that exposes us to others and to ourselves in the process of becoming-other. Nevertheless, Nancy does not deploy a sustained discourse of "exposure" in his reflections on the photographs of Georges or in his other writings on photography. This lack of a sustained discourse motivates the present study to extend Nancy's philosophical reflections on exposure and community to thinking about photography via an examination of particular case studies in the United States throughout the twentieth century.

BEING-WITH WARHOL

The canonical status of Andy Warhol as *the* American artist and impresario of the twentieth century has become a truism. The literature in the fields of art history, visual culture, and critical theory on every aspect of his career has reached "superstar" proportions, and the establishment of the Andy Warhol Museum in Pittsburgh has further institutionalized the artist's work as a permanent collection. It is widely understood that the appropriation of sensational photographic imagery from tabloid culture was central to Warhol's ready-made aesthetic and his cool persona. To begin thinking about photography from a perspective that is exposed to community, I would like to focus on a study of Warhol's aesthetic that appeared in *October* magazine in the mid-1990s—Hal Foster's "Death in America"—and to rethink Foster's

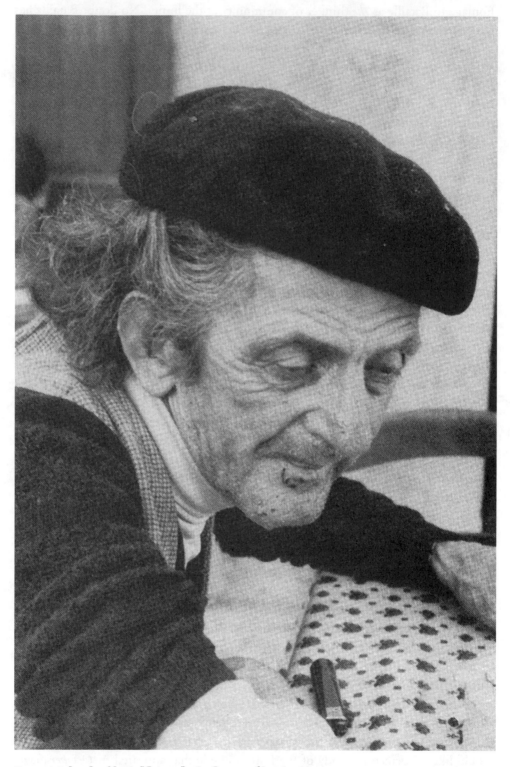

FIGURE I.4. Jean-Luc Nancy, "Georges," 1985. Courtesy of Jean-Luc Nancy.

analysis of Warhol in light of Nancy's photo ontology.[37] Applying the terms of the inoperative community and being-with photography, one could view Warhol as the perfect photographic "in-operator" who disengages with photography as a work or as a project in a practice that opens unto community as an experience of finitude. This reading suggests that Warhol's silk screen appropriations be viewed as photographic exposures of being-in-common in terms of both their subject matter and their technique.

In his study, Foster attempts to fit Warhol into a psychoanalytic mold as an example of what he calls "traumatic realism." The Warholian subject is both a shock absorber and an inducer whose multiples replay a series of traumatic incidents that are somehow "missed encounters with the real." Foster turns to Jacques Lacan's "The Unconscious and Repetition" to bolster his case that Warhol's repetitions of disaster function as both "a warding away of traumatic significance and an opening out to it, a defending against traumatic affect and a producing of it."[38] It is interesting to note that rather than beginning with a discussion of Warhol's art, Foster begins with an illustration that conflates physical wounds with traumatic experience by wheeling out Warhol's lacerated body after his being shot by Valerie Solanas. The image is Richard Avedon's exposure of the body in question—St. Andrew exposing his wounds. The caption has art photograph written all over it—"Andy Warhol, Artist, New York City, 8/20/69." Foster's regrafting of Avedon's graphic photo portrait sets up Warhol in the register of the martyred artist and photo-traumatized subject, and the use of an epigraph from J. G. Ballard's Atrocity Exhibition makes matters even more mutilated. One notes that Foster does not discuss Avedon's portrait in the text, thus making the image even more hallowed.

However, Foster's focus on traumatic realism as crucial to understanding Warhol's disaster series overlooks the question of community that is embedded in this photo-assisted ready-made practice. The traumatic reading of Warhol overlooks that Death in America articulates exactly the exposure to "someone else's death" that opens unto community and its openness. One recalls the words of Maurice Blanchot in "Someone Else's Death" in this context: "To remain present in the proximity of another who by dying removes himself definitively, to take upon myself another's death as the only death that concerns me, this is what puts me beside myself, this is the only separation that can open me, in its very impossibility, to the Openness of a community."[39] Putting us beside ourselves and thereby open to the (death of the) other, Warhol's Death in America series reminds us that America is exposed to its being-in-common when it exposes itself to someone else's death. Death and disaster—these are what opens up the thinking of America, and it is press photography that shoots them, exposing finitude in a mortifying array of sensationalist images such as car crashes, fires, and suicides. One recalls that this series also features the celebrated silk screens of Marilyn Monroe, who was then recently deceased. Such iconic images illustrate "how the experience of mourning . . . institutes the community but also forbids it from collecting itself."[40] This ghastly repertoire illustrates Warhol's proximity and debt to

his forebearer Weegee in the sense that Warhol appropriates and colorizes Weegee's world.[41] In an early interview, Warhol thinks of Death in America as community-exposed photography in the following way: "My show in Paris is going to be called 'Death in America.' I'll show the electric-chair pictures and the dogs in Birmingham and car wrecks and some suicide pictures."[42] Warhol's plan to do Death in America as an exposition in France is quite telling. This expatriate location becomes the perfect vantage point from which to show America bringing out its dead in order to expose the lacerating means by which it opens itself up to community.

Foster reads Warhol's interest in the silk-screened multiple as a traumatized repetition compulsion. In other words, he seeks to return to those sites of trauma where the death drive goes into overdrive, whether in the form of car crashes or electric chairs. But a reading inflected by Nancy's *Inoperative Community* sees something other than a "compulsive repetition" in Warhol's multiples.[43] For what do these multiples add up to if not a community of versions that enact a complex play of repetition and difference? In this light, each of the multiples constitutes its own community at loose ends. The photographic in-operator screens not a work of identity but a play of iterations. The slipping of the register of the image or the sudden opening of a tear serves as a model of belonging in difference. Foster does not miss the opportunity for staging another traumatic encounter with the real when dealing with such slippages. "These pops, such as the slipping of the register of the image . . . serve as visual equivalents of our missed encounters with the real."[44] In contrast to traumatic realism, being-with photography deploys the mathematics of set theory. These multiples operate according to the laws of set theory that demand both redundancy and singularity, or as Nancy phrases it, they show us that only "a being in common makes possible a being separated."[45]

In thinking about Death in America as community-exposed photography, one can see that the repetitions allow the Warholian subject to be protected from such a disastrous exposure to the gruesome cuts that forge community. But one does not need photo-traumatic theory to grasp this situation. As Warhol puts it, "But when you see a gruesome picture over and over again, it doesn't really have any effect."[46] From this vantage point, Warhol's celebrated numbing and loss of affect are the protective means by which to deal with an overexposure to mass media's death rays. Sontag's view that Warhol's is a "self-protective blandness with which he insulates himself from the freaky" is only half there.[47] It is the flip side of Warhol's dependence on and addiction to the contamination of the community of freaks exposed in his practice. In "Freud and the Scene of Writing," Derrida writes of the need of photo writing to protect itself against itself, against its own exposure. The Warholian subject requires such protection in order to expose itself better to the limit where photographic communication (and ecstasy) takes place. Using the same photographic metaphor, Derrida writes, "There is no writing which does not devise some means of protection, to protect against itself, against the writing by which the 'subject' is himself threatened as he lets himself be written: as he exposes himself."[48]

Thus, Warhol's strategy is to play the part of the photographic in-operator who does nothing but solicit the gaze in the direction of Death in America and who repackages this sensationalist material as photo silk screen and art commodity. As has been noted, Warhol's silk screens do not constitute an active work of creative production. Instead, these image appropriations are constituted in the unworking of reproduction. This is the special province of the photographic in-operator. In this way, Warhol's methods follow Nancy's idea that community is exposed only in withdrawal of the work—in an unworking that relies (unreliably) on our relation to death. To recite this passage from Blanchot: "If the community is revealed by the death of the other person, it is because death is itself the true community of mortal beings: their impossible communion." This true community of mortal beings applies especially to the series known as Death in America, in which the in-operator marks the deadly decisions that register belonging and nonbelonging, inclusion and exclusion. Warhol's Electric Chair silk screens provide a perfect example of this procedure by exposing and reiterating the violence of the law and the decision of community regarding whom to cut or excise—and by defining themselves in the process. The ready-made spotlight is turned onto the death machine that registers the sensationalist shock that gives community the jolt it needs.[49]

Situating Warhol's practice in terms of "in-operativity" complements Stephen Koch's reading of him as "the tycoon of passivity" in *Stargazer*, his fascinating book on Warhol as filmmaker. Koch foregrounds a privileged relation to Marcel Duchamp and the "aesthetic of indifference." Koch reviews how Warhol expanded the practice of the ready-made to the world of images and to the pop-culture artifacts that became arty facts through the effect of framing them in an aesthetic context. Koch concludes this chapter with a statement that returns to Warhol and the question of community: "His alienation, his otherness has the power to fascinate—we stare at it—because when we look at it, at him (I cannot choose the pronoun) we intuitively know that, despite this glittering negativity, this man is also One of Us."[50] But the analysis of Warhol as photo in-operator could be phrased differently, not in the assuredly affirmative (this man is also "One of Us"), but as someone who gives us more to consider than we know how to consider when he goes to the Factory (his "un-workplace") to pose the question Who is one of us? amid the glittering negativity of a frayed community at loose ends. Indeed, this question is applicable to any of the photographers of community considered in this volume.

Foster contends that the Warholian brand of traumatic realism produces spectators who are suspended between contemplative integration and schizoid dissolution. He invokes the following passage as proof: "'I never fall apart,' Warhol remarks in *The Philosophy of Andy Warhol*, 'because I never fall together.'"[51] In the mad dash to a psychoanalytically based photo theory, Foster does not mention that the original context of this statement relates to Warhol's speculations about media subjectivity and the impact of being on television. In other words, the original register of Warhol's remarks is media theory rather than psychoanalysis, prime time rather than primal

scene. While Marshall McLuhan speaks in a phallocentric manner of understanding media as the extensions of man, Dandy Andy, playing as a drag performativity theorist, inverts the media guru in a typically carnivalesque gesture that depends on making the switch. Man—if that's what you still want to call him—now becomes an extension of the medium. Rather than being posed as a missed encounter with the REAL, the televisual subject of this image world is now constituted as an effect of the REEL. While this positioning of the subject is not as electrifying or lethal as the electric chair, it gives identity the switch. Warhol writes: "The camera turns them on and off."[52] In contrast to Warhol, who never falls apart because he never falls together, the magic of televisual subjects happens because they come together only in the REEL. "Certain people have TV magic; they fall completely apart off-camera but they are completely together on-camera."[53]

Thus, "I never fall apart because I never fall together" is about being on television in a way that does not live up to the demands of the switch. Warhol invokes this feeling of angst in terms of vertigo, but in an exaggerated manner of being on the verge and at the limit. "I just sit there saying 'I'm going to faint. I'm going to faint. I know I'm going to faint. Have I fainted yet? I'm going to faint.'"[54] If this is traumatic, it is also pretty hysterical. It points to the deadpan humor of the Warholian subject who transforms trauma into laughter. One recalls a passage from Freud's essay "Humor" that is applicable to the silk screener of *The Tunafish Disaster:* "The ego insists that it cannot be affected by the traumas of the external world; it shows in fact, that such traumas are no more than occasions for it to gain pleasure."[55] The terms of traumatic realism are troubled by Freud's humorous remarks that offer another kind of opening, one that is linked to a community of shared laughter. It is another way of articulating this (wounded) body of experience that is not experienced. Freud's humorous conversion troubles Foster's traumatic reading of Death in America and suggests a more comic or camp look at Warhol's appropriation of media culture in general.[56]

But what if this statement were about community? What if we were to read Warhol's suspended statement ("I never fall apart because I never fall together") as a gesture toward being-in-common—being-in-common as always being at loose ends? Never falling apart into anarchy and confusion, never falling together into communion and fusion, the Warholian subjects mark a community at loose ends. Being at loose ends is another way to think about the photo in-operator. As mentioned, Nancy's *La communauté désoeuvrée* has been loosely and alternatively translated as "The Community at Loose Ends." This interpretation calls for a rethinking of the Factory under the sign of a "community at loose ends." In Thierry de Duve's study "Andy Warhol or the Machine Perfected," the loose ends of the Warholian community are showing, whether he knows it or not. "This world of 'freaks' gravitated around a central figure who had himself called the 'boss' but who made it a point of honor never to seem to have the slightest individuality. He didn't manage the Factory like a boss but like a madam, if he managed it at all."[57] Duve invokes the promiscuity of the brothel as the "proper" metaphor for the Factory community only to revoke it.

His analysis affords the carnivalesque opportunity to fantasize a transgendered Warhol as a madam. As queer as this might seem, Duve's analysis helps Andy to become the woman that he always wanted to be. He allows Warhol to camp it up as madam and to play loose with gender. But then he just as quickly takes back this managerial assertion with the disclaimer "if he managed it at all." The loose and frayed edges are showing in an analysis that glides from Warhol as factory boss to bordello madam to a state approaching disorganization. If the analysis cannot be managed, this is a direct consequence of dealing with the polymorphously perverse "community at loose ends" called the Factory. This is the community that could threaten to fall together by means of the S&M bonding of Gerard Malanga's whip dance, just as it could threaten to fall apart in any of the tripped-out multimedia performances of the Plastic Exploding Inevitable. In this community on the verge of being bound together or of unraveling altogether, Warhol plays the role of the photo in-operator who flipped on the switch that turned on (to) the Factory's manufacturing in "real/reel" time.

From David Antin to Nan Goldin, "I'll Be Your Mirror" has been heralded as the classic Velvet Underground song that demarcates the photographic economy of Warholian reproduction and its specific pop relationship to media culture.[58] But when it comes to a thinking of community as marking the advent of the other who is always arriving, another Lou Reed composition must be taken for a spin—"All Tomorrow's Parties," sung by the diva Nico (Figure I.5). Is not this song title but a rephrasing of Giorgio Agamben's *The Coming Community?* It is possible to imagine a

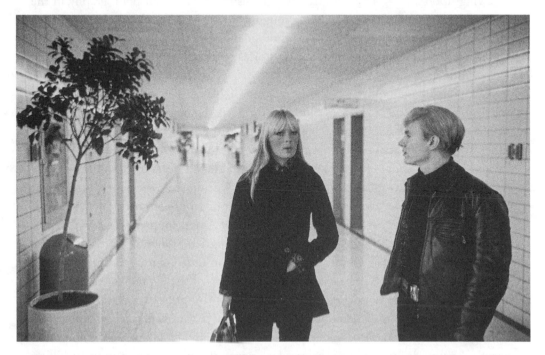

FIGURE I.5. Stephen Shore, "Nico and Andy Warhol at Rutgers University for a Velvet Underground Gig," New Brunswick, New Jersey, 1966. Photograph by Stephen Shore.

dialogue between the late chanteuse of the Velvets and the philosopher of *Language and Death*. Nico poses the first question, and it exposes the question of the pose. It is the photo-theatrical question par excellence: "And what costume shall the poor girl wear to all tomorrow's parties?"[59] How would this Italian philosopher respond to the Factory party member? In the section called "Example," Agamben illuminates what to wear to all tomorrow's parties, and he entertains the thought of who will be coming. "They are expropriated of all identity, so as to appropriate belonging itself. Tricksters or fakes, assistants or 'toons, they are the exemplars of the coming community."[60] Agamben lists and enlists four cryptic categories of Factory production at the disposal of the photo in-operator who exposes the coming community: tricksters, fakes, assistants, and cartoon characters. To which Nico adds two more possibilities: "For Thursday's child is Sunday's clown." In this extended weekend interval, Nico invokes the Warholian double gesture that shuttles between childlike naïveté and clownish put-on as the proper pose by which to signify belonging to the Factory's coming community. It is in entertaining such exemplary encounters that the thinking of Nancy, Blanchot, and Agamben allows for a "being-with Warhol" that affirms his photo appropriations of the 1960s and the Death in America series in particular as exposures of American community.

Scenarios

Drawing upon a number of diverse case studies from American photography in the twentieth century and proceeding in a roughly chronological fashion, this book provides an opportunity to think about photography and community from changing perspectives, through an array of sociohistorical contexts, and through a variety of angles and lenses of vision.

"'Living Photographs' and the Formation of National Community: Reviewing the Troops with Mole, Goldbeck, and Company" is the first foray into the dynamics of photography and community. It takes a look at the *living photographs* of the military photographer Arthur Mole and other photographers of mass formations. These images enact what Caputo states regarding the military aspects of community. Mole staged elaborate mass spectacles at military camps during the period 1917–1920, when he and John Thomas arranged tens of thousands of troops in artful formations in order to embody the national icons and symbols of American patriotism, whether in the shape of the living Statue of Liberty or the living Uncle Sam (Figure I.6). Mole's propagandistic images illustrate how national community is imaged and imagined during a time of war and plague (against the backdrop of the United States' entry into World War I and the pandemic influenza of 1918–1919) and war's celebratory aftermath (a leisure period of demobilization). This was a time when it was imperative to forge unifying symbols of fraternity, comradeship, and citizenship ("us") over and against "them." Indeed, Mole's spectacular images of national community as killing (and dying) machines can be productively paired with the following observation of

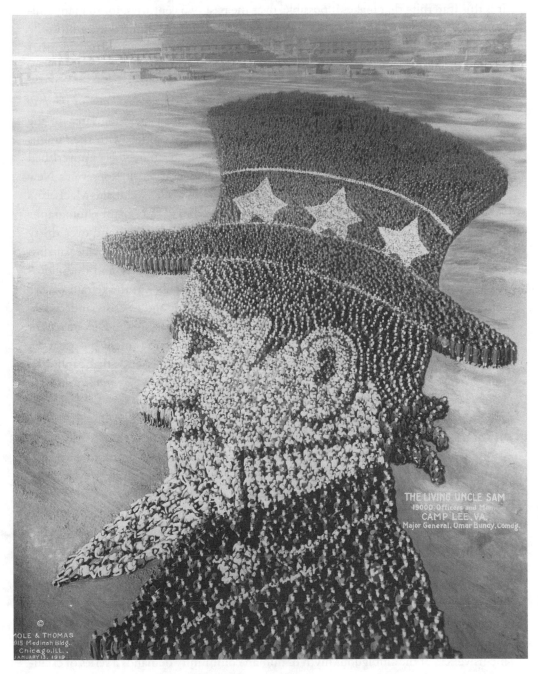

FIGURE 1.6. Arthur Mole and John Thomas, "The Living Uncle Sam," Camp Lee, Virginia, 1919. Courtesy of the Chicago Historical Society, negative ICHi-16309.

Benedict Anderson: "Regardless of the actual inequality and exploitation that may prevail, the nation is always conceived as a deep, horizontal comradeship. Ultimately, it is this fraternity that makes it possible, over the past two centuries, for so many millions of people, not so much to kill, as willingly to die for such limited imaginings."[61] This chapter also reviews how the same nationalist functions are repeated in other highly staged images—the films of Busby Berkeley, the panoramic images of Eugene O. Goldbeck, and the recent digital photomosaics of Robert Silvers.

The second chapter ("'We Don't Know': Archibald MacLeish's *Land of the Free* and the Question of American Community") is situated a generation later, in the period of the Great Depression. It provides an oblique encounter with the famous photographs of the Farm Security Administration that illustrate the impoverished condition of rural America and promoted the implementation of Roosevelt's New Deal programs. Composed in 1937 and published in 1938, Archibald MacLeish's *Land of the Free* is a singular image-text that he referred to as "a book of photographs illustrated by a poem."[62] Incorporating over fifty FSA photographs and over thirty others, *Land of the Free* raises the question of American community and issues of class conflict in a voice and a vision full of uncertainty. Both the poetry and the photographs partake of a rhetoric steeped in epistemological doubt (in the refrain of "we don't know") that locates the foundation of community in and as crisis, indecision, and the experience of limits. Rather than enlisting and mobilizing the FSA images of unemployed laborers to ideological ends or to function as government propaganda, *Land of the Free* resists with the vision of a community at loose ends that cannot be put to work. Drawing upon Jean-Luc Nancy's *The Inoperative Community* and his book *The Experience of Freedom,* this chapter analyzes the implications of MacLeish's "poetography" (a hybrid form at the crossroads of poetry and photography) for being-in-common.

Chapter 3 moves the photo imaging and imagining of community to an even more inclusive category with a look at the global rhetoric of the Family of Man exhibition of the mid-1950s, with its totalizing claim to give us the world (and what it has in common) by means of five hundred easy and legible (photojournalistic) images. "Photo Globe: The Family of Man and the Global Rhetoric of Photography" examines this canonical project of universal humanism that was instituted at the Museum of Modern Art in New York and traveled the globe under the auspices of the United States Information Agency during the height of the Cold War. "Photo Globe" is more than just a critique of the argument that photography is a universal language. It pinpoints the hegemonic gesture guiding the exhibition as it substitutes global claims for particular ideological interests. This translates into the ways in which the utopian inclusiveness of the ambiguous myth of human community demands a series of exclusions that mask inequality and cultural hierarchies. The chapter focuses specifically on two incidents related to the show's visit to Moscow, incidents that point to the racial and political agendas bubbling under the surface of the goodwill message that "we are the world." With the help of Jean-Luc Nancy and Roland Barthes, this chapter rather

affirms an unworldly and "unworlding" approach to photography that resists the claims of any global positioning system and the myth of communal fusion.

While moving out of chronological sequence, chapter 4 is in some respects a logical response to chapter 3, because it juxtaposes the Family of Man with "the Family of Nan." With this turn of phrase, *American Exposures* looks at the photography of Nan Goldin as the return of what was repressed by patriarchal family values and the heterosexist couplings dominating Steichen's exhibition. "Photography and the Exposure of Community: Reciting Nan Goldin's *Ballad*" examines Goldin's community-exposed photography of her re-created family and its subcultural excesses. It analyzes her work of the 1980s (e.g., *The Ballad of Sexual Dependency*) and early 1990s (e.g., *The Other Side*) in terms of Jean-Luc Nancy's essay "Shattered Love" in *The Inoperative Community*. This chapter reviews Goldin's subcultural groupings (her "community of lovers," drag queens, and AIDS victims) in terms of Nancy's concept of shattered love as "being broken into" at the limits of communication. In sociohistorical terms, these exposures of community are to be read against the background of the attempt to queer the normative concepts of American family values. The chapter concludes with a critical examination of the risks of essentialism and nostalgia that pervade Goldin's later community projects with the help of Alexander García Düttmann's study *At Odds with AIDS* in order to affirm "being-not-one with AIDS" and a loss of community that is constitutive of community.

The second half of the book (chapters 5 through 8) focuses on questions and issues related to the construction of racial and ethnic communities in post–World War II America. This period has been marked in terms of a shift from the myth of the melting pot to the rhetoric of multiculturalism, and this will become apparent in these studies. "Community in Fragments: Romare Bearden's Projections and the Interruption of Myth" rethinks Bearden's Projections series of 1964 and its articulation of African-American community in light of Jean-Luc Nancy's study "The Interruption of Myth." Bearden's work has been viewed as the foremost articulation of the African-American diasporic experience and of black community at the time of the emerging Civil Rights movement. This chapter seeks to recall Bearden's project in terms of an art of interruption rooted in Dadaist montage strategies. Rather than celebrating Bearden's Projections series as the production of a "creative mythology" (as does Mary Schmidt Campbell), this chapter examines this series of photomontages in terms of the fragmentary foundations of the African-American diaspora. Bearden's photo collages expose the displaced origins of African-American identity as a community in fragments (among competing African, Christian, and modernist claims) following Nancy's ideas about the interruption of myth. The final section of this chapter examines the limits of the dialectical approach of Kobena Mercer (informed by the dialogical imagination of Mikhail Bakhtin) for understanding Bearden's photomontages. In contrast to Mercer's approach, chapter 5 situates Bearden's Projections and the interruption of myth in relation to the general economy of Derridean *différance* and of "negativity without reserve."

The next chapter, "Slashing toward Diaspora: On Frédéric Brenner's *jews/america/a representation*," offers another investigation of photography and an American ethnic community grappling with issues of diaspora and acculturation. Brenner's ambiguous and ironic images of contemporary Jewish American communities (taken between 1994 and 1996) allow us to grasp the paradoxes that permeate postmodern Jewish experience. This chapter focuses on the figure of the slash as the mark of Jewish/American diaspora, which, among other things, advances Nancy's notion (in "Cut Throat Sun") that identity is constituted through cuts. Brenner's slashing wit (in the tradition of Jewish humor) exposes the ironies and incongruities that go along with these split (and even impossible) subject positions. With a sly sensibility informed by Jean Baudrillard's speculations on America as the land of spectacle and simulation and by other French theorists (such as Blanchot and Derrida), the Parisian-born Brenner constructs highly staged and theatrical images that foreground particular and peculiar performances of Jewish community and, in their studies of emergent forms, reflect on the shifting borderline of Jewish belonging (wherever it is located). "Slashing toward Diaspora" also uses Brenner's images as a means to contest the concept of "diasporized identity" as articulated by Jonathan and Daniel Boyarin in their study "Diaspora: Generation and Ground of Jewish Identity."

Chapter 7, entitled "Digital Chicanos: Pedro Meyer, *Truths & Fictions,* and Border Theory," introduces contemporary debates related to the rise of the digital image, which is often said to be "postphotographic" in nature. Nonetheless, Pedro Meyer's photography in *Truths & Fictions: A Journey from Documentary to Digital Photography* maintains the focus of the second half of the book on the photo exposition of ethnicity and race by analyzing the Mexican photographer's portrayal of Chicanos in the United States. My goal in this chapter is to bring the technical aspect of Meyer's digital manipulations into dialogue with the content of some of his images—the photographic imaging of mestizo culture in the United States and Mexico. The objective here is to foreground the parallels between the technical emphasis on digital manipulation and the loss of unadulterated reality, on the one hand, and the exposure of Chicano community in terms of its mestizo (or mixed) culture and syncretistic Christianity (which mixes Aztec and colonial strains), on the other. This chapter also relies on Nancy's "Cut Throat Sun,"[63] which in itself is an exploration of Chicano culture and identity, an exploration that refuses to essentialize them and affirms them as *mestizaje*—as an example of a community that opens itself to innumerable and uncountable couplings and cuttings. All in all, *Truths & Fictions* reviews a being-with photography Chicano-style that attends to the border and to the advent of the other.

The final chapter of the book brings these studies of photography and community to century's end with a look at the Korean-American photographer and performance artist Nikki S. Lee and her dazzling simulations of belonging that involve a range of subcultural groupings. "Performing Community: Nikki S. Lee's Photographic Rites of Passing" examines her recent performances of American communities with projects (and projections) that can be considered as a kind of "communal

transvestitism" (e.g., the Hispanic Project, the Lesbian Project, the Seniors Project, etc.). Lee's infiltrations of subcultures are "rites of passing" that raise the question, Who is one of us? Whether seen as failed mimicry or successful postmodern simulations, these Projects force a consideration of the meaning of group belonging and membership. While Lee's camouflage operations and her photographic proofs rely on the rhetoric of self-determination ("be who you want to be"), such extreme voluntarism is in tension with her Projects, which expose how identity is processed and projected only through being-in-common. Thus, *American Exposures* deploys Nancy's critique of individualism to challenge some of the assumptions guiding Lee's Projects. This chapter also discusses the theories of Judith Butler in *Gender Trouble* and the performances of Adrian Piper and Cindy Sherman. Such analysis situates Lee's Projects in relation to major postmodern artists who have made photographic representation a staging ground for parody and the performance of identity, gender, and community.

TARRYING WITH THE (IM)POSSIBLE

In "Loving in Friendship: Perhaps—the Noun and the Adverb" in *The Politics of Friendship,* Jacques Derrida addresses the commonality that he finds in the thinkers of community (i.e., Georges Bataille, Jean-Luc Nancy, and Maurice Blanchot) as they posit concepts that only appear to depose themselves. Alluding to his own impossible naming of this phenomenon as "community without community," Derrida proposes

> to speak this community without community. To speak to it and thereby—let us not hesitate to clarify this—to form or to forge it. And to do so in the language of madness that we must use, forced, all of us, by the most profound and rigorous necessity, to say things as contradictory, insane, absurd, impossible, undecidable as "X without X," "community of those without community," "inoperative community," "unavowable community": these untenable syntagms and arguments—illegible, of course, and even derisive—these inconceivable concepts exposed to the disdain of philosophical good conscience, which thinks it possible to hold out in the shade of the Enlightenment; where the light of the Enlightenment is not thought, where a heritage is misappropriated. For us there is no Enlightenment other than the one to be thought.[64]

These studies seeking to form and to forge relations between photography and community are fraught with contradictions and even impossibilities. Yet, these consequences are in keeping with a being-with photography and with a thinking that exposes the limits. In other words, *American Exposures* insists that community and photography—as discourses of exposure that pose and open unto finitude, death, and exteriority—are explored and experienced only as and at the limits. While photography, along with its light writing, may have been a brainchild of the Enlightenment, with its birth in the early nineteenth century amid a scientific vision steeped in

positivism, empiricism, and truth claims, this heritage will have become misappropriated when community is exposed—where "the light of the Enlightenment is not thought" and where finitude and finite existence are shared.

But this is not to say that reflection on the relationship of photography and community dwells in the darkness of the camera obscura either. It is, rather, to think of photography and community in terms of relation and communication and in terms of the passage from the one to the other. (In *Being Singular Plural,* Nancy calls "between us" the first philosophy.)[65] It is, rather, to advance these "inconceivable concepts exposed to the disdain of philosophical good conscience," yet exposed to photography as a mode of exposition to the common and the in-common. It is, rather, the acknowledgment of death, absence, and finitude at the core of this relationship that removes "community-exposed photography" as an object of knowledge and that poses and exposes it at the limit where work is interrupted (in the terms of the "inoperative" or "unavowable" community).[66]

It is, rather, to tarry with these (im)possible formulas that speak the mad truths of photography and community that this book has been written.

Community-exposed photography—so much for an opening.

1. "Living Photographs" and the Formation of National Community

Reviewing the Troops with Mole, Goldbeck, and Company

A Patriotic Mole

As recent political events in the United States have reminded us, a wartime environment produces and reproduces a collective investment and communal identification in the figures and emblems of national sovereignty. In post–9/11 America, "rallying around the flag" appears to be endemic to a political moment in which the display of a variety of patriotic icons and symbols functions as a talisman to heal a wounded political body and to bolster national pride. This "mass conversion to flag waving" functioning as a political reaction formation and a homeland security blanket is documented in a recent online photography project and Web site wittily titled "Flagging Spirits."[1] These photographs expose how the flagging spirits of the American body politic appear to be lifted with the raising of the Stars and Stripes. One also could argue that such times of crisis are the privileged moments for a sovereign political power to assert its authority by means of visual spectacle and iconic emblems on account of the readiness of an anxious and insecure public to be receptive to such figures of national security. This chapter will address the enactment of this visual rhetoric of patriotism and the forging of national community through a unique set of photographic figurations rooted in the *living photographs* of Arthur Mole and continuing to the present day in the digital images or photomosaics of Robert Silvers. This nexus of case studies revolving around Mole's photographs as a pivot will illustrate numerous photographic formations of community that deploy masses of male soldiers to stage national and patriotic symbols. In this way, the very enforcers of national sovereignty are enlisted to perform optical illusions in the service of community. At the precise moment when the United States entered the Great War in 1917,

an itinerant photographer by the name of Arthur S. Mole began to make spectacular images at various military bases throughout the United States.

In his *War and Peace in the Global Village,* the media savant Marshall McLuhan reminds us: "When our identity is in danger, we feel certain that we have a mandate for war. The old image must be recovered at any cost."[2] In taking up these communal photo formations of Arthur Mole, I would like to posit the opposite as well: when we have a mandate for war, we feel certain that our identity is in danger; the old image must be recovered at any cost. The so-called living photographs and *living insignia* of Arthur Mole are photo-literal attempts to recover the old image of national identity at the very moment when the United States entered the Great War. In these amazing images structured as mass ornaments, thousands of military troops (and other groups) were choreographed by the photographer in artful formations and arrangements that reveal patriotic symbols, emblems, or military insignia from a bird's-eye perspective that mimes aerial photography.[3] Mole's photos assert, bolster, and recover the image of American national identity via photographic imaging. Moreover, these military formations serve as rallying points to support United States involvement in the war and to ward off any isolationist tendencies. In life during wartime, Mole's patriotic images function as "nationalist propaganda"[4] and instantiate photo-cultural formations of citizenship for both the participants and the consumers of these group photographs.[5] Then, after the war was over, Mole continued to make many more iconic images as the troops awaited their demobilization.[6] According to Jeffrey Schnapp, Mole was so successful that he and his partner, John Thomas, were almost granted a special assignment to commemorate Armistice Day (November 11) symbolically and to foreground its numerological significance. Schnapp writes, "By the end of the war, Mole and Thomas's success was such that they very nearly persuaded the American armed services to permit them to cross the Atlantic so as to shoot the most massive living portrait ever assembled: a clock marking the eleventh hour, portrayed by the entirety of the American armed forces stationed in Europe."[7] Orchestrating tens of thousands of military troops in these photo formations, Mole's images include national symbols (e.g., the American flag, the Liberty Bell, the Statue of Liberty) as well as the insignia of various military fighting units (e.g., the U.S. Navy, the Marine Corps, etc.). These widely distributed photographs of patriotic icons both image and imagine American community at a heightened moment of national self-consciousness.

Not much has been written or recorded about this unusual military photographer, and Mole appears not to have left any diaries of his photographic adventures.[8] But we do know that he was born in England in 1889, that he immigrated to the United States at the age of twelve, and that he would live out his years in Florida, where he died in 1983. Mole's foreign-born status is surely an important fact for his life writing, and it foregrounds the question of citizenship and national community from the outset. Indeed, the shift from "God Save the Queen" to "God Bless America" as patriotic anthems would help to explain why this photographer became so obsessed with group portraits of military formations devoted to the symbols and

emblems of American nationalism from Uncle Sam to the Stars and Stripes. Not being a native son, Mole bends over backward or cranes his neck forward from his aerial photographic position—often working in a self-fabricated rickety tower seventy to eighty feet above the ground—so that he can prove his patriotism to his newly adopted fatherland. The living insignia become the photographic proofs of how he pledges allegiance to the United States. In this way, the darkroom development process also functions as a naturalization process and helps to recast Mole from an alien British subject to a full-fledged American citizen.

Given this transatlantic leap in citizenship, it should come as no surprise to learn that the American flag serves as the overdetermined subject for Mole's first image that transforms a military unit into pointillistic pixels in the formation of a national symbol. This is his "Living American Flag" (Figure 1.1), which was taken to commemorate Memorial Day of that fateful bellicose year, 1917. This patriotic photo-cultural formation consists of ten thousand sailors stationed at the Naval Training Station in Great Lakes, Illinois. They appear snapped by Mole during an act of excessive flag waving at the time of America's entry into the Great War. The mimetic likeness of Mole's "Living American Flag" goes so far as to appear as if it were animated and rippling in the wind. In addition to satisfying the British-born photographer's overcompensatory need to feel like an American, the image is perfectly suited to the soldier-subjects who constitute the flag and who lose themselves in the process. For this military group portrait offers a clear-cut enactment of how each soldier who stands phallically rigid at attention gives himself over to the symbolic order (which is represented by and inscribed as the flag) in a cathexis of male libidinal energies in the service of the fatherland. The image offers living proof that the flag is being protected and celebrated in the performance of the soldier's patriotic duty and that the paternal order of the nation (or, as the French call it, *patrie*) is being upheld. The French psychoanalyst Jacques Lacan employed the term *symbolic order* to demarcate the rules, laws, and language that compose the sociocultural realm and explained how this order maintains and reinforces paternal and patriarchal demands. (This is what Lacan referred to as the *paternal metaphor*.)[9] As Judith Roof points out in the introduction to her book *Reproductions of Reproduction: Imaging Symbolic Change*, "the paternal works as the emblematic metaphor of the Symbolic."[10] In applying Roof's analysis to Mole, we can see that this image using an all-male military formation to inscribe the flag as nationalist symbol in a photo-literal way articulates how "male-centered hierarchies jealously protect the realm of metaphorical figuration by which order is understood."[11] Moreover, what makes this image even more spectacular is the theatrical and self-reflexive gesture of a salute that the sailors give to the camera and to the flag they constitute. The regimented martial salute of these ten thousand strong registers their total subordination and submissiveness to the symbolic order and illustrates what the colloquial expression "being in the service" really means. With this unifying gesture, Mole's "Living American Flag" underscores the idea of self-sacrifice and collective action necessary for the success of any fighting unit. In this way, the

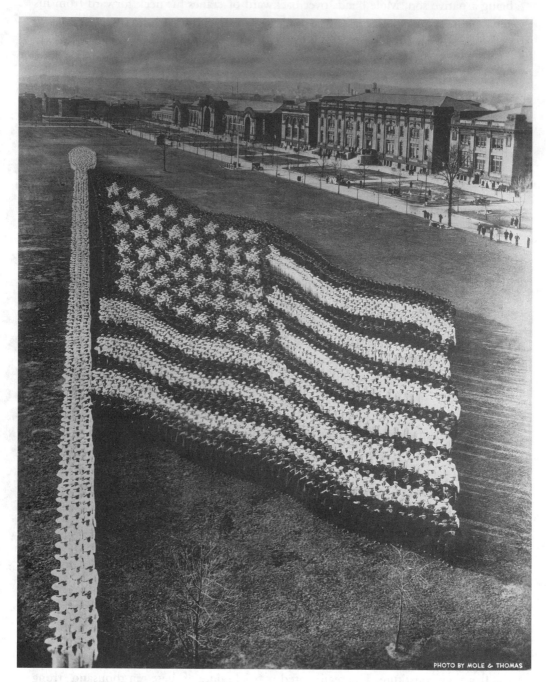

FIGURE 1.1. Arthur Mole and John Thomas, "Living American Flag," Great Lakes, Illinois, 1917. Courtesy of the Chicago Historical Society, negative ICHi-16299.

loss of individual will locates the totalitarian risk that is always an essential part of this stripe of militarism, to which this analysis will return later.

This is not to say that Mole's flag photo formation is the first (or the last) one on record in the annals of the history of photography.[12] For example, an anonymous stereographic vernacular image with a similar title ("The Living Flag") was shot at a national convention of the Grand Army of the Republic (GAR) in Cleveland, Ohio, in 1901. This charming 3-D image would reinforce communal bonding when sold to the attendees of this Civil War veterans' convention as a keepsake to remember the event in a lifelike illusionist manner. As in Mole's image, the Union veterans pay their respects to the living flag, which represents the flag they fought to defend against the Confederate rebels. But unlike Mole's totalizing spectacle, which offers no outside to its formation on account of its air traffic controlling bird's-eye view, this earlier image is shot from a lower angle and a longer view. In this way, it is divided between actors (the flag makers) and spectators (the GAR conventioneers), who gaze upon the spectacle and the flag that they honor.

MOLESQUE AND BERKELEYESQUE SPECTACLE

Some might think it improper to compare Mole's military formations in the photographic medium with the Hollywood film choreography of Busby Berkeley (or what one historian refers to as "hyperspectacularized Berkeleyesque cinema").[13] Nevertheless, Mole's fervent desire to "aestheticize the political" (to use Walter Benjamin's famous phrase) and to offer up the theater of war as an entertaining visual spectacle is not that far removed from Berkeley's filmic strategies. Of course, there is a major difference involving the issue of gender here, for while most of Mole's martial group portraits depict the direction and manipulation of a male cast of players dressed in military uniforms, Berkeley's visual spectacles for the most part feature the chorus girl as choreographic agency in order to entertain and captivate the male gaze. But the most uncanny point of comparison between the two symbol makers involves their similar penchant for design formations and living insignia strikingly displayed from bird's-eye camera perspectives. As Siegfried Kracauer wrote in his essay "The Mass Ornament" (1927), invoking a term that can be applied equally to both Mole's and Berkeley's practices: "The [mass] ornament represents the *aerial photographs* of landscapes and cities in that it does not emerge out of the interior of the given conditions, but rather appears above them."[14]

In 1933, Berkeley released with the Warner Brothers Studio a musical entitled *Footlight Parade,* starring Jimmy Cagney and Ruby Keeler. The title already hints at a spectacle involving a mixture of marching and theatricality. The film is most remembered for the hydrotechnics of the musical number "By a Waterfall." Part of this scene is shot with an overhead camera, by which one hundred bathing beauties are transformed into intricate geometric designs, or, as *The Busby Berkeley Book* describes it with all of its sexual connotations, "an elaborate aquacade of one hundred girls, led

by Ruby Keeler, performing kaleidoscopic patterns in the water and climaxing in a huge human fountain."[15]

However, this is just the beginning, because the next and final musical number—the so-called Shanghai Lil sequence—has even more connections with Mole's symbolic photo formations and nationalist propaganda. James Cagney (who was renowned for his Academy Award-winning portrayal of George M. Cohan in *Yankee Doodle Dandy*) plays a sailor in this fabulous plot, and he is in search of his love, Shanghai Lil, who turns out to be none other than a "yellowfaced" Ruby Keeler. The romantic couple's discovery of each other provides an opportunity for an elaborate celebratory parade featuring a squadron of marching American sailors, who are later joined in the finale by a group of "Chinese" women. But, as if to ward off the threat of the other in their midst or to assimilate them already to the American way, the players turn themselves into living insignia here, propagating the symbols of American nationalism, with the women sporting sailor uniforms as a further marker of their Americanization. As Martin Rubin points out in his book *Showstoppers: Busby Berkeley and the Tradition of Spectacle*, "The final movement of the number collapses depth into surface, here via placard formations depicting the American Flag and FDR, and an overhead pattern in which the tops of the chorus's caps create an image of FDR's National Recovery Administration eagle."[16]

While the Stars and Stripes are a constant symbol of national community during this fifteen-year interval, the other two symbols deployed by Berkeley signal the historical difference of the political era that separates Mole's wartime photo stagings circa 1918 and Berkeley's own New Deal cinematic production. Although the presidential motif has remained in place, Mole's Woodrow Wilson (Figure 1.2) is replaced with Franklin Delano Roosevelt in *Footlight Parade*. Furthermore, Berkeley's display of the imperialist eagle of life during wartime is not à la Mole. Nor does this choreographer aestheticize the political in a manner similar to that of Roy Stryker's contemporary FSA photographers and the social documentary realism of hard times.[17] Shirking the brutally realistic or visually ironic depictions of a Dorothea Lange or an Arthur Rothstein (to be discussed further in the next chapter), Berkeley's symbolic eagle is the fanciful product of a major production number incorporating dance, show music, and an elaborate visual illusionism formed out of the tops of the chorus's caps. While much in Berkeley's film fantasies is to be understood as the perfect escape valve from the difficulties of the Depression, the showstopping appearance of the NRA eagle and the living insignia in this scene are meant to rally the nation around FDR's New Deal policies by means of spectacle. Thus, while the FSA photographers and Berkeley were both making propaganda for the New Deal, they deployed radically different visual rhetorics—the photograph as social document versus the cinematic hyperspectacle.

Interestingly enough, Tony Thomas and Jim Terry point out that it was Berkeley's own military training during World War I that provided him with his introduction to the art of choreography. It so happened that part of Lieutenant Busby Berkeley Enos's duties in France was to conduct the parade drill. A telling anecdote of Berkeley's

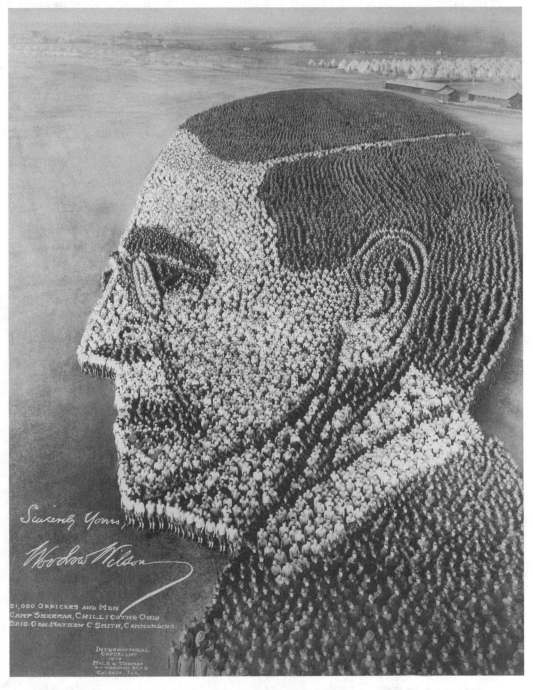

FIGURE 1.2 Arthur Mole and John Thomas, "Living Portrait of Woodrow Wilson," Camp Sherman, Chillicothe, Ohio, 1918. Courtesy of the Chicago Historical Society, negative ICHi-16304.

reveals how he "worked out a trick drill for the twelve hundred men" when he tired of the same old routine.[18] As Thomas and Terry describe the climactic scene in *Footlight Parade,* "Berkeley now has an opportunity to show his virtuosity with military drills as the sailors and their Chinese girlfriends go through the paces doing configurations of the American eagle, the Stars and Stripes, and even Franklin Delano Roosevelt's face."[19] From this perspective, Berkeley's career in Hollywood might be understood as the (over)production of the spectacle of war by another means: on the silver screen. This set of circumstances brings Mole and Berkeley much closer in a mutual concern for pageantry and spectacle and in the convergence of the military drill formation and the Hollywood musical showstopper.

PHOTO-RELIGIOUS FORMATIONS IN THE COMMUNITY OF ZION

In the communal constitution of Arthur Mole, a strong set of formative ties requires recognition. This takes us back to his religious community. To rephrase contemporary pop singer Lauryn Hill, the joy of Mole's world was in Zion. Mole's promised land was not located in Jerusalem but rather in Zion, Illinois. Arthur Mole came to the United States because he was a follower of Dr. John Alexander Dowie, whose dream for a Christian communal utopia spurred him to establish the city of Zion, located six miles north of Waukegan, in Lake County, Illinois. Although Dowie founded the Christian Catholic Church in Chicago in 1895, this controversial faith healer decided to get away from the evils of the big city and to set up his own community under church leadership in answer to the call of "Salvations, Holy Living, and Divine Healing."[20] If Dowie is credited with converting the Mole family to his way of Christian living, then Arthur Mole is responsible for converting the person of John Dowie into a living portrait approximately fifteen years later in one of his first large-scale group productions. This is an amazing image, positioned to give the faith healer a nimbus in the shape of the circular walking path of Zion Park.

Mole arrived in Zion, Illinois, just around the time when the faithful had begun building homes and when the Christian Catholic Tabernacle (which was able to seat a Mole-like crowd of up to ten thousand people) was built, in the summer of 1901. The church was also the place where Arthur Mole met John Thomas. John D. Thomas was to become Mole's choreographic collaborator for the living photographs, and he worked as the director of the church choir. Thomas's white-robed choirboys and the church congregation provided a readymade resource for the hundreds of religious bodies that were required for the staging of their first group portraits around 1913. Under the direction of Mole and Thomas, the choir functioned as both a singing *and* a marching unit, whose bodies as well as voices were enlisted to create visual patterns and harmonies in living insignia designed to illustrate religious motifs. These first communal images may be viewed as photo-religious formations of Christian community. Assuming the shape of crosses, crowns, and other religious symbols, the members of the Christian Catholic Church of Zion seemed to be taking communion

together via photographic means, with Arthur Mole as the officiating priest, conse-crating the sacrament from on high with the snap of his 11-by-14-inch-view camera.[21] "The Cross and the Crown" (1913) is considered the first Mole and Thomas living photograph, and it enlists approximately fifteen hundred congregants in a forma-tion that shows the visible signs of a religious transfiguration. According to Jean-Luc Nancy, "Communion takes place, in its principle as in its ends, at the heart of the mystical body of Christ."[22] However, in Mole's photo communion, mystical embod-iment takes place in the transfiguration of bodies into Christian religious symbols when they congregate under the direction of such group photographic stagecraft.

Mole also tried out other specific symbolic formations designed to expose the special bonds that held together this religious community. One image, which at first glance evokes the formation of a football marching band, shows a clock face with the big hand on the twelve and the little hand on the nine. But closer investigation of "The Living Clock," taken at the Shiloh Park in Zion City, reveals a religious motive to this analogical piece of timekeeping. Alternatively titled "The 9 o'Clock Hour of Prayer," it marks the witching hour when the Zion faithful of the Christian Catholic Church paused like clockwork for prayer and meditation every day and evening. It must be confessed that not every number shows up so well in this image. The four, five, six, and nine could use a somewhat better alignment, whether because of per-spective problems or some slippage in discipline on the part of the choirboys.

Mole would return to this same park field after World War I, on July 19, 1920, to compose "The Zion Shield" (Figure 1.3). This image foregrounds the militant and militaristic impulse of this photo practice of religious community and the inclusive closing of its ranks around the sword and shield of its emblematic warrior figure, con-stituted by the religious faithful. Not fully pixelated by human means, the formation also includes textual components in the form of handheld banners. These large-scale placards preach the gospel according to this Zionist crusader. For instance, one reads the word SALVATION on the band of his Roman gladiator helmet, RIGHTEOUSNESS at the top of his breastplate, and TRUTH in the middle. WORD OF GOD is emblazoned on the sword that the crusader wields in his right hand, and the symbol of the cross is placed in the middle of the human shield that is held in the crook of the left arm. All in all, this (Spartanesque) crusader image delivers an aggressive portrait of reli-gious community that illustrates Zion's fighting spirit and missionary zealotry.

AMERICAN MILITARY INSIGNIA

It is only a short step from a militaristic image in the service of Christian communal-ism to a spectacular image using the American military to affirm the bonds of national community and sovereignty in the transfiguration of the Zion shield with the cross into the American shield in Mole and Thomas's largest living photograph. They assembled thirty thousand enlisted men and officers in 1918 to form this image, "The Human U.S. Shield" (Figure 1.4), at Camp Custer, in Battle Creek, Michigan. It is

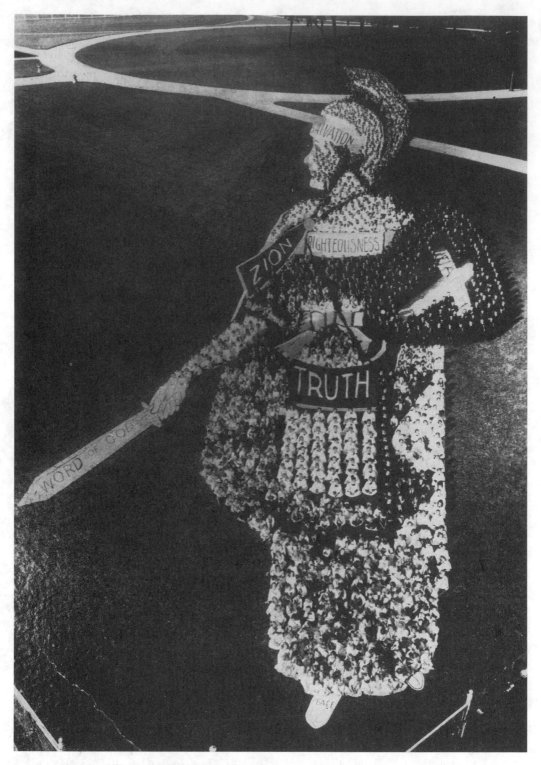

FIGURE 1.3. Arthur Mole and John Thomas, "The Zion Shield," Zion, Illinois, 1920. Courtesy of the Chicago Historical Society, negative ICHi-16261.

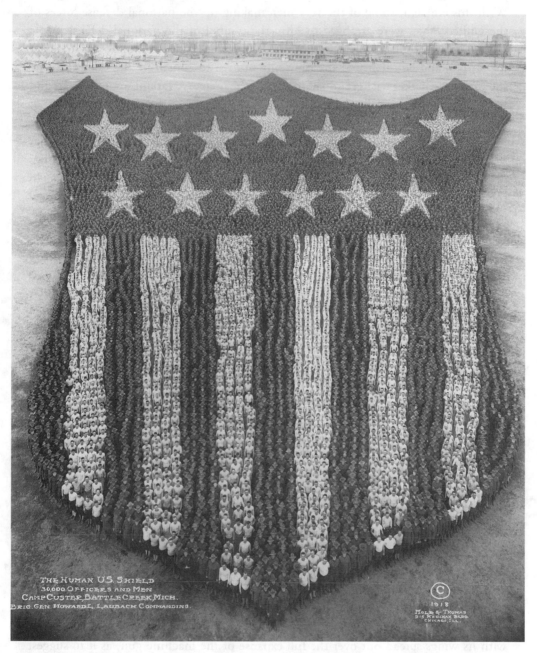

FIGURE 1.4. Arthur Mole and John Thomas, "The Human U.S. Shield," Camp Custer, Battle Creek, Michigan, 1918. Courtesy of the Chicago Historical Society, negative ICHi-16303.

interesting to note that it was recently included in the Rhetoric of Persuasion exhibition at the Museum of Modern Art in New York, where it was presented as an example of state-serving military propaganda on a par with Soviet and Nazi examples.[23] With this emblem, some of the very men making up the national defense forces of the United States were arranged to form the symbol of the national defense. Mole aligned the troops in thirteen swathes, alternating white and dark uniforms to depict the stripes, and he calculated the right mix of men to constitute the thirteen white stars against a darker background at the top of the image. A variant upon the stars and stripes of the American flag, the shield protects and secures the territorial borders of the nation-state and the community of American citizens. The armoring of the male body in the service of the nation-state is quite explicit here, and there is the sense that the individual soldier's investment in this collective shield and the resultant feelings of solidarity would allay or sublate his potential fears regarding any deadly chinks in the armor. In other words, such an excessive image celebrates patriotism and paternal law even as it displays an anxiety about the stability of the symbolic order under the threat of war and potential collapse.

In addition to the patriotic symbolism of the flag and the shield, Mole's camera also shot a number of military units in photo formations inscribing their own insignia. For instance, Mole and Thomas assembled a unit of sailors in uniform to represent the navy in the undated "U.S. Navy Insignia Anchor," for which there is little archival information. Shortly after the end of the Great War on December 10, 1918, Mole and Thomas staged another intricate and spectacular living-insignia photograph at Camp Hancock, in Augusta, Georgia. The caption reads: "Machine Gun Insignia. Machine Gun Training Center. 22,500 Officers and Men. 600 Machine Guns" (Figure 1.5). Here, we witness the community of those who have machine guns in common. While the "Living American Flag" stages an interactive relationship between the saluting soldiers and the flag they form, the "Machine Gun Insignia" turns out to be more metonymic in its relationship of the part to the whole. In other words, each machine gunner in the middle is photographed (or shot) in the act of firing, but collectively they form a living machine gun. Mole and Thomas choreographed a Berkeleyesque maneuver in the foreground of this image by having the troops lying prostrate and sprawled over the field to form the trimming of the insignia, the trigger of the gun, and the initials MG. All in all, the "Machine Gun Insignia" imposes a violent act of graphic inscription upon the male bodies of these armed defenders of the United States that subjects each gunner to playing the part of a cog in the American war machine.

In addition, the upper portion of this insignia features a living American eagle with its wings spread out over the full expanse of the machine gun, as if to suggest that the weapon is under the protection of this nationalist symbol. The imperial and statist symbol of the American eagle also shows up in two other Mole and Thomas bird's-eye group portraits of 1918, one involving the staging of 12,500 troops in an American eagle formation at Camp Gordon in Georgia, the other of 9,100 marines in

the formation of the Marine Corps emblem under the cover and protection of the national bird at the military base in Parris Island, South Carolina, on January 24, 1918. But what makes the "Living Emblem of the United States Marines" (Figure 1.6) even more fascinating is the introduction of the globe at the very heart of this insignia. Significantly, it is turned to the American hemisphere and is pierced by the marine anchor, suggesting that the globe can be anchored only in and through the United States Marine Corps, rather than signaling a kind of global citizenship. At the height of the United States' involvement in World War I, Mole staged a living formation inscribing American ideals that answer to the symbolic demands of the imperial and imperialist eagle that oversees this scene.[24]

LIVING PORTRAITS AND OTHER NATIONAL SYMBOLS

The "Living Portrait of Woodrow Wilson" (Figure 1.2) is the most widely known and circulated of all Mole and Thomas's photographs. It contains that characteristic aspect of the living photographs that wavers between the compositional effect of the whole

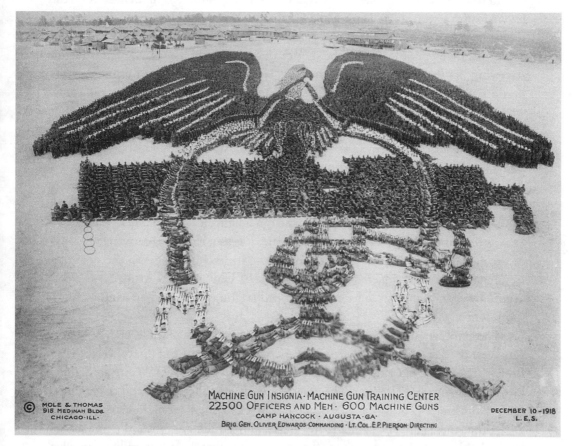

FIGURE 1.5. Arthur Mole and John Thomas, "Machine Gun Insignia," Camp Hancock, Augusta, Georgia, 1918. Courtesy of the Chicago Historical Society, negative ICHi-00107.

(i.e., a portrait of Woodrow Wilson) and the desire to focus upon the obscured individuals who constitute the image, thereby making the optical illusion of the totality disappear. In this photograph, twenty-one thousand American citizens assembled at Camp Sherman in Chillicothe, Ohio, in 1918 to form the head of Woodrow Wilson. To call this image a portrait would be a bit misleading, because its purpose is not so much to represent the countenance of Woodrow Wilson as to signal what he represents and symbolizes. In other words, he clearly functions as a "figurehead," as Lacan's *paternal metaphor*. Wilson symbolically represents the paternal function of the American fatherland—the power that accrues to the presidential office and to the commander in chief of the armed forces or, as they say, to the dignity of the executive office. The effect of his signature flourish and the personal salutation "sincerely yours" mask the photo-copied status of Woodrow Wilson as the impersonal representative of the symbolic order. Unlike many of Mole's wartime photo formations and exposures of national community, this living photography included both men and women, purportedly to unite the entire nation in hailing to the chief and in affirming the bonds of American citizenship.[25]

In this regard, we can say that Woodrow Wilson's status as a figurehead is no different from that of Uncle Sam. Mole's photograph called "The Living Uncle Sam" (Figure I.6) was taken a little later on January 13, 1919, and it may be viewed as another one of his living photographs to be shot in the wake of the Great War and to figure American national icons as part of the mass victory celebration prior to the demobilization of the troops. The profile of Uncle Sam consists of nineteen thousand troops who were stationed at Camp Lee in Petersburg, Virginia. Unlike the Woodrow Wilson image, "The Living Uncle Sam" appears more in the mold of a caricature with his pointy white goatee, American star-studded top hat, wavy hair, and ribbon bedecked ponytail. (For a point of comparison with these stereotypical features, one might find the same characteristic markers by looking at Diane Arbus's freaked-out portrait of Max Lander playing at Uncle Sam in the sixties.) Mole and Thomas's "Living Uncle Sam" performs a feat of political propaganda in a light-hearted manner. With Uncle Sam as the subject of their photographic desire, it is as if these troops were answering to the demand of interpellation of the man who had wanted them in the first place (recalling the popular advertising campaign of the United States Army, "Uncle Sam Wants You") and, in consequence, further propagating that same demand to future spectators of the image.

The photographs of the other two national symbols that Mole orchestrated in 1919 were the "The Human Liberty Bell" and "Human Statue of Liberty" (Figure I.7). Both of these images focus on a crucial aspect of the ideology of American national identity—liberty and freedom. The choice of both the Liberty Bell and the Statue of Liberty illustrates Mole's practice as one in quest of American national community. Given that these patriotic symbols are composed of military troops, the images also imply the rhetoric of war, and they offer the platitude that American military involvement is always made in the defense of liberty. For "The Human Liberty Bell," Mole

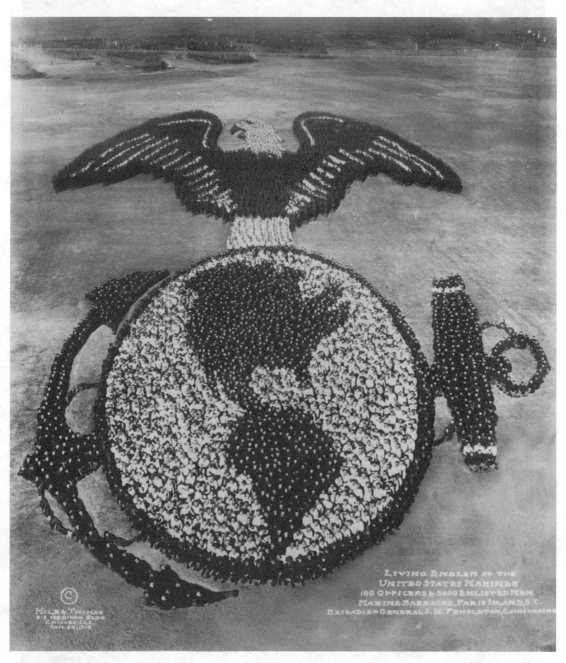

FIGURE 1.6. Arthur Mole and John Thomas, "Living Emblem of the United States Marines," Marine Barracks, Parris Island, South Carolina, 1918. Courtesy of the Chicago Historical Society, negative ICHi-18598.

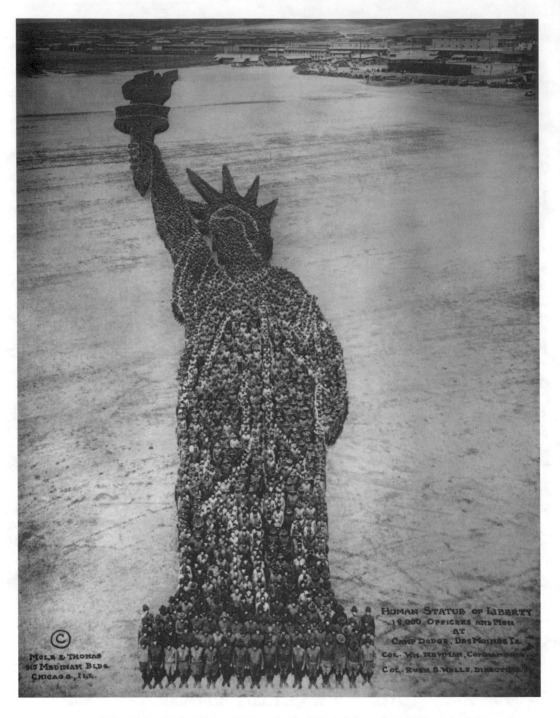

FIGURE 1.7. Arthur Mole and John Thomas, "Human Statue of Liberty," Camp Dodge, Iowa, 1919. Courtesy of the Chicago Historical Society, negative ICHi-16308.

and Thomas went to Camp Dix, in New Jersey, not far from the City of Brotherly Love, to assemble twenty-five thousand troops in the shape of the national symbol. The photo stages the Liberty Bell replete with its famous crack to increase its mimetic likeness and symbolic power, and one notes the human inscription of the word *LIBERTY* at the top of the bell, which signals an advance from the earlier cue cards of the Zion images. Meanwhile, Mole and Thomas's "Human Statue of Liberty" is a cross-dressed affair that assembled eighteen thousand officers and men at Camp Dodge, in Des Moines, Iowa, to play Lady Liberty. This image was one of the most challenging technically for Mole and Thomas. From the top of the torch to the base, Mole and Thomas's Statue of Liberty measures 1,235 feet, and, in consequence, the image is extremely top heavy in personnel. The Statue of Liberty would be especially overdetermined as a patriotic symbol for an immigrant like Mole, especially at this particular point in American history. It is important to recall that Mole's image was taken just five years before the passage of the Immigration Restriction Act of 1924 and at a time when the terms of naturalization and citizenship were hotly contested issues in the public sphere. (Appropriately enough, this image is now on permanent display at the Statue of Liberty Museum on Ellis Island.)[26]

EUGENE GOLDBECK'S LIVING INSIGNIA

The tradition of living insignia photographs in a military context was carried on in the next generation by the itinerant photographer Eugene Omar Goldbeck (1891–1986), who was based in San Antonio, Texas, began his career as an instructor in the U.S. Army Signal Corp's School of Photography in World War I, and founded the National Photo Service as a commercial agency that would evolve into the National Photo News Service. In her essay review, Ellen Zweig astutely links Goldbeck's choice of subject matter to his own staunch patriotism. "He was intensely patriotic, which is part of the reason he devoted much of his career to photographing the military troops of his country."[27] In contrast to the undervalued Mole, Eugene Goldbeck has been the subject of three major monographs, and his vast archive of photos is housed in the Harry Ransom Humanities Research Center at the University of Texas in Austin.[28] Goldbeck always credited Mole with inventing the concept of living insignia, but Goldbeck applied his technical innovation by making a few of them as panoramas using his specially modified Cirkut camera.[29] While Goldbeck's fame is grounded in panoramic group images in general, three of his important living insignia photos are often reproduced. These images forge photo formations of military community and patriotic bonding.

The first image, the "Living Air Service Insignia," was shot on January 20, 1926, and in it the insignia is formed by thirteen hundred men at Kelly Field, outside San Antonio, Texas. Flanked by their airplanes in the background, the group inscribes a living shield emblazoned with the letters *US* and with a pair of wings on either side. The second panoramic insignia, made in the same year, consists of eighty-five

hundred soldiers of the Hawaiian Division in the form of their Taro Leaf insignia at the Schofield Barracks, outside Honolulu. Unlike other of Mole's and Goldbeck's images, this one was published in drawings, and even a set-up shot survives of this intricate insignia showing the exaggerated shape of the design on the field, which was necessary to make the exact figure of the final print of the "Taro Leaf Division" as well as to affix the miles of tape required to mark the final pattern on the ground.

Goldbeck's last major insignia effort was also his most spectacular. It enlisted the support of more than twenty-one thousand men stationed in the indoctrination division of the air training command at the Lackland Air Force Base, in San Antonio, Texas, to form its symbol in the "Lackland Air Force Base Insignia" (Figure 1.8) on July 19, 1947. (If this formation is considered as a piece of military propaganda, it is quite appropriate that the actors employed were in the process of being indoctrinated and that the image is alternatively titled "Indoctrination Division.") Staging this formation required two months of planning as well as the special 212-foot tower that Goldbeck built. Moving into Berkeley's cinematic domain, Goldbeck added another dimension to this still image: that of using a film camera to show both the formation and its dispersal as moving images. This last living insignia also was the most commercially successful of Goldbeck's career, and it was featured in *Life* magazine and as a newsreel.

The historical context of Goldbeck's "Lackland Air Force Base Insignia," which was shot in the jubilatory aftermath of American victory in World War II, parallels the context of success of Mole's post–World War I images. If one looks closely at the image, however, one notices that it raises troubling issues of race and color that may go unnoticed at first glance. In staging this segregated image, Goldbeck directed all of the black soldiers in the unit to wear their helmets and to form the circular center of the Air Force star, which was formed by white soldiers in white shirts surrounding the darker center. Ironically, this patriotic image of national unity, taken in the pre-Civil Rights South, is riddled with racial division. With the war theaters of Korea and Vietnam waiting in the wings, Goldbeck's "Indoctrination Division" also marks the end of an era of the popularity of this vernacular photographic genre using military troops as design elements to stage elaborate patriotic symbols of American national community.

FORMATIONS ON BEYOND LIVING

Perhaps one of the most intriguing things about Goldbeck's and Mole and Thomas's images is their designation as living photographs, human photographs, or living insignia. From Mole's perspective, they are deemed to be in the land of the living because the emblems and symbols are brought to life by means of the soldiers who embody and constitute them. But, as indicated previously, one can look at these images from the opposite perspective and argue that when we focus on the emblem, we deaden the human being as form and formation. For the emblem comes into focus

only when the living element drops out of the group portrait in these spectacular optical illusions. This total subjection of the individual to the symbolic order or to submersion in the collective body exposes the fascistic risk that is inherent in these militaristic images.

The formalist and deadening aspect of Mole's choreography, in which the human individual appears to drop out in favor of the beautiful design, the decorative flourish, and the totality of form, bears comparison with the choreography of the Nazi

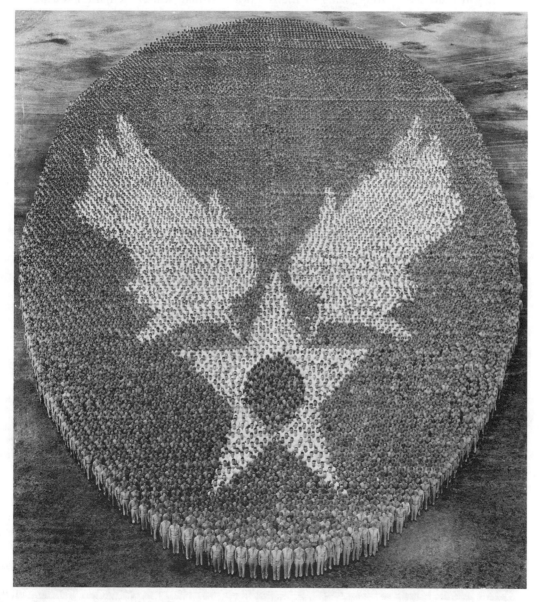

FIGURE 1.8. Eugene O. Goldbeck, "Lackland Air Force Base Insignia (Indoctrination Division)," Air Training Command, Lackland Air Force Base, San Antonio, Texas, July 19, 1947. Photography Collection, Harry Ransom Humanities Research Center, the University of Texas at Austin.

Party rallies at Nuremberg filmed by Leni Riefenstahl in both *Triumph des Willens* (*Triumph of the Will*) in 1934 and *Tag der Freiheit—Unsere Wehrmacht—Nürnberg* (Day of Freedom—Our Army—Nuremberg) in 1935 (Figure 1.9). According to Susan Sontag, Riefenstahl's propaganda films for Adolf Hitler illustrate many of the themes embedded in a "fascist aesthetic" in which military troops, arranged in artful formations and displaying the strictest discipline, parade and perform for the *Führer,* the *Volk,* and the *Vaterland.*[30] Mole's and Riefenstahl's practices both register that tendency toward the "aestheticizing of the political," which Walter Benjamin warned against in his classic essay "The Work of Art in the Age of Mechanical Reproduction" (1936). One recalls his famous one-liner: "The logical result of Fascism is the introduction of aesthetics into political life."[31] An impulse shared by the American patriotic photographer and the Nazi film propagandist is to make war appear beautiful by means of aesthetic and symbolic form. Both Mole and Riefenstahl follow the "war is beautiful" program that Benjamin locates in F. T. Marinetti's Futurist manifestos and what he terms "the Fascist apotheosis of war."[32]

It is also interesting to point out that Benjamin's last footnote in this essay locates the nexus by which propaganda enlists the photography of the masses in the service of the war machine via the staging of spectacle. "One technical feature is significant here, especially with regard to newsreels, the propagandist importance of which can hardly be overestimated. Mass reproduction is aided especially by the reproduction

FIGURE 1.9. Unknown Nazi photographer, "Leni Riefenstahl at the Zeppelin Platz, Arbeitdienstag," Nuremberg, Germany, September 1935. Siegfried Lauterwasser Collection, George Eastman House, Rochester, New York.

of the masses. In big parades and monster rallies, in sports events, and in war, all of which nowadays are captured by camera and sound recording, the masses are brought face to face with themselves." Written while he was living in Paris in exile, Benjamin's critique appears to be a thinly veiled allusion to the dynamics of *Triumph of the Will* and other Nazi newsreels. But some aspects of this analysis can be applied to Mole's war-related photographic spectacles as well. If one were to substitute "tens of thousands" for "hundreds of thousands" and place the emphasis on the stationary mass rather than its movement, the following passage could be applied to Mole and the success of his particular brand of still-life war photography transposing America's military masses into beautiful form and mass mechanism. "A bird's eye view best captures gatherings of hundreds of thousands. This means that mass movements, including war, constitute a form of human behavior which particularly favors mechanical equipment."[33]

In the essay "Photographers at War," the contemporary critic Max Kozloff also takes up the photography of Arthur S. Mole and John D. Thomas as a dehumanizing and antihumanist project (as "deeply inhumane") in a number of ways. For one thing, Kozloff sees Mole's living insignia as a "triumph over the flesh." One notices here how the specter of the Nazis (and Riefenstahl's *Triumph of the Will*) haunts Kozloff's very phraseology.

> It's sufficient to point out that particularly in images of martial pride, flesh is not depicted in any empathetic relation to the beholder, but rather as something that is dissociated, thingified—truly an other. As it swells up, warlike pride is manifested as a deadening condition, triumphing over the flesh. Even in a decorative project—or I should say, above all in a decorative project—such as *The Human U.S. Shield*, 1918, that triumph is really stupefying. It appears to have come naturally to the photographic team, Mole and Thomas, to treat 30,000 men as so many white, gray, and black points. These are not human beings brought together for a group portrait, nor are they a crowd or a mob. They are presented as something far lower, a *pattern* of insensate, deindividuated elements.[34]

In the above passage, we again witness the flip whereby the so-called *living* photograph is said to exhibit a deadening condition. And when Kozloff recalls the title of the photograph as "The Human U.S. Shield," this humanist appellation further foregrounds its paradoxical dehumanization process. Moreover, Mole's living photographs and Goldbeck's living insignia expose the materiality of the photographic grain that shifts the focus of the viewer away from the level of human investment and the constitution of photographic desire and that marks the return of what lies exterior to meaning. This is another way of getting at what Kozloff means in saying that Mole and Thomas "treat 30,000 men as so many white, gray, and black points" and that flesh becomes "truly an other." These factors move our attention away from the signified to the conditions of photographic signification, and they force reflection on

how we invest communal desires in Mole's granular stagings of light writing. Thus, the terms of Mole's entitlement of these images through the use of the modifiers *living* and *human* repress how it is death and exteriority that drive these formations in so many facets.

Nevertheless, Kozloff's analysis runs into difficulties in his attempt to articulate some sort of communal space outside these deadly parameters and this "deadening condition" in order to maintain the borders between a normal (or life-affirming) and a pathological (or death-dealing) foundation of community. It is as if Kozloff hopes to find a space that would be free from the contamination of spectacle, free from the decorative or the threat of the human transposition into the decorative. And Kozloff articulates this space in a classically liberal way as a community that arises out of free will and that occurs naturally. To cite Kozloff here, "The war photograph often makes us aware of communal status, not as occurring naturally and with free will as in pictures of work, festival, or dance, but as distorted, obsessional experience—a spectacle of pathology."[35] Kozloff refuses to acknowledge here the constitutional violence and death drives at the foundation of every community and communal impulse as well as every attempt at its documentation (i.e., the violence of photographic inscription). Rather than standing as aberrations or pathology, Mole's living insignia showcase the community's most natural—and naturalizing—formation. The foregrounding of the symbolic investments of the political community openly exposes the violent inclusions and exclusions that divide "us" (citizens) and "them" (aliens). From this vantage point, Mole and Goldbeck normalize the war photographic spectacle as foundational to national community and to the securing of its borders in the modern era.

But rather than positing death here in any absolutist sense, Kozloff overlooks something else that bears on Mole's practice in terms of the particular historical context of its production. In *The Inoperative Community*, Jean-Luc Nancy flags World War I as a turning point in the thinking of community in Western societies. "Doubtless such immolation for the sake of community . . . could and can be full of meaning, on the condition that this 'meaning' be that of a community, and on the further condition that this community not be a 'community of death' (as has been the case since at least the First World War.)"[36] From this perspective, Mole's photographs from 1917 to 1920 are instantiated at this momentous turning point, when—on account of World War I—the meaning of community gets inscribed as the community of death. Mole's living photographs expose this "community of death," and they seek to make meaning out of it via patriotism's proud symbols and grand gestures.

It is also important not to generalize Nancy's positing of a post-1914 community of death across cultures and to differentiate the American and European experiences of World War I. Such historical specificity recalls another face of death plaguing American society at that moment. Indeed, there was another war raging across the United States from the spring of 1918 to the end of 1919, but here the enemy was the pandemic influenza virus that infected 28 percent of all Americans and killed hundreds of thousands of people. Molly Billings cites the following astounding statistics

about this largely forgotten horrific episode in American history, and she compares its devastation with the United States' losses in World War I. "An estimated 675,000 Americans died of influenza during the pandemic, ten times as many as in the world war. Of the U.S. soldiers who died in Europe, half of them fell to the influenza virus and not to the enemy (Deseret News). An estimated 43,000 servicemen mobilized for WWI died of influenza (Crosby)."[37] Ironically, the flu first spread in the crowded housing of American military camps in the spring of 1918, and then the end of the war brought a second, more virulent strain of the virus back to the United States. This particular context of death and doom serves as the backdrop for Arthur Mole's "living photographs" at some of these same military camps. In the dark light of the pandemic flu, Mole's images of communal bonding raise the risks of another deadly type of exposure and contamination in these tightly packed military formations as they strive to expose photographic symbols of national community and to construct meaning in the face of imminent death.

But Nancy also suggests an absurdity in this type of enterprise—of constructing meaning out of death, of that which delimits the death of meaning.[38] With their tendency toward overblown spectacle and their exposure of community as it relates to the "community of death," Mole's living photographs are compelling records of this absurd enterprise. There is a structural flip side to the fascistic aspects of Mole's project, and it aligns the excesses of the living photographs with contemporaneous Dada gestures to some extent. In this manner, these photographic formations of the Great War confront Dadaist nonsense as their antiauthoritarian unconscious. After all, the anarchic birth of the draft-dodging Dadaists was a response to the chaos and destruction of World War I. The Dadaists, ranting and raving about the war's absurdity, might have interpreted Mole's "over the top" spectacles in the same light. Let us recall the opening of Tristan Tzara's first manifesto in 1916 and imagine a photo formation of Arthur Mole as its referent. "DADA is our intensity: it erects inconsequential bayonets."[39] Thus, the very anxieties and insecurities about the symbolic order displayed in Mole's overblown group images offer the possibility of a self-subversion into their opposite. In this way, they bear a similar status to the dysfunctional war machines of Francis Picabia that were designed to drive technology into absurdity and potential self-destruction.[40]

The Dadaist undertones of Mole's work do not fit with the bulk of Kozloff's critique. However, he does temper his remarks with the suggestion that Mole's "grandiose conceit merely demotes human beings for the purposes of the stunt."[41] It is the recognition of their stunt quality that brings Mole's photography into the realm of popular entertainments and aligns them with the extraordinary antics and nonsensical frivolities of the Dadaists, whom Tzara once compared to circus ringmasters. But this more subversive interpretation resonates with Benjamin's astute appreciation of the shock value of Dadaist ballistics and their outrageous antics that "hit the spectator like a bullet."[42] Likewise, the excessive military formations of Arthur Mole necessitate a jaw-dropping response that can stun and overwhelm viewers into a

flipped-out recognition of the inane and ridiculous demands of the symbolic order and their impossible fulfillment. Consequently, Mole's photographic formations of national community designed to serve the fatherland and to give a communal meaning to death in the face of World War I threaten to topple over or even self-destruct into spectacular stagings of Dada-inflected nonsense. These very images, designed to defend and uphold the symbolic order, expose its deepest instabilities and its most (un)founded fears. While fighting in the trenches, our Mole threatens to go under and underground.

POSTSCRIPT: PHOTOMOSAICS AND THE DIGITAL SYMBOLIC

The present era of digital photography has witnessed the contemporary craze and the pop commodification (in books, posters, and even jigsaw puzzles) of a software program known as Photomosaics, designed by Robert Silvers when he was a graduate student at the MIT Media Lab in Cambridge, Massachusetts.[43] Photomosaics are images that are generated by a computer program drawing upon a large image bank. As one description states, "The software sorts thousands of tiny images by color, density, internal shapes, and light, and arranges them so that when viewed from a distance, they combine to form a single larger image."[44] To provide an art historical frame, this is the tradition of Georges Seurat's pointillism applied to computer technology, and Silvers pays homage to this neo-impressionist artist of the late nineteenth century with his own pixel version of *La grand jatte* in his book, and, in this way, he underlines how Seurat deserves to be celebrated as the first dot matrix printer. The living photographs of Arthur Mole and Eugene Goldbeck may be viewed as a middle phase of this historical trajectory in visual culture. But unlike Seurat's scientific brushstrokes or Silvers's image pixels, Arthur Mole's deployed human beings serve as the tesserae and the compositional elements for his large-scale, chemically based, photographic mosaics. While Silvers treats photo images as digital information and constructs them into symbols, Mole designs (and shoots) photographic images that yield the best analog and mimetic likenesses to the symbols that he seeks to represent.

But while the means and the technologies of the works of Arthur Mole and Robert Silvers may differ, they draw a shared interest in the mass reproduction of the icons that constitute the American symbolic order. If one thinks about the content of Silvers's icons in terms of the issues of photography and community with a strictly American ideological agenda, the results are quite comprehensive and reinforce the paternal function. His photomosaics include such patriotic figures as George Washington (the father of the nation in the hegemonic form of an American dollar constructed of all the currencies of the world) and Abraham Lincoln (who is composed of more than one thousand Civil War photographs). The *Abraham Lincoln* photomosiac (Figure 1.10) is quite interesting for its photo-historical resonances in that the likeness is based on a portrait by the Civil War impresario Matthew Brady, and it is a construction of Lincoln's portrait from an archive of images from the American

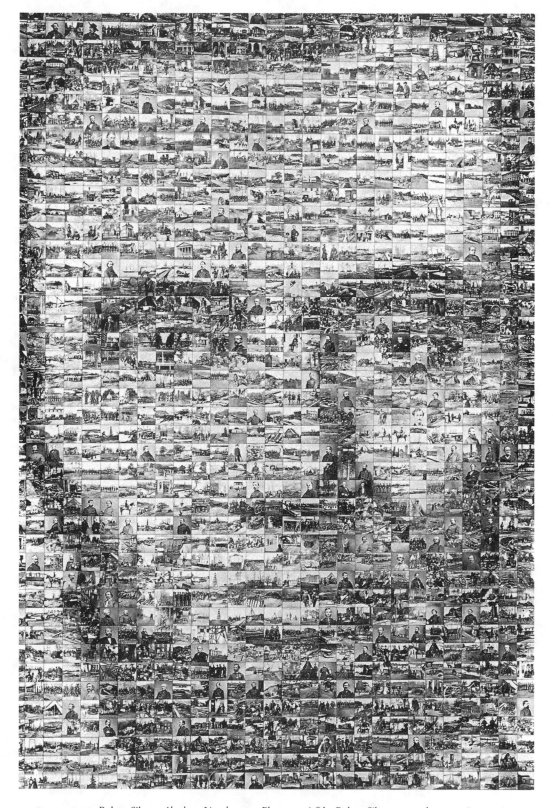

FIGURE 1.10. Robert Silvers, *Abraham Lincoln*, 1997. Photomosaic® by Robert Silvers; www.photomosaic.com.

Memory digitalization project at the Library of Congress. Moreover, it serves as a fitting image to be included in this chapter, because Lincoln's face has been constructed from images of war and soldiers in combat in one of the first major wars captured via photographic images.[45] Like Mole and Thomas's living photograph of Woodrow Wilson, Silvers's digital software program choreographs these warriors into the iconic figure of the president who defended national community and the national Union against the threat of Confederate secession and at the expense of his own life.

Silvers also has created five-hundred-piece jigsaw puzzles of the bald eagle, which is described as "America's national symbol and the most majestic of birds" and—in an exact replication of the Arthur Mole living photograph—a rippling American flag wherein "famous Americans combine in Stars and Stripes."[46] In addition, the book includes reifying tributes to the two most celebrated and photographed American pop-culture icons of the twentieth century: Elvis Presley in a stamp photomosaic; and two images of Marilyn Monroe, one composed of *Life* magazine covers and the other based on her "Golden Dreams" *Playboy* magazine centerfold. In this way, Silvers's images celebrate and reinforce the doxologies of contemporary American cultural citizenship and national community. Or as S. Paige Baty observes in her insightful book *American Monroe: The Making of a Body Politic,* "Representative characters like Marilyn . . . allow for the development of a discourse in which community is realized, belonging becomes a possibility, and knowledge is circulated throughout the political culture."[47]

Like Mole's and Goldbeck's living insignia of yesteryear, Silvers's digital photomosaics propagate the national symbols and the mass media icons of American community by means of a visually appealing game played out between the separating and dissociating part and the restorative and ordering whole. So it should come as no surprise to learn that Silvers also includes a photomosaic of the Statue of Liberty in his book. The component tiles are photographs from the Stock Market Photo Agency's *American Mosaic* catalog, and a number of them also feature flags. In this way, the Statue of Liberty is literally composed of a diverse group of citizens, thereby reinforcing the assimilationist myth of the melting pot that was the dominant paradigm in Mole's era and that guides the photo-cultural formation of his living photographs and their nationalist agenda. In other words, both Mole's and Silvers's Statue of Liberty images offer a visual transcription of the unifying nationalist rhetoric of "one among many." Yet, it is possible to challenge Silvers's photomosaics in a manner that is similar to Mole's *Human Statue of Liberty* by pointing out that the monument is revealed only when the subjects who constitute it disappear or, in other words, when they become absorbed by the totality of the symbolic image. This is a paradoxical yet fitting conclusion for a project that claims to advance both individual liberty and communal ideals only to further the value of the cyber-commodity and to pose the digital lure of what lies beyond the human.

2. "WE DON'T KNOW"

ARCHIBALD MACLEISH'S *Land of the Free* AND THE
QUESTION OF AMERICAN COMMUNITY

THE LAY OF THE LAND

"We don't know. . . ." With these three crucial words of collective doubt describing a collectivity at a time of crisis, Archibald MacLeish (Figure 2.1) begins the "soundtrack" (as he dubs it) of *Land of the Free*.[1] Of all the hybrid projects that combined Resettlement Administration (RA) and Farm Security Administration (FSA) photographs of the Great Depression in the United States with a sustained literary component and complement, *Land of the Free* (composed in the summer of 1937 and published in the spring of 1938) remains the most unusual and enigmatic of these "word and image" collaborations.[2] The encounter with these photographs prefigured MacLeish's future involvement with them in archival form; he would become the librarian of Congress in June 1939 and would administer the resettlement of these images to this national bibliographic institution when the Farm Security Administration disbanded. In this capacity, he was responsible for archiving and maintaining this vast collection of 270,000 images. Foregrounding the haptic sense, MacLeish stresses the close contact that he had with these images in his *Reflections:* "These photographs were constantly under my hands as Librarian of Congress because we accepted them, kept them, took care of them, and so forth."[3]

The enigmatic quality of *Land of the Free* derives in part from the choice of the allusive medium of poetry rather than prose to stand in relation to the eighty-eight documentary photographs that MacLeish selected and carefully arranged in sequence as the "image track" for the project.[4] MacLeish's free verse appears on the left page of every two-page spread, and an image appears on the right. But what is the exact nature of the relationship between the words and the images? MacLeish humbly

enjoins the reader/viewer of his "Notes" at the end of the volume to think counterintuitively when approaching *Land of the Free* and to reverse the normal logocentric privileging of the word over the image in the construction of meaning. Emphasizing the image over the word in a form described as "unusual," MacLeish concedes that the book has veered from its "original purpose." Instead of photographs that provide commentary and function as illustrations for the poem, MacLeish asserts that the results put poetry in the illustrative service of visual culture. In administering this reversal of plan, MacLeish's dislocation of convention makes its own contribution to the question of resettlement, or of what belongs where.

> "Land of the Free" is the opposite of a book of poems illustrated by photographs. It is a book of photographs illustrated by a poem. The photographs, most of which were taken for the Resettlement Administration, existed before the poem was written. The book is the result of an attempt to give these photographs an accompaniment of words. In so far as the form of the book is unusual, it is a form imposed by the difficulties of that attempt. The original purpose had been to write some sort of text to which these photographs might serve as commentary. But so great was the power and the stubborn inward livingness of these vivid American documents that the result was a reversal of that plan.[5]

FIGURE 2.1. Anonymous, "Archibald MacLeish, Librarian of Congress," Washington, DC, 1939–44. Photograph from Library of Congress.

The last sentence demands explication in that it reveals how MacLeish's rhetoric bypasses questions of representation in a desire to have photography grasp the real in a neutral and impartial manner. MacLeish does this by stressing the direct and index-ical connection of these images to their referents in lived reality. These photographs are enlisted into documentary and national service as American documents and as stubborn empirical facts. MacLeish overemphasizes the connection of these photo-graphs to real life, and he authorizes their authenticity with the drawn-out phrase "the stubborn inward livingness of these vivid American documents." In this way, photo-graphic discourse is grounded in the real and in living history as a counterbalance and overcompensation for the epistemological doubt disseminated by MacLeish's image-text that undermines indexicality by raising the question (and the exposition) of community. But MacLeish's characterization of the photographs as documents that are doubly alive—as noun (*livingness*) and as adjective (*vivid*)—also downplays their status as representations and their artificial and constructed nature. This includes the theatrical possibilities of staging, the tendentious possibilities of propaganda, and even the effects of reframing and sequencing to which he has subjected them.

Indeed, one insightful criticism raised against the book by the reviewer John Holmes at the time of its publication was that the reframing and reinscription of FSA images played fast and loose with the photograph as historical document. "He gets himself all worked up over some photographs, and thousands of eye-minded people know that they can't always believe what they see in photographs, for the camera does lie, or it can be made to tell things that aren't truth. By this I don't mean that any of the photographs are faked, but that MacLeish's method in using them to make a book is unfair, and that the result cannot be defended."[6] Playing with the context of meaning, the "reality effect" of the photographs is subject to issues of storytelling and stagecraft so that the images are "made to tell things that aren't truth." In this way, MacLeish's method demonstrates the principle of iterability (repeatability) that adheres to all images and that puts them beyond any line of defense or sense of fairness.[7] Aside from any moral judgments, *Land of the Free* is an enactment of how photographs (like any other graphic material) can be recontextualized and reframed, thereby changing their meanings (even drastically) in the process.

While insisting that these photographs demand commentary, MacLeish did not opt in the end for the descriptive caption as his preferred means of communication. This was certainly a formal device with which MacLeish worked on a regular basis as a contributing editor to Henry Luce's *Fortune* magazine for most of the thirties. But, instead of the caption, he chose to mix poetry with the so-called news picture to produce a new hybrid form. An anonymous critic of *Time* magazine called this new half-breed "socio-poetry." "Latest socio-poetic graft that Poet MacLeish has produced is *Land of the Free*, in which he top-works his poetry onto the art form of the news-picture magazine."[8]

At the commencement of the project, the caption appears to have been the pro-posed textual format. Roy Stryker states as much in a letter to Dorothea Lange (who,

with thirty-three images, would turn out to be the leading photographic contributor to the project). According to Stryker, MacLeish would provide standard explanatory captions for each of these social documentary photographs and tell the story in this way. This idea is conveyed to her in his first mention of the "top secret" project on March 23, 1937.

> A little information that you may keep under your hat for a while—Harcourt, Brace, Arch MacLeash [*sic*], and ourselves are going to collaborate on a book of photographs, captions and story by MacLeash, photographs by Resettlement Administration photographers. The general theme is the people left stranded by the out wash of industry in America, industry being used in a broad sense. The hope is to use about 200 pictures with accompanying captions on the facing page by MacLeash—captions to be from 100 to 400 words in length.[9]

From this sneak preview, it becomes clear that, in addition to not knowing how to spell the last name of his Pulitzer Prize-winning collaborator, Stryker was off in his sense of the literary format of *Land of the Free*, expecting functional prose rather than poetic license and free verse. Contrary to Stryker's first actuarial assessment, most of the segments in *Land of the Free*'s spare yet compelling poetic economy turned out to be well under one hundred words, and many are pithy one-liners under ten words.

By August, Roy Stryker notes to Russell Lee (in a letter that conveys MacLeish's request for a specific type of land picture) that the structure of the book had changed dramatically. "The thing is somewhat changed at the present time. MacLeish is now writing the text around the main set of pictures, that is the Resettlement exploitation pictures. Sections two and four, the exploiters, and man against waste, have been dropped. He is now anxious to get some good land pictures."[10] The allusion here to what has been removed from the original outline of the book is quite telling. The letter suggests that section two of the *Land of the Free* was to be specifically about "the exploiters"—that it would have directly pointed the finger at the class of capitalists and corporate special interests that MacLeish deemed to be responsible for both the causes and the effects of the Depression and for swelling the ranks of the expropriated class of workers.[11] We can speculate as to why this material did not make the final cut, but the net result was that the book was toned down as a document on class conflict. However, even without these two sections, Stryker describes *Land of the Free* in a way that takes aim at the culprits who had wreaked damage on the environment and its people. It was not just drought or a bad crop that was to blame for the consequences of the Great Depression but rather the "empire builders," who were depicted as environmental criminals and destroyers of community. In Stryker's outline of the project to Lee (who would contribute nine images to the book) in April 1937, he describes it as "a series of pictures which will portray the people left behind after the empire builders have taken the forests, the ore and the topsoil."[12] Carl Mydans's poignant image of a destitute couple, entitled "Arkansas Cotton Workers Headed for Tennessee

with All They Possess" (Figure 2.2), is a good example of this photographic category taken up by MacLeish in *Land of the Free.*

Ben Shahn, who contributed four images to *Land of the Free* and was perhaps the most socially conscious and politically active of all of the photographers associated with Farm Security, remembers that MacLeish originally took the project for *Fortune* as a journalistic assignment dealing with land use. But upon seeing the FSA images, MacLeish had a poetic revelation that led to his abandonment of the original design of the project and his restructuring of the text as a "sound track" for the FSA images. MacLeish's response already touches on the question of abandonment at the heart of *Land of the Free.* Shahn discusses the lay of the *Land:* "Archibald MacLeish, who was then the editor of *Fortune,* was doing one of those enormous studies on the use of land. And someone suggested that he might look at our photographs. I don't think he was very excited about the idea. When we sent him our photographs—we sent down a big portfolio—he said, 'I'm abandoning my text, I'm using just your photographs, and I'll write a single line sound track for it.'"[13]

But for all its cutting-edge quality, surprisingly little critical analysis of *Land of the Free* has appeared in photography and literary studies in the sixty-five years since its publication, except for the numerous reviews it garnered in major periodicals soon after. Among photo historians and critics, only A. D. Coleman has given it more than

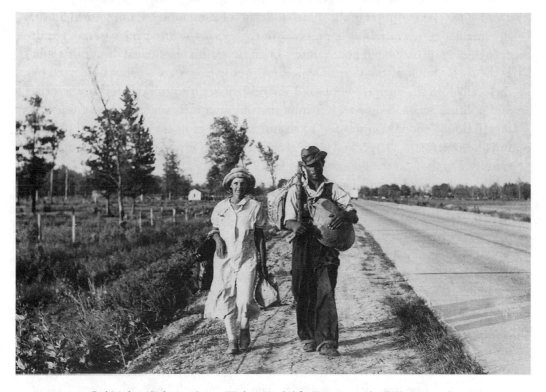

FIGURE 2.2. Carl Mydans, "Arkansas Cotton Workers Headed for Tennessee with All They Possess," 1936. Photograph from Farm Security Administration, Library of Congress.

a passing comment in his introduction to the reprint of the book, which he edited in 1977.[14] Aside from that, the project has been largely ignored. It could be that scholars of both disciplines have felt uncomfortable with the way in which it straddles the line between them. For MacLeish literary scholars, it is a book of social documentary photography that they best ignore. For photography scholars, it is this strange free verse poem that best be ignored. However, if we instead think about poetry and photography as two modes of writing—and think about them working together in tandem as "poetography"[15]—through which we expose (ourselves to) the question of community and thereby "let the singular outline of our being-in-common expose itself" (as Jean-Luc Nancy suggests),[16] then this image-text project, speaking with a stammering collective voice (which does not know), offers a model for exploring the relations of poetry, photography, and community and the relations of their communication at and on the limit.

THE CRISIS AT LARGE: FROM COPING WITH DEPRESSION TO EXPOSING COMMUNITY

The concept of the enigmatic applies to *Land of the Free* for another important reason, which is inscribed in the catchphrase that punctuates it at six strategic points— "We don't know." This much is certain: the word and image narrative that constitutes *Land of the Free* transpires in the midst of a crisis of community. From start to finish, the singular narrator of *Land of the Free,* who speaks in the first-person plural, pleads epistemological doubt and uncertainty. On one level, this heightened degree of doubt is the direct result of the Great Depression, whose effects are so ably illustrated by these ideologically charged words and images that seem to call out for direct social and political action. However, it is important to situate *Land of the Free*'s epistemological doubt not only in relation to an instrumental program of New Deal politics but also in terms of a larger and more general crisis that exposes the question of community. Drawing on the philosophy of Jean-Luc Nancy and Jacques Derrida among others, we can understand *Land of the Free* as an attempt to communicate the experience of community as an acknowledgment of crisis and as a coming up against limits.[17] In other words, the crisis of community that is the subject of the *Land of the Free* exposes community *as* crisis through images and words that are emblems of doubt and bewilderment. In figuring and exposing community, the ruptures evoked by *Land of the Free*—the eroded earth, the interruption of work, the Depression—break with the propagandistic program of the Farm Security Administration and its New Deal policies and point to a "general economy" of crisis, one that registers an indeterminate "unknowledge" of community that is in excess of its meaning. As Derrida writes in another context but one that can be applied to the crisis of community, "It will not be a determined unknowledge, circumscribed by the history of knowledge as a figure taken from (or leading towards) dialectics, but will be the absolute excess of every episteme, of every philosophy and every science."[18]

In terms of the restricted economy, the crisis of American community circa 1937 was deemed to be containable, and it was the job of a government agency—its image makers and its policy makers—to restore order and security. For the crisis to pass, it had to be brought under the auspices of the Farm Security Administration. It is clear that FSA chief Roy Stryker applied instrumental reasoning to the MacLeish project. He saw it as a good antidote to the crisis, and therefore he understood it in terms of an economic calculus. Indeed, he calculated that much was to be gained from its publication. For instance, he wrote that *Land of the Free* "certainly will be a good use for the RA pictures."[19] He spoke of the blessings that the project had received from Secretary of Agriculture Henry Wallace. He wrote to Lange on March 23, 1937: "Full credit is to be given to photographers, and I hope, a nice foreword on the type of thing that we are striving to do here in the R.A." Even though MacLeish did not write a foreword, suggesting that he was less interested in plugging the RA than Stryker thought, Stryker showed further evidence of being satisfied when the project was completed. He wrote the following to Ben Shahn: "Under separate cover I am sending you your copy of the MacLeish book. . . . I am certainly well pleased with this job. I think you will be too."[20] The use of the operative word *job* illustrates how Stryker restricted the crisis and overlooked its engagement with the larger question of the "inoperative community."

To Stryker's way of thinking, *Land of the Free* would give his photographers and his agency good publicity. It would enlist a well-respected *Fortune* magazine writer and literary luminary as an advocate for New Deal social programs. In this way, both MacLeish's text and the FSA photos would work in tandem as propaganda for government programs designed to assist the ailing farmers and workers who had been hit so hard by the Great Depression. FSA photography historian F. Jack Hurley reviews the one-two punch of the project as means to an end. "The photographs in *Land of the Free* were so strong that they sometimes overshadowed the text, but the overall effect was quite successful from the standpoint of both art and propaganda. No one who read *Land of the Free* could fail to grasp its message that the country folk were restless and in need of stabilizing programs."[21] In alluding to the country folk as restless, Hurley indirectly touches on their status as migrant workers and the uprooted who had taken to the road. But Hurley suggests that nothing is out of control because the crisis represented by *Land of the Free* could be resolved through stabilizing programs. This underscores a key aspect of any analysis of *Land of the Free* within a restricted economy. Hurley refuses to acknowledge that the crisis articulated by *Land of the Free* is constitutive of community itself and that it cannot be stabilized or patched up via a few social programs.

The approach to the project in terms of a restricted economy also seeks to limit its freedom—to bind *Land of the Free*'s meaning and its purpose into the service of Roosevelt's New Deal programs. This is the instrumental function of New Deal photography as it is put into the service of sociology. Or as Robert Girvin describes it in "Photography as Social Documentation," an essay on FSA photography, "The

camera truly became an instrument of social science."[22] There is no doubt that MacLeish was a strong advocate and supporter of the programs of Roosevelt. But it is also important to insist that the instrumental reading of *Land of the Free* misses what this text and these images pose at the limit: community as the "limit where partitioning and sharing is exposed."[23] Even as it is put to work for the New Deal as propaganda, the project is exposed to the resounding ringing of a freedom that cannot be bound to instrumental reason. The freedom of *Land of the Free* communicates a more radical notion of community that touches on nonknowledge ("we don't know"), in which the public works projects of the New Deal (and their progress) cannot be put to work or into service.

For one thing, *Land of the Free* delivers images of the expropriation of people who have been stripped of their property and of bourgeois proprieties. One example of this is found in Dorothea Lange's photograph "Hitch-hiking Family in Georgia" (Figure 2.3). In other words, these people cannot appropriate to themselves the proper status of a subject. This is not to say that this approach is advocating impoverishment or expropriation as the preferred model of society and that it must be instituted if we aspire to be in a relation with the inoperative community. Any prescriptive and goal-directed approach with such self-assured knowledge would contradict the idea that community signals a condition in which, as Gayatri Spivak says, "all decisions are made in urgent non-knowledge."[24] However, this approach does acknowledge that community comes only in "this extreme *abandonment* in which all property, all singular instance of property, in order to be what it is, is first of all given over to the outside. . . . And this abandonment abandons to nothing else but being-in-common."[25] Endemic both to photography and writing, this practice of expropriation acknowledges community's being outside itself in the sharing of images and words that expose our abandonment to the loss and incompleteness of being-in-common. From this perspective, the Great Depression gave the American social and communal body the jolt it needed to understand that it comes into its own only via the abandonment of the proper, in its own expropriation.

The words and images of expropriation suggest that "stripping bare" to the markers of finitude and dispossession affirms what touches community. This is precisely what the FSA photographs of Russell Lee, Ben Shahn, and Dorothea Lange and the poetic texts of Archibald MacLeish make available to us. In his reflections on *Land of the Free,* MacLeish uses the language of exposure—of ripping away veils and stripping naked—in order to articulate the crisis of community to which these words and images respond. "The Depression had the effect of doing lots of things. It ripped all the veils away. It stripped things naked that one had not before looked at nakedly."[26] However, this should not be confused with a practice of demystification that would provide a rational understanding and knowledge of community. Rather, *Land of the Free* is a stripping naked in words and images so that one can look with a greater degree of uncertainty at the crisis of community and community as crisis.

Amid these expressions of crisis, we should not forget that MacLeish thought of *Land of the Free* as a relation to "purgatory." To recite MacLeish, "*Land of the Free* is trying to find words for the *purgatory* of the Depression, for the American hopes and expectations and what had happened to them."[27] Purgatory has always been viewed as occupying the space in between and the space of indecision. It is the place of limbo of which Giorgio Agamben speaks in *The Coming Community:* "Neither blessed like the elected, nor hopeless like the damned, [the inhabitants of limbo] are infused with a joy with no outlet."[28] From the perspective of the restricted economy, purgatory

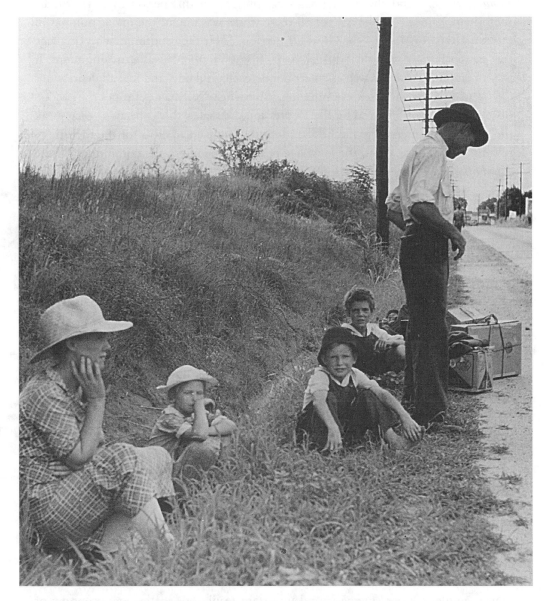

FIGURE 2.3. Dorothea Lange, "Hitch-hiking Family in Georgia," 1937. Photograph from Farm Security Administration, Library of Congress.

leads to a purging of sins and to eventual joining up with the blessed. But from the perspective of the crisis in general, purgatory is forever in communication with community as a "community at loose ends." *Land of the Free* exposes a land and a people in an active state of deconstruction. It is because of this crisis that they are exposed to such radical instabilities and to a radical sense of freedom. While this may always be the case, the extreme circumstances of the Great Depression as crisis ripped the veils away to leave the question of community exposed and in purgatory.

Playing off its emotional and psychological overtones, A. D. Coleman situates *Land of the Free* and the other image-text projects in this period in terms of the rhetoric of trauma. "At the core of all these works was one of the major traumas of the American experience—the Great Depression."[29] He then continues with language that evokes both MacLeish and Agamben: "It was a limbo. It was a turning point. It was an emotional state as well as an economic/ecological one, and like all depressions one of its functions was self-examination." But when Coleman examines the process of self-examination induced by the Depression, he makes this collective voice speak the language of interiority, and he abandons the language of crisis for the rhetoric of self-discovery. Once again, the language of crisis endemic to the community of the *Land of the Free* comes under siege. Coleman writes:

> Archibald MacLeish found such a voice for the narrator of his "sound track" for his book. Blunt, terse, embittered, and all but defeated, it is carefully chosen and constructed—a collective voice, first-person plural. This is not the individual standing in witness of the acts of others; it is the culture taking account of itself. It is a voice full of disillusionment and shattered expectations, stripped of hope for outside help, turning inward. It is the voice of distressed introspective community discovering itself.

From the perspective of the inoperative community, however, culture cannot take account of itself without acknowledging how it is exposed to the outside. It is something that is always open and at stake, something that exceeds (its own) self-accounting. As Jacques Derrida asserts in *The Other Heading*, "What is proper to a culture is to not be identical to itself."[30] Similarly, community cannot be found by a turning inward or through some introspective self-discovery of its own unity or its own identity. Instead, community can be exposed only when it is posed in exteriority (when it is shared) and when it partakes of the crisis that such photographs and such poetry relate. Rather than articulate community as Coleman does, as the voice of an interiority appropriating itself, Nancy would view *Land of the Free* as a resistance to appropriation, "as the common experience of the exposure in which the community is founded, but founded only through and for an infinite resistance to every appropriation of the essence, collective or individual, of its sharing, or of its foundation."[31] This antifoundational resistance to the appropriation of community and its sharing guides a more enigmatic and uncertain reading of the general economy of crisis articulated in *Land of the Free*.

Land of the Free's INOPERATIVE COMMUNITY

It is because the work came to a standstill and there was a general idleness that the community had time to reflect and to wonder. This is indexed in photographs such as Dorothea Lange's image shot on Main Street in Sallisaw, Oklahoma (image 51), during the 1936 drought, which pictures the farmers in town squatting on the side walk and whiling away the time with nothing to do. This type of circumstance provides the chance to step back and consider the question of community and to recall how it is addressed in Nancy's formulation as "the inoperative community." In other words, community can be exposed only in the withdrawal of community as an operative term and in its withdrawal from the domain of work. As Nancy writes:

> Finitude, or the infinite lack of infinite identity, if we can risk such a formulation, is what makes community. Community is made or is formed by the retreat or by the subtraction of something: this something, which would be the fulfilled infinite identity of community, is what I call its "work." All our political programs imply this work; either as the product of the working community, or else the community itself as work. But in fact it is the work that the community does *not* do and that it *is* not that forms community.[32]

This community of Main Street idlers is echoed by the seventy-sixth image of *Land of the Free* (Figure 2.4). It is another image taken by Dorothea Lange, and it features three men sitting on the ground next to a solitary pole. They appear to be doing nothing in particular, caught only in the act of sharing their finitude. The title provides a specific Depression-era context for this image in limbo: "Waiting for Relief Checks in California." Here is the paradox of three able-bodied men hanging out in idleness, wearing their work boots and yet not gainfully employed. Again, it is the negation of "the community itself as work" that takes center stage here and forges the inoperative community that, according to Maurice Blanchot, "does not allow itself to create a work and has no production value as aim."[33] The retreat or the subtraction of the operational something that constitutes community is underscored in MacLeish's one-line statement in juxtaposition to Lange's image. "All we know for sure is— we're not talking." This statement aligns the epistemological doubt at the crux of the *Land of the Free* with a retreat from speech. This paradoxical retreat from speech— announcing that the collective voice is withholding its utterance—occurs a few more times toward the end of the poem. The clause "We're not talking" also accompanies John Gutmann's FSA-unrelated photograph of the railroad station in Lovelock, Nevada, which features four men on an immobile Railway Express Agency cart who stare blankly off into space (image 78). Again, the situation suggests a contradictory "communication without communication" on an immobilized vehicle.

While *Land of the Free* never explicitly informs us why these men are not talking, the retreat from speech raises two distinct possibilities. The first relates to the

restricted economy, and it points to the power relations to which these unemployed workers have been subjected. After all, talk is never appropriate for the expropriated. They fear reprisal on the part of the powerful. Hence, there is this bitter irony for the inhabitants of the *Land of the Free,* who know better than to exercise freedom of speech. One direct consequence of this silencing of utterance is that the poem's collective voice is fragmented and split so that it is not really about the nation as a whole interrogating itself (as Coleman suggests) but about a specific class of workers who are not talking because they have witnessed the kinds of payback that striking labor has received, whether at the Ford Plant in Detroit (image 11) or at the one in South Chicago (image 10). One recalls MacLeish's embittered lines at these factory workers' denial of their right to assemble and protest in liberty's name: "But try it in South Chicago Memorial Day / With the mick police on the prairie in front of the factory / Gunning you down from behind and for what? For liberty?" (verse 10).

But the retreat of and from speech that dominates the concluding section of *Land of the Free* also points to the excessive terms of a general economy that cannot be confined to a specific political program. Viewed in this way, the paradoxical statement "we're not talking" articulates the opening to the political in general and to the possibility of political speech in and of itself. Another way to express this point is to

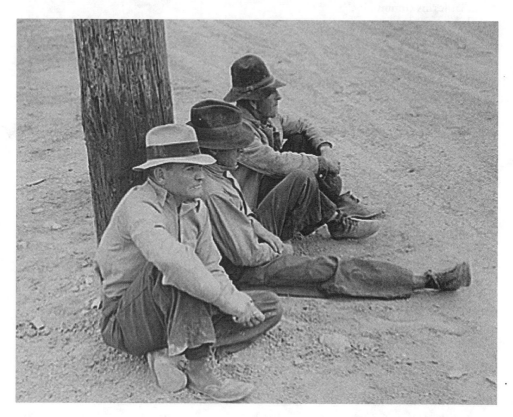

FIGURE 2.4. Dorothea Lange, "Waiting for Relief Checks in California," 1937. Photograph from Farm Security Administration, Library of Congress.

say that *Land of the Free* moves the reader from politics to the political, from the in-
strumental work of programmatic forces to the crucial limit (or limbo), where what
it means to be in common becomes open to definition and underlines the need for
decision. The collective voice and visions of *Land of the Free* open unto this experi-
ence of possibilities and limits. The book communicates at the limit of communi-
cation ("we're not talking"), and, in doing so, it touches on community-exposed
"poetography."

Such a communication does not offer communion or the essence of a "common
being" but rather demands the subject's dis-location. This communicative structure is
implied in verse 77, in which MacLeish intones: "All we know for sure is—We've got
the roads to go by now the land's gone." In other words, the theme of dis-location
("we've got the roads to go by") and the migratory status of the unworked worker—
who "possesses" freedom in the way that Janice Joplin taught us, as "nothing left to
lose"—takes the place of (literally dis-locates) the words "we're not talking" (the limit
of communication), as stated in verse 76. This text appears in relation to a Dorothea
Lange image that depicts Texas flood refugees with their possessions in a wheel-
barrow, walking down an open road in the middle of nowhere. With such image-text
juxtapositions, *Land of the Free* maps what Nancy calls "places of communication."
This is where sharing takes place but where it is necessarily dis-located as it passes
from the one to the other. "These 'places of communication' are no longer places
of fusion, even though in them one passes from one to the other; they are defined
and exposed by their dislocation. Thus, the communication of sharing would be this
very dis-location."[34]

The exposure of community and its communication in and as dis-location and
in relation to unworking provides one of the central motifs of *Land of the Free*. In
fact, it constitutes the narrative flow of image-texts 58 to 62, prefaced by another ref-
erence to the road in terms of both its travels and its travails. Ironically, *Land of the
Free* figures the road as the only thing to be relied on and yet as that which perpetu-
ally unsettles the collective narrator. "We've got the road to go by when we've got
to: / Blown out on the wheat we've got the road: / Tractored off the cotton in the
Brazos— / Sawed out in the timber on the Lakes— / Washed out on the grass
land in Kentucky— / Shot-gunned off in Arkansas—the cotton—." Here, MacLeish
unleashes a set of verbal thrusts and adverbial modifiers that signals a series of direct
hits that have dislodged the collective subject on an uncertain trajectory in response
to both human and natural disasters. The subject gets vacated and becomes lost in
this sequence of five dislocations that interrupt and suspend production and produc-
tivity (i.e., the proper domain of work). Blown out, tractored off, sawed out, washed
out, and shot-gunned off. Each of the terms offers a confrontation with impending
demise and an encounter with finitude. MacLeish marks here the trials and tribula-
tions of the RA/FSA clientele who have withdrawn from the work that occupies the
productive industries of American agriculture (whether wheat or cotton or lumber).
Land of the Free shows and speaks of the breaks with productivity and the domain of

work, and thereby it breaks with the propagandistic program of the Resettlement Administration seeking to reclaim this rupture and resolve the crisis at hand. Unsettling both scores, *Land of the Free* communicates community in dislocation. For this is a project of broken tables (image 57), broken dolls (image 45), broken bodies, and broken sentences (replete with dashes). It is only in this context—this dis-locating of contexts—that "we" (the we who do not know and who are not talking) encounter community in terms of rupture, interruption, and the experience of finitude. "That is why community cannot arise from the domain of work. One does not produce it, one experiences or one is constituted by it as the experience of finitude. Community necessarily takes place in what Blanchot called 'unworking,' referring to that which, before or beyond the work, withdraws from the work, and which, no longer having to do either with production or with completion, encounters interruption, fragmentation, suspension."[35]

COMMUNAL DOUBTS

It is never easy to accept the inoperative community's critique of the community as work, especially in the time of crisis when there is a job to be done, when action seems so imperative and so necessary. It is never easy to admit (when seeing the photographic proofs) that community exposes itself to unknowledge in experiencing itself as something posed in exteriority and at the limit of knowledge. Perhaps these were the factors that drove the film director Pare Lorentz to write a negative review of *Land of the Free* in the *Saturday Review,* under the title "We Don't Know . . ." In this review, Lorentz turns MacLeish's interrogative self-questioning into something to chastise. He splits the collective pronoun yet again and insists that he does not belong to MacLeish's community ("and when he speaks for *his* people" [my emphasis]). In saying that he does not know about Mr. MacLeish and where he stands, Lorentz opts out of MacLeish's collective self-doubts from start to finish. All in all, Lorentz challenges MacLeish's right to represent "we the people": "And it is when he speaks for his people that I quarrel with Mr. MacLeish and his sound track. For them he says on page 1, 'We don't know . . .' And for them he concludes: 'We wonder if the liberty is done. . . . We're asking.' And we don't know either, Mr. MacLeish."[36]

Interestingly, Lorentz splits the project into image and textual components in order to invalidate MacLeish's contribution and to prop up the worth of the FSA photographers. It is a critical strategy that denounces their sharing and is based on binary opposition and a mind/body dualism. It pits the poetic mind of MacLeish over and against the flesh and blood of the embodied and embattled photographers, who represent and double the subjugated bodies of their Great Depression-era subjects. And what Lorentz finds most wanting in MacLeish appears to be his unwillingness to go beyond epistemological doubt, this refusal to go beyond "wonder," "interrogation," and intellectual questioning when it comes to the representation of American community. Lorentz repeats MacLeish's own adjective (*vivid*) to describe these FSA

photo documents as alive. In Lorentz's twist, photographic re-presentation acquires the status of the real, while poetry is deemed to be lifeless. Lorentz adds insult to injury by insisting that the photographs appear lyrical while MacLeish's poetry is not. In his review, Lorentz lodges an indexical critique, preferring photographic document to MacLeish's poetographic exposure of community. Inasmuch as Lorentz was a more conservatively centrist New Dealer than the left-wing MacLeish, who even dabbled in Popular Front possibilities, it is not surprising to see how Lorentz uses MacLeish's reliance on the index and photographic facts as a cover for lodging a political attack on him in reacting to the more complex relationship of "word and image" of *Land of the Free* and its more radical and uncertain vision of the political. Here is the full extent of Lorentz's criticisms with their emphasis on certainties:

> Certainly there is more than wonder in these women pop-eyed with poverty. Certainly there is more than interrogation in the faces of the men standing in the streets, waiting for rain. And while the land is vivid and lyrical in your imagery, the people are not flesh and blood, but an intellectual question: "We don't know."
>
> Beautifully produced, intelligently designed, and written by a poet with a fine ear, *Land of the Free* remains thin-blooded and cool. What sweat there is in it is due to the photographers who talked and ate and slept with the roving dispossessed, and as Dorothea Lange contributed thirty-one [*sic*] of the eighty-eight photographs in the book, I give her chief credit for putting on celluloid what Mr. MacLeish failed to put in words: the sorrow, and the dignity, and the blood of the people.[37]

But Lorentz's critique refuses to acknowledge that the question of community in all its urgency demands a relationship to the limit of knowledge (or unknowledge)— what is repeated in the refrain "we don't know." To his credit, MacLeish resists any knowledge of the community, or being-in-common, that would recuperate it as such. Similarly, community is not to be reified in fascistic terms as communing with the blood of the people. Being-with photography is, rather, the exposure to an "excess" that does not let itself be appropriated and to which being is abandoned. Instead of a communal fusion of subjects bathed in blood, sweat, and tears, the inoperative community (whom one does not know) exposes being-in-common in its incomplete relationship to death and finitude and to "the impossibility of making a work out of death."[38]

Lorentz praises Dorothea Lange for her authentic encounters with farmers and migrant workers, such as the encounter represented in her image of an Indiana woman in a migratory labor contractor's camp in California, who tells the photographer, "It's root, hog, or die for us folks" (Figure 2.5). But if we are dealing with "the roving dispossessed" (as Lorentz refers to them), then we cannot expect to appropriate or possess them in or as the truth of community. Rather, the poetographic practice expressed in MacLeish's writing (on paper) and Lange's photography (on film) exposes community as a relationship to loss and dispossession. Both involve a writing

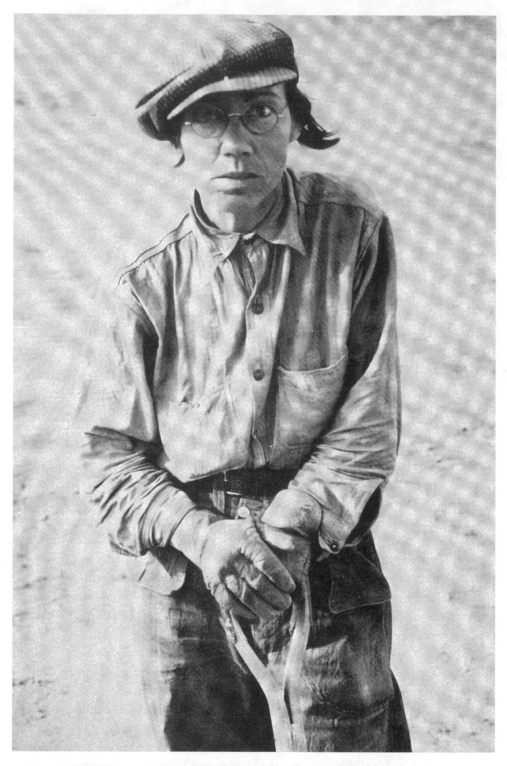

FIGURE 2.5. Dorothea Lange, "Indiana Woman in a Migratory Labor Contractor's Camp in California," 1937. Photograph from Farm Security Administration, Library of Congress.

otherwise (a posing in exteriority) that lets the singular outline of our being-in-common expose itself. In contrast to Lorentz, wonder, interrogation, and intellectual questioning are the modi (in)operandi for *Land of the Free,* and they alone provide access to community as an opening to others, to the questions raised by being with and sharing with others.

It does well to point out that another motive prompting Lorentz's ire appears to be territorial in nature. In other words, this critical outburst also could be viewed as a turf war between Lorentz's film *The River* and MacLeish's book (with all its cinematic pretensions) *Land of the Free.* The two projects were almost contemporaneous in their making and public release.[39] Indeed, Ruth Lechlitner compared them in her review of *Land of the Free.* She wrote there that Lorentz's film *The River* (also accompanied by a book) contained a sound track that he "wrote as a functional accompaniment to his movie."[40] Meanwhile, Eda Lou Walton reviewed the book version of *The River* and *Land of the Free* together in the *Nation.* Her review indicates how Lorentz's project was on the side of the restricted economy—art as propaganda in the service of the administration. Produced for the Farm Security Administration, *The River* "portrayed the drama of the spoilation of the Mississippi Valley and offered government planning as a means to restore this part of the country and its economy. It is propaganda become art—one of the most beautiful and dramatic 'shorts' ever produced in this country."[41] I take this characterization as a possible hint regarding Lorentz's displeasure. For *Land of the Free* is not so much art as propaganda as it is art marking the limits of propaganda in images and texts that return to the crisis of community.

On the other hand, T. K. Whipple's review in the *New Republic* offers a more optimistic assessment of *Land of the Free* and its proclivity toward epistemological doubt. Whipple begins with a discussion of poetic voice, and he focuses on the constitution of the "we" in terms of class issues so that "we the people" becomes synonymous with the exploited and the expropriated for both Archibald MacLeish and Carl Sandburg (who is also one of the supporting actors of the Family of Man exhibition in the next chapter).[42] Whipple insists that both of these poets speak out for being singular plural in a nationalist sense (rallying "the American 'We'"). However, Whipple articulates this collective voice and its poetic communication in terms of communal fusion rather than as an openness and exposure to the outside.

> Nothing is more important for a poet than who are "We" to him; and here, in the people, the exploited, and expropriated, is a new "We" for MacLeish. Among our poets, only he and Sandburg feel the American "We," they only, because they share our experience, instead of talking about it from the outside, are fit mouthpieces for us. And because of his very reluctance, MacLeish is capable of being the more articulate. If even at present he is willing to go no farther than most of us—"We wonder: we don't know: We're asking"—he may yet forge ahead and give the answers to the questions that are bothering him and us.[43]

Whipple shows impatience in this conclusion as he looks for answers even as he acknowledges the questions that bother MacLeish and America. But these questions cannot go away, for they are the questions that haunt community as it grapples with the stakes of being-with (*Mitsein*) in words and images.[44]

One final example of a contemporary reviewer fixated on the doubt that drives the poem comes from Peter Monro Jack in the *New York Times Book Review*. "The monotonous choral iteration of 'We don't know'—'We aren't sure'—'We're asking,' is helped by the pictures, indeed depends entirely on them, and would be an affectation in words alone."[45] If one follows Jack's statement that MacLeish's iteration of epistemological doubt depends on the pictures, then one does well to take stock of the images in *Land of the Free* that are coupled and combined with the statement "we don't know." There are indeed six points in the sequence when images are paired with the statement "we don't know"—three images by Dorothea Lange (the first image, three "Arkansas Sharecroppers"; the "Pea-Pickers in California" [image 8]; and the last image, "Dust Bowl Farmer Who Has Migrated to California for Fresh Start"),[46] one image by Russell Lee ("Iowa farmer" [image 31]),[47] one by Ben Shahn ("Girl in Louisiana Home" [image 80]),[48] and one landscape photograph by Willard Van Dyke ("The Smokies" [image 15]).

MacLeish's selection of what is considered the most important image of all FSA photographic production is not obvious from this list. For the eighth image of *Land of the Free*, entitled "Pea-Pickers in California" there, has become better known as "Migrant Mother," photographed in Nipomo, California, 1936 (Figure 2.6). This is the image that documents Florence Thompson surrounded by her children and holding a baby who perhaps has just finished nursing. It is an image that has become an American icon.[49] It is fascinating to compare the presentation of the image in *Land of the Free*, where the photo is accompanied by simple doubting text ("Now we don't know"), with the manner of its presentation in other contexts. For example, it is featured as an untitled but captioned image in Paul Taylor's article "From the Ground Up," in *Survey Graphic* in September 1936. In contrast to MacLeish's expression of subjective doubt and unknowing exposure, Taylor's caption is more an indexical matter of (sociological) fact about the migrant family's dispossession: "A blighted pea crop in California in 1935 left the pickers without work. This family sold their tent to get food."[50] An even more interesting comparison comes in the way the image is canonized and sanctified in Roy Stryker's book *In This Proud Land*. Admittedly, a difference of thirty-five years separates Stryker's treatment from MacLeish's, separates the present crisis of the *Land of the Free* from the retrospective mythmaking of *In This Proud Land*. For Stryker, "Migrant Mother" has become a site of transcendence. The social documentary realism of the suffering and hardships of a migratory pea picker by the effaced name of Florence Thompson has become aestheticized and immortalized.[51] Stryker refers to "Migrant Mother" as "*the* picture of Farm Security. . . . She has all the suffering of mankind in her but all the perseverance too. A restraint and a strange courage. You can see anything you want to in her. She is immortal."[52]

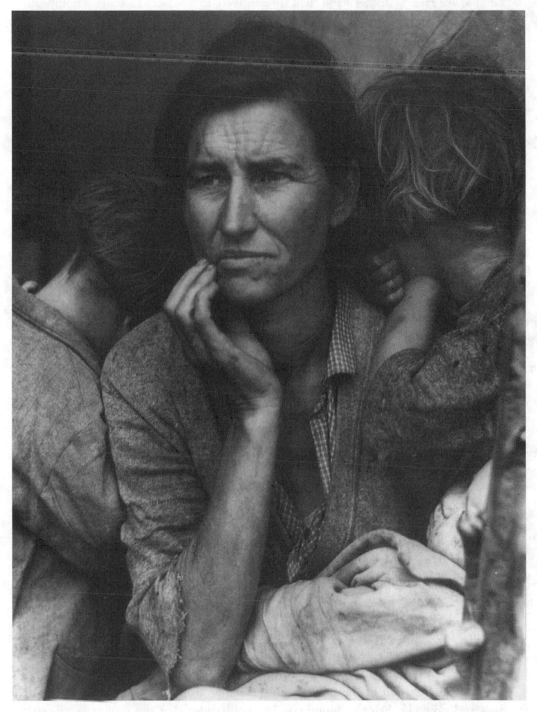

FIGURE 2.6. Dorothea Lange, "Pea-Pickers in California (Migrant Mother)," 1936. Photograph from Farm Security Administration, Library of Congress.

This canonization process is a far cry from the interruption of myth implicit in *Land of the Free*. With her hand held up pensively to her face, Florence Thompson enters the community of those who do not know, of those who enter community in this way. She is positioned by MacLeish as a key representative of self-doubt, as one who doubts the self-evident freedoms implicit in American national identity prior to the Depression (when "All you needed for freedom was being American" [verse 8]). She is followed immediately by another Dorothea Lange photograph—of a woman sitting on the side of her bed and making the same gesture, with her right hand held up to her face and staring out into space, and the accompanying line "we're wondering" (image-text 9). This image is entitled "Daughter of a Migrant Tennessee Coal-Miner in California."[53] Without a name, she too becomes another (dis-located) representative of the relation to doubt who helps to forge MacLeish's inoperative community.

FREEDOM: FROM SELF-EVIDENCE TO FREE THINKING

The epistemological doubt running through *Land of the Free* is directly connected to the fear (the only thing to fear, as FDR's most famous aphorism goes) that the American dream of liberty had run its course. As one reviewer commented on the central narrative thread of the book, "Particularly stressed is the bewilderment of the agricultural population which sadly debates whether the American dream of liberty is finished."[54] This fear is based on the idea that American liberty was only a by-product of the availability and disposability of land in the light of "manifest destiny" and westward expansion. Obviously, the Native American inhabitants are overrun (and written out) in this colonial narrative of conquest. Now that the era of open land is past, the dream of liberty might be over, and this alone is a cause for bewilderment. Thus, some verses in the poem function in the gap between then and now, between the then time of land (and hence freedom) and the now time of landlessness (and hence depression). We encounter lines such as "Now that the pines are behind us in Massachusetts" (verse 24) and "Now that the forests of Michigan lie behind" (verse 26, which is illustrated with the image of a forest fire in progress). These examples are summarized in the following manner: "Now that the land's behind us we get wondering / We wonder if the liberty was land and the Land's gone: the liberty's back of us . . ." (verse 29). These words are paired with the wistful image of an old couple (Figure 2.7) by Theodor Jung entitled "Early Homesteaders in Brown County, Indiana: Now Dispossessed."[55] From this perspective, American liberty was a happy accident of territorial plentitude and environmental resources, both of which had been depleted in the space and time of 150 years.

The organization of the poetographic material around the difference between then and now also helps to illuminate MacLeish's idea that the project is situated in purgatory. While he does not specifically refer to the purgatory passage from MacLeish's *Reflections*, Alan Trachtenberg touches on this aspect of the "between" in

his reading of the placement of Walker Evans's photograph "Graveyard and Steel Mill in Bethlehem, Pennsylvania" (image 83) in MacLeish's photographic sequence in *Land of the Free* (Figure 2.8). He refers to his image as "the alien hell that lies between there and here, between then and now." As one of the few photo historians and American studies scholars who have reflected on *Land of the Free,* Trachtenberg does so amid a close reading of Walker Evans's famous "Bethlehem" image as he reviews the varied contexts of its publication and its changes in meaning. Trachtenberg relates Evans's image and MacLeish's text to a crisis of liberty and community that "evokes the dubiousness of the American dream."[56] Trachtenberg suggests: "The image takes its place in a sequence of words and images, the governing theme of which is proclaimed in the poem's opening words, 'We don't know / We aren't sure,' which evoke the dubiousness of the American dream at a time typified by images of gaunt faces, resigned bodies, gnarled hands, ragged children, abandoned farms, police violence, and barbed wire."[57]

The poem reaches its climax immediately after Evans's image with words that strive to imagine another mode of liberty that would be based not on the land but, rather, on "men."

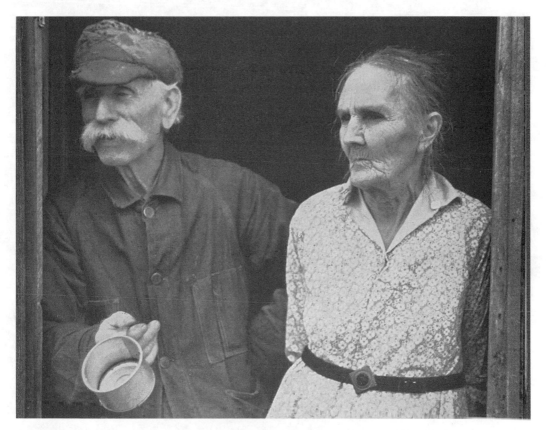

FIGURE 2.7. Theodor Jung, "Early Homesteaders in Brown County, Indiana: Now Dispossessed," 1935. Photograph from Farm Security Administration, Library of Congress.

We wonder if the liberty is done:
The dreaming is finished
We can't say
We aren't sure
Or if there is something different men can dream
Or if there's something different men can mean by
Liberty. . . .
Or if there's liberty a man can mean that's
Men: not land.[58]

This passage looks for hope amid the Depression and touches on hope as one of the key emotional ingredients (along with mourning) that punctuate and mobilize community.[59] The glaring fact of gender exclusion in this passage is not something that can be discounted so easily in a book that wants to speak in a collective voice of America's citizens nearly twenty years after the granting of women's suffrage. One wonders why MacLeish did not say "people" to make this humanist point. Furthermore, his move toward freedom and liberty in terms of human beings rather

FIGURE 2.8. Walker Evans, "Graveyard and Steel Mill in Bethlehem, Pennsylvania," 1935. Photograph from Farm Security Administration, Library of Congress.

than territory leads to other conceptual problems. The humanist (or rather "half-humanist") gesture that the meaning of liberty is grounded in "men" is merely a restating of foundational freedoms, whether articulated in a social contract or in a declaration of rights. This gesture risks essentialism, because it posits that individuals partake of freedom on account of belonging to some given, the category of human beings.[60] However, this would be an incorrect formulation of how freedom relates to the human. It would forget that human beings belong to being-in-common and that this cannot be posited as an essence but only as and in relation ("being-with"). Therefore, Nancy argues just the opposite: that it is "freedom that gives humanity" in terms of and on account of a relation that shares being. Such a perspective challenges the premise of the social contract and the ability to secure freedoms on the basis of the human. In this extended and rigorous philosophical formulation, Nancy asserts freedom as the (groundless) ground of humanity.

> If it is indeed true that freedom belongs in this way to the "essence" of human beings, it does so to the extent that this essence of human beings itself belongs to being-in-common. Now, being-in-common arises from sharing, which is the sharing of being. On the archi-originary register of sharing, which is also that of singularity's "at every moment," there are no "human beings." This means that the relation is not one between human beings, as we might speak of a relation established between two subjects constituted as subjects and as "securing," secondarily, this relation. In this relation, "human beings" are not given—but it is relation alone that can give them "humanity." It is freedom that gives relation by withdrawing being. It is then freedom that gives humanity, and not the inverse.[61]

If *Land of the Free* speaks in the voice of American community, then it is with a voice that tells us repeatedly that it does not know what is self-evident and what is not, what is secured and securable and what is not. (In other words, *Land of the Free* undercuts Farm Security.) This declarative mode (always) belongs to the past and its myths—something inherent in the "foundational" moment of American community, whether indexed as the Declaration of Independence or as the Bill of Rights. However, one is no longer at liberty to believe in them. Once upon a time, MacLeish says: "We told ourselves / The Proposition was self-evident" (verse 5).[62] This text is juxtaposed with Dorothea Lange's image entitled "Six Texans, Ex-tenant Farmers, Now on Relief and Unable to Vote Because of Poll Tax" (Figure 2.9). Ironically, MacLeish reminds the reader of the foundational freedoms at the very point when we look upon these men who have been denied their democratic right to vote. The levying of a tax has made the right to vote a class issue, and the myth of the human securing freedom is hereby interrupted. Interestingly enough, this image also appears in Dorothea Lange and Paul Taylor's *An American Exodus*, which includes both additional background facts about the bewildered farmers and their questions as they begin to fathom their newly found refugee status. The men ask questions that expose

the presence of some fighting words at the heart of fraternity: "Where we gonna go?" "How we gonna get there?" "What we gonna do?" "Who we gonna fight?" "If we fight, what we gotta whup?"[63] Taylor's commentary adds: "All displaced tenant farmers, the oldest thirty-three. All native Americans, none able to vote because of Texas poll tax."[64]

A few pages later in *Land of the Free,* the three "maybes" of the narrator cast doubt upon the propositions again: "Maybe the proposition was self-evident / Or maybe it isn't / Maybe we just thought so" (verse 14). But the doubt expressed by the poet here is not to be seen as a lapse that is somehow in need of repair. MacLeish's questioning of the viability and the truth claims of "self-evidence" does not lead to a return to or a relapse of foundationalism. According to Nancy, the desire to ground freedom—whether as a divine or as a human right—points to a major fallacy of constitutional democracies. Ironically, the attempt to found freedom becomes the very obstacle to the experience of freedom. "The first kind of obstacle consists in the self-evidence of the common notion of freedom."[65] For Nancy, freedom does not depend on a constitutional ground or a declaration of inalienable rights that can easily be taken away (as indexed in the Lange photograph). Freedom should be understood not as a property of beings but as a free expenditure without reserve. "In this

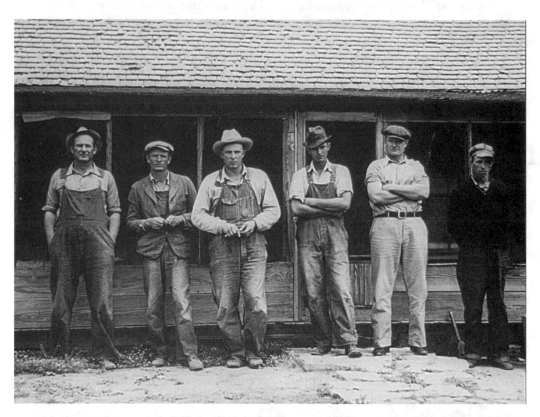

FIGURE 2.9. Dorothea Lange, "Six Texans, Ex-tenant Farmers, Now on Relief and Unable to Vote Because of Poll Tax," 1937. Photograph from Farm Security Administration, Library of Congress.

way, the freedom of being is not a fundamental property that would be above all else posited as an essence, but is immediately being in freedom, or the *being-free of being,* where its being is expended."[66] Despite their dispossession of the right to vote, "being in freedom" is what has been exposed and expended in this Lange photograph of the six inoperative men standing around, arms folded or hands in pockets, staring directly and curiously at the camera wielded by this female government dispatcher. In contrast to grounding or founding freedom in terms of a constitutional necessity, the issue is one of "liberating human freedom from the immanence of an infinite foundation or finality." It is an issue of "letting freedom exist for itself" and of acknowledging freedom as a direct consequence of "the infinite inessentiality of its being-finite."[67] While this last statement is part of a philosophical reflection on the nature of being and freedom in relation to time, it also resonates with photographic practice, for it is an acknowledgment of both the contingency and the finitude that go into the making of every photograph. The "infinite inessentiality of its being-finite" has provided photography with its own temporal signature, and this charac-teristic marks the eighty-eight photographs of *Land of the Free.* In the inessential and arbitrary click of the camera, photography cuts out a contingent slice of time and converts it into a memory of finite experience. This is what aligns photography to being in freedom, to the "burst of freedom" that it enacts in its blinding and inter-ruptive flash.[68] In this way, photography exposes being in freedom, being in the *Land of the Free.*

Freedom is never a settled or a secure thing. How could it be such and still be free? *Land of the Free* resists the forces of the Farm Security Administration when it posits freedom otherwise. The poetographer wonders: "Or if there's something dif-ferent men can mean by Liberty" (verse 86).

TOWARD A POETOGRAPHIC COMMUNISM

The specter of a radical leftist politics of community is always lurking in the discourse on New Deal programs and Farm Security Administration photography in general. The failures of America's rugged and radical individualism were obvious at the time of the Great Depression. By 1938, the ideology of the self-reliant individual dependent on the figure of the open road (of westward colonizing expansion) had reached its end and the mentality that "there was always some place else a man could head for" (verse 18) could not be sustained. For political conservatives, the move toward government intervention in the name of the common good was anathema, and the photographs of the FSA were perceived by them as a key part of a propaganda machine designed to support Roosevelt's socialist programs. Their criticism came to a head with the scandal over Arthur Rothstein's alleged removal of a cow's skull from one location to another (yet another resettlement project) to connote drought in the badlands of South Dakota. In part, this debate involved photographic truth claims, with the stag-ing of the image understood as a betrayal of documentary truth. However, another

allegation was embedded in the critique of Rothstein's skull pictures, and this one implicated the image as socialist propaganda. This critique rears its head in a widely distributed article, entitled "It's a Fake!" which was first published in the *Fargo Forum* on August 27, 1936.[69]

> The revelation that Dr. Rexford Tugwell's "Resettlement Administration," the principal socialistic experiment of the New Deal, has been guilty of the circulation of at least two flagrantly faked "drought" pictures, designed to give the public an exaggerated idea of the amount of damage done by the lack of rainfall, is a highly instructive but not especially surprising development. The whole resettlement program is a ghastly fake, based on fake ideas, and what is more natural than that it should be promoted by fake methods similar to those used by ordinary confidence men?[70]

With the cry of "fake" (announced three times in one sentence) and the accusation about confidence men, this report illustrates very clearly how photographic truth is exposed to its other—photography as mere artifice and exaggerated stagecraft. Photography is envisioned here as a deceitful double and a "ghastly fake" that goes against nature. Rather than perceived as the reputable "sociologist with a camera" (what Ansel Adams had said about the FSA photographers)[71] who collects empirical data, Rothstein is now envisioned as a phony con man presenting the public with a bunch of fakes in order to prop up and propagate the "principal socialistic experiment" of the New Deal.

In a similar vein, comments contributed by gallery goers to the exhibition of Farm Security Administration photographs included in the First International Photographic Exhibition in Grand Central Palace in New York City during April 18–24, 1938, are also quite revealing. A few of the most scathing comments were "Purely propaganda for Communism" and "Subversive propaganda."[72] This is not to suggest that this opinion was a majority one. However, these comments do support the idea that the risks of socialism and communism, as articulated in conventional political terms, hung over FSA photographic practice. In addition, these conservative charges allow for a better understanding of why the Roosevelt administration was particularly cautious about owning up to such rhetoric in words or in images.

If applied to the MacLeish project, these charges suggest reasons to situate it as a call to collective action with socialist implications. This is especially so in regard to three of the book's final images and accompanying texts. Interestingly enough, these images were made not by Resettlement Association photographers but rather by news agencies. In this regard, they belong to a different class of images in the book, and therefore perhaps their socialist implications are less in need of veiling. All of these images depict workers striking against capital—a May Day demonstration in Philadelphia, labor leaders addressing textile workers in North Carolina, and a celebration of the end of a steel strike in Pennsylvania. In her book review, Eda Lou Walton comments on the workers in these images: "Slowly they are becoming aware that they

are actually enslaved and will be until they understand another kind of freedom, to be gained by men acting together."[73] From Nancy's perspective, calculated risks are involved in forging the question of community in such a politically programmatic way. For the call to men and women to "become free" through collective action by organizing the bond of community around labor and work goes only so far. However, it will not arrive at the heart of freedom or of community and its sharing. Freedom exposes community to its unworking and to the necessary resistance to its essence or its completion—or to what would enslave it yet again. In this context, one recalls that Maurice Blanchot refers to the "unfinishedness or incompleteness of existence" as "the principle of community."[74]

From this perspective, *Land of the Free*'s strength lies in its resistance to the claim that a particular political program founds community. Rather, *Land of the Free* articulates community as the possibility of the political as such, which Nancy describes as "that way of destining ourselves in common that we call a politics, that way of opening community to itself, rather than to a destiny or to a future."[75] In this light, the image of the May Day demonstration, rather than acting as communist propaganda in and of itself, illustrates one possible way of opening community to itself. At this poetic-photographic crossroads, *Land of the Free* is to be viewed not as a prescriptive or legislative book but as one that marks the crisis and the decision (the decisive spacing of the between) necessary for the formation of American community. This open-ended reading is underscored by the poetic text accompanying the May Day image. It is juxtaposed with a potentiality or a musing that opens community to itself and to the possibility of its possibilities: "Or if there's something different men can dream" (verse 85). For what is liberty if not the possibility of dreaming differently? Here, the question of community or being-in-common is articulated in terms of a meditation on difference and alterity—always a different spacing of the between—rather than on identity and unity.

This meditation on the something different to be dreamed and the resistance to the appropriation of the essence of community also helps to explain how and why MacLeish does not fit so easily into either the right or the left side of the political spectrum and evades any attempt to pigeonhole him with certainty. According to MacLeish biographer Scott Donaldson, "He presented a confusing target, to be sure, for even as he denounced the tycoons as insensitive money grubbers, he belittled the comrades for their lack of understanding about American history and culture."[76] In this way, the purgatorial state can be applied to MacLeish's own political maneuverings on the question of "being-with." While the right accused MacLeish of being a Communist conspirer for his antifascist stance during the Spanish Civil War, the Marxists condemned him for (among other things) never believing that "class" defines and determines the position of the artist in society.[77]

At this politically volatile juncture, one turns to another theoretical resource offered by *The Inoperative Community*. For the thinking of community and being-in-common in *Land of the Free* is invigorated by relating it to Nancy's provocative

gesture of "literary communism."[78] If we were to transpose media, *Land of the Free* could be viewed as invoking a type of photographic communism (in terms of its images) or a poetographic communism (in terms of its image-texts). "Literary communism" does not refer to a specific Communist political agenda. For Nancy, literary communism, rather, depends on the acknowledgment (taking place at the limit of knowledge) that community is unworked and that myth is interrupted (by poetry, by literature, by photography, or, in the case of *Land of the Free*, by poetography) and in such a way that community—in order to pose itself as community—is unable to complete itself. To quote Nancy, "It is because there is community—unworked always, and resisting at the heart of every collectivity and in the heart of every individual—and because myth is interrupted—suspended always, and divided by its own enunciation—that there exists the exigency of 'literary communism.'"[79]

This chapter has argued that such an attitude lies at the heart of *Land of the Free*. The unworking of community and the interruption of myth provide the crucial combination that makes *Land of the Free* a compelling and singular image-text marked by epistemological stutters in its being-with *poetography*. As such, *Land of the Free* uses doubt, interrogation, and wonder as the markers of resistance that simultaneously announce community and interrupt its own enunciation and the appropriation of its essence. In this way, *Land of the Free* recalls and invokes the double bind announced by Georges Bataille's "community of those who do not have a community."[80] From start to finish, it is a text that challenges the very terms of closure and dwells in a purgatory (to return to MacLeish's term) that exposes community as and at the limit of knowledge. This is repeated in MacLeish's incessant poetographic call to resistance and attention to the general crisis. *Land of the Free* is a book that can be concluded only inconclusively—doubtfully, uncertainly, interrogatively. "We don't know. We aren't certain. We're asking" (verse 88).

3. Photo Globe

The Family of Man and the
Global Rhetoric of Photography

"What is the shape of the world?"

"I don't know."

"Well, what shape are my cuff links?"

"Square."

"Not my weekday cufflinks. The ones I wear on Sundays."

"Oh. Round."

"All right, what is the shape of the world?"

"Square on weekdays, round on Sundays."

—THE MARX BROTHERS, VAUDEVILLE ROUTINE

WHAT IS THE SHAPE OF THE WORLD?

The curator of the photography department at the Museum of Modern Art in the 1950s, Edward Steichen (Figure 3.1), was not Groucho Marx, and, that obvious point being made, he did not respond to this question with an absurdist non sequitur or epistemological doubt (i.e., "I don't know"). Instead, he gave us the Family of Man exhibition, not only to prove that the world was round, but also to illustrate how the medium of photography helped to supply the proof. In traveling around the world to forty countries in a six-year span from 1956 to 1962 and in having been viewed by about nine million people, this circulating exhibition was an international blockbuster, and the organizers had no qualms about indulging in P. T. Barnum– like superlatives in referring to it in the promotional material as "the greatest photography exhibition of all time."[1] The exhibition was accompanied by a popular catalog that reproduced for the masses most of its five hundred or so images in an inexpensive format. Keeping things all in the family, Steichen's brother-in-law Carl Sandburg wrote the prologue for the exhibition catalog. Instead of listening to Groucho's

FIGURE 3.1. Edward Steichen (on the right) at the opening of La Grande Famille des Hommes (the Family of Man exhibit) at the Musée Nationale d'Art Moderne in Paris, where the blockbuster was exhibited from January 26 to February 26, 1956. Photograph from United States National Archives and Records Administration (NARA 306-FM-10-35).

pithy cynicism puncturing holes in *globalicity* (i.e., the possibility of the global and its thinking), we listen to a poet waxing eloquent and gushing with sentiment about the virtues of "one big family hugging close to the ball of Earth for its life and being."[2]

In the history of photography and in photography studies, the Family of Man exhibition has achieved canonical status. Moreover, it has also become one of the most controversial and debated subjects in the history of photography in the past half century. Even at the time of its appearance at the height of the Cold War, a number of insightful critical essays questioned the superficiality or hypocrisy of the doctrine of "universal humanism" preached in the Family of Man. Written by intellectuals, these critiques of photo-global thinking range from Roland Barthes's Marxist-inflected review on the French left to Hilton Kramer's "red scare" analysis from the right of the American political spectrum.[3] More recently, a symposium called "The Family of Man 1955/2000: Humanism and Postmodernism: A Reappraisal" was held at the University of Trier, in Germany, in October 2000. The existence of this international conference indicates considerable continuing interest in the famous photography exhibition seen around the world. In fact, the announcement on the World Wide Web—that virtual locus of technologically global claims—stresses the relevance of the exhibition in and to the present era of globalization or, as it states, "the process of globalization of the 90's," even though it does not attempt to spell out the meaning of this sometimes nebulous term.[4]

In the politics of his own day, Edward Steichen offered a liberal alternative to those who supported a divisive McCarthyism in domestic life and an aggressive foreign policy against the threat of communism on the international front. The Family of Man was supposed to function as a bridge, to promote dialogue and foster community in the face of the U.S./Soviet polarization of the Cold War. But the noble intent of Steichen's liberal foreign policy, promoting itself as the most sympathetic of humanisms, was based on unspoken assumptions about global community (about community taking the shape of a globe) that were highly problematic and would lead to the policy's own set of exclusions, excisions, and suppressions. In this chapter, I am interested in reviewing how global rhetoric was crucial to Steichen's conceptualization of his project and its hegemonic destiny. For the Family of Man exhibition, this means that the particular moves inextricably toward and represents itself as the universal and imposes necessary exclusions in the process. In addition, I am interested in reviewing how Steichen extends his analysis so that this global rhetoric encompasses the medium of photography. Steichen's global rhetoric illustrates the deployment of a logic of control and domination that seeks to get a grip on the world or to allow him to hold it in his grasp by constructing the Family of Man exhibition as a worldwide visual spectacle and the medium of photography as a universal language. Given these totalizing assumptions, Steichen rules out the subversive possibility of considering a world (dis)order that takes its cue from the obstinate questioning offered by a pair of square cuff links.

GLOBAL RHETORIC UNTO THE DEATH

Writing in the 1950s and 1960s and well before the present vogue, Steichen rarely uses the terms *globe* or *global*. However, one usage does appear in an article from the late sixties that is brimming with nationalist sentiment and manifest destiny. Entitled "The U.S.A.," this short article appeared in *Travel and Camera: The International Magazine of Travel and Photography* in 1969 as an introduction to "a portfolio of significant photographs of our country," selected by Steichen. The reader of *American Exposures* already notes the exclusive language of nationalist community in the invocation of "our country." In this text, Steichen uses the figure of the globe but only to stress the uniqueness of the United States and what makes it a travel photographer's dream. "This country offers as much to a photographer as any country on the globe. Perhaps more—certainly more to me and many others who traveled widely and came home not to roost, but to awaken to all the variety of scenery, climate, people and possibilities that make these states so vitally interesting and almost unbelievable."[5] This is a peculiar sentiment, because it introduces the figure of the globe only to bolster the self-image of one's own nation. This passage sets the geoterritorial beauty and splendor of the United States in competition with other parts of the globe, and it concludes with the nationalist assertion that America has more to offer—"certainly more." Of course, this move opens itself up to the oft-repeated charge made against the Family of Man exhibition over the years: that its globalism masked a particular ideological agenda that put "America first."

But while Steichen may not have used the exact word *global* in his writings on the Family of Man, his language and rhetoric match the standard meaning of the term as "the becoming worldwide of the world." For Steichen, the Family of Man is quite literally the exhibition of the principle of the becoming worldwide of the world. In this context, it should come as no surprise to learn that the concept of circulation in terms of a worldwide encirclement of the globe was a crucial one for the players and institutions involved with this traveling exhibition, from Porter McCray, whose title was the Museum of Modern Art director of circulating exhibitions, to the United States Information Agency, responsible for (as one MoMA memo states) "duplicate versions . . . being circulated overseas."[6] To understand how this global rhetoric operates in the Family of Man, it is necessary to review the assumptions that Steichen makes about "universality" and how these assumptions guide both his construction of community and the "universal language argument" that he applies to photography.

It is a globalized rhetoric of photography that underpins the Family of Man exhibition. In his essay "Photography: Witness and Recorder of Humanity," Steichen stages photography as the completely transparent medium of the communication of our "common being" that speaks for and to the global community. "We have in photography a medium which communicates not only to us English-speaking peoples, but communicates equally to everybody throughout the world. It is the only universal language we have, the only one requiring no translation."[7] From this perspective,

the Family of Man becomes the utopian search for the community that would have its humanity in common and would commune in that recognition via the evidences and assurances of photojournalistic communication. Yet, Steichen does not think about the peculiarity of converting into a universal language something that looks like an issue of *Life* magazine, in terms of both the exhibition's layout and the large number of images that were originally published in this magazine. In setting up photojournalism as the photographic lingua franca, his account excludes the opacities of abstract or subjective photography that automatically complicate such a universal language claim. For Steichen, photography constitutes a universal language without any need of translation because of the way in which the referent adheres to each and every photograph. As Barthes writes in *Camera Lucida,* "It is as if the Photograph always carries its referent with itself."[8] In this manner, Steichen falls into the trap of viewing these photographs as universal indexes of a common reality in an active forgetting of photography as a signifying practice, not to mention as an expository mode (in Nancy's sense) that poses community at and to its limits.

The Family of Man exhibition framed itself as a communitarian photographic project in the widest possible sense. To understand its model of community, I would like to apply some of the concepts developed in Jean-Luc Nancy's *The Inoperative Community.* From Nancy's perspective, the Family of Man embodies the nostalgic lure of the fusional model of community that expresses the utopian desire to achieve mythic communion in its self-professed desire to illustrate "the essential oneness of mankind throughout the world."[9] The Family of Man exhibition seeks what Nancy calls "the immanence and the intimacy of communion" on a global scale.[10] The exhibition illustrates this type of intimacy through the various communal activities that it depicts (mourning, dancing, birthing, etc.) as well as in establishing an emotional intimacy with the spectator, who is asked to identify with these activities.

This last point relates to Steichen's insistence that the success of the Family of Man can be explained in the way that it fostered communal identification. In other words, it held up a mirror to the world that allowed people to recognize themselves as belonging to a human collective. Steichen writes: "I believe now that the answer is that people participate in the exhibition personally: they feel they are a part of it. As a Japanese poet said: 'When you look into the mirror, it is not you that sees your reflection; your reflection sees you.' These people look into the mirror of life and their reflection looks back at them and smiles."[11] While Steichen cites a Zen *koan* that uses the mirror to question the primacy of the real and to affirm the power of the double, his appropriation of this text is much less radical as he shifts from the level of the signifier to the signified. "They're not looking at photographs—they're looking at people they know, and they're even looking at *themselves* a good deal."[12] One might argue (à la Lacan) that Steichen's reading of his own exhibition enacts humanity's mirror stage. He relates a primal scene of mis-recognition for the Family of Man, wherein it looks into the mirror of life and says "that's us." But this gesture mistakes the reflection for the real and substitutes the communal signified for the photographic

signifier. The Family of Man achieves this sleight of hand by positing what Barthes calls "the ambiguous myth of the human 'community.'"[13]

It is the figure of death that serves as the founding truth for this fusional model of community. To recite Nancy, "That is why political or collective enterprises dominated by a will to absolute immanence have as their truth the truth of death."[14] Paradoxically, "nonbeing" becomes the shared element for this collective enterprise, dominated by a will to include and incorporate all of mankind in an absolute manner. One of the first press releases for the exhibition pinpoints the "truth of death" in this way. "The exhibition poignantly points out the way in which death is a great leveler."[15] But the Family of Man does not remain at this abstract level in raising the specter of death at and as the foundation of community—and photography. Instead, the exhibition zeroes in on the "challenge" posed by the hydrogen bomb and the threat of the impending doom of nuclear holocaust. In this way, the Family of Man partakes of the apocalyptic visual culture and the "imagination of disaster" dominating the Cold War paranoia of the mid-1950s, from Godzilla movies to abstract expressionist explosions on canvas.[16] This press release continues:

> This great parade of human emotions and feelings, seen in people, characterized by dignity and hope wherever they were found by photographers all over the world, is climaxed at the end of the exhibition by a series of photographs which dramatically raise one of the greatest challenges of our time—the hydrogen bomb and what it may mean for the future of the family of man. Nine photographs of questioning faces, triptychs of three children, three women and three men are shown with a quotation from Bertrand Russell, "the best authorities are unanimous in saying that a war with hydrogen bombs is quite likely to put an end to the human race. . . . There will be universal death—sudden only for a fortunate minority, but for the majority a slow torture of disease and disintegration."[17]

In this way, the exhibition climaxes in the bomb and in Bertrand Russell's apocalyptic warning about universal death. In the exhibition design, the apocalyptic text was preceded by a panel of nine portraits of questioning faces; at the entrance of the next gallery, these were followed by Raphael Platnick's image of a dead soldier, who functions as the metonymic stand-in for all humanity (Figure 3.2); and then, as Steichen recalls, "a great picture of the hydrogen test-bomb being exploded on that same island."[18] This was a dramatic backlit color transparency of the H-bomb that was not reproduced in the exhibition catalog. While Steichen insists that making the bomb a thing of beauty is a "kind of untruth,"[19] this does not stop the Family of Man from positing the aura of the bomb as the deadly truth and the truth of death around which the exhibition turns. But the irony here is that the mortal truth of death is also the reason that any possible communion of the fusional community is rendered impossible. From the perspective of the expository approach to photography, the common denominator of death (what is shared) is the limit of experience around

which community can never become united (what is never shared). This latter point—what renders the exposure of community inoperative—marks the consistent blind spot of the rhetoric of the Family of Man exhibition.

Another fascinating aspect regarding the stagecraft of the exhibition and its design registers the figure of the globe and (unconsciously) the truth of death at the basis of the globally fused community. The exhibition featured a total of eighteen photographs purporting to show children around the world playing the game of ring-around-the-rosy. As the MoMA press release explains:

> Photographs of children playing Ring Around the Rosie show that this universal pastime of the young is equally enjoyed in 12 countries. Arranged in a large ring in the center of a gallery, are photographs of children in German streets, on a Swiss hillside, in an oil field in Peru, in a schoolyard in Israel, who "clasp the hands And know the thoughts of men in other lands . . ." (John Masefield).[20]

FIGURE 3.2. This overhead shot shows the installation web and a few visitors at the exhibit the Family of Man at the Corcoran Gallery of Art, Washington, DC, August 1955. On the right side in the back is Raphael Platnick's photograph of a dead soldier at Enewetak, in the Marshall Islands, the problematic figure of the corpse around which global community turns. Photograph from United States National Archives and Records Administration (NARA 306-FM-15-6).

In terms of the exhibition layout, this final quotation by the poet John Masefield was used as the globalizing caption to accompany and frame these images. Whether or not these children are playing the same game (which is debatable),[21] the global symbolism of all of this is quite obvious. Ring-around-the-rosy illustrates the universal humanist claim that "we are all alike," and the visual figure involved here is a circle or a ring. Thus, the world celebrates the possibility of the global by playing the game that approximates its very shape. As if to underscore this point, the exhibition design produces the three-dimensional installation of these eighteen photographs by means of a large wheel (or carousel) in the center of the gallery (Figure 3.3). In order to view these images, the spectator must circumnavigate the circumference of this ring and thereby trace the figure of the globe. A photograph of the exhibition in Stockholm shows that a bouquet of roses was placed in the middle of the installed carousel, thereby adding an aesthetic touch and a visual symbol of the nursery rhyme. Unfortunately, some of the traveling versions of the exhibition could not replicate the full impact of the original installation and this three-dimensional interactive component. (Such versions circulated in a panel form that had to be hung.)

An interesting aspect of this children's game suggests why it might have been an overdetermined selection for Steichen, given the way in which the Family of Man

FIGURE 3.3. The "ring-around-the-rosy" carousel, showing children playing this game (or its semblance) around the world, enacted the global rhetoric of the Family of Man exhibition, 1955. Photograph by Ezra Stoller; copyright Esto.

constructs global community via the common denominator of death. According to many folkloric accounts, the nursery rhyme "Ring around the Rosy" originated as a response to the Great Plague that swept through Europe in the 1600s, and the game allows children to act out the fatal consequences of the disease when singing the last two lines, "Ashes, ashes, we all fall down." This indicates the Euro-American sources of this nursery rhyme and the way in which death—the falling down of All—becomes the basis of the communal myth ("we") that guides the Family of Man. In the wake of the horrific genocides of the Holocaust and the bombing of Hiroshima, Steichen unconsciously turns to this grim nursery rhyme that commemorates the death and destruction of a former era.

"WE ARE ALL ALIKE" EXCEPT . . .

The universal demand of the Family of Man is captured in the most repeated and dubious phrase in Steichen's photo-global rhetoric: "we are all alike."[22] Steichen states the third main purpose of the Family of Man exhibition: "to express my own very firm belief that we are all alike on this earth, regardless of race or creed or color."[23] But Steichen does not want to leave the claim that we are all alike—or, as the next generation would say, "we are the world"—merely as abstract assertion and empty platitude. Instead, he supports this claim with evidence that makes the family unit serve as the basis of "our alikeness." Steichen states the show's credo with a foundational metaphor that invokes mythic origin and a return to roots: "Wherever you turned in the exhibition, you saw this grouping of family and were reminded: 'This is the root. The family unit is the root of the family of man, and we are all alike.'"[24] It is important to note that this insistence on the nuclear family unit as universal fact also served to reinforce stereotypical gender roles and the heteronormativity of 1950s American domestic life (as witnessed in Figure 3.4, in which Richard Nixon gives his vice presidential paternal blessing to the exhibition). Steichen's credo was represented with large-format portraits of a group of families from the major continents working as the centerpiece—or, to use Steichen's photographically inflected phrase, as the "focal point"[25]—of the exhibition.

To reiterate Barthes's cogent critique, the myth of the "family unit" and its universality can be constructed only by suppressing the "determining weight of History" and the inequalities that it generates.[26] For example, the comparison of the family portraits from Bechuanaland (photographed by Nat Farbman) and the United States (photographed by Nina Leen) represents just one attempt to mask differences under the universal category of the family unit (Figure 3.5).[27] But there is no equal footing here. Rather we are confronted with the vast differences between a family who has access to photography and media images, a family that displays its genealogy on the wall with its ancestral portraits, and a family of hunter-gatherers who have no such image bank but rather a tribal memory based on an oral tradition, a family who have been subjected to photographic technology for the first time. These inscribe the

power relations that the Family of Man writes over in the rhetoric of global reductionism. In other words, these images raise questions dealing with a group's access to knowledge, to technology, and to the production and reproduction of images that do not make for one big happy family.

One can also focus on Steichen's inappropriate choice of language in "describing"—as if this category were not always already fraught with interpretation and evaluation—these two families and on the unequal treatment that he gives them, both in the amount of space and in the tone of his language. This unequal treatment connotes racialist stereotyping when Steichen equates the African other with primitivism in a rather ambivalent manner. The family from Bechuanaland is "said to be contemporary cave men." (Meanwhile, in the previous paragraph, Steichen refers to "a so-called savage in Africa teaching his boy to shoot a poisoned hunting arrow.")[28] While Steichen attributes these statements in both cases to somebody else ("that's what they

FIGURE 3.4. The official caption on the back of this photograph reads, "Edward Steichen escorts Vice-President Nixon and Mrs. Arthur W. Radford, wife of Admiral Radford, chairman of the Joint Chiefs of Staff, through his exhibit, 'The Family of Man' at the Corcoran Gallery of Art, Washington, D.C., in August 1955." Much can be said about the naturalization of gender roles and the heteronormativity of the Family of Man in the paternal gazes of the vice president and the show's "creator" along with the smiling admiral's wife (with the unknown first name) as they review the images in the "Marriage" and "Pregnancy" sections. Photograph from United States National Archives and Records Administration (NARA 306-FM-15-38).

believe . . .") through the device of what is "said to be" or "so-called" in order to distance himself from racialist typologies, one wonders why he would make this attribution with all its negative associations or invoke this type of authority in the first place ("but I'll say it anyway"). After all, he could have said nothing at all or something far more neutral or even positive. But these ambiguous statements are especially troublesome considering that Steichen wants us to believe that we are all alike despite our racial differences. In contrast to this slide into racial slurring, the American family for Steichen appears to be closer to home and to his heart. The Nina Leen image is lauded as "a wonderful picture of good, hearty, earthy farmers posed around an old kitchen stove. In the center is a grandmother in a rocking chair, silver-haired, surrounded by her children and her grandchildren; and on the wall behind, a row of grim-looking ancestors."[29] The positive, value-laden adjectives pile up in Steichen's lengthy and effusive review of this Nebraska representative of American family values. When placed in comparison with the Bechuanaland family, this image appears to

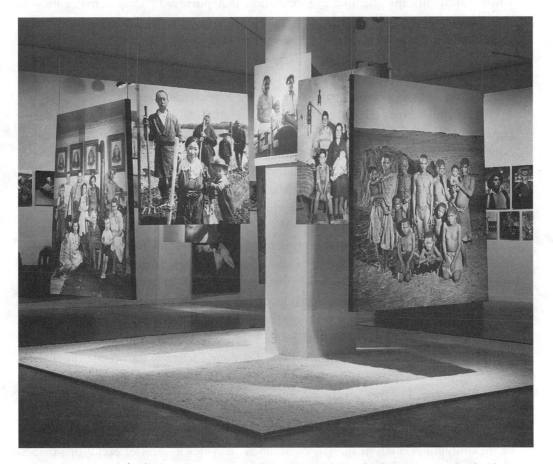

FIGURE 3.5. Assumed to be equivalent, with their differences repressed, these family portraits were placed at the center of the Family of Man exhibition, with Nina Leen's "Family in Nebraska" suspended on the far left and Nat Farbman's "Family in Bechuanaland" suspended on the right. The installation was part of the premiere showing at the Museum of Modern Art in New York City in February 1955. Photograph by Ezra Stoller; copyright Esto.

offer Steichen a closer and better resemblance (and splitting image in the Lacanian sense) when he looks into the mirror of family life.

Allan Sekula and others have pointed out that Steichen's global rhetoric was matched by one of the multinational corporate sponsors of the Family of Man exhibition. When the traveling exhibition appeared in Johannesburg, Union of South Africa, for the first two weeks of September 1958, it received the proud sponsorship of the Coca-Cola Bottling Company. "An arrangement was made earlier this year with the Secretary of the Witwatersrand Agricultural Society and the Coca-Cola Bottling Co. of Johannesburg to assist in the sponsorship of 'The Family of Man' Photographic Exhibition which was the feature event of the annual Spring Show."[30] From the utopian perspective of "universal humanism," it is possible to argue that the Family of Man functioned as a means of enlightenment for this nation under the oppressive rule of apartheid and the division of its citizens according to skin color. Yet it is also clear from the illustrations in the *Coca-Cola Overseas* brochure that only white South Africans attended the exhibition that purveyed the underlying message "we are all alike." While the ring-around-the-rosy carousel did not make it to Johannesburg, the bottlers managed to set up a globally inflected installation of their own. "At the entrance of the hall, the large globe of the world encircled by bottles of 'Coca-Cola' created a most attractive eye-catching display and immediately identified our product and organization with 'The Family of Man' sponsorship."[31] The image in the brochure shows the placement of the ring of Coke bottles at the line of the equator of the globe so that the soft drink bisects the world into its Northern and Southern hemispheres. For Allan Sekula, this display "attempts to link the universalism of the exhibition and the global authority of the commodity."[32] Yet, the global status of Coca-Cola and the Family of Man is undermined through the exclusion of black South Africans from the traveling exhibition and from access to the pop-culture beverage.

In his essay "Reification and Utopia in Mass Culture," Fredric Jameson argues that the coexistence of these gestures toward universal humanism and global harmony and the return of the repressed (that oppresses) should come as no surprise.[33] He discusses how both ideological manipulation and utopian impulses are endemic to mass-culture phenomena. "I will now argue that we cannot fully do justice to the ideological function of works like these unless we are willing to concede the presence within them of a more positive function as well—their utopian or transcendent potential."[34] In the mass photo-cultural event known as the Family of Man, this dialectic works in reverse. In other words, we will not do justice to the utopian potential of its universal humanism unless we are willing to concede the copresence of a coercive ideological function. This translates into the ways in which the utopian inclusiveness of the ambiguous myth of human community demands a series of exclusions that mask inequalities and cultural hierarchies.

The prior comparison of the families from Bechuanaland and the United States is just one example. The images of people voting around the world as somehow doing

democracy's bidding in nations as diverse and politically different as China, Turkey, France, and Japan are another example of the utopian and transcendent potential of the Family of Man masking an ideological function.[35] Steichen recalls: "Another section dealt with voting, with a caption taken from Jefferson: 'I know of no safe depository of the ultimate powers of society but the people themselves.' All the pictures showed women voting along with their menfolk—in Japan, China, France, the United States—a step towards a universal human right that has been taken in my lifetime."[36] One notices here how Steichen directs attention to his selection of photographs that document women engaged in exercising the right to vote and asserting it as a "universal human right." (Perhaps this comment is a response to the protofeminist criticism of the patriarchal bias of the Family of Man.) However, this utopian emphasis sidesteps the peculiar use of the slaveholder Thomas Jefferson as the one who speaks for democracy and universal suffrage. By ignoring the particularities of why these people are voting and their particular forms of governance, Steichen suggests that women in China, Japan, Turkey, and France are somehow doing the bidding of America's founding father in casting their ballots. This series of images is rendered even more problematic in the exhibition catalog, where they are accompanied by a Sioux Indian citation instead of the one by Jefferson. It reads: "Behold this and always love it! It is very sacred, and you must treat it as such." In this word-image combination of political incorrectness, the voice of a people subject to mass extermination by the white colonialist powers that constituted the United States advises us to respect the sacredness of voting. In these ways, Steichen's decontextualized images stuff the world's ballot boxes with democracy American-style and with American ideology.

COMMUNITY AGAINST COMMUNITY: A RANGE OF INCIDENTS

While Jean-Luc Nancy does not use Fredric Jameson's terms, he does point to the same set of problems in the section of *The Inoperative Community* entitled "Myth Interrupted." He discusses one of the central paradoxes of the fusional community: that every gesture it makes toward inclusion always represses some sort of exclusion. Nancy writes: "The fusion of community, instead of propagating its movement, reconstitutes its separation: community against community. Thus the fulfillment of community is its suppression. To attain to immanence is to be cut off from another immanence."[37] In other words, the Family of Man is bound to failure because every inclusion marks another exclusion, and that, in turn, turns community against community, difference against difference. Seduced by the lure of global immanence, the fusional community buries the question "Whose community?" In this way, Jameson's ideological manipulation is rearticulated in Nancy's terms as the suppression of community.

A primal scene at the founding of the Family of Man reveals how Steichen's move toward immanence is constructed through a paradoxical suppression of community. While it is an anecdote that Steichen repeated on a few occasions, it has never been discussed in the voluminous critical literature on the exhibition. Unlike the ambiguous

comments cited previously, this racial slur has no qualifiers. Steichen recalls the ori-
gin of his exhibition with a biographical incident that involves an anti-Semitic slur
he made when he was a boy. His expression of his own remorse about being such a
bad boy results in a suppression of community that happens against all of Steichen's
best intentions as a liberal reformer and curatorial idealist who seeks global under-
standing. The exhibition that affirms the post-World War II ideology that "we are all
alike" and universal humanism owes its origin to the suppression (and a sublimation)
of Jewish difference. The scene shifts to Milwaukee, Wisconsin, circa 1900 as Steichen
recalls the incident:

> My mother had a millinery store on Third Street, and I came home from school
> when I was about seven or eight years old and as I closed the door of the store I yelled
> out to a boy in the street, "You dirty kike!" For hours [my mother] talked to me
> about how wrong that was, because all people were alike; that I was in America,
> because in bringing me to America she had hoped I would have a chance in a world
> that didn't have that thing. That's where my exhibition really began—with a great
> woman and a great mother.[38]

Rather than locating the origin as a reaction to the slur (the differential source
of the animosity that must be overcome), our family man quickly sublimates it with
a tribute to his saintly mother and the universality of motherly love.[39] Yet, Steichen's
remarks expose the inclusivity of the Family of Man as founded in part on the exclu-
sion of a particular difference as well as on a globalization of the American melting
pot ideal. In other words, Steichen's willingness to include the Jew in the Family of
Man in assimilated form depends on the exclusion of the Jew as "kike" or, more
broadly, as the representative of those aspects of Judaism that resist assimilation. In
Steichen's defense, this subject position is articulated in a post-Holocaust context in
reaction to the catastrophe in which Jewish difference had led to mass extermination.
Indeed, the Family of Man includes that infamous image of the Nazi's destruction of
the Jews of the Warsaw ghetto (Figure 3.6) in the section "Man's Inhumanity to Man"
to underscore the disastrous consequences of anti-Semitism and racist thinking. From
this perspective, the Family of Man exhibition has to be understood as seizing an
opportunity to reestablish the doctrine of universal humanism after the battering it
took in the Holocaust.[40] Thus, it also should come as no surprise to learn that the first
stop of the international exhibition circulated by the Museum of Modern Art was in
Berlin (West) at the Höchschule für Bildende Künste (Figure 3.7) in the fall 1955.[41]
However, Steichen never considers how the liberal move toward assimilation premised
on racial tolerance demands its own excisions, cuts, and separations of community.
For, as Leo Rosten reiterates in *The Joys of Yiddish*, the original etymology and the use
of the word *kike* before it became a pejorative racial slur is the Yiddish word *kikel*,
which refers to those who signed with a circle instead of an X or a cross and, in that
way, differentiated themselves as Jews and set themselves apart from Christianity.[42] As

a final unintended consequence, Steichen's recollection, it should be noted, figures the "world" in terms of America alone. His affirmation of racial tolerance (and his mom) states, "In bringing me to America . . . I would have a chance in a world that didn't have that thing." This use of the word *world* in reference to America alone would be later repeated and expanded in the photo-global rhetoric and hegemonic posturing of the Family of Man exhibition.

In a similar fashion, Nancy's ominous warning about how the "fusion of community" generates its opposite was actualized when the Family of Man traveled to the Soviet Union in 1959, where it was exhibited as part of the American National Exhibition in Moscow. This historic visit in particular has bolstered the interpretation that the Family of Man functioned as an ideological tool concerned with exporting an American way of life during the height of the Cold War. The United States Information Agency now took Captain Steichen's exhibition into the heart of the communist world order, where the vision of "immanence" elaborated in the Family of Man went head-to-head with its Soviet other. In reading a headline such as "Sandburg, Steichen to Explain Man's Universality to Russians,"[43] one senses the irony in the apparent need for the all-inclusiveness of "man's universality" to be explained and translated in a situation that seems to counteract photography as a universal language.

In Moscow in the summer of 1959, two major incidents occurred in which the Family of Man came under fire from conscientious objectors who felt the divisive force of the exhibition's inclusion of particular images that, for them, underscored

FIGURE 3.6. This infamous photograph, taken by a Nazi photographer of the destruction of the Jews of the Warsaw Ghetto in 1943, was in the Family of Man exhibition and helps to account for some of the "universal humanist" inclusions and exclusions at its basis. Photograph from United States National Archives and Records Administration (NARA 238-NT-282).

FIGURE 3.7. Ambassador James B. Conant and Edward Steichen (right) at the opening of the exhibition in Berlin, West Germany, at the Höchschule für Bildende Kunst on October 9, 1955. They are in front of Arthur Witmann's photograph of an audience of amused and delighted spectators. It is important to point out that Berlin was selected as the first stop on the global tour. Photograph from United States National Archives and Records Administration (NARA 306-FM-4-4).

economic and racial divisions and inequalities, whether between capitalists and communists or between blacks and whites. To apply Nancy's terms, these critics clearly believed that the inclusion of these images in the exhibition did not lead to the fusion of community or any humanist achievement of universal harmony or global understanding. Instead, they felt that the inclusion of the images reconstituted the separation of the world into capitalist and communist regimes, into First World and Third World socioeconomic and racialist hierarchies.

The first incident involved a photograph by George Silk that was published first in *Life* magazine (Figure 3.8). This photojournalistic image shows a young Chinese peasant boy standing in the street with an empty rice bowl in his left hand. The boy holds out the bowl in an imploring manner that suggests he is begging for food. The image produced two contrary interpretations. From the perspective of global rhetoric and "universal humanism" as elaborated by Harold McClellan, the director of the United States pavilion that housed the exhibition, this innocent photograph could only be understood as a universal symbol for world hunger. But the Soviet authorities did not perceive it in the same way and forced its removal. They interpreted it as an inflammatory Cold War strike designed to set community against community. For Comrade M. S. Nesterov, who served as the chairman of the Soviet Chamber of Commerce, this image could only be viewed as a calculated jab at China, the newly founded communist state and Soviet ally. In excising the image, the Soviet authorities clearly registered their belief in the photograph as offering an indexical proof of the socioeconomic facts on the ground in communist China. But, the grand irony here was that the Silk image was taken sometime in 1946, three years before the Communist Revolution in China. The Associated Press also reported the incident, and it was reproduced in dozens of American newspapers. In colorizing the communist enemy as red, the newspaper headlines did not seem to reflect any attitudes of "one love," of global harmony, or even of mutual respect. One of these headlines read: "Reds Object. U.S. Drops Picture at Moscow Fair."

A.P. Moscow. August 24. The picture of a Chinese child holding an empty rice bowl, taken by George Silk of *Life Magazine,* has been removed from Edward Steichen's Family of Man display at the American exhibition. U.S. Officials said today it was taken down in response to Soviet objections. They said fair director Harold McClellan first explained to complaining Russians that the picture was meant to be a universal symbol of hunger and had a rightful place in the collection. But he agreed to the removal after liaison authorities were backed up by M. S. Nesterov, Chairman of the Soviet Union Chamber of Commerce, which helped Mr. McClellan arrange the fair. The picture was taken by Mr. Silk in famine stricken Hunan Province in 1946.[44]

One notices that the newspaper report does not offer any explanation of the Soviet objections. However, an interesting editorial column at the time, entitled "Empty

FIGURE 3.8. George Silk, "Ragged Child Begging for Food during Famine," Hunan Province, China, May 1946. This photograph became a hotbed of controversy between capitalist and communist ideological positions when included in the American National Exhibition in Moscow in Sokolniki Park in the summer of 1959. Copyright George Silk/Time Life Pictures/Getty Images.

Bowl, Empty Head" in the *Hartford Courant,* suggested two possible rationales for the complaint. "Whether they objected on behalf of their Red Chinese colleagues or the general notion that nobody goes hungry under the Communist system wasn't brought out." Even as the editorial insists on the global rhetoric of photography, it situates the universal impulse in "us" (i.e., in the United States representative) alone "Despite the fact the [American] director of the Moscow showing pointed out that the picture is only meant to be a symbol of universal hunger, the Russians would have nothing of it." Having put the blame for the failure of the universal on the enemy, the editorial lapses into a diatribe against the Soviet Union that reinforces all of the binary oppositions of Cold War politics and removes any question of a glass being half-empty or half-full. "It is this kind of sheer obtuseness of reducing everything to ideology, of arrogance that makes the free nations despair of getting anywhere with communism. To a picture of a hungry kid with an empty bowl, you get an empty headed objection."[45] The editorial positions political ideology as somehow endemic to communism but not a part of the discourse of "free nations." It is this kind of sheer obtuseness of denying that "we" have anything to do with ideology that can make the reader despair, for it comes off as either the ultimate in arrogance or empty-headedness when the discussion involves the realm of the political.

Upon their return to the United States after their trip to Moscow, both Steichen and Sandburg appeared on the television program *Meet the Press* on September 13, 1959. In this interview, the recent exclusion of the George Silk photograph was one of the central talking points. In a highly melodramatic and florid manner, Bob Considine, reporter for the Hearst newspapers, introduced the removal of the Silk photograph from the Family of Man:

> CONSIDINE: Captain Steichen, I agree with your distinguished brother-in-law that that is an epic poem, "The Family of Man," magnificent work, as we all know. But it lost one of its stanzas the other day. I see that this particularly poignant photograph—George Silk's, I believe—which symbolizes the hunger of the world, was given the bum's rush, let's say, out of the exhibit. Do you have any comment on your loss at this time, sir?
>
> STEICHEN: Yes. I didn't like to see the picture go. It was one of a series showing family. I think they had some leg to stand on because there was an understanding between our government and their government that there was to be nothing of the nature of propaganda in any of these exhibitions. I could see how they would stretch that as anti-communist propaganda. However, they did not object to the picture which was much more significant, of "Famine in India." They just chose that particular one.[46]

Considine's literary analogy likens the loss of a photograph in the exhibition to the removal of a stanza in an epic poem in what reads as yet another variant of photography as a universal language. The loss of the Silk photograph is viewed as somehow

destructive of the totality of the exhibition as a work of art and its claim to speak for the world (as a symbol of the hunger of the world). Steichen's reply is neither acrimonious nor defensive. Recalling the antipropagandistic credo of the Family of Man exhibition that he authored ("we are not concerned with photographs that border on propaganda of or against any ideologies"),[47] Steichen sees how this particular image could have crossed the line when placed in the context of a communist vision of a world order. Yet, there is no denying that the Silk incident constituted a setback for the defender of the doctrine of universal humanism, because it illustrates the fraying effects of community against community ("between our government and their government") when the will to universal fusion has to confront "that particular one" and when propaganda becomes a very subjective term. In meeting the press, the Family of Man's attempt to "propagate its movement" (i.e., the fusion of community) turns out to be divisive, stretching into "anti-communist propaganda" or "the nature of propaganda"—and, therefore, into something objectionable.

But rather than locating this "stretch" as either a communist or a capitalist plot, one could see it as related to what it means to communicate and to propagate oneself via photography in terms of the sharing and splitting of being-in-common. From this perspective, photography functions as a medium of communication (from the one to the other) and as the propagation of information that forges and cuts the lines of community. Rather than being global, community-exposed photography is "destined to this edge and called forth by it."[48] For what is a stretch if not an extension that reaches out across a given space but does so in a way that is bound to interrupt and contaminate boundaries as it touches upon the other. To intercut Nancy at this juncture, this is the very meaning of community. "Interruption occurs at the edge, or rather it constitutes the edge where beings touch each other, expose themselves to each other and separate from one another, thus communicating and propagating their community."[49] In this way, the global project succumbs to the edges, where separation and interruption stake their claims to (inoperative) community and its photographic exposure.

The other objectionable incident at Sokolniki Park in Moscow in the summer of 1959 illustrates that it was not the Soviet authorities alone who were at odds with the Family of Man's brand of communal fusion. This case study in the politics of photographic exhibition happened a few weeks prior to the Silk incident, but it was not discussed on the *Meet the Press* program. However, there were dozens of newspaper reports of the incident as early as August 7, 1959. These were published by both the Associated Press (AP) and United Press International (UPI) but as slightly different accounts. In the list enumerating the wide dissemination of this article in the Museum of Modern Art archives, the title reads: "Student Arrested for Slashing Photographs in THE FAMILY OF MAN in Moscow." The Associated Press report reads as follows:

> Moscow, August 6, AP. A medical student from Nigeria has been arrested by Soviet Police for slashing four photographs in the U.S. Exhibition. The Nigerian was arrested

Wednesday after he cut up pictures from the photographic series, "The Family of Man" which he clearly disliked. One picture showed an African dance. Another was a large tattooed face. A third was a hunter holding up a deer. The fourth showed African lips drinking water from a gourd. Exhibition officials withdrew the damaged pictures and said an effort will be made to restore them.[50]

Even though the report provides few details about these images, it is possible to deduce which images were considered to be objectionable to this Nigerian medical student. The second one is probably Peter W. Haberlin's close-up portrait of a woman in Africa whose facial tattoo markings appear to be scars. Fitting into Steichen's contrived narrative, the image functions as one of the nine large portrait heads questioning the impending doom of nuclear holocaust. The third image is clearly Lennart Nilsson's photo of a man with a big smile on his face holding up a dead deer in the Belgian Congo. The fourth image (referred to as the "African lips") was also photographed by Nilsson in the Belgian Congo. Published by *Black Star*, it shows a close-up of an African man with his head tilted back so that we barely see his eyes or nose as he pours water from a gourd directly into his mouth.

In contrast to the AP news report, the UPI report mentions only two photographs, stating that an unidentified Nigerian tore them down and suggesting that he was motivated by their lack of photographic truth and photojournalistic objectivity.

> Moscow, August 6, American exhibition officials said today that two photographs in the exhibits' Family of Man display were torn down by a Nigerian visitor who immediately was taken into custody by Soviet police. The Nigerian, not otherwise identified, claimed the pictures were "unobjective" portrayals of the Negro race and ripped them from the wall after exhibition officials refused his demand to remove them.[51]

Both these accounts fail to mention that this Nigerian visitor did have a name, Theophilus Neokonkwo, and that he had some definite reasons beyond the AP report that he clearly disliked these pictures. The UPI report that the images were unobjective portrayals of the Negro race only skims the surface of what he considered objectionable. Fortunately, there is an alternative journalistic account that was published in the *Afro-American* on August 22, 1959, giving Neokonkwo the opportunity to speak in his own articulate voice and as something quite other than a mindless or deranged art vandal. The critical commentary of Neokonkwo helps us to understand the limits of photo-global rhetoric and how this slashing act of violence functions as a direct response to the violence instituted in the name of the Family of Man and its decisive and divisive cuts of community. Neokonkwo states:

> The collection portrayed white Americans and other Europeans in dignified cultural states—wealthy, healthy and wise, and American and West Indian Negroes, Africans and Asiatics as comparatively social inferiors—sick, raggerty [sic], destitute, and

physically maladjusted. African men and women were portrayed either half clothed or naked. I could not stand the sight. It was insulting, undignified and tendentious."[52]

Without having read the questionable attributions made by Edward Steichen in his descriptions of Nat Farbman's Bechuanaland photographs, Neokonkwo intuits how any number of images in the exhibition reinforced the dichotomy of primitive Africans in contrast to civilized Americans. In a sense, his analysis of the Family of Man concurs with Walter Benjamin's brilliant analysis in the "Theses on the Philosophy of History" that every cultural document is always already an act of barbarism from the perspective of those whom it excludes or oppresses. "There is no document of civilization that is not at the same time a document of barbarism."[53] That is why Neokonkwo can so easily invert matters in commenting how the representation of these "dignified" Euro-Americans appears to be so insulting, undignified to him. In the face of the tendentiousness of the global rhetoric of photography and the necessary blind spots that constitute its discourse, the outraged Neokonkwo tells us that he could no longer stand the sight before him. And so he decides to photo-philosophize with a hammer—or, at least, with a razor-sharp object—and to engage in an activist act of empowerment and aggression against images that, in his estimation, do not appear to be smiling back at him. Neokonkwo responds to the Family of Man and its mirror reflection in the negative, and this prompts him to excise the unrecognizable images of Africans that have always already been excluded. The photo slasher enacts the cut that demonstrates the central aporia of the Family of Man: the fusion of community serves only to reconstitute its separation.[54]

GLOBAL TRAFFICKING AND AN UN-WORLDING RESISTANCE

Of all of the literature on the Family of Man exhibition, Allan Sekula's "The Traffic in Photographs" (1981) is the one piece that pinpoints its photo-global rhetoric and is most critical of it. Sekula has no qualms about utilizing the terminology of the global in order to talk about the goals and intentions of the Family of Man exhibition. The Family of Man and its photo globalism is not the demonstration of a priori universals, as it claims, but a willful attempt to universalize in the name of a particular American bureaucratic agenda. "My main point here is that The Family of Man, more than any other single photographic project, was a massive and ostentatious bureaucratic attempt to universalize photographic discourse."[55] From Sekula's perspective, the Family of Man is an exercise in hegemony—a capitalist cultural tool in the struggle for world domination at the height of the Cold War. "In the foreign showings of the exhibition, arranged by the United States Information Agency and co-sponsoring corporations like Coca-Cola, the discourse was explicitly that of American multinational capital and government—the new global management team—cloaked in the familiar and musty garb of patriarchy."[56] Sekula reviews how the Family of Man, under the auspices of its not-so-secret cultural agent, the United States Information Agency,

traveled to many Cold War hotspots, such as Guatemala (Figure 3.9) and Indonesia, to bolster the agenda of American foreign policy and to quell pro-communist dissent.

Sekula gives no credence to photography as a universal language but rather sees it as a language of domination that subjects the neocolonial peripheries to or aligns them with the imperial centers of power. This signals the return of nineteenth-century photo colonialism in a subtler guise. As the study concludes, "The worldliness of photography is the outcome, not of any immanent universality of meaning, but of a project of global domination. The language of the imperial centers is imposed, both forcefully and seductively, upon the peripheries."[57] But this imperialist practice is not

FIGURE 3.9. Diplomats at the Family of Man exhibition in Guatemala City, Guatemala, where it was shown in conjunction with the Conference of Central American States from August 24 to September 18, 1955. The image shows a few of the "half clothed or naked" depictions of Africans that the Nigerian medical student Theophilus Neokonkwo held in contempt. Photograph from United States National Archives and Records Administration (NARA 306-FM-5-15).

confined to the global rhetoric of photography. According to Sekula, it guides the positing of the universality of the family unit as well. "The Family of Man universalizes the bourgeois nuclear family, suggesting a globalized, utopian family almost, a family romance imposed on every corner of the earth."[58]

The force of Sekula's arguments against the photo globalism of the Family of Man and its ideological agenda is quite powerful and laudable. But the logic of domination that circumscribes and circumnavigates the global risks repetition here. Functioning to some extent as oppositional ideological critique, it remains embedded in a set of power relations that cannot give up—and cannot give up on—the global. For example, one might well ask what gives Sekula the assurance (especially if viewed from a contemporary postcolonial photographic moment) that he knows where the peripheries end and where the center begins? Like Steichen, Sekula's guarantee lies in the shape of the world—"the worldliness of photography." Furthermore, another aspect remains to be considered when regarding the political stakes raised by "The Traffic in Photographs." For while Sekula claims to defend the particular against global domination, his own neo-Marxist rhetoric directed against "bourgeois science and bourgeois art" implies a global positioning that posits the proletariat as the universal revolutionary class in its struggle against capital.[59]

Twenty years later, Sekula has returned to the Family of Man in an article in *October* entitled "Between the Net and the Deep Blue Sea: Rethinking the Traffic in Photographs," which navigates the registers of economic liquidity and oceanic sensibility in the age of electronic reproduction. This bold and stunning study rethinks the quaint conceits of the Family of Man in the current age of globalization, digital media, and the Internet with a particular critical focus on the global-archiving exploits of Bill Gates and Corbis. Sekula relates how the political stakes of community that occupied the 1950s have been replaced by economic questions of empire in hot pursuit of globalizing capital. "The exhibition, with its claims to globality, its liberal humanism, its utopian aspirations for world peace through world law, can be reread now in the context of the contemporary discourse of 'globalization,' the discourse being advanced by the promoters of an integrated global capitalist economic system. . . . Today, the all-encompassing regime of the market, the *global imperium* of the dismal science, seems all the more pertinent to the discussion of archives and culture."[60] This is the (economic) state of the art wherein the power of the market drives the archive and culture into becoming species of capital and business as usual.

This chapter, "Photo Globe," has neglected neither the field of power relations that have been set into motion by the Family of Man exhibition and its photo-global agenda nor the ideological critique of global capital that challenges it, as staged by Allan Sekula. But it is also important to remember the limits of these power relations and how they open themselves up to what withdraws from these useful and productive powers—the exposition of (the inoperative) community. This is not to posit community as an extrapolitical or extrapoliticized space. Quite the contrary, the political is

the place of community where we are exposed (via photography) to being-in-common and where political instrumentality is brought into play. But being-in-common also poses as the limit of the political and its attendant hegemonic and ideological functions. This is not the fusional community that seeks to impose the global rhetoric of photography as the hegemonic proof of its will to power, as in Steichen's myth. It is, rather, the inoperative community (that cannot be put to work or utilized) as the shared place of exposition, the photographic exposure of community that shares and divides us.

No set of photographic power relations would exist without this exposition of community and its exposure of finitude. As Nancy puts it, "We must not lose sight of community as such, and of the political as the place of its exposition."[61] It is the light writing of photography that insists that we do not lose sight of these things. In this way, community-exposed photography seeks to unwork the Family of Man, or any photo-global venture that seeks totality, by ceaselessly posing and exposing such a venture to its own limits, its own "un-worlding." The expository approach to photography and community signals what cannot be made to speak and to work in the name of the global and its worldliness.

This chapter has turned to the Family of Man exhibition to call attention to the dangers that go with the decision to globalize or to engage in rhetoric that constructs a project revolving around the globe. The positing of the global rhetoric of photography stands in danger of two risks—the "universal language" argument that sentimentalizes photography as utopian myth and risks naturalizing itself as "the immanent universality of meaning"; and any self-assured practice of ideological critique and demystification that risks constructing itself as yet another project that would repeat the same globalizing gesture in the very act of opposition. Somewhere in between these two risks and at the limit of ideology and its critique, an expository approach to photography studies and to photographic practice reflects on these grave decisions to globalize and to totalize. Only this type of unworldly thinking and un-worlding inquiry would expose photography and community to a reading that dares to lose track of the shape of the world.

4. Photography and the Exposure of Community

Reciting Nan Goldin's *Ballad*

Making an Introduction

This chapter introduces the photography and writings of Nan Goldin to the thought of Jean-Luc Nancy. First and foremost, it juxtaposes Nan Goldin's *Ballad of Sexual Dependency* (1986), the visual diary and photographic exposure of her "community of lovers," with Jean-Luc Nancy's reflections on the inoperative community in the book of that title (as translated into English; originally published as *La communauté désoeuvrée* in Paris, also in 1986). These shooting stars from very different worlds (an American art photographer and a French philosopher-theorist) will share the spotlight together. They will shed some light and some darkness on each other in this co-appearance, this compearance.[1] A photographer and a philosopher will relate to us the fundamental acknowledgment that sharing constitutes each of us, that our being-in-the-world is always already a being-with, or what Nancy refers to as our being-in-common. But if that is the case, then the introduction of Goldin and Nancy, of the one to the other, will have already begun.

As discussed in the introduction, Nancy reminds us that "'to be exposed' means to be 'posed' in exteriority,"[2] or to be in a relationship with the outside. This makes photography an act of sharing in which we are exposed to one another and to being-in-common when we are exposed to the camera lens. Another way to figure the relationship between photography and community is to state that photographic exposure allows us to become available as communication and open to communicability. If we take a picture of another person, we pose him or her in exteriority— exposing this singular being to the gaze of others and to himself or herself as other. In this way, photography (as well as the plane of the photograph) opens up a space of

communication and connection that is posed at the border of the sharing and the splitting of singular beings. This is why Nancy posits the "inoperative community" in terms of *partage,* meaning both to share *and* to divide. As a medium of *partage,* photographic communication exposes the divisibility of singular beings in contrast to the indivisibility of the self-contained and indivisible individual. In this way, photography exposes community to itself. It gives community the medium of its sharing as well as the incompleteness of its sharing (in a resistance to the myth of communal fusion). One can paraphrase Nancy by saying that photography lets "the singular outline of our being in common expose itself."[3]

From the time of her student days at the Museum School in Boston, Nan Goldin's photo practice has been guided by the dynamics of this type of community-exposed photography. For Goldin, the photographic act grows out of a relationship, and the introduction to *The Ballad* is quite overt on this point: "These pictures come out of relationships, not observation."[4] Rejecting the objectivist model of the distanced and circumspect observer, Nan Goldin's photography is derived from a position that is in intimate proximity to her subjects. The introduction continues: "The instant of photographing, instead of creating distance, is a moment of clarity and emotional connection for me." Thus, it is not surprising to learn that this aspiring photographer took Larry Clark and his book *Tulsa* (originally published in 1971) to heart.[5] As an intense insider's look at his own subcultural community and its sundry addictions, Clark's confessional mode of photography—which shoots from the perspective of those who shoot up—became a formative role model for the young Nan Goldin. Such intimacy and proximity give this work its transgressive edge and allow viewers to feel as if they have stepped over the line in witnessing private spaces and spectacles, to have gone where they should not be allowed to go. This is how such work leaves itself open to the charge of voyeurism, even obscenity. But from Goldin's perspective, this approach to photography raises the question of community by interrogating the very limits and possibilities of sharing. "It's about trying to feel what another person is feeling. There's a glass wall between people and I want to break it."[6] But how far can the so-called insider position go in the direction of the other person in breaking down the walls? How far has it already gone in the direction of the other, given its very indebtedness to being-in-common? And how does the closest proximity come up against its limit so that such sharing never seems to be close enough? For instance, one thinks of the cover photograph of *The Ballad of Sexual Dependency,* entitled "Nan and Brian in Bed" (1983) (see Plate 1). As Goldin rests her head on a pillow, she gazes toward her lover Brian, who is smoking a cigarette at the edge of the bed. In this image, one wonders how far even the closest proximity can go to break down the walls that still divide the lovers, and this gives the lie to the romantic illusion of fused identity. Such a practice poses and exposes the space of liminality between the inside and the outside, or "inside/out," as Abigail Solomon-Godeau both shares and splits the title of her piece on photographic point of view in the work of Clark, Goldin, and Diane Arbus.[7]

PHOTOGRAPHY'S BEING IN LOVE

Bringing together the photography and writings of Nan Goldin with the thinking of Jean-Luc Nancy involves an act of coupling. Now it turns out that the question of coupling (both its necessity and its difficulty), especially how coupling relates to the "community of lovers," is at the heart of the pursuits of both. *The Ballad of Sexual Dependency* presents a vision of relationships in which the push and pull of the desires for intimacy and estrangement go hand in hand. The introduction prefigures that popular bestseller about Martian men and Venutian women.[8] "I often fear that men and women are irrevocably strangers to each other, irreconcilably unsuited, almost as if they were from different planets. But there is an intense need for coupling in spite of it all."[9] Nancy appears to touch on these same issues in thinking about the dynamics of being-in-common as being coupled. He writes about the community of lovers this way: "For their singularities share and split them, or share and split each other, in the instant of their coupling."[10]

While the previous statement by Goldin focuses on heterosexual relationships, gay and lesbian couples are not exempt from what she calls the "struggle between autonomy and dependency." In this bisexual photographer's most quoted statement from *The Ballad,* she addresses the problem of being coupled as the central problem for her vision of community-exposed photography.

> I have a strong desire to be independent, but at the same time a craving for the intensity that comes from interdependency. The tension this creates seems to be a universal problem: the struggle between autonomy and dependency. The *Ballad of Sexual Dependency* begins and ends with this premise, from the first series of couples including the Duke and Duchess of Windsor—the epitome of the Romantic ideal—crumbling in the Coney Island wax museum to the picture of the skeletons together in an eternal embrace after having been vaporized. In between I'm trying to figure out what makes coupling so difficult.[11]

From start to finish, the community-exposed photographer finds herself "in between." What are the ramifications of being in between, and how is this liminal position bursting with meaning, bursting with the meaning of community? Goldin's last sentence has both a direct and an oblique referent. Taking her book as the direct object, she refers here to the layout of *The Ballad.* For the book begins with the decomposing romantic ideal of the duke and duchess, and it ends with the post-mortem coupling of the two skeletons (Figure 4.1). In between the wax effigies and the skeletons, the book is framed in a way that places death as and at its (im)possible limits. (One recalls that Nancy also insists that community reveals itself through death, and this point will be taken up later in the chapter.) Moreover, this "in between" statement also reflects upon Goldin's sense of the nature of relationships in general. In other words, the community of lovers exposes what it means to be in

FIGURE 4.1. Nan Goldin, "Skeletons Coupling," New York City, 1983. Copyright Nan Goldin; reproduced by permission.

between—what shatters integral selfhood on the one side, yet resists the fusion of bodies into communal hypostasis on the other. Finally, "in between" marks the difficult coupling of the photographer with her subjects. For Goldin's intimate practice also makes every relationship between photographer and subject into a subset of the community of lovers. Grounded in all life's little melodramas, Goldin's practice foregrounds the intensities of the relationships between herself as photographer and her intimate friends as photographic subjects over an extended period of time.

In his study "Shattered Love," Nancy offers another way to articulate the question of why Goldin finds herself in between. To put it bluntly, she is in love, and this reveals a difficult and unsettling state of affairs that plays between the promise of completion and the threat of decomposition. To cite Nancy's poetic declaration: "Thus, love is at once the promise of completion—but a promise always disappearing—and the threat of decomposition, always imminent. One can neither attain it, nor free oneself from it, and this is exactly what it is: the excess or lack of this completion, which is represented as the truth of love. In other words . . . the impossible."[12] From this perspective, Goldin makes photography an amateur practice in the best sense of the word. She returns the idea of amateur photography to its roots, to the Latin word *amas*—the crazy little thing called love. Goldin's photography is founded on being in love, and she has stated it so matter of factly and so impossibly: "I photograph out of love."[13] But if such is the case, Nancy reminds us that the "I" who photographs in and out of love must be constituted broken. For what is love if not being "broken into" or, even more ecstatically, being in shatters? As Nancy writes:

> Love re-presents *I* to itself broken. . . . From then on, I is *constituted broken.* As soon as there is love, the slightest act of love, the slightest spark, there is this ontological fissure that cuts across and that disconnects the elements of the subject proper—the fibers of its heart. One hour of love is enough, one kiss alone, provided that it is out of love.[14]

It should come as no surprise to learn that the kiss has always been a standard trope of snapshot photography and of the rhetoric of the decisive moment for this reason. In *The Ballad*, Nan Goldin gives a nod to this tradition with "Philippe H. and Suzanne Kissing at Euthanasia" (1981). This image portrays the two lovers craning their necks forward and mashing up their lips and faces against each other as they are situated against a symbolic ruby red wall. Here, we witness both the passionate desire of the lovers to get out of their own skins and the representation of the "I's" who are constituted broken.

One could say that all of Goldin's photographs, whether of singles or couples or groups, offer a long refrain with love as its impossible object. That is what *The Ballad* cannot stop singing and lamenting about, laughing and crying about. As community-exposed photography, the community of lovers exposes love's incessant comings and goings in each and every snapshot. And, in this way, every snapshot is somehow

marked as a gift or token of love. While Goldin has used the analogy of breaking down glass walls to mark her photographic practice as one of communication, it might be better to say through the lens of Nancy that her project exposes the always already broken into state of being in love. Each exposure functions as a photographic communication of love and love's impossibility, one of shattered or broken love.

In the photograph "Heart-Shaped Bruise" (1980), an unidentified woman shows her thigh (see Plate 2). In this way, she exposes an uncanny marker on the surface of her body that symbolizes these matters of the heart crossed by love and of the lover broken into at the limit somewhere in the vicinity between touch and wound. As Nancy reminds us, "It is the break itself that makes the heart."[15] It does not really matter who this person is, and the cutting off of the rest of the body should not automatically be read as some kind of modernist fetishization of the female figure as in Edward Weston's nudes. For here it is a question not of identity or fetish object but of a singular being exposing the limit. The photograph is not unlike this heart-shaped bruise, whose exposure of being-in-common circulates between touch and wound. While the following passage alludes to the heart as broken, Nancy may just as well be talking about the photographic image and its being-in-the-world: "The break is nothing more than a touch, but the touch is not less deep than a wound."[16] A feminist reading would intervene at this juncture to place Goldin—who appears in one of *The Ballad*'s most horrific images, "Nan after Being Battered" (1984)—or the owner of the bruise in the subject position of the abused woman. This subject position perpetuates the stereotype of female masochism (I love him because he is cruel to me). From this perspective, "Heart-Shaped Bruise" would be understood as a criticism of men who batter and beat their female partners in domestic relations. Indeed, part of the story in *The Ballad of Sexual Dependency* involves Goldin getting herself out of a self-destructive heterosexual relationship with Brian, in which she played the role of the victim. From Nancy's perspective, this type of intense physical violence offers a pathological means to give couples the illusion of a total bonding (and often bondage) experience. However, this is far removed from the vision of "shattered love," which acknowledges the depth of wounding that goes into even the lightest of caresses and exchanges of intimacy, for what matters to Nancy's community of lovers is the exposition of finitude.[17] Many of Goldin's images are taken in the bedroom, which becomes the privileged site for the shared intimacies that take place among the couples in *The Ballad of Sexual Dependency*. The bedroom is both the battleground and the sacred temple of love where the community of lovers expose themselves to each other and where the photographer and her camera become part and parcel of the love play. Goldin's book culminates in "The Ballad of Sexual Obsession" with erotically charged bedroom images that range from the kinky "Man and Woman in Slips" (1980) to the "Skinhead Having Sex" (1978). The latter features the close contact of a couple in London, where the skinhead rubs his head against the skin of his female lover on purple-colored bedsheets.

In situating this photo practice as one that comes out of love, Goldin articulates

the purpose and the function of the snapshot in a way that is quite different from an indexical theory of photography that posits the photograph as a trace of an (absent) referent. As she informs J. Hoberman, "[My photography] comes directly from the snapshot, which is always about love."[18] In the semiotic theory of the index as applied to photo theory, the snapshot is a sign of absence, an effect of framing, a deposit of the photographic trace. In Goldin's community-exposed photography, the snapshot yields a relationship of immediacy and intimacy, a performative "I love you," the touch and the caress of the haptic.

In "Notes to the Index," Rosalind Krauss conceptualizes the photograph as an indexical sign. She enlists Marcel Duchamp's writings on the *Large Glass* to think about the photographic sign in the same terms in which Duchamp articulates the readymade. One recalls that Duchamp interpreted his "ready making" of art as an effect of framing by using a photographic figure—the "snapshot effect."[19] Krauss writes: "It is also, then, not surprising that Duchamp should have described the Readymade in just these terms. It was to be a 'snapshot' to which there was attached a tremendous arbitrariness with regard to meaning, a breakdown of the relatedness of the linguistic sign."[20] If the snapshot effect stages a breakdown for Krauss, it is only in posing the idea that the photographic sign (like the ready-made) is empty. However, the relationship between the photograph and its referent (of which it is the trace) is never questioned here. As Duchamp says of the readymade, it is just a "matter of timing." In this "aesthetics of indifference" and its tremendous arbitrariness, it doesn't really matter what goes into or what fills the frame.[21] Perhaps we can refer to this "it doesn't really matter" as that something called content.

Meanwhile, Goldin's conception of the snapshot puts a very different value on content. Here we have an aesthetic that is keenly interested in content where it is never arbitrary because it is always in direct relationship or in a state of emotional attachment to the photographer. It is not an aesthetic of indifference but the photographic exposure of the beloved that makes a world of difference. To borrow from the writings of Roland Barthes, Goldin articulates her vision of the snapshot in terms of a photographer's "lover's discourse."[22] She states: "My work does come from the snapshot. It's the form of photography that is most defined by love. People take them out of love, and they take them to remember—people, places, and times."[23] As a consequence, every snapshot of this photographic lover's discourse and its memorializing of loss serves as an exposure of finitude. This is not to suggest that differing beliefs in the photograph as indexical sign and as expository relation cannot be allied with each other. Indeed, Roland Barthes's *Camera Lucida* provides us with an example of a validation of both indexical reference (the *noeme,* or the photograph's "that has been") and the expository relationship driven by love (the absent Winter Garden photograph of his mourned mother). However, the semiotic focus on the photograph as a type of sign often obscures the question of being-in-common. For example, even though the editors of *October* once called for a "radical sociology of photography" in

the mission statement of the inaugural issue,[24] the question of community has never been a major preoccupation for Rosalind Krauss and her cohorts. This might be explained by the way in which the emphasis on indexical theory and the photograph as the (empty) sign of the referent shifts attention away from photography as a mode of sharing on and at the limits and as the impassioned call of the community of lovers. In this way, the expository approach to photography and community answers the call of a radical sociology of photography by acknowledging the dynamics of exposure, communication, and "shattered love" that is articulated in Nancy's *The Inoperative Community*.

If the snapshot comes out of love, then the photographic act itself must be understood as a mode of touch, as a mode of touching that touches the limit. Reciting Nancy, "touching—immanence not attained but close, is the limit."[25] In the tradition of Julia Margaret Cameron, Goldin thinks about the nature of the photographic act in terms of its tactile and haptic qualities.[26] For Goldin, photography is a way of being-in-touch. "For me it is not a detachment to take a picture. It's a way of touching somebody—it's a caress. I'm looking with a warm eye, not a cold eye. I'm not analyzing what's going on—I just get inspired to take a picture by the beauty and vulnerability of my friends."[27] But a less generous view of Goldin's photography would insist on the exploitative aspect of this type of relationship. Indeed, this is the same type of ethical critique often registered against the work of Diane Arbus.[28] The sincerity and genuineness of the lover's discourse is cast into doubt as more manipulative or even abusive motives are attributed to the community-exposed photographer who profits from these exchanges of intimacies.

One example of the coexistence of a more positive reading alongside the possible attribution of ulterior motives to the photographer is Figure 4.2, "Cookie and Millie in the Girls' Room at the Mudd Club" (1979). Here we see two of Goldin's partying pals sitting side by side on toilets and relieving themselves at the famous punk rock music club. One could follow the image maker and assert that she was inspired by the beauty and vulnerability of her friends in this intimate moment of a usually private nature and that this image was a way of getting even closer to them. But this exposure might not be so innocent, because it plays up the voyeuristic pleasure to be had by the photographer and the viewer on seeing two women posed in the act of pissing. (The image "Boys Pissing" [1982] offers an even more explicit view of men urinating.) However, this more cynical analysis of Goldin's work would be antithetical to one based on the premise of "shattered love," which does not grant the community-exposed photographer the authority to advance independently other than as a being who is posed in exteriority. Given such a premise, one would look at this image quite differently. The unleashing of the bodily excesses documented in these bathroom scenes is symptomatic of the subject's exposure to its own becoming-waste-product that is a crucial element of Goldin's exposure of the "partying being" (to be discussed in the section "The Partying Being and the Excesses of the Theoretical").

FROM THE FAMILY OF MAN TO THE "FAMILY OF NAN"

With this simple turn of a letter, two critical accounts play off Goldin's photo practice against the most significant exhibition of community-exposed photography in the postwar era—the Family of Man. "The Family of Nan" serves as the title of Max Kozloff's review of *The Ballad* as it appeared in *Art in America* (November 1987), and it is also the caption of one section of J. Hoberman's interview published in the Whitney retrospective catalog, *I'll Be Your Mirror*. In reviewing *The Ballad*, Kozloff notes the disparity between the book's adopting the "familial tone" of a snapshot model and the absence of the typical naïveté of this genre. "There can be no doubt that the work has been realized as a 'family' snapshot album—this is her extended family—and that it is a sad album."[29] Sadly, Kozloff's introduction of the question of family in Goldin's work quickly degenerates into a facile judgment of whether the book is a happy or a sad one, and he does not get beyond this turn of phrase to pursue the fascinating comparisons with the Family of Man exhibition.

The second invocation of the Family of Nan is found in the Hoberman interview, in which the phrase serves as a section title. Interestingly enough, this account also sidesteps Edward Steichen's blockbuster show. It turns out to be about Goldin's relationship with the photo in-operator and impersonator Andy Warhol, and it turns around the question of community. Hoberman's first question aims for parallels between the

FIGURE 4.2. Nan Goldin, "Cookie and Millie in the Girls' Room at the Mudd Club," New York City, 1979. Copyright Nan Goldin; reproduced by permission.

Family of Nan and the photo construction of the Warholian Factory. "Did you ever feel that your slides were documenting a scene, something like Warhol's Factory?"[30] The photo insider immediately slips into the rhetoric of emotional intimacy and immediacy. "I'm too close to it. I was documenting my life." Then, Goldin confesses that she was a Warholian wannabe as far as filmmaking was concerned. "I wanted to make Warholian films, like *Chelsea Girls*. I used to have my friend Suzanne sit there naked under these bright lights and I would zoom in and out on her. It was 1972." It is clear from the reference to the split-screen *Chelsea Girls* that the camp aesthetics and the drag performativity of the superstars had a particular drawing power for the aspiring filmmaker. This indebtedness to Warhol shines through in the early black-and-white image from 1973, "Ivy with Marilyn" (Figure 4.3). This photograph depicts one of Goldin's first superstars, the drag queen Ivy, who, wrapped in a boa, strikes a glamorous and seductive pose against the backdrop of a reproduction of Warhol's silk screen of this Hollywood icon—an image that has been interpreted as Marilyn's own becoming drag queen. The image amuses in its mirroring of the beauty marks featured on both Marilyn's left and Ivy's right cheek. "Ivy with Marilyn" lends support to Goldin's assertion that she wanted to make not only Warholian films but photographs as well.

It is at this juncture in the interview that Goldin distances herself from Warhol but in a way that exposes her own variant of community-exposed photography. "I had a good eye for finding fabulous people and developing a community with them in a less passive way than Warhol."[31] It is important to underscore that Goldin does not use the word *rapport* in this context. She does not say that she was able to develop a rapport with these fabulous people. Instead, she specifically uses the word *community* to describe this relationship. Goldin's use of the word *developing* resonates with the photographic process itself. It also stresses the importance of the narrative element and of extended portraiture in her work. If one were to give Nan Goldin a job description, one might say that she works in "community development." But, unlike the work of a border-patrolling sociologist, Goldin's photo development of a community with these fabulous people involves a strategy of unworking and unraveling. It is a strategy so wrapped up with her "community at loose ends" that it is always threatening to come apart at the seams from either, as she puts it, "euphoric crisis" or "extreme excess."[32]

But to return to the reviewers, neither Hoberman nor Kozloff explicates the photohistorical significance of the wordplay deployed to make Nan's family rhyme with Man's, and in so doing, they miss an opportunity to compare two exemplary visions of photography and community in the so-called American century. As I discussed in chapter 3, the Family of Man exhibition was organized by Edward Steichen and the Museum of Modern Art in the midst of the Cold War era to spread an American-inflected doctrine of "universal humanism" and the message that photography speaks a "universal language."[33] Fredric Jameson, Roland Barthes, and Allan Sekula have all demonstrated how this exhibition served to export a particular ideology under the cover of universal and how it repressed social and historical differences and inequalities under the platitude that "we are all alike."[34] The images of the Family of Man

FIGURE 4.3. Nan Goldin, "Ivy with Marilyn," Boston, 1973. Copyright Nan Goldin; reproduced by permission.

are examples of what is known as straight photography, not only because they are straightforward photo-journalistic documents, but also because they privilege the heterosexual nuclear family. From this perspective, Goldin's project—like that of Diane Arbus, to whom Goldin is greatly indebted—might be understood as a de-familiarization of the normative conventions surrounding Man's family as it seeks to unhinge the official doxologies of 1950s family life and to reinvest in the value of those subcultural differences repressed by the Family of Man exhibition. In other words, there is a strategic series of shifts in moving from the Family of Man to Goldin's extended family. This registers a number of alterations—in point of view (from a predominantly male to a female gaze), in sexual orientation (from heterosexual to bisexual and transgender), in the locus of family itself (from the biological family as unit to the rhizomatic family as pack), and in the project's scope (from universal humanism to singular beings exposing finitude). Finally, there is the movement from photojournalistic reportage to autobiographical confession.

One also should not forget the more immediate political context of "family values" in the United States and the conservatism of the Reagan eighties, in which the subcultural photography of Nan Goldin struck a nerve. For Goldin's work offers an alternative vision of community that recorded the "new wave" artistic underground, celebrating drag queens, gay and lesbian sexuality, and "the other side" over and against nuclear-family values and the nostalgic idealization of the 1950s. In addition, Goldin's work became a marker of resistance to an administration that refused even to acknowledge the reality of AIDS. However, as in the case of Robert Mapplethorpe, this exposure of community also generated a backlash, because it opened itself up to the charge that it was advocating a pathological spectacle of degenerate morals. There-fore, the Family of Nan offers a permissive view of human relations at odds with the puritanical status quo of 1980s America. It envisions (and exposes) American com-munity along the lines of a queering of the nation and the body politic.[35]

But when it comes to figuring out whether the community-exposed photography designated as the Family of Nan is to be understood as a particularist or a universal-ist vision, the photographer runs into conceptual difficulties. On the one hand, there is no doubt that Goldin feels very comfortable with tribalism and that she can become incredibly possessive about it. This leads to another version of her photo-graphic credo from *The Ballad:* "There is a popular notion that the photographer is by nature a voyeur, the last one invited to the party. But I'm not crashing; this is my party. This is my family, my history."[36] All of these invocations (one's party, family, and history) stress the particularism of a partisan subject position. And then there is the most self-absorbed and narcissistic statement in the Mark Holborn interview, in which any notion of desire as the desire of the other appears to have split the scene: "*The Ballad of Sexual Dependency* is an exploration of my own desires and problems."[37]

And yet, elsewhere it is clear that Nan finds herself pretty uncomfortable with the particularistic ramifications of her project and the kinds of exclusions that it necessi-tates. So, in a classic maneuver, she tries to find a way to make the particular speak as

a representative for the universal. Whether she is aware of it or not, this repeats the very gesture of the Family of Man and its universalizing claims. This move from the particular toward universal validation occurs in no fewer than three places in the 1986 *Aperture* interview with Holborn. To quote two instances: "Even if the slide show involves some people who keep nocturnal hours, drink heavily, or do drugs, the issues are universal"; and "There is a universal aspect about the slide show, and I hope it transcends the specific world in which it was made and applies to the whole nature of the relationships between men and women. It addresses people who are involved in pursuing close relationships."[38] One wonders how those who are defined as outsiders (druggies, alcoholics, transsexuals, drag queens, demimonde denizens) can speak for everyone. How do the margin and the extreme represent us all when people of such subcultural lifestyles are defined as those who have been expressly excluded by the norm in and of itself? This is clearly the dilemma that the Family of Nan faces when it begins to talk and think like the Family of Man.

It is interesting to think about Goldin's dilemma (as well as Nancy's formulation of the concept of singularity) in light of the significant body of recent work in contemporary philosophy and politics that has examined the relationship between the particular and the universal. An important project in this vein involves the intellectual exchanges initiated among Judith Butler, Ernesto Laclau, and Slavoj Žižek that are collected in the volume *Contingency, Hegemony, Universality: Contemporary Dialogues on the Left*.[39] The rethinking of hegemony marks the contributions of Laclau specifically.[40] For Laclau, hegemony functions as the means in any social life whereby particular claims pose and assert themselves as the universal: "The theory of hegemony is a theory about the universalizing effects emerging out of socially and culturally specific contexts."[41] In this regard, hegemony provides a key theoretical resource by which to understand Goldin's rhetorical posturing and the move toward universalization that punctuates the Holborn interview.

Laclau also theorizes the underside of the hegemonic relation in the sense that these particular claims can never adequately represent the universal. In other words, the hegemonic relationship is both a necessary and an impossible one.

> If its necessity requires access to the level of representation, its impossibility means that it is always going to be a distorted representation—that the means of representation are going to be *constitutively* inadequate. We already know what these means of representation are: particularities which, without ceasing to be particularities, assume a function of universal representation. This is what is at the root of hegemonic relations.[42]

In the Holborn interview, it becomes apparent that Goldin has not acknowledged this representation of an impossibility as a crucial aspect of the hegemonic relationship. In other words, no matter what Goldin might say about them, these images depicting the antics of a decadent subculture and artistic bohemia are going to be constitutively

inadequate to the task of universal representation. This is the type of resistance that one discerns in those images in which there is a radical incommensurability between this particular class of people (the Family of Nan) and the desire to identify them with universal goals (the Family of Man). According to Laclau, Goldin's gesture represses the competing claims of other antagonistic particularities that would reject this process of translation—the "equivalential moment,"[43] which produces the effect of universality (wherein the Family of Nan = the Family of Man). For instance, an abject-looking figure such as Scarpota in "Scarpota at the Knox Bar, West Berlin" (1984) appears to be the kind of person with whom it would be difficult for the mainstream of society to identify. Even as Goldin posits him in a hegemonic manner as a universal representative, he remains a distorted representation, a particular spectacle of otherness. Furthermore, it is possible to imagine how the voices of sobriety and temperance (e.g., a group like Alcoholics Anonymous) would be able to appropriate this image in an advertising campaign against the dangers of drugs and alcohol and thereby to establish an antagonistic hegemonic relationship by means of the very same image.

Following Laclau, Judith Butler's analysis of hegemony in the study "Restaging the Universal" is also keenly aware of the impossibilities that accrue to the politics of identity. For every particularist attempt to fill the space of universality (which is necessarily the space of emptiness) finds that it fails to do so. To quote Butler, "Thus, a certain necessary tension emerges within any political formation inasmuch as it seeks to fill that place [of universality] and finds that it cannot."[44] One can apply this tension to Goldin's representation of the drag queens and "gender troublemakers" who inhabit *The Other Side*.[45] Two of the final sections of the book, "The Queen and I" (Manila, 1992) and "Second Tip" (Bangkok, 1992), are particularly interesting because they provide a case in which Goldin's "other" becomes racialized in the sense of the representation of non-Western people. Whether Goldin is conscious of this or not, these images also play into the hegemonic power relations that have marked the history of photo colonialism. These portfolios document her visits to the drag underground culture of the Philippines and Thailand. They offer a study in hegemonic relations wherein the particularity of the Asian drag queen is used to represent the universality of Goldin's "community of lovers." If we look at an image such as "C. with Her Boyfriend" (Bangkok, 1992) (Figure 4.4), we encounter yet another variant that seeks to support Goldin's universalizing tendency that her work "addresses people pursuing close relationships." C. is sitting on the lap of her boyfriend at a drink-filled table in the nightclub called the Second Tip. He has his arm around her and looks off camera while C. in her slinky dress smokes a cigarette and gazes doe-eyed directly into the camera. The image uses the couple's proximity and touch as encoded visual signs in order to universalize the nature of relationships whether gay or straight or something in between. Goldin's image plays around a set of gender ambiguities in terms of how to classify C. (as male, female, or transgender) in order to function as Laclau's universal equivalent. However, the specific context of drag performance that

pervades this and the series of related images recalls the incompleteness of this par-
ticular identity and its inability to fill up the space of universality. Instead, the drag
subculture (and its parodic mode of representation) has to be viewed as existing in a
field of differential relations with other (often antagonistic) discourses of gender and
sexuality. Meanwhile in this image, there is no confusion around the signifiers of racial
difference reproaced in the service of universalization. However, there is a marker
of resistance in other images in the series when C. is shown in drag performance
wearing a platinum wig and playing the part of Madonna. In a bizarre way, C. per-
forms and parodies the hegemonic relation while representing himself/herself as and
through the figure of Madonna as the universal pop star. In the haunting figure of a
lip-synching Bangkok drag queen, the following dictum of Judith Butler is realized:
"The assimilation of the particular into the universal leaves its trace, an unassimilable
remainder, which renders universality ghostly to itself."[46]

Whereas Laclau follows Gramsci with the assertion that hegemonic universality
is "universality contaminated by particularity,"[47] Nancy relies on a different theoreti-
cal resource to undermine this classic dichotomy. Nancy turns to the concept of sin-
gularities as his means to expose the excess that deconstructs the Hegelian dialectic.
In this way, Nancy reworks the problem in a manner that bypasses the hegemonic
relationship by means of a concept that is foreclosed by the theory of hegemony (as
set forth in a recent study by Laclau's former student Nathan Widder).[48] Nancy's dis-
cussion of this term is at the heart of a long study titled "Being Singular Plural," in

FIGURE 4.4. Nan Goldin, "C. with Her Boyfriend," Bangkok, 1992. Copyright Nan Goldin; reproduced by
permission.

which he reformulates his central axiom that being is always already being-with. As Nancy writes, "That which exists, whatever this might be, coexists because it exists."[49] Refusing to adopt the liberal language of a society of unique individuals, these "singularly plural" beings provide Nancy with the type of constituency that he needs to talk about community in terms of what exceeds the dialectic of the particular and the universal. In this way, Nancy draws upon the (excessive) Bataillean tradition in which community seeks the (im)possible points of communication and contact between these terms. For Nancy, there is never any overreaching for a false universality, because every attempt at inclusion necessitates a move toward exclusion. Conversely, there can be no particularist reduction to a unitary subject that is somehow self-contained and self-actualized. As he states in the preface to *The Inoperative Community,* "Existence-in-common resists every transcendence that tries to absorb it be it an All or an Individual."[50] This mode of theorizing guides the interpretation of many of Goldin's images in this study in contrast to some of her own published statements that ignore the excessive logic of singularities, a logic that (literally and figuratively) brings the dispersed elements of community-exposed photography back into the fold.

Thus, according to Nancy, when Goldin stakes her universal claim on "the nature of relationships" and in the pursuit of "close relationships," she falls into a philosophical trap. For it is not possible to make an absolute out of "the relation," which, as Nancy reminds us, is merely another way of saying "the community."[51] Rather, the relation problematizes the reification of any absolute. Or, to frame it another way, the absolute (whether deemed as universal or particular) is what is put into relation. Rather than Goldin's universalizing of the relationship, it is the relationship—the posing of and at the limits—that sets the binary opposition (the universal vs. the particular) into motion. When all is said and done, the relating of the relation undoes and unworks the overarching and overreaching imperative of the universal, whether inscribed as the Family of Man or the Family of Nan.

THE PARTYING BEING AND THE EXCESSES OF THE THEORETICAL

In one of the last footnotes to her article "In/Of Her Time: Nan Goldin's Photographs," Elizabeth Sussman insists on a parallel between the slide show presentation of Goldin's *Ballad* and the films of John Cassavetes. Sussman locates one of these shared aspects in terms of a resistance to "abstract theory."[52] To support this idea, Sussman quotes from Raymond Carney's analysis of Cassavetes in his book *American Dreaming.* Carney notes that the film director "never lets us even for a moment escape from the specific situations, characters, and the time bound progress of the narrative into a realm of pure abstraction or transcendental theory."[53] Sussman's analogy is a bit simplistic in that she overlooks the possibility that this body of work may also engage "impure" levels of abstraction and theory. When presented as a forty-five-minute slide show consisting of about 750 to 800 images, Goldin's project assumed the form of a cinematic and multimedia event. Set to a sound track ranging from

the Velvet Underground to Maria Callas, the photographer exposed her family in extended portraits, thematic groupings, and narrative sequences that pushed the medium to the limits of film. Both Cassavetes's *Love Streams* and Goldin's love *Ballad* demonstrate how the question of finitude challenges the totalizing claims of all modes of "transcendental" theory, which might be defined à la Paul De Man as theory that has forgotten how to resist itself.

However, there is another way to look at this resistance to transcendental theory in the Family of Nan. In this regard, Nancy's *Inoperative Community* can be brought to bear on Goldin's photo praxis in order to elucidate further what *The Ballad* says—or does not say—about the thought of community and its excessive relation to the theoretical. For even as Nancy utters the words *community* and *sharing* to articulate the "place of communication" where both graphic and photographic inscription reside, he remains dissatisfied.

> But this still says nothing. Perhaps, in truth, there is nothing to say. Perhaps we should not seek a word or a concept for it, but rather recognize in the thought of community a theoretical excess (or more precisely, an excess in relation to the theoretical) that would oblige us to adopt another *praxis* of discourse and community. But we should at least try to say this, because "language alone indicates, at the limit, the sovereign moment where it is no longer current." Which means here that only a discourse of community, exhausting itself, can indicate to the community the sovereignty of its sharing.[54]

The excess of the theoretical or what is named by the thought of community provides a fascinating way in which to think about the sovereign value of Goldin's work as a photographic praxis or discourse of community. In contrast to Edward Steichen and the global rhetoric of the Family of Man, which asserts that photography speaks a universal language, the Family of Nan marks the limit where photography's meaning encounters theoretical excess. These are the excesses marked by "community" and "sharing"—the place of communication that is always already the place of dislocation. In this light, the Family of Nan offers a photographic discourse of community in the act of exhausting itself—exposing these acts of exhaustion to community. Goldin's photographs give back to community what is its due: the sovereignty of its sharing, which can be neither possessed nor appropriated but only posed in and as a relationship to exteriority, as community-exposed photography.

The language of a community in the process of exhausting itself also resonates with the latter part of Nan's defense against the accusation of voyeurism found in the *Aperture* interview. "Some people believe that the photographer is always the last one invited to the party, but this is my party. I threw it."[55] Having already discussed the tribal aspect of this quotation, let us now turn our attention to the throwing of the party and its significance for photography and the exposure of community. The party (as the festive occasion for expenditures without reserve and of singularities

testing the limit) becomes the privileged site for Goldin to practice Nancy's *partage* (the simultaneous sharing and splitting of our being-in-common) as a practice of community-exposed photography. This aspect is not the generalized thrownness of being as a being-toward-death in the Heideggerian sense that is articulated in *Being and Time*.[56] It is rather the thrownness of the partying being that marks the Goldin economy. One encounters the expenditure and the wasting of these singular beings and their shared excesses in a discourse of community exhausting itself. It is a festive community engaged in dancing and drinking, smoking and doing drugs, fucking and vomiting—for the throwing of the party is always bound to lead to such discharges of and for the partying being.[57] And it is a throwing of the party that dislodges the "I" who threw it from any possible mastering of the situation. So while Goldin might speak possessively of her family and her party and her birthday, these images expose to the contrary how the partying being in the pose of documentary photographer "loses it" in the very act of throwing. And yet the throwing of the party and its photo documentation expose community to itself and to the sovereignty of its sharing.

It is against the background of the partying being that one might read an image such as "Twisting at My Birthday Party" (New York City, 1980) (see Plate 3). This snapshot contains multiple centers of interest. It includes the kinetic movements of a couple doing the twist in the foreground, two party people in midbite directly behind them, and a female figure who lights up a cigarette and casts a suspicious gaze at the camera at the right-hand side of the frame. It is clearly an image that exposes community to itself by means of a party caught in the act of exhausting itself. As related to pop music, Goldin's turn of phrase (and this correlated image) also paraphrases the words of Leslie Gore and her early sixties classic, "It's My Party." This is a love ballad and an affective lament in which the tears of Eros flow freely as expended by the partying being in this crying-shame refrain: "It's my party, and I'll cry if I want to, cry if I want to, cry if I want to. You would cry too if it happened to you."

Whether crying or laughing, the partying being of these images communicates what Nancy calls "the experience of freedom." In his book of the same name, Nancy figures freedom in terms of bursts and leaps, in terms of active movements expended without return and without determination.[58] These remarks appear quite relevant for the partying beings whose expenditures—whether the postcoital retractions in "Brian after Coming" (1983) or the disco gyrations in "Robin and Kenny at Boston/Boston" (1978)—have been exposed via Goldin's subcultural photography. But we should never think that these particular images record the experience of freedom (which is another name for ecstasy) in some empirical manner or, on the contrary, that Goldin's photography somehow has reached and tapped into a mystical state of ecstatic transcendence. (The latter gesture again marks the risk of turning these extreme and marginal types into heroic figures.) Nancy cautions against such a dialectical approach as he pushes the thinking of freedom to its limits. Thinking otherwise, he poses a more paradoxical understanding of the intricate connection that exists between community

(as being-shared) and ecstasy (as being-outside-of-itself). "If existence transcends, if it is the being-outside-of-itself of the being-shared, it is therefore *what it is* by being outside of itself."[59] Such a viewpoint opposes a central tenet of the art market and its construction of the photograph as commodity fetish. This ideology assumes that the consumer can somehow get a piece of "the experience of freedom" by owning one of Nan Goldin's photographs. For Nancy, this appropriation of freedom does nothing more than establish a sense of belonging to the possessed object. On the contrary, "*Freedom as the 'self' of the being-outside-of-itself does not return to or belong to itself.* Generally speaking, freedom can in no way take the form of a property."[60] These formulations of the experience of freedom provide another way to understand what is at stake in the photographs of Nan Goldin. Her images expose how being-shared touches upon the limit of being-outside-of-itself. Whether twisting at the party, passing around a joint, sharing a six-pack, or playing a friendly game of monopoly, these bursts of being-shared put (the partying) being in communication with the experience of freedom, for, to recite Nancy, "there is no freedom without some drunkenness or dizziness, however slight."[61]

The wasted state of the partying being and the faulty lines of memory that are induced provide another reason for Goldin's becoming a "serious photographer." Goldin's sweetest hangover comes in the images that give access to and counteract the instant amnesia of all yesterday's parties. In the *Aperture* interview, she recalls (or tries to anyway): "The major motivation for my work is an obsession with memory. I became a serious photographer when I started drinking because (the morning after) I wanted to remember all the details of my experiences."[62] Paradoxically, photography becomes the artificial aid to memory that provides the possibility for the being-present of lived experience for the hungover, partying being.

THE COMMUNITY OF THE "OTHER SIDE": OF DRAG QUEENS AND AIDS VICTIMS

With her book on drag queens entitled *The Other Side* (1993) and her portfolios on AIDS victims, the highs and lows of gay and lesbian sexuality—both the affirmation of drag performance and the mourning of the AIDS epidemic—moved to center stage in Nan Goldin's exposures of community. It is important to review how Goldin has approached these photo subjects and, with the help of Nancy and others, to consider some of the difficulties endemic to her articulation of community on "the other side." In the 1990s, Goldin's rhetoric became more conscious of itself as occupying an activist role in gender identity politics and much less concerned about what makes coupling so difficult. This move has often involved the essentializing and idealizing of her subjects as a *third gender* or even a *third sex* and a romanticizing of the lived experience of AIDS. In these ways, Goldin puts at risk both the shattered foundations of her community of lovers and the carnivalesque pretenses that problematize the concept of identity.

Part of this shift in attitude is related to her own return to sobriety after getting off drugs in the late 1980s, and part of it reflects the historical moment of the AIDS crisis and its sobering impact on her "community of lovers." In this respect, Goldin's turn to identity politics can serve as a paradigmatic case study for Christopher Wood's textbook work "Postmodernism and the Art of Identity." Wood reviews how "identities rooted in gender and sexuality became central forces in the development of postmodernism" for many artists across a number of media, and he goes on to recall how AIDS in particular focused art activism for the gay community.[63] In Goldin's own life narrative, the AIDS epidemic and her new sobriety combined to push her back from the edges of excess to a more restricted economy. Indeed, she makes AIDS the responsible party for restraining her community at loose ends and for changing her romantic idea that "creativity has to come out of euphoric crisis, or out of extreme excess."[64] But there is another way of seeing this point: that what Goldin has done here (along with other artists) is to exchange the terms of one crisis (euphoria) for another (AIDS) as the driving force for the artistic exposure of community.

Goldin has recalled that in the early seventies the drag queens at the Boston bar the Other Side sparked her interest in community-exposed photography. Indeed, her first public exhibition in Cambridge, Massachusetts, at the age of nineteen was devoted to the community of those who do drag performance. "I never saw them as men dressing as women, but as something entirely different—a third gender that made more sense than either of the other two. . . . I had no desire to unmask them with my camera. Since my early teens, I'd lived by an Oscar Wilde saying, that you are who you pretend to be."[65] However, an image such as "Misty, Tabboo!, and Jimmy Paulette Dressing" (1991) (Figure 4.5) offers direct resistance to her artist statement that she never saw them as men dressing as women and that she had no desire to unmask them with her camera. In this particular image, we see three drag queens in different stages of performative readiness. The viewer is given a backstage pass and transported behind the scenes to get a voyeuristic peek at the becoming-feminine of these performers who have strayed from the male-identified portrait on the wall behind them. Rather than enabling the thinking of a *third gender,* this particular image appears to reinforce the battle of the sexes and genders.

Somewhere between a drag groupie and an aspiring fashion photographer, Goldin rendered homage to the queens through such images of adoration. "Part of my worship of them involved photographing them. I wanted to pay homage, to show them how beautiful they were."[66] Goldin's understanding of why these drag queens were beautiful is derived from an aesthetic of pretense and masquerade. It is founded in the bottomless abyss of the camp master Oscar Wilde's dictum that serves as one of the major guiding principles of her photo aesthetic and of her worldview. This carnivalesque credo offers a critique of essentialism by affirming gender performance and the construction of sexual identities. But a real problem occurs when Goldin begins to make this Wilde style dictum serve as the basis for a new identity politics and begins to offer programmatic statements regarding how this third gender somehow makes

more sense. It is one thing to say that she did not want to unmask gender; it is another to categorize the mask as a third gender in and of itself. If pretending and pretense rule (whatever that means), then how can "the other side" (Goldin's "something entirely different") hold or be held to any kind of identity politics? How and why would one want to classify and to count the "wide range of gender identities among [one's] friends" if identity is somehow steeped in a masquerade that shields its own identification? This is the central aporia of Goldin's project of *The Other Side*—of turning "the other side" into a project.[67]

Similar to her photo subjects, Goldin's introduction to *The Other Side* undergoes a shift in subject positions. In one paragraph, the photographer acknowledges the limits of gender classification. First, she says, "in the last years I've learned more about the varieties of desire that can't be compartmentalized, that can't be classified as either straight or gay."[68] But, in the next paragraph, she enumerates a catalog of sexual communities on the other side, ranging from "pre-ops transsexuals" to "gay boys" to "drag queens." The same thing can be said for the way in which our bidirected photographer shuttles back and forth on the question of the normative. On the one hand, Goldin claims that the drag queens resist "normal society's version of gender," and yet she insists elsewhere that they are normal.[69] Now it just might be that the play of gender performance that depends on the advance and protection of masks has gotten the better of Goldin's attempts to make the rhetoric of pretense serve as the ground

FIGURE 4.5. Nan Goldin, "Misty, Tabboo!, and Jimmy Paulette Dressing," New York City, 1991. Copyright Nan Goldin; reproduced by permission.

for gender identity. One also wonders how to reconcile gender performance's presumed problematizing of the truth with her insistence that photography shows us the truth—unless it is to be configured as the truth of pretense. These considerations place Goldin in a more deadpan Warholian position or raise the possibility that she may be posing as a third-gender theorist in drag.

As stated, Nan Goldin narrates her life history in terms of a break. That was when she went into a clinic in 1987 and 1988 to dry out from alcoholism and to kick her drug habit. But this personal crisis is tied to a much larger crisis of community—the deadly impact of AIDS on the Family of Nan and its sobering effects on her photographic vision. In other words, Goldin's community-exposed photography now became photography of the community exposed to AIDS. As she says in the interview with Thomas Avena in *Life Sentences: Writers, Artists, and AIDS,* "So many people were sick or dying and there was no way for me to talk about my community or reenter it without dealing with that subject."[70] That subject (too scary to spell out) led her to curate the exhibition Witnesses: Against Our Vanishing, at Artists Space in New York in 1990. Goldin recalls, "It was about how one community had been devastated. I asked artists who had been directly affected to be in the show; there were twenty-five people living with the effects of AIDS and four or five people who had died, including Mark Morrisroe and Peter Hujar, who was David Wojnarowicz's best friend and one of my close friends."[71] Goldin also began to publish portfolios and extended portraits of friends such as Alf Bold, Gilles Dessain, and Cookie Mueller living and dying with AIDS. In taking the postmodern virus as its subject, this work runs parallel to Nicholas and Bebe Nixon's *People with AIDS.*[72] However, many of these morbid images were criticized for their equation of AIDS with death.[73] The rise of AIDS photography returned the medium to one of its oldest functions as a cult of remembrance. Such images provide a contemporary variant of nineteenth-century memento mori (reminders of death) that use the photographic medium as a means to memorialize one's parting from the loved one. In other words, photography serves as an aid to memory in its memorializing of the victims of AIDS. While a gut-wrenching image such as "Gotscho Kissing Gilles" (1993) has to be seen in the larger context of a photo series that traces the history of Goldin's relationship with her Parisian art dealer, Gilles Dessain, it clearly partakes of AIDS photography as memento mori when presented alone as an aesthetic photo-art object (Figure 4.6). This particular image contrasts the bodybuilder-survivor Gotscho with his stricken lover Gilles and records Gotscho giving Gilles a farewell kiss. The AIDS crisis also brought a distinct note of nostalgia into Goldin's voice. For one, it made her reassess her photographic practice as a discourse of loss.

> Photography doesn't preserve memory as effectively as I had thought it would. A lot of the people in the book are dead now, mostly from AIDS: I had thought that I could stave off loss through photographing. I always thought that if I photographed anyone or anything enough, I would never lose the person, I would never

lose the memory, I would never lose the place. But the pictures show me how much I have lost.[74]

And in another video interview, she specifies this loss as AIDS related, and she does so by invoking the first-person plural pronoun that signifies her belonging to the activist community of those who target AIDS. "The work about AIDS is talking about how much we've lost." But Goldin runs into dangerous territory here in romanticizing the time before AIDS when there was fullness as opposed to the time after AIDS, which reveals how much we've lost.[75] What this nostalgia overlooks is that loss—what Avital Ronell has termed "finitude's score"[76]—is somehow intertwined in the founding of community itself. Nancy is very clear about this loss of community that summons forth community. "What this community has 'lost'—the immanence and intimacy of a communion—is lost only in the sense that such a 'loss' is constitutive of 'community' itself."[77] The attempt to institute a temporal break before and after AIDS is troubled by the realization that it is loss and being broken into that has always driven Goldin's photo project and that it is constitutive of community.

One has to go further and be even more precise about the loss of community that is constitutive of community and locate it specifically as a relationship to death and to the other. In a move that parallels Alphonso Lingis's *The Community of Those*

FIGURE 4.6. Nan Goldin, "Gotscho Kissing Gilles," Paris, 1993. Copyright Nan Goldin; reproduced by permission.

Who Have Nothing in Common, Nancy asserts that it is through death that the community reveals itself and constitutes itself. In other words, community is formed in the movement by which one exposes oneself to death, and this is revealed in the death of others.[78] These ideas are crucial to the opening sections of *The Inoperative Community,* and they are crucial to this series of photo-community studies. Nancy writes: "Community is revealed in the death of others; hence it is always revealed to others. Community is what takes place always through others and for others. It is not the space of the *egos*—subjects and substances that are at bottom immortal—but of *I's* who are always *others* (or else are nothing)."[79] This strand of Nancy's thinking has particular resonance for the book called *The Other Side.* While the title can be seen in a site-specific way as the name of the drag bar in Boston where Goldin began her career as a subcultural photographer, it also has symbolic value as the generalized name for her project *as* community-exposed photography. In other words, she shoots those who tarry with the other—not the *egos* who seek immortal substance, but the "*I's*" who constitute the community of mortal beings. In focusing on the subcultures of drag queens and AIDS victims, *The Other Side* delivers those for whom to be an "I" is to be an "other."[80]

To apply Lingis's phraseology to *The Other Side,* Goldin shoots those who expose themselves to the other, to forces and powers outside themselves, to death and to the others who die. In this regard, Goldin once proclaimed that finitude and death were crucial for her photo exposures of community: "I'm trying to get at the briefness of our mortality."[81] But she has also made other statements about the AIDS crisis that contradict this remark. For example, it is difficult to give credence to Goldin's comments that "AIDS changed everything" or that "our history got cut off at an early age."[82] If the discussion is death and its uncertainty, then how can a temporal attribution such as "dying before one's time" have any real meaning? What does a history getting cut off at an early age mean when one is dealing with death, which has the capacity to strike us down at any time? In other words, we are always exposed to finitude, and photography remains the ongoing record of this deadly exposure. Indeed, one might propose that the condition of our being exposed to photography breeds its own brand of contamination and one that is somehow "infected before all contagion."[83]

The difficulties of applying the concept of dying before one's time to and in the time of AIDS are one of the major themes of Alexander García Düttmann's savvy and astute analysis *At Odds with AIDS: Thinking and Talking about a Virus.* Indeed, "Dying before One's Time" is the title and subject of the first chapter of the book. Düttmann sees this language as both misguided and premature, because it turns the indefiniteness that goes along with our finitude into "the definiteness of a point in time," which leaves the AIDS victim for dead and represses the mortal possibility of "dying at any moment."[84] Moreover, Düttmann's deconstruction casts doubts on the type of activism that guides Goldin's curatorial response to the AIDS crisis. In his view, an exhibition such as Witnesses: Against Our Vanishing would "perpetuate a

reactionary politics of identity" because it leaves no room for equivocation—for a discourse that refuses to identify with AIDS.[85] Ironically, in being dead set against AIDS, such witnessing falls into a being one with it. In this way, such an exhibition gives testimony about AIDS in a manner that engenders an immanence closed in itself. This constitutes a morbid and essentialized discourse that bears witness to the AIDS victim with whom we are asked to identify over and against death, over and against (our) vanishing. Yet, the paradox is that this gesture often does nothing in the end but equate the AIDS victim with death. In contrast, Düttmann poses an approach to AIDS activism that "sees its task as marking and giving testimony of Being-not-one, as a preparation for a life that depends only on the possibility of exhibiting Being-not-one as such and consists precisely of this exhibition, of this always uncertain, never secured transformation of the fragmentary, equivocal, obscure, aporetic, unsolvable, and indistinguishable."[86] It is very difficult to read an overly melodramatic, morbidly inevitable image such as "Gotscho Kissing Gilles" according to Düttmann's terms, because its kiss of death fails to summon the equivocal or the uncertain in its witnessing.

Instead of abandoning Nancy's "community at loose ends" in face of the AIDS epidemic or exchanging it for a politics of identity that registers "how much we've lost" (Goldin's defensive gesture), Düttmann introduces the notion of the "*im-pertinent*" being in order to mark a being-not-one and being-not-one with AIDS. Interestingly enough, this is a construct that draws upon the work of Roland Barthes, whose posthumous book *Camera Lucida* also serves as a pivotal text for positing photography's ongoing untimely relationship to death.[87] According to Barthes, there is something that rational society will not tolerate—"that the *something* that I am should be openly expressed as provisional, revocable, insignificant, inessential, in a word: impertinent."[88] Now, this provisional and revocable element is exactly what one finds most revealing about Nan Goldin's subcultural photography, and the vulnerability of her subjects can be reinscribed in the terms of the impertinent being. Indeed, it is the impertinence of being (rather than the fetishization of death) that one takes away—and that takes us away—from her riveting portfolios of those singular beings living and dying with AIDS and posed in exteriority.

In Düttmann's analysis, the loss of community as constitutive of community has been rearticulated by recalling our primordial belonging to nonbelonging. He concludes: "Only an existence that is a primordial non-belonging, an impertinence that precedes every belonging, can measure up to AIDS—to the uncertainty of all boundaries—and meet the challenge posed by the epidemic."[89] Thus, the point is not just to defend the tribe from extinction by turning photography into a kind of salvage operation for the collection of photographic keepsakes—as in Goldin's injunction "to maintain the traces of the lives of these people and to keep them among us."[90] It is to think about how photography—whether dealing with shattered lovers, drag queens, or AIDS victims—can interrupt the politics of identity. Community-exposed photography exposes the impertinent being who lets go of any defensive or reactive

relationship to loss and death and who does so in "letting the singular outline of our being-in-common expose itself."[91] Only such an approach to photography, being exposed to photography, meets the impertinent demands raised by any community of "the other side."

POSTSCRIPT: RESTATING THE TRUTH OF COMMUNITY

In the afterword to *The Ballad,* Goldin reflects upon her own investment in the truth claims surrounding photography. She casts herself as a prehistoric animal for still believing in documentary truth in a postphotographic era of digital manipulation: "I still believe in photography's truth, which makes me a dinosaur in this age."[92] Indeed, one might comprehend Goldin's popular success as linked to this resistance to the digital and the desire to hold on to untainted snapshot intimacies and emotional truths. In the interview for the Whitney retrospective, she elaborates what photography's truth means to her by insisting on her refusal to manipulate content: it's "about wanting to see the truth, and accepting it, rather than about trying to make a version of it."[93] There is no doubt that a privileging of lived experience occurs in Nan's photo program of "capturing life as it's being lived" and that this is somehow incompatible with the "loss" and absence that she later recognizes as inhabiting the scene of what it means to take a picture.[94] But perhaps her photography touches on another quotient of truth that has nothing to do with the phenomenology of experience—a quotient wherein loss is figured into the equation of truth automatically. This is the truth of community that her photography communicates over and over again. This chapter has brought Jean-Luc Nancy's *Inoperative Community* to bear on Nan Goldin's *Ballad of Sexual Dependency* to expose community as this dispossessed truth and truth of dispossession at the heart of her photographic project from its drag queens to its AIDS victims, from its shattered lovers to its party animals. For, as Nancy would have it, what Nan Goldin's love ballad communicates "is in no way a truth possessed, appropriated or transmitted—even though it is, absolutely the truth of being-in-common. There is community, there is sharing, and there is the exposition of this limit."[95]

PLATE 1. Nan Goldin, "Nan and Brian in Bed," New York City, 1983. Copyright Nan Goldin; reproduced by permission.

PLATE 2. Nan Goldin, "Heart-Shaped Bruise," New York City, 1980. Copyright Nan Goldin; reproduced by permission.

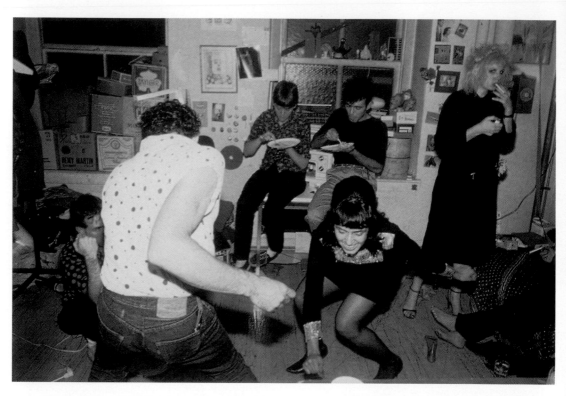

PLATE 3. Nan Goldin, "Twisting at My Birthday Party," New York City, 1980. Copyright Nan Goldin; reproduced by permission.

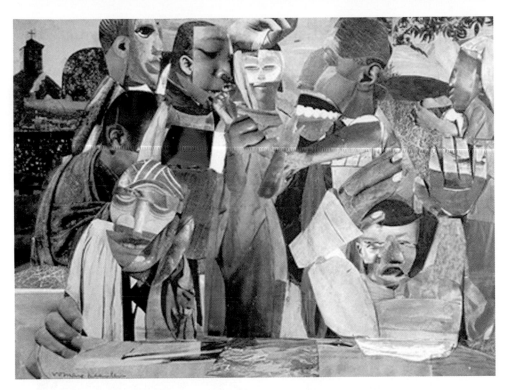

PLATE 4. Romare Bearden, *The Prevalence of Ritual: The Baptism*, 1964. Copyright VAGA (New York)/SODART (Montreal) 2004.

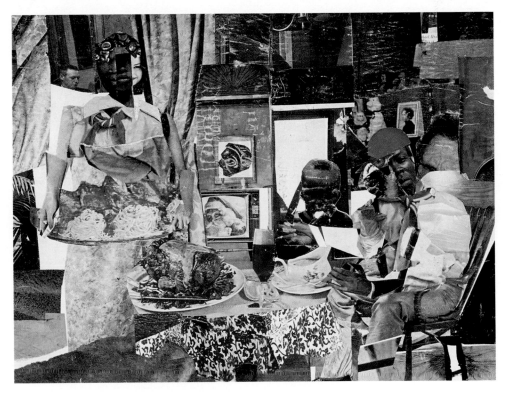

PLATE 5. Romare Bearden, *Evening Meal of the Prophet Peterson*, 1964. Copyright VAGA (New York)/SODART (Montreal) 2004.

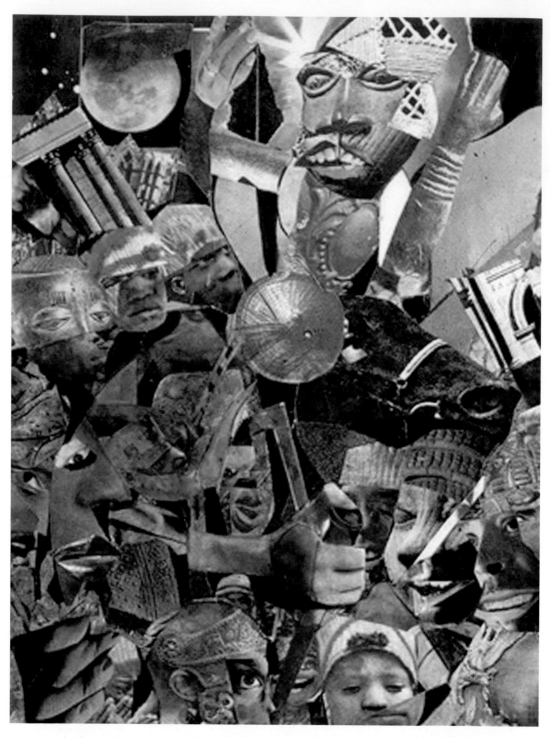

PLATE 6. Romare Bearden, *Sermons: The Walls of Jericho*, 1964. Copyright VAGA (New York)/SODART (Montreal) 2004.

PLATE 7. Pedro Meyer, "The Arrival of the White Man," Magdelena Peñazco, Oaxaca, Mexico, 1991/1992. Courtesy of Pedro Meyer.

PLATE 8. Pedro Meyer, "From Conquest to Reconquest," Oxnard, California, 1992. Courtesy of Pedro Meyer.

PLATE 9. Nikki S. Lee, image 7 of the Ohio Project, 1999. Copyright Nikki S. Lee. Courtesy of Leslie Tonkonow Artworks + Projects, New York.

PLATE 10. Nikki S. Lee, image 13 of the Tourist Project, 1997. Copyright Nikki S. Lee. Courtesy of Leslie Tonkonow Artworks + Projects, New York.

PLATE 11. Nikki S. Lee, image 14 of the Lesbian Project, 1997. Copyright Nikki S. Lee. Courtesy of Leslie Tonkonow Artworks + Projects, New York.

5. Community in Fragments

Romare Bearden's Projections and
the Interruption of Myth

We no longer live in mythic life, or in a time of mythic invention or speech.
When we speak of "myth" or of "mythology," we mean the negation of something
at least as much as the affirmation of something. This is why our scene of myth,
our discourse of myth, and all our mythological thinking make up a myth: to
speak of myth has only ever been to speak of its absence. And the word "myth"
itself designates the absence of what it names. This is what constitutes the
interruption: *"myth" is cut off from its own meaning, on its own meaning, by its
own meaning.* If it even still has a proper meaning.

— JEAN-LUC NANCY, *The Inoperative Community*

Living with Ironies

In *Romare Bearden: A Creative Mythology,* Mary Schmidt Campbell finds a great deal
of irony in the African-American artist's relationship to and reliance on Dadaist
photomontage as the basis for his Projections and other photo-related works of the
1960s. "Ironically, it was Dada which gave Bearden the photomontage technique;
ironic, since Dada with its disgust for art and love of the irrational runs counter to
Bearden's desire for a communal, affirmative art."[1] In this passage, Campbell suggests
that an extreme incompatibility exists between a practice that is beholden to a Dadaist
(anti-)aesthetic and a practice that is in quest of community, and she appears to be
confounded about how to reconcile these two impulses. The goal of this chapter is to
work through this apparent contradiction in a reading of the artistic practice of
Romare Bearden (Figure 5.1) that affirms both a Dadaist impulse toward photomon-
tage and a passion for community (to be differentiated from Campbell's communal-
ism). I will draw on the ideas of Jean-Luc Nancy as set forth in the chapter "Myth
Interrupted" in *The Inoperative Community,* which proposes a vision of community
and of being-in-common that relies on interruption. As Nancy states, "There is a

FIGURE 5.1. Fern Logan, "Portrait: Romare Bearden," New York, 1983. Courtesy of Fern Logan.

voice of community articulated in the interruption, and even out of the interruption itself."[2] Rather than insisting that Bearden's program was to formulate a "creative mythology," the present study situates Bearden's practice in terms of the interruption of myth.

In the years since the publication of Mary Schmidt Campbell's dissertation, Bearden's Projections has been the subject of a number of art critical and historical accounts ranging from Lee Stephens Glazer's "'Signifying Identity': Art and Race in Romare Bearden's Projections" to Kobena Mercer's "Romare Bearden: African American Modernism at Mid-century."[3] It has been the focus of a small exhibition (entitled Romare Bearden in Black and White: Photomontage Projections 1964) curated by Thelma Golden and Gail Gelburd at the Whitney Museum of American Art in 1997, which traveled to eight other American venues through 1999. Most recently, a number of the enlarged black-and-white works in Projections and color collages (that serve as their sources) have been featured in the major retrospective and traveling exhibition (the Art of Romare Bearden) organized by the National Gallery of Art in Washington, DC.[4] This recent body of critical writing adds to the contemporary accounts of the sixties provided by such insightful writers as Ralph Ellison, Dore Ashton, and Charles Childs.[5] While aware of the art historical and critical attention given to the Projections series, the present study insists that all of the aforementioned accounts and numerous others (with the possible exception of Mercer) have not come to terms with the interruptive and fracturing force of Bearden's collage and photomontage practice, and it discusses how this force challenges any simple reading of the Projections as an unproblematic representation of African-American identity, myth, and community.

The analysis of Bearden's practice in terms of the interruption of myth is premised on an understanding of community that resists the lure of communal fusion embodied in the doctrines of Christian communion. The Christian vision seeks "unity" when it comes to the question of community, and it utilizes the holy sacrament of communion as the sacred ritual to achieve its mythic and mystical ends. As Nancy describes it, "Communion takes place in its principle as in its ends, at the heart of the mystical body of Christ."[6] There is no denying that Christian myths and rituals—particularly those portrayed in the group The Prevalence of Ritual—are important components of Bearden's artistic cosmography and pictorial iconography. For instance, Bearden acknowledged the importance of baptism (the subject of one image in this series) as the crucial initiation rite of Christianity and its will to a "common being." As Bearden states in an interview, "Yes, I was impressed by the baptism. By those things, yes I was, because I looked at it as a continuity of what had happened earlier in many societies."[7] But the approach here is not one of a devout believer or of the "good Christian."[8] When Bearden takes up these rituals, he assumes the voice of the visual cultural investigator and the anthropological observer fascinated by the continuity of religious rites and practices of community formation that spanned biblical times and have continued into contemporary black vernacular culture. Nevertheless,

the attempt to establish the continuity of myth is countered by the technical means that Bearden utilizes: the interruptive force of photomontage that brings questions of fragmentation and discontinuity in its wake.

However, Bearden's encounters with Christianity are just one element in a kaleido-scopic and diasporic vision that incorporates elements equally from African artistic sources, European avant-garde strategies (particularly cubism, surrealism, and Dada), African-American folk culture, and American pop art and media culture, among other things. In this way, the *mythemes* of various cultural systems rub up against and inter-rupt one another in the puzzling patchworks of Bearden's collages and photomon-tages. *The Baptism* provides an exemplary case study of this unsettled and unsettling friction (see Plate 4). This supposed performance of Christian community features figures whose faces are partly constituted by African masks (that recall the photo-montages of the Dadaist Hannah Hoch) and whose limbs are massively dispropor-tionate to their bodies in a bulky Picasso-like cubist style. Glazer's reading of the image adds other sources to the mix. "In *Prevalence of Ritual: The Baptism,* the densely arranged figures are built up of magazine fragments as well as photographically repro-duced bits of African masks, Oceanic sculpture, and perhaps Byzantine icons."[9] Mary Schmidt Campbell sees the image rooted in Africanist sources. "The mask fragments can be identified as, in the bottom left, an Okpu mask of the Kalabari Ijo: at the cen-ter, a Kwele mask from the Congo; and at the right a Nimba mask of the Guinean Baga tribe."[10] The only overtly religious symbol proclaiming that this is a "Christian" ritual is the small cross on top of a church in the upper left-hand corner of the image.

Bearden's *Prevalence of Ritual: The Baptism* reveals that the performance of this ancient Christian rite is by no means monolithic and self-contained but happens in an eruptive, fragmented, and diasporic space that comes into being only in the juxtaposition of conflicting pieces of mythic thought and ritual practice (i.e., Judeo-Christian, African, and modernist) that interrupt one another. But there is another level to this montage and its interruption of myth. As a mode of graphic inscription, photomontage underscores its alliance to writing (with light) and not to myth. In exhibiting itself as montage and in fragments, *The Baptism* withdraws from myth and interrupts itself. It intimates that we no longer live in mythic life and that to speak of myth (via photomontage) is always already to speak of its absence. In light of these ironies, this chapter proposes another vision of community in Bearden's mosaic art practice—that of a community in fragments and of myths in the process of being cut off from themselves and their own meanings. This practice inscribes a community forged out of and through interruption and a community whose appropriate (and appropriated) means of communication are found in the avant-garde techniques of collage and photomontage.

This interruptive reading of *The Baptism* is directly at odds with Gail Gelburd's analysis of the same image steeped in the rhetoric of communal fusion and of an ideal cultural synthesis that brings the unification of African and Christian mythical traditions. In her study "Romare Bearden in Black-and-White: The Photomontage

Projections of 1964," Gelburd writes: "In Bearden's 1964 *Baptism,* a figure in an African mask stands next to John the Baptist in place of Christ. The mask brings the Christian and African traditions together; the photomontage not only resonates with traditional imagery of Christ's baptism, but also Bearden's memories of the provincial scenes of baptisms performed in the shallow streams of the South. The Christian and African spirits together enter the body of the individual, who is transmuted into an emblem of a universal quest for purification."[11] This is clearly a utopian vision of communion in which Gelburd actively forgets the "absence of myth." She ignores the contaminating logic of the "cut" as the cornerstone of the collage vision that resists the rhetoric of purity. Furthermore, there is no reason to assume that the masks in these images "bring the Christian and African traditions together." This invocation of mystical harmony forecloses other more complex and problematic understandings of the sharing and the splitting of these two traditions. For example, it forecloses the politically loaded (and burdened) possibility of a postcolonialist reading that it is the forced colonization of Africa and the history of slavery that have produced syncretistic streams of African-American Christian expression. Gelburd also does not account for the appropriation of these masks as part and parcel of the avant-garde strategies of cubism and Dada. Is Bearden's reappropriation of these masks "a caustic comment about the appropriation of primitivism in Western art,"[12] or is it an affirmation of the appropriateness of African art or of avant-garde modernism to represent the African-American experience? Whatever the solution to this puzzle, Gelburd's evasion of any discussion of the cubist and Dadaist aspects of *The Baptism*—or, to go back even further in the Western art historical tradition, Bearden's insistence of the importance of the Dutch masters to his work—represses those elements that make of his collages and photomontages an interruptive experience.

In proposing this reading of Bearden in terms of Nancy's interruption of myth and of the community in fragments, I do not intend to argue that the end result would be some sobering demystification of myth. Neither does this analysis seek to pronounce the dissolution of the passion for community. On the contrary, Bearden's photomontage Projections expose a passion for community born out of the interruption of myth as beings approach and touch the edge or the limit of their singularities in an experience of finitude. With all their edges exposed, Bearden's photomontages give expression to and represent this "passion to be exposed" that is crucial to the inoperative community. To recite "Myth Interrupted": "Interruption occurs at the edge, or rather it constitutes the edge where beings touch each other, expose themselves to each other and separate from one another, thus communicating and propagating their community. On this edge, destined to this edge and called forth by it, born of interruption, there is a passion. This is, if you will, what remains of myth, or rather, it is *itself the interruption* of myth."[13] From this perspective, Romare Bearden's dislocating and interruptive practice is quite different from the staging of another myth of community, and it is the goal of this chapter to examine and to explain how the Projections photomontages expose being-in-common to and at this edge.

CONTEXT: THE PROJECTIONS AS
COMMUNITY-EXPOSED PHOTOMONTAGE

In October 1964, Romare Bearden exhibited photostat enlargements of twenty-one collages at the Cordier and Ekstrom Gallery in New York City. When asked about the derivation of the term *projections* for these works, Bearden disclaimed authorship and attributed the name to his gallerist, Arne Ekstrom. "He called them 'Projections,' because they were large heads and they seemed to project themselves right out to the viewer."[14] The projection of these heads in fragments onto the viewers and into their psyches exposes a space of communication and of sharing at the limits of identity. Given this description, Bearden's Projections photomontages are not about "signifying identity" (as Glazer would have it), but rather they expose "each one's non-identity to himself and to others, and the nonidentity of the work to itself."[15] Bearden reviews the steps involved in this process in the interview with Henri Ghent initiated by the Archives of American Art. "I did small collages, say about the size of a piece of typewriter paper, out of certain magazine photographs and colored material that I put together, and these were photostatted and enlarged to about four by five feet and the photostats were then mounted onto masonite."[16]

When asked to recall the origins of the Projections, Bearden speaks again of a desire to disclaim individual authorship in their production. They were to be works of art produced by a collective subject, similar to the surrealist practice of the "exquisite corpse," in which a number of individuals contribute only one part or fragment to the final product. Bearden had the same idea in mind for the Projections when he conceived them as a photomontage activity for the Spiral community of artists, which he helped to organize in July 1963. This black art activist group had been formed as a forum to respond to political events related to the burgeoning Civil Rights movement and to research the question of community at the intersection of art and race: What is a Negro artist? Bearden recalls the significance of the Spiral group on his artistic practice: "And these meetings and discussing the identity of the Negro, what a Negro artist is, or if there is such a thing, all of these pro and con discussions, meant a great deal to me especially in the formulation of my present ideas and way of painting."[17] This incident turns out to be a great example of inoperative community. That is, after designing a procedure because it would lend itself to collective production, Bearden is left to pursue this vision of a community of ruptures on his own because of the group's lack of interest. To recall Bearden's account:

> My idea in doing the *Projections* was—I mentioned Spiral, this group of Negro artists—we were talking one day about the possibility of a group of the artists working jointly on a picture and I was thinking of a possible way that this could be done. I thought that if we had photographs maybe we could each paste some down. And I mentioned this to several artists, one who was a landscape painter. I cut out some trees and I cut out some figures, and I said maybe you could make a landscape and

I could paste some of the figures on it and let's see what we can do. I worked on one or two alone just to try to get the idea myself to show the other artists. But they didn't seem to be too interested in it and I continued.[18]

The logic of interruption enters into the very way in which Bearden articulates the project—interrupting himself in his very attempt to discuss these collages and their enlargement in terms of "kind of a breaking." To quote Bearden, "In the last works that I did, these Projections so-called, collages that I made small and had them blown up photographically was kind of a breaking—using the photographic image in painting which I have done is a kind of breaking of convention."[19] The breaking that Bearden discusses here alludes to the specific way in which he imported the photographic image into the field of painting with a mixed-media result. This dislocating and even iconoclastic gesture is similar to Robert Rauschenberg's collages and silk screens of the same period in staging a critique of the autonomy and medium-specificity of modernist painting. Bearden's cut-up photographs on the painted surface interrupt the space of painting, and then their enlargement as photostats adds another layer of photographic processing. In relying first on collage and then on photomontage projection, Bearden becomes the displaced author of a series of interrupted narratives. He enters into a practice of the "always already" so that his work affords a web of deferrals—of borrowings and reinscriptions that offer a visual rendition of African-American diaspora. In his 1968 catalog essay, the writer Ralph Ellison, who was Bearden's friend and an astute analyst of the African-American experience, analyzes Bearden's art of interruption in a way that explains how the collage technique matches the meaning of African-American diaspora in a text that engages with metaphors that signal rupture. "Or to put it another way, Bearden's meaning is identical with his method. His combination of technique is in itself eloquent of the sharp breaks, leaps in consciousness, distortions, paradoxes, reversals, telescoping of time and surreal blending of styles, values, hopes and dreams which characterize much of Negro American history."[20] With this series of images, Bearden becomes the projection screen of the collective imaginary of African-American diaspora at a moment of an intense crisis of community—the political unrest and turmoil of the Civil Rights movement. This idea supports Dore Ashton's sociohistorical analysis of the series: "They arrived at a particular moment in American history and cannot be seen—at least not for the moment—as divided from the crisis."[21] Bearden exposes the ruptured state of African-American being-in-common circa 1964 as a space in fragments, as a place of tension and resistance, as a locus of sharing and splitting—in the terms of a community-exposed photomontage.

Another fascinating art and visual cultural context demands attention when one considers the historical moment of the Projections in terms of their production and reproduction. The years 1963 and 1964 also signal the emergence and the branding of the pop art movement in New York as a major artistic and cultural force. In contrast to the cool ironies of Andy Warhol's Death in America series and the ready-made

repetitions of the mass media spectacles that are the subject matter of his photo silk screens discussed in the introduction of this book, Bearden exposes what has been left out of Dandy Andy's community. It is the question of race that rears its head and that looms large in the cut-up faces and masks of Romare Bearden's Projections in images that are also appropriated from mass media sources and that mark what was too often excluded from Warhol's vision of photography and community and from the dominant artistic discourse of the day. Interestingly enough, the idea of confronting the repressed other of the dominant discourses circa 1964 and their inherent racism is revealed when Bearden recalls a discussion with a reporter who was convinced that the Projections "was a show of head-hunters." Bearden's pedagogic response to the paranoid journalist returns her own racist and colonialist thinking to her, and asks her to project herself across 110th Street and thereby engage "the other within." To quote Bearden, "Well, it was frightening to her. Here were Negroes with big heads and something within her reacted to this; you know they were frightening; they were after her. I told her head-hunters are in the Solomon Islands and these are the people that you must deal with, that live in Harlem. You have to look at them a little longer."[22]

While one may look to Warhol's *Race Riot,* from 1963 (in which he appropriates documentary images of the police dogs attacking black protesters in Birmingham, Alabama), as an example of how he acknowledged racial politics by utilizing the same appropriating strategy of the "blow-up," this silk screen, with its cool and blank stare at the police violence directed against the protesters who demand an end to the segregation of black and white communities in the Deep South, redoubles race as a commodity and a mass spectacle for the consumption of white America.[23] This approach is drastically different from Bearden's photomontage series of Projections, whose themes are much less sensational, illustrating African-American cultural life from the insider's position—via folk memories (e.g., *Pittsburgh Memory*), religious rituals (e.g., the four images of *The Prevalence of Ritual*), biblical stories (e.g., *Expulsion from Paradise*), vernacular scenes (*The Street*), and musical allusions (*Jazz*). Yet, in a subtler and more nuanced manner, these images—and their less than seamless cuts—expose the fault lines of African-American community and of black and white community relations circa 1964.

In pursuing this last point, I will analyze one photomontage in particular that happens to share the same image world and iconography as pop art. *Evening Meal of the Prophet Peterson* (1964) offers a direct response to American consumer culture and mass-media images, and its product display easily rivals the ironic pop paintings of James Rosenquist (see Plate 5). But here the subject matter also forces a consideration of what it means to be "minorized" in white America. A montage made out of fragments from magazine ads and other images from popular journals, *Evening Meal* pieces together a domestic dinner scene in which a woman made up of black and white parts brings a bountiful tray of meat and pasta to a kitchen table, which has on it a holiday turkey with all the trimmings, a big cup of gravy, and a glass of red wine. It is clearly a feast, and the image of Santa Claus beaming out of the television screen

leads one to the conclusion that Christmas dinner is being served at the Peterson household. This seems to be the coherent and ideal narrative traced by this domestic scene. But the dislocation of these figures and their inability to cohere as unitary subjects point to a less than mythic scenario. The fragmentation of these split subjects makes the viewer skeptical about the extent to which they are sharing in the American dream or at what price. (The little boy seated at the table appears to have a hole carved into his head as if he has become a piggybank for the deposit of money.) The split subjectivity is most apparent in the triply cut-up face of Mrs. Peterson, whose left third (our right) appears as the smiling face of a little doll-like white girl who has partly occupied her body. Meanwhile, the right side of the torso of the man who is presumably the Prophet is occupied by nonhuman aspects. In this manner, *Evening Meal* stages the split subjectivity and the multiplied or "double-consciousness" of African-American diaspora dwellers looking at themselves through the eyes of others.[24]

One also notices that an African mask has been framed immediately above the television set, as if offering a direct challenge and interruption to the consumerist and Christian myth of Santa Claus. In contrast to pop's mythic desire to universalize the field of consumer images around a communal Santa Claus and to efface racial difference, Bearden fractures the field of consumption and marks how it is racially coded. The question then becomes Whose community? If community is to be forged around the electronic hearth of the television set, then this mythic program of white America will have to be interrupted. Like many of Bearden's photomontage Projections, *Evening Meal of the Prophet Peterson* raises the question of community in its interruption of myth along the frayed edges and the fault lines where beings (of whatever color) share and split their differences.

FROM CREATIVE MYTHOLOGY TO MYTH INTERRUPTED

When asked in a 1976 interview in *Art and Man* about the sources of inspiration for his art, Bearden pointed to the power of myth and ritual as indexed in the following exchange: "Q. Where do you get your inspiration from? A. Mainly they come out of myths and rituals, which have always interested me."[25] In another statement, Bearden asserts his desire to bridge artistic traditions—northern Renaissance and African-American to be exact—in alluding to a mutual concern for formalism. "I want to show that the myth and ritual of Negro life provide the same formal elements that appear in other art, such as Dutch painting by Pieter de Hooch." Taking their cues from such statements, the bulk of scholarship and critical writings on the art of Romare Bearden has been a litany of tributes and testimonies to its mythic quality—to its ability to articulate the guiding rituals of contemporary African-American community and to illustrate how these rituals are rooted in a long and complex tradition. Ralph Ellison discusses how Bearden "had become interested in myth and ritual as potent forms for ordering human experience" and that the Projections provide "renderings of those rituals of rebirth and dying, of baptism and sorcery which give

ceremonial continuity to the Negro American community."[26] All in all, these are said to be images that depict "abiding rituals and ceremonies of affirmation."[27] This wording is closely aligned to the term that Bearden (in collaboration with his friend and jazz musician Albert Murray) adopted for a number of the works in the Projections series and that became the title of his 1971 retrospective at the Museum of Modern Art in New York and his 1972 exhibition of collages and paintings at the Studio Museum in Harlem—*The Prevalence of Ritual* (Figure 5.2).[28] According to Mary Schmidt Campbell, "The 'Prevalence of Ritual' is what Bearden named this philosophy, and it remained the unifying basis for his art until the end of his career."[29] However, this approach is based on a misguided premise, in that it collapses myth into philosophy and simultaneously attempts to totalize Bearden's artistic practice. But the prevalence of ritual can never become a philosophy (even if philosophy is itself not immune to unexamined myths and fiction). What is troubling about the move to philosophize myth is that it again represses the fictional quality of mythic speech and Nancy's idea that "the being that myth engenders implodes in its own fiction."[30]

This foregrounding of the concept of the prevalence of ritual as the center of Bearden's art leads Mary Schmidt Campbell to situate his work in relation to the writings of the mythologist Joseph Campbell. Indeed, the title of her thesis contains the subtitle of one of his many books about myth, *The Masks of the Gods: Creative Mythology*.[31] Joseph Campbell's appearance in the documentary film *Bearden Plays Bearden,* produced in 1980, lends support to the mythological reading of the Projections. In Mary Schmidt Campbell's understanding of the relationship between myth and community and their mutual sustenance, she expresses the idea that "the practice of a ritual ceremony also assures continuity of the values of a community."[32] Quoting *The Masks of the Gods,* Mary Schmidt Campbell goes on to outline how and why Bearden's art is an example of what she calls creative mythology: "In a 'creative mythology,' the individual creates his own vision, choosing those signs and symbols which communicate that vision. Using 'the general treasury, the dictionary, so to say, of the world's infinitely rich heritage of symbols, images, myth motives, and hero deeds,' the private mythology becomes public."[33] But one must take issue with this reading, because it gives the individual the power to create or invent myth, which involves too much hubris. Instead of myth as the site of invention (i.e., that Bearden invents myth), as in Campbell's interpretation, it is Bearden who invents himself in the myths and rituals of African-American life that he fashions. This attribution of authorship understates the primacy of myth in which the inventor must be understood as an effect. For Mary Schmidt Campbell, "the signs and symbols in [Bearden's] collages have yielded seemingly infinite variations on the ritual content of Black American life." Thus, she concludes, the "'creative mythology' which evolves from the ritual content in the Projections forms the basis for his work in the next 15 years. . . . Bearden's collages, his remembrance of the rituals of his past, without question gained the force of living myth."[34]

But what upsets the smooth operation of this mythical system of thought, whether

FIGURE 5.2. Anonymous poster for the opening of Romare Bearden's *The Prevalence of Ritual* at the Studio Museum in Harlem, July 16, 1972.

invoked as creative mythology or as the prevalence of ritual for the interpretation of the Projections, is the interruptive force that these works project in terms of their collage technique (as a mode of photo writing rather than mythmaking) and in terms of their modern (or artistic modernist) consciousness of the "absence of myth." Bataille articulated this absence of myth as a double bind. "If we say quite simply and in all lucidity that present day man is defined by his avidity for myth, and if we add that he is also defined by the awareness of not being able to accede to the possibility of creating a veritable myth, we have defined a kind of myth that is the *absence of myth*."[35] These interruptive forces run counter to "the force of living myth" as Mary Schmidt Campbell conceives it. That is why she takes great pains to police Bearden's oeuvre to keep it from any overt contamination with the anarchic and iconoclastic spirit and destructive force of Dadaist photomontage, even though she reviews the formidable influence of George Grosz on Bearden at the Art Students League.[36] The ironic and satirical force of Dadaist photomontage is generated out of this type of interruption (and absence) of myth. The idyllic story of Bearden's creative mythology makes him and his works into "myth motives" and "hero deeds," but it does not address the aspect of his work that *dismembers* as well as remembers the rituals of the past (despite his own avidity and proclivity for myths) and that undercuts and intercuts the ritual content of black American life by means of the collage cuts that interrupt myth and withdraw the possibility of mythic communion at the basis of the interpretation of the two Campbells. These unconscious and cutting ironies are too often repressed by mythic thought. Instead of gathering community toward a mythic center in a unifying point of communion (as would occur in a "creative mythology"), the interruptions of collage and photomontage turn community toward the outside, toward the experience of limits. They insist that the communication of community happens only in beings' exposure to the outside—in the exposure of the limit (or the cut) on which communication (photographic or other) takes place.

Given this framing of the Projections in terms of the interruption of myth, the four images that constitute *The Prevalence of Ritual* (*The Baptism, Tidings, Conjur Woman,* and *Conjur Woman as an Angel*) take on new dimensions. They are to be viewed as photomontages that interrupt myth and are engaged in the common exposure of singular beings (what takes place in the interruption of community as communion). We have already explored to some extent how this happens in *The Baptism*. *The Baptism* is also analyzed by Mary Schmidt Campbell but not in terms of a community in fragments. Like Gail Gelburd's reading, Campbell's is insistent on fusing or yoking together (the phrase she uses) the different traditions enlisted by Bearden in *The Baptism:* southern Negro roots, African purification rites, and Christian Renaissance sources. Her summary statement leads to her conclusion of the "'Prevalence' or omnipresence of his ritual concept."

> Metaphor is essential to Bearden's concept of ritual. . . . He wishes to show that a
> Virginia Baptism is like a Renaissance scene of John the Baptist and like African

purification rites. To make that comparison, he yokes together the past and the present by maintaining an extraordinary degree of visual accuracy in the literal event, yet representing the literal event with a composition "quoted" from Renaissance sources. It is this use of art historical conventions (which force the viewer out of the Black community into the past and into another cultural universe) that permits Bearden to achieve the "Prevalence" or omnipresence of his ritual concept.[37]

Again, the montage principle has given way to metaphor (actually simile, in the repetition of the word *like*) in Campbell's analysis. While Campbell is willing to accede to the possibility of quotation, she forgets that the montage principle of iterability relies on repetition with a difference (what allows for the unforeseen possibility of what is "unlike"). It would be a lot more difficult to make this argument if one were to think of *The Baptism* as a "ritual in fragments" that resists the violence of such a yoking together. The seams are still showing in these cuts that mark the different registers in the construction of mythic meaning that risks making the omnipresence of ritual seem like a hollow concept. Mythic thought represents the collapse of history, the yoking together of the past and the present. But it must be insisted that collage, as an interruptive medium, refuses to accede ahistoricity to myth. Indeed, if the Projections "force the viewer out of the Black community into the past and into another cultural universe," then this can happen only as a disjunctive act and one that would resist mythic universalizing by means of cultural and historical critique (e.g., in the name of a postcolonialist reading of African-American history). In comparison to Campbell's positing of an already established community that looks to the past and to the similitude of ritual, Nancy's formulation is radically different. The act of looking interruptively and disjunctively forges a community that is unable to avow itself in any fused or communal way. This underscores the difference between Campbell's creative mythology and Nancy's interruption of myth. To quote Nancy: "On the contrary, it is the interruption of myth that reveals the disjunctive or hidden nature of community. In myth, community was proclaimed: in the interrupted myth, community turns out to be what Blanchot has named 'the unavowable community.'"[38]

Campbell also provides a detailed analysis of Bearden's *Conjur Woman* (Figure 5.3) and sees the various versions of this collage as another example of his creative mythology. The conjure woman made her first appearance in the 1964 Projections series and continued to be an ongoing motif in his work for the next two decades. A source of folk legend in the Negro South, the conjure woman as the sacred healer and sorcerer represents a resistance to modern medicine and patriarchal authority in matters related to the heart, mind, and body of the traditional community that she served. Bearden speaks of the magic and mystery of the conjure woman in his writings, in which he spells *conjure* without a final *e* (for some unknown reason): "A conjur woman was an important figure in a number of Southern Negro rural communities. She was called on to prepare love potions; to provide herbs to cure various illnesses

FIGURE 5.3. Romare Bearden, *Conjur Woman*, 1964. Copyright VAGA (New York)/SODART (Montreal) 2004.

and to be consulted regarding vexing personal and family problems. Much of her knowledge had been passed on through generations from an African past, although a great deal was learnt from the American Indians. A conjur woman was greatly feared and it was believed that she could change her appearance."[39]

In terms of composition, Campbell reviews the cut-up depiction of Bearden's *Conjur Woman* in one of its multiple versions and indicates how she is part animal and part human in her representation: "Her mouth is the photograph of a real mouth, her eyes, the photograph of cat's eyes. Her face, composed of strips of paper, gives her the appearance of being masked as her cat eyes stare from behind the strips of paper."[40] Again, the masking of the subject in this way evokes African sources without actually incorporating a mask fragment and can be viewed as part of Bearden's diasporic aesthetic. Interestingly enough, one of the only times in Campbell's entire project that she acknowledges the paradox of the absence of myth as a driving force for Bearden's work occurs in her reading of *Conjur Woman*. It underscores Nancy's idea that "when we speak of 'myth' or of 'mythology' we mean the negation of something at least as much as the affirmation of something."[41] Specifically, the reader gets the impression that Bearden's obsessive interest in the conjure woman is based on the desire to counteract the sense of loss and nostalgia that he feels for the passing away of rural community and its mythic character. Campbell writes, "The sense of loss, of a community and its values passing away, is present in many of Bearden's pieces. It is especially effective in the *Conjur Woman*. The dark mournful eyes of the *Conjur Woman,* her body frozen, frontal, artificial and unlifelike conveys an other-worldliness. . . . Increasingly, the collages would become a hedge against loss and death, not only of a private community, but of an entire people."[42] From the perspective of the inoperative community, we see the need to reverse any feelings of nostalgia for the loss of community and to recognize instead that what the interrupted community in Bearden's photomontages has lost is the "immanence and the intimacy of communion."[43] Like the artist Bearden and his photomontage conjurations, *Conjur Woman* can be seen as representative of one who communicates this vision of inoperative community as she exposes the finitude of the singular beings whom she touches with her contagious magic. In this way, the mythological reading of *Conjur Woman* yields to one mediated by the interruption of myth that exposes community (via collage and photomontage) to the loss of communion.

FROM THE COMMUNAL TO COMMUNITY IN FRAGMENTS

This chapter began with Mary Schmidt Campbell's delimitation of the Dadaist influence on Bearden's work and the refusal to recognize the possibility that one can affirm a vision of community if one is engaged in a Dadaist-inflected practice such as photomontage. Campbell further elaborates this position and offers a "form and content" distinction that further polices Bearden's potential investment in this radical and anarchic art movement.

Dada provided Bearden with the photomontage technique of including photographs and thus, images of a literal reality; but Dada did not provide the underlying spirit of Bearden's collage. In tone, the collages are much more akin to the assemblages of African art. The art historian Arnold Rubin has identified the end goal of African objects as fostering social cohesion and community stability and unity.[44]

In this passage, Campbell makes a dubious and potentially separatist distinction between Dadaist technique (which is superficial and only on the surface) and the African spirit (which is essential and "underlying" the project). Rather than maintaining the tensions of Du Bois's "double-consciousness" or Bearden's own "dual culture,"[45] Campbell aligns Bearden with the tradition of African assemblage, and she privileges it as somehow more akin to matters of the spirit. In a peculiar institutional gesture, she mobilizes the authority of Museum of Modern Art curator Arnold Rubin to insist that the goal of such assembled objects is to assert the communal—to foster "social cohesion and community stability and unity." Yet, in the process of boxing Bearden in this way, something has been lost—namely, the possibility of a *photomonteur* Bearden, who speaks for a vision of a community in fragments.

In contrast to Campbell's analysis, the Projections analysis of art historian Dore Ashton, written at the time of the series' first exhibition, offers an assessment of Bearden's relationship to Dada that sees Bearden's photomontage practice as infused by and as a corollary of Dadaist activist politics and satirical social commentary. She writes: "Although Bearden sees his projections in the cubist tradition, his images relate as much to the activist photomontages that gained currency during the First World War. . . . From these graphic accounts such artists as John Heartfield and George Grosz (who was Bearden's teacher years later) derived a medium which they turned into a vigorous protestant tool. In his own terms, Bearden has done no less."[46] In an unpublished manuscript from the same period, Ashton adds further historical context and parallels: "Bearden's teacher at The Art Students League, George Grosz, was one of the originators of photomontage. He used it, as did his illustrious colleague, John Heartfield, to sharpen his acerbic commentaries on the abysmal human conditions following the First World War."[47] There is a clear sociopolitical subtext in Ashton's reading as she mobilizes Bearden's Projections in the service of social protest and political activism. As the Dadaist photomontages responded to World War I, so Bearden's images respond to the Vietnam War and, most pressingly, to the Civil Rights movement.

The astounding photomontage *Untitled* (1964), not included in the Cordier-Ekstrom exhibition but reproduced in the Whitney catalog, is Bearden's most overtly politicized image of the period, and it lends support to Ashton's activist reading of the photomontages as a direct response to the riots that flared in many urban centers that year (Figure 5.4). Against the backdrop of the New York skyline and a cropped Statue of Liberty, a mass of people (some black and some white) have taken to the streets along with what appear to be National Guardsmen or riot police. On the left, a black woman in a kerchief has her right arm raised in a fist, as if signaling black power. On

the right, an old white woman who holds an American flag serves as a counterpoint. In the middle, an unidentified arm holds up a rifle. Meanwhile, United States Air Force planes fly overhead, and a few appear to be in a nosedive. *Untitled* shows a community in a state of unrest and at the moment of crisis when civil rights were at stake. The image conjures the return of King Kong as a black revolutionary storming and wreaking havoc on Manhattan. Ashton also believes that other less dramatic and more mundane images in the series are also connected to an activist agenda. "Bearden ultimately arrives at a piercing activist bill of particulars of intolerable facts."[48] Nevertheless, it should be noted that Ashton's politically engaged reading contradicts one of Bearden's own neutralizing statements published at the time, which appears to be informed by modernist formalism and the rhetoric of the autonomy and authenticity of the work of art. As he told *Art News:* "I have not created protest images because the world within the collage, if it is authentic, retains the right to speak for itself."[49]

However, Ashton's instrumental and activist reading of Bearden's work as a "protestant tool" against white oppression is still caught up in a set of humanist assumptions that rely on a universal standard of community that does not address the "unavowable" demands posed by the other. The goal of an interruptive reading of Bearden's photomontages runs counter to their employment as a means to measure, compare, or account for one community's oppression over and against another's. This is not to minimize or to make light of the question of race and oppression as articulated in a politics of identity, but to acknowledge, on the contrary, the "incalculable differences"

FIGURE 5.4. Romare Bearden, *Untitled,* 1964. Copyright VAGA (New York)/SODART (Montreal) 2004.

that underwrite the invocation of community, of us and of them. Rather than turning to modernist art formalism as a means of escaping (and depoliticizing) this issue (as Bearden did in *Art News*), a deconstructive and interruptive analysis of Bearden's photomontages and the question of community turns to the incomparability of the other as the basis of any ethics or politics of representation. Such an analysis is directed otherwise, and it focuses on the immeasurable responsibilities that go along with saying "we" or that are at stake before "we" are in a position to act. As Bill Readings states, "Deconstruction rephrases the political, not by adding race along with gender and class to the categories by which we calculate oppression but by invoking an incalculable difference, an unrepresentable other, in the face of which any claim to community must be staked."[50]

In her same unpublished manuscript, Ashton continues the line of inquiry that refuses to undercut the Dadaist impulse in Bearden and brings it into communication with (rather than positions it as radically distinct from) the tendency toward "Africanicity." When it comes to the use of masks in these collages, Ashton insists that they are not just symbolic signifiers of African religion. Instead, the overall effect on the viewer is achieved because of the shock of photomontage with its "disjunctions, exaggerations, and shocking juxtapositions." In other words, Dadaist photomontage and African masks work in tandem. "Bearden has frequently alluded to the dark expressive power of the mask, and specifically, the exorcist function it performs. He has heightened the compelling magic, and the accompanying fearsomeness, by making use of disjunctions, exaggerations, and shocking juxtapositions. In so doing, he has told of the abiding African mores that seethed beneath the surface of black life in America, both North and South."[51] In this regard, Ashton's reading of Bearden is the complete antithesis of one that insists on fusional unity and purity. What is exposed as seething beneath the surface of things through the compelling magic of Dadaist and African practices is the shared and divided space of photomontage. Photomontage relies on disjunctions and shocking juxtapositions that expose community (being-in-common) as always in relation to the outside and at the limit and therefore always on (the) edge.

It is interesting to point out in this context that Bearden resisted the radical separatist position of the black power movement of the mid- to late sixties as exemplified by the Black Panthers. According to the separatists, African-American artists should forget about appealing to white America (deemed to be hopelessly racist and reactionary) and rather concentrate their artistic efforts exclusively on black communities. Bearden's position on this hotly debated issue of cultural politics was a constant refusal to exclude the white community (as witnessed by his dealers, Daniel Cordier and Arne Ekstrom) and at the same time an acknowledgment of the need to make a concerted effort to increase black community exposure for the "Negro artist."

> HENRI GHENT: Do you think that the Negro should now direct his efforts to the black community? That is, by exhibiting exclusively in black communities, colleges, universities, etcetera.

ROMARE BEARDEN: Well, I don't think that this should be exclusively done but since so little of it has been done before I think that a great deal of effort should be made in this direction to make the communities, to use a cliché, more art conscious, or more aware of the Negro artist.[52]

This rejection of exclusivity is closely aligned with what Bearden told Charles Childs in the study subtitled "Identity and Identification," in the *Art News* published at the time of the Projections exhibition. "If subject were just a matter of race and identity, then one could not have affinities with anything other than one's own culture."[53] But Bearden did risk falling into the opposite trap of the loss of cultural and racial differences in an active forgetting of the interruptive force of diaspora in the service of integration. For instance, in the Childs's review, Bearden advocates "cultural synthesis."[54] This position appears to be in line with a melting-pot myth of hybridity, as Bearden is said to create in and out of the "intermingling mold of the New York environment." Perhaps this assimilatory political gesture in *Art News* is offered so as not to alienate the predominately white readership by acting too independent—or interruptive—on the question of community.

The image reproduced in the Childs's study and placed opposite Bearden's playful and doubly conscious avowal of a "dual culture" and his unwillingness "to deny either the Harlem where [he] grew up or Haarlem of the Dutch masters" is *The Burial* (Figure 5.5).[55] While not among *The Prevalence of Ritual* images, it is certainly related to them in theme. Indeed, one can think of the burial as what stands opposite the initiation rite of the baptism in Christian life-cycle rituals—one about entering the community and the other about leaving that community for the afterlife. For Thelma Golden, "Works such as *Baptism* and *The Burial* centralize and document the rituals of the Southern black experience. Bearden created these works from memory—his own memory and the collective black experience."[56] This means that even though *The Burial* shows five people praying and weeping over a beloved, it is meant to stand in for something larger—a collective black experience or even a more universal collective experience. On the other hand, Lee Stephens Glazer has researched this image, and she hypothesizes that it refers to and is inspired by a particular sociopolitical event that has already been discussed in the context of Warhol's *Race Riot*. Glazer argues that one should see *The Burial* as a photomontage reworking of a documentary news photograph of a funeral published in *Newsweek* magazine on September 30, 1963, in an article called "Bombing in Birmingham." Glazer also notes that the vertical format that Bearden used for the photomontage mimes the *Newsweek* image.[57] But whether it is an image responding to a specific event in the concrete political struggle for civil rights or a more generic image about the collective experience, *The Burial* represents the bonding experience that looks to death and finitude in order to expose "the experience of community" as what comes out of loss and as what is revealed in the death of others. In contrast to Golden's or Campbell's position, mine is that *The Burial* reveals how (inoperative) community is exposed only in the impossibility of communion

FIGURE 5.5. Romare Bearden, *The Burial*, 1964. Copyright VAGA (New York)/SODART (Montreal) 2004.

by means of this collaged close-up of a group of mourners wrapped up in their grief and lamentations. To recite Nancy's phrasing, "Community is revealed in the death of others; hence it is always revealed to others. . . . The genuine community of mortal beings, or death as community, establishes their impossible communion." If, as Nancy writes, "a community is the presentation to its members of their mortal truth,"[58] then Romare Bearden's coffin-shaped *The Burial* offers a wonderful illustration of this presentation by means of community-exposed photomontage.

FROM THE DIALECTICAL CUT TO THE EXPERIENCE OF FINITUDE

A recent critically insightful essay in the reception history of Romare Bearden's photomontage Projections is Kobena Mercer's "Romare Bearden: African-American Modernism at Mid-century." This study breaks new ground because it does not shy away from applying insights taken from visual cultural studies and new theoretical methodologies or from rethinking an older critical study (by Ralph Ellison) in light of these new models and approaches. Mercer chastises what he calls the "folksy humanism" that has confined Bearden studies to naive and essentialist readings of his work and its relationship to African-American identity and community. As Mercer writes, "In contrast to the 'folksy' humanism that characterizes prevalent interpretations of Bearden's work, this reading seeks to restore the controlled negativity of the dialectical 'cut' to the Photomontage Projections."[59] It is interesting to note the choice of the word *prevalent* to discuss Bearden's reception history. It alludes to interpreters such as Mary Schmidt Campbell who have made *The Prevalence of Ritual*—the concept and the body of work—the centerpiece of a communal and mythic interpretation of Bearden's art. Instead, Mercer approaches the Projections through the dialogical imagination of the Russian literary theorist Mikhail Bakhtin. While Bakhtin deals primarily with linguistic material (language) in this work, Mercer believes that his views are relevant to the study of the visual image as well. Bakhtin insists that language (as a medium of communication) is never a monolithic or monological thing. Instead language happens "dialogically—one point of view opposed to another, one evaluation opposed to another, one accent opposed to another."[60] There are always many languages in circulation, and meaning is always up for grabs and being put into play in a dialogical process of negotiations, interpretations, and appropriations by different speakers with different intentions and agendas.

From this perspective, one might say that Bearden's photomontages are dialogical because they show how images are always in circulation and being recycled, how their meanings are being negotiated and appropriated by different users and receivers. Mercer argues that it is the *cut* of photomontage that marks the dialogical nature of visual images. It signals the space or the opening that allows for dialogue and for dialectical response. Moreover, Bearden's use of the cut inscribes a diasporic aesthetic. "I suggest that Bearden's dynamic fragmentation of pictorial space inscribes the creative presence of the 'cut,' which James Snead identified as a distinctive feature of

diaspora aesthetics."[61] Unlike the monological and rooted national subject, the diasporic subject is constantly dealing with and negotiating images from many registers (African, Christian, American, etc.), and each register is brought into dialogue with one other. All in all, Mercer's objective in analyzing Bearden's photomontages is "to underline the cut or the paper tear as both a stylistic signature and a mark of critical discrepancy between different regimes of representation."[62]

Mercer also argues (in agreement with Ralph Ellison) that Bearden's major achievements were to find a way to deal with the representation of race—what is referred to as the black artist's "burden of representation"—and, simultaneously, to establish himself in the mainstream of modernist aesthetics that resists realistic modes of depiction and representation. In other words, Bearden found a middle way to maintain a documentary link to issues of race and representation that had been left out of the dominant discourse and at the same time a way to have enough artistic freedom so as not to be confined or pinned down by the representational politics of identity or community. Bearden found this liberating solution in the montage principle. Mercer suggests that "the answer Bearden discovered in the montage principle was a dialogic mode of double voicing which would loosen and undo the double-binds of 'race' and representation that had created the impasse of the 'Negro artist's dilemma.'"[63]

For Mercer, the dialectical cut becomes the methodological means to understand the diasporic and double-voiced articulation of the Projection photomontages. But what is not addressed in Mercer's reading is this presupposition: Why is the cut bound necessarily to the logic of the dialectic? Moreover, what are the consequences of framing the cut in this way? It is my contention that this dialectical mode operates in terms of a restricted economy (or, to repeat Mercer's own phrasing, a "controlled negativity") that contains the rupturing force of the interruption of myth and community that is opened up by Bearden's photomontages. This becomes apparent at a certain juncture in Mercer's argument where dialectics fails but the failure is not recognized. In further analyzing the cut, Mercer makes a theoretical move that undercuts his argument when he invokes the Derridean mark of "*différance*"—with its differencing and deferring *a*—as an appropriate tool for the cultural analysis of black diasporic subjectivity and for the breaking of the boundaries between what is properly or exclusively "African" and "American." "If it is by virtue of such cultural deferral or differ*a*nce . . . then I suggest that what Bearden's Photomontage Projections did, in their double-voiced dialogue between the compositional elements of line, plane and color in post-Cubist pictorial space and the heterogeneous cuts and folds of diaspora subjectivity, was to issue a 'coupre' or break to the boundary that once separated African and American as if they were mutually exclusive identities."[64]

While there is no objection to the critique of racial exclusivity, Mercer cannot invoke cultural deferral or *différance* and at the same time declare that he "seeks to restore the controlled negativity of the dialectical 'cut' to the Photomontage Projections." This gesture seeks to elide what might be viewed as an undialectizable difference. Taking my cue from Jacques Derrida's study of Georges Bataille, "From a

Restricted to a General Economy: A Hegelianism without Reserve," I argue that Mercer's framing of Bearden as a dialogical and dialectical master of the cut operates within a restricted Hegelian economy and one that is not in keeping with the general economy unleashed by the cut and its play of *différance*. As Derrida reminds us, the blind spot of Hegelianism and of all systems of controlled negativity is their inability to account for anything that "can no longer be determined as negativity in a process or a system." To quote this passage at greater length: "The blind spot of Hegelianism, around which can be organized the representation of meaning, is the point at which destruction, suppression, death and sacrifice constitute so irreversible an expenditure, so radical a negativity—here we would have to say an expenditure and a negativity without reserve—that they can no longer be determined as negativity in a process or a system."[65] This radical negativity, this negativity without reserve, is very different from Snead's dialectical idea cited by Mercer: that the cut is emblematic of African-American cultural experience because it "mak[es] room for [accident and rupture] inside the system itself."[66]

If one were to choose one of the Projections as a case study illustrating the community in fragments and the interruption of myth that permeates Bearden's photomontage practice and cannot be subjected to dialectics and the controlled negativity of the dialectical cut, then it would be *Sermons: The Walls of Jericho* (1964) (see Plate 6). Here, Bearden has chosen to restage a myth that is aligned with other biblical stories such as the Tower of Babel or the breaking of the first tablets of the Ten Commandments. All of these stories make interruption and the fragmentation of meaning their central point of focus in a confrontation with limits. To recall the Old Testament story, Joshua was instructed by the Lord to march seven times around the walls of the city of Jericho. After making these circuits, the shouting and trumpeting of the Israelites were enough to knock down the walls of the ancient city. This story is celebrated in the old Negro spiritual that sings of this miraculous victory of the Israelites in the title and the refrain: "Joshua fought the battle of Jericho and the walls came tumbling down."[67] In Bearden's visual rendition, the fractured pictorial space is littered with fragments of masks, statuary, body parts, weapons, and architectural columns so that we appear to be looking at the ruins of some ancient battlefield. As Mary Schmidt Campbell views it, "*Walls of Jericho* shows the destruction of African, Egyptian, and Greco-Roman structures with bits and pieces of masks, statuary, and architecture erupting over the surface."[68] Erupting all over the place, the photomontage cuts that are inscribed and recounted in Bearden's *Walls of Jericho* cannot be accounted for as inside the system itself. Rather, the cuts inscribe the interruption of myth and community by means of the forces of a radical negativity (the violence of war, death and destruction) that cannot be sublated. As Nancy writes of the losses of war, "Millions of deaths of course, are justified by the revolt of those who die: they are justified as a rejoinder to the intolerable, as insurrections against social, political, technical, military, religious oppression. But these deaths are not sublated: no dialectic, no salvation leads these deaths to any other immanence than that of . . . death

(cessation, or decomposition) which forms only the parody or reverse of imma-nence."[69] In this way, Bearden's *Walls of Jericho* marks the nonlocatable locus of defer-ral and of *différance* upon which the system of meaning depends and around which the concept of community circulates.

Acknowledging the limits of the dialectical cut, or, in Mercer's words, "the dialogic role of the cut in Bearden's dialectical photomontage,"[70] as the operative means by which to understand the photomontage Projections, Nancy's *Inoperative Community* and Derrida's "From a Restricted to a General Economy" intervene by pointing to death, finitude, and sacrifice (perhaps to be viewed as the ritual that interrupts myth) as the experience of limits through which community is "comprehended" and through which it is tied inexorably to incompleteness, excess, and a negativity without reserve. This is what is marked in the cuts of Bearden's collages and photomontages as they offer a community in fragments, a sharing and splitting of being-in-common. In Bearden's community-exposed collages and photomontages of the midsixties, cut-and-paste beings (call them Africans, Americans, African-Americans, or whomever) are exposed to *and* separate from one another. Contrary to Mercer's dialectical impulse, Bearden's collages and photomontages do not just inscribe synthesizing and dialogic cuts that break the boundaries of mutually exclusive identities. After all, this could lead the analysis of community back into the snares of communal fusion and mythic space. Instead, the community in fragments that (in)operates as an effect of Bearden's general economy involves the recognition that any move toward community both shares *and* divides as beings touch the limit in the experience of finitude on whatever boundary. The distinction between Bakhtinian dialogical dialectics and Derridean *différance* cannot be reconciled so easily when engaging with the split subjectivities of African-American diaspora and the image fragments appropriated by the Dadaist-inflected photomontage techniques at the heart of Romare Bearden's Projections. The dialectical cut gives way to the experience of finitude in a vision of community and myth articulated in the interruption, and even out of the interruption itself. In the next chapter, this difference will be explored further in the theatrical photographs of Frédéric Brenner's project *jews/america/a representation* and in their move from the dialectical figure of the hyphen to the slash as the interruptive marker of diaspora and *différance*.

6. SLASHING TOWARD DIASPORA

ON FRÉDÉRIC BRENNER'S *jews/america/a representation*

> The words exodus, exile—as well as those heard by Abraham, "Leave your country, your kinsmen, your father's house"—bear a meaning that is not negative. If one must set out on the road and wander, is it because, being excluded from the truth, we are condemned to the exclusion that prohibits all dwelling? Or would not this errancy rather signify a new relation with "truth"? Doesn't this nomadic movement (wherein is inscribed the idea of division and separation) affirm itself not as the eternal privation of a sojourn, but rather as an authentic manner of residing, of a residence that does not bind us to the determination of place or to settling close to a reality forever and already founded, sure, and permanent?
>
> —MAURICE BLANCHOT, "Being-Jewish," in *The Infinite Conversation*

RAISING THE STAKES OF DIASPORA

The placing of diaspora on the map of visual cultural studies is witnessed in a publication such as Nick Mirzoeff's collection, *Diaspora and Visual Culture: Representing Africans and Jews.*[1] This innovative comparative project seeks to articulate the nature of "diasporic identity" and to define its characteristics for the two so-called victim/refugee diasporas noted in its subtitle.[2] In his introduction, Mirzoeff asserts, "There is a growing sense that we now find ourselves at, to use Stuart Hall's phrase, 'the in-between of different cultures.'"[3] Mirzoeff refers here to the seminal work of cultural studies theorist Stuart Hall, "Cultural Identity and Diaspora," which is included in his volume.[4] But there is something peculiar about such a project. For if diaspora is posited as the in-between of cultures, then it would seem to evade the attempt to settle it down to any definition of self-same (cultural) identity. As Alexander García Düttmann writes in his book *Between Cultures: Tensions in the Struggle for Recognition:* "One cannot form another culture from the in-between; the in-between is the not-oneness of culture, as it were, its openness." And he continues somewhat later in the

131

same chapter: "The belonging of that which moves in an in-between is as uncertain as the belonging of the in-between itself."[5]

In taking up the work of Frédéric Brenner, I am drawn to a photographer who is acutely aware of the uncertainties of Jewish diasporic belonging and whose images of Jewish communities demonstrate an openness to that which moves in between. It is via the figure of the slash that Brenner articulates the not-oneness of Jewish diasporic culture—and marks what is absented or interdicted from its visual field of representation. For the past twenty-five years, this Parisian Jewish photographer has taken his camera to over forty countries to record the Jewish diaspora in the international project "A Chronicle of Exile." This photographic itinerary has culminated in a large retrospective exhibition on an international tour and the publication of a two-volume set, *Diaspora: Homelands in Exile.*[6] Born in 1959 and educated as a social anthropologist, Brenner has moved from the ethnographic and documentary artifact in his earlier work to focus on the theatrical spectacle and constructed art object over the years.[7] This latter direction is most pronounced in his spectacular book full of slashing wit and titling: *jews/america/a representation.*[8] In his positing of "america" as the United States alone, one might want to accuse Brenner of engaging in a hegemonic gesture. But Brenner inscribes both "america" and "jews" in the lower case on the spine and the cover of his book as symptomatic of their slashed representation. Instead of receiving entitlements, both terms have been "decapitalized" and refused the status of proper nouns. As common nouns, they have been exiled or banished from the realm of the capital. So, while on first impression, one is tempted to accuse Brenner of a colonizing insensitivity by equating "america" with the geoterritorial confines of the United States, on further consideration one sees that this gesture is neutralized with the suspect term's loss of its heading. Brenner's book is divided into three sections of images that each partake of a traditional photographic genre: the communities (or group portraits), the icons (or celebrity portraits that play with their framing quite self-consciously), and, finally, the inventories (or a visual anthropology of the artifacts of contemporary Jewish American life). This chapter focuses on Brenner's diverse and divergent stagings of Jewish/American communities in order to elucidate the impulse toward diaspora and the nomadic movement that propels these images.

Brenner's photographic vision of contemporary Jewish communal life in the United States has left itself open to the charge that while it may be a representation, it is not representative. The photographer has responded this way: "My book is a map, it's not the territory. It doesn't pretend to be exhaustive. Not everybody is represented, but what is represented is, I believe, what is at stake."[9] This statement means that Brenner is interested only in staging and shooting what is at stake—what is at issue or what is in contention regarding who is to be included and excluded as Jews in America. In other words, Brenner focuses on what raises the question of community so that his work involves an interrogation of the limits and possibilities of "being Jewish" in the United States in the 1990s. A group image such as "Jewish Lesbian Daughters of Holocaust Survivors and Their Mothers" (1994) can serve as an exemplar.[10]

Such an image evokes the Holocaust as the unprecedented historical threat to Jewish community in the twentieth century in addition to illustrating a nonnormative response of a being-in-common to surviving it. Thus, Brenner's is not one of those self-congratulatory and comforting coffee table books produced only to reaffirm and strengthen Jewish diasporic identity in its integrity, normativity, and self-congruence. Instead, Brenner's camera is fascinated by emergent, radical, and liminal forms on the borders of being and becoming Jewish. The book *jews/america* is not a stakeout, not the staking out of a fixed and stable Jewish subject position. To the contrary, each of these fraying images—these slashed representations—is an inquiry that raises the stakes of Jewish belonging by recognizing the cuts that mark the decisions and divisions made in the name of Jewish/American community/ies.

"Faculty, Students, Rabbis, and Cantors" (1994) (Figure 6.1) locates the challenge of feminism to traditional patriarchal Jewish orthodoxy as these holy women at the Jewish Theological Seminary of America in New York City don the customary symbols of Jewish religious ritual (the tefillin, tallit, and kippah) and as they number the ten worshippers necessary to constitute a minyan (or religious congregation). Brenner foregrounds the political stakes of the inclusion/exclusion of women in Jewish ritual observance and religious leadership and their struggle for recognition. In this slashed representation, there is both a sublation (from the perspective of the feminists) and a transgression (from the perspective of the orthodox) of the interdiction. On the one hand, Brenner poses the question of inequality and hierarchy for the patriarchs. On the other hand, he asks the feminists why the religious theater of Jewish patriarchy is mimed in staking out a claim to Jewish observance.[11] In this manner, *jews/america/a representation* is a book that is not afraid to run risks at every turn of its spiral-bound pages as it disperses this contentious message: what represents community also risks and challenges community. Through the maxim "what is represented is what is at stake," the book offers a variety of performances of identity that expose these communities in Jewish/American diaspora to the necessary violence that brings them into being and simultaneously risks their being.

FIGURE 6.1. Frédéric Brenner, "Faculty, Students, Rabbis, and Cantors," Jewish Theological Seminary of America, New York City, 1994. Copyright Frédéric Brenner. Courtesy of the Howard Greenberg Gallery, New York.

In addition, Brenner's representations are highly loaded and contrived images that are full of symbolic and iconic impact and require unpacking on the part of their viewer-interpreters. In my interview with the photographer, Brenner speaks of his desire "to find the subjects which crystallize as many issues as possible in a very compressed way . . . to succeed in getting to the most elliptical expression."[12] In a review of Brenner's photography, the sociologist Egon Mayer also supports this reading: "For lack of a better term one might say that each photograph is an exercise in symbolic compression."[13] In privileging symbolic compression and ellipsis as his preferred modes of producing—and withholding—photographic meaning, Brenner has seized upon a rather diasporic mode of representation. For what is ellipsis if not a device of deferral that relies on the displacement of something that has been cut out of the picture or something that is implicit and connotative rather than explicit and denotative in its meaning? Functioning as a diasporic figure that provokes errancy and evades the fixity of truth and certainty, Brenner's deployment of photographic ellipsis signals the exegetical demand invoked by his images. Symbolic compression and ellipsis insist on the need for interpretation and simultaneously resist and evade the closure of meaning. In a sense, Brenner's photographs offer parallels with Sigmund Freud's techniques in regard to the psychoanalyst's claim that both dreams and jokes must be understood according to the logic of condensation and displacement whose meaning resides in the unraveling of the unconscious mind.[14] This linkage helps in the explication of Brenner's image "The New York Psychoanalytical Society," in which he pays homage to the Freudian followers of the so-called Jewish science that was founded in part to assist Jews in diaspora and to help them cope with the assimilatory neuroses of their emancipation in Western cultures. In marking the unconscious as the dislocating source and site of ellipsis, Brenner's image leaves empty the distended psychoanalytic couch that occupies the right side of the frame.

SLASHING BORDERS

In situating Brenner's book in terms of the slashing of Jewish/American diasporic identity, I am directly opposing it to the fusional model of the hyphenated American citizen characterized by the myth of the melting pot or even the later model of cultural pluralism that stressed the separation of the private religious worshipper with the public citizen.[15] Both models refuse to acknowledge that hyphenation splits the subject that it seeks to unite and that to encounter the hyphen is already to be exposed to a being-not-one. In this way, the dream of unity that guided the hyphenated Jewish-American yields to the diasporic production of "slashed subjects" in the gap of the in-between and in the era of multiculturalism. (My reading here parallels the insistence on moving from the dialectical cut to the interruption of myth in regard to Bearden's Projections in the previous chapter.) It is at this critical juncture that Brenner's photographs of *jews/america* intervene. In the same way that Jean-Luc Nancy's study "Cut Throat Sun" addresses Chicano/American identity through the

notion that "your identity is obtained through cuts,"[16] Brenner's photographs expose how Jewish/American identity (as a being-not-one) is fashioned through a series of slashes—slashing toward diaspora. Brenner turns to the thinking of Franz Kafka to make a point that troubles self-same identity and the fallacy of a common being. "One of the excerpts of my book is this sentence from Kafka in his diary where he says, 'What do I have in common with the Jews? I have so little in common with myself.' And the very idea of discontinuity is at the heart of my project. I would say that the three key words are paradox, ambivalence, and discontinuity. And to say that this very discontinuity starts within ourselves."[17] It is important to point out that Brenner's divisive Kafkaesque assumption of discontinuity ran directly counter to the express ideology of Jewish community organizations in the 1990s and their genealogical project, referred to as "Jewish continuity."[18]

As a photographic project that exposes Jewish diasporic community to its "foundation in the cutting,"[19] Brenner's is far removed from Roman Vishniac's legendary photography of pre-Holocaust Jewish life in central and eastern Europe in the 1930s. Vishniac's salvage photo-ethnological project was designed to capture the "spiritual essence" of the ultraorthodox and their esoteric traditions.[20] It was about establishing Jewish religious icons and the patriarchal Hasidic community as the authoritative and authentic representatives of being Jewish. This tightly knit group used religious practice and Torah study to maintain tradition and to secure rigid borderlines between Jew and other. Vishniac founds Jewish community by drawing a circle around these subjects via the image of their faith.[21] His work upholds tradition by insulating and protecting his subjects in images that are all the more poignant because of the utter destruction of this community in Poland by the Nazis just a few years later. If the outside appears in Vishniac's photography, it is always as a threat to Jewish identity and to the sanctity of Jewish communal living. Brenner reacts vehemently to this photographic father figure as follows: "Don't get me started on Roman Vishniac. I definitely say, more and more every day that my work is totally opposite. I would say that if there is one thing that I would like to achieve, it is first and foremost to break an emblematic representation of the Jew."[22] If Vishniac's representation of patriarchal Jewish orthodoxy was to secure the center, then Brenner seeks the margins and the peripheries in his attempt to confound our ability to know exactly what it means to be or to look Jewish. Simon Schama's introduction to *jews/america* rightly observes that "it is the impurity of Jewish life, the ragged edge that frays into the surrounding culture," that attracts Brenner's attention as he makes his visual reports from the "ambiguous, shifting border between the Jewish and Gentile worlds."[23] This acknowledgment of ragged borders as well as a sense of group permeability leads to Brenner's celebration of contemporary Jewish communities on the periphery and emergent forms in images that slash an emblematic representation and test the limits of Jewish being-in-common.

Brenner confounds the codes and slashes the stereotypes in the hilarious and ironic image "Jews with Hogs" (1994) (Figure 6.2). The comedy begins with the playful pun of its title. Here, the nonkosher or tabooed animals of Jewish dietary laws turn

out to be the Harley-Davidson motorcycles that are affectionately nicknamed "hogs." This image illustrates an instance of Jewish diasporic community via a synagogue motorcycle club in Miami Beach, Florida. In thinking about this image, Jacques Derrida reflects on the dangers of communal fusion that are exemplified by the Jews with hogs and the militaristic overtones of such a community formation. He positions the motorcycle gang as a mobile army and draws out the metonymic associations of such a group for Jewish religious community in general. "Their community,

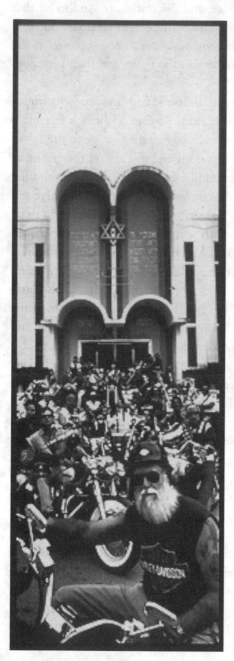

FIGURE 6.2. Frédéric Brenner, "Jews with Hogs," Miami Beach, Florida, 1994. Copyright Frédéric Brenner. Courtesy of the Howard Greenberg Gallery, New York.

their very gregariousness, their obvious communitarianism sends chills down my spine. Even in front of a synagogue, especially in front of a synagogue. They *go together,* they are in step; what is more, that is what the Greek word *synagogue* means. They are a mechanized synagogue."[24] Nevertheless, the motorcycle gang as mechanized synagogue stages a marvelous metonym for the mobile membership that adheres to the becomings of Jewish diaspora. The image depicts the members in front of their synagogue as the vertical composition mimics the form of the Ten Commandments. The protective Shield of David hangs over these gang members, who are the devotees of their Davidsons. The Harley helmet of the leader of the pack (whose tattoos would be a scandal for any orthodox Jew) takes on new resonances in juxtaposition to the tablets, and it ironically recalls the orthodox Jewish requirement to wear a head covering as a sign of respect before God. All in all, "Jews with Hogs" is an elliptical and oxymoronic image of a Jewish motorcycle pack, an image that demands to be "unpacked" and expresses Brenner's desire to confound the stereotypes of the Jewish Talmudic scholar with those of the easy rider.[25]

Brenner's ironic account of Jews in the United States illustrates that the fraying of borders and the exposure of the other (within) also applies to those traditional communities who are thought to be impermeable to change or free from any postmodern contamination. While there is a photograph of a legendary Hasidic leader in Brenner's book, the Lubavitch rabbi (the late Menachem Mendel Schneersohn) is presented in terms of a technological spectacle. Brenner is drawn even here to the ragged edge that frays into the surrounding culture—in exposing the paradoxical negotiation of ultraorthodoxy with postmodern media technologies. Any trip to the famous cut-rate computer and electronics store B & H in New York, owned and operated by a group of Hasidic Jews, testifies to this technomystical conjuncture. If there is a miracle in the *Chanukah Live* (1993) simulcast at the World Lubavitch Headquarters in Crown Heights, it does not seem to be derived from the rebbe or from the menorah (which burned for eight days in the sacred temple in the foundational Chanukah narrative). The miracle, rather, seems to lie in the satellite hookup that enables this Hasidic sect to enjoy the Festival of Lights at five remote locations across the globe via teletechnologies. Brenner reveals the programming of Hasidic televangelism at the crossroads of religion and media.[26] He poses and exposes the cultish and protomessianic rebbe (for his groupies at least) as a multimedia star, beaming out in fractured form from the video screens. In this interruption of myth, Brenner's image "Chanukah Live" demonstrates how the society of the technospectacle and MTV tactics inhabit Lubavitch religious ultraorthodoxy in terms of both the medium and the message and how this produces ambivalent subjects in spite of any rhetoric of religious purity.[27]

Ragged edges and slashed borders also guide another of Brenner's photos of Chanukah in which no Jews are represented at all: "Citizens Protesting Anti-Semitic Acts," in Billings, Montana (1994) (Figure 6.3). This image also appears as the book cover for the volume entitled *Insider/Outsider: American Jews and Multiculturalism,*[28]

a book marked by the slash in its very title to indicate how Jews are sometimes included and sometimes excluded when it comes to the debates around multiculturalism. The cover not only demonstrates the currency of Brenner's images for any discussion of the politics of recognition; it also exposes how the slash is to be figured at the center of these debates. In a typical Brenneresque panoramic lineup, we witness a group of multicultural Americans who are caught in the act of "becoming Jewish" as they wield their electric menorahs as weapons in a show of solidarity against the anti-Semitic vandals who sent a brick through the window of the home of a Jewish family in Billings, Montana, in December 1993. And yet they make this statement in the costumes of their own tribal or religious affiliations, whether in Native American headdress or clerical robe. In this protest that cross-dresses and performs in solidarity with Jewishness, the invocation of freedom of religion as a universal human right is doubly mediated. It is invoked both in terms of everyone's own cultural particularity and in terms of identification with the Jew as the exemplar of an oppressed minority. But this is not the only act of "identification" along the shifting borders of identity portrayed in this image. As viewers of this reenactment, we assume the subject position of the Jewish family whose house has been vandalized but now lacks the symbol that would mark this vantage point as Jewish. In this interplay of identification and its other, Brenner utilizes the slashed window, the slashes of the road, and the slash enacted by the guardarm for the train crossing (which symbolically slashes the American flag) to mark a destabilizing image that opens up identification and communication with American Jews (i.e., philo-Semitism) at the very moment that it acknowledges what cuts off this attempt and threatens its existence (anti-Semitism). Jacques Derrida comments on this crossed-up and slashing image as follows: "There is only traversal, passage across frontiers, there are only crossings without a crossing of populations at this railway crossing."[29]

Derrida also sees this protest image in terms of bearing witness to an act of intolerance. The image foregrounds the importance of the witness at the heart of Jewish diaspora as well as its extension—what Derrida calls the "making worldwide of

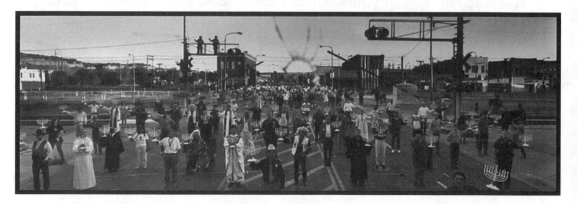

FIGURE 6.3. Frédéric Brenner, "Citizens Protesting Anti-Semitic Acts," Billings, Montana, 1994. Copyright Frédéric Brenner. Courtesy of the Howard Greenberg Gallery, New York.

witnessing" and its "globalization."[30] This interpretation of "Citizens" bears comparison with the universal humanism of the Family of Man exhibition in that the latter was formulated specifically as a response to anti-Semitism in regard to both a particular incident in Edward Steichen's personal biography and Holocaust history in general. From the idealist perspective, the Family of Man bore witness to "man's inhumanity to man" and to the renewed hope and promise of the global unity of mankind in the face of any potential or divisive differences of race, creed, and religion. Nevertheless, Steichen's photographic assimilation of differences in the Family of Man exhibition is very different from the more recent politics of multiculturalism and its strong assertion of cultural differences and particular rights of relative value that conflict and contend with one other without a universal arbiter of value. Indeed, one can even question whether the Enlightenment term *citizen,* given that it operates in a universal field, is applicable to multiculturalism and to the politics of recognition that insists on particular rights. (After all, this hate crime was provoked by the assertion of a group akin to the Aryan Nation.) Therefore, what is at stake in Brenner's "Citizens" is whether the slashes of multiculturalism can be smoothed over and made compatible with the Enlightenment project of civil society and the universal rights of man.

If "Citizens Protesting Anti-Semitic Acts" demonstrates rallying around the Jews under the threat of persecution, then Brenner's "Nice Jewish Boys" (1994) illustrates the opposite risk in its potential scapegoating of the Jew as the capitalist exploiter of the labor of other minority groups (Figure 6.4). This image also represents Jews primarily in their absence, and this absence or invisibility might be read as an index of power. "Nice Jewish Boys" exposes some volatile multicultural issues, in particular, the conflicts and alliances that have existed between Jews and African-Americans since the Civil Rights movement.[31] This image is a group portrait of the Nice Jewish Boy Moving and Storage Company in Palm Beach, Florida. But there is a gap between the text and the image, for the workforce consists of people who might be classified as either black or Hispanic. At first glance, this image conveys the negative stereotype of the Jewish capitalist, the pejorative "Hymie image" that is not so nice. In other words,

FIGURE 6.4. Frédéric Brenner, "Nice Jewish Boys," Palm Beach, Florida, 1994. Copyright Frédéric Brenner. Courtesy of the Howard Greenberg Gallery, New York.

the image risks being appropriated as a representation of the Jew as the evil capitalist of anti-Semitic paranoid fantasies. However, as Brenner relates the untold story, the irony turns out to be that this company was started by an Israeli who became a Jew-for-Jesus and, moreover, that the current owner is not even Jewish.[32] The juxtaposition of the company title with the people of color in the workforce exposes another risk—namely, the Jews' becoming insiders and passing for white in America and how this practice of assimilation and upward mobility has meant that they may no longer identify with the oppressed.[33] In other words, in their acquisition of power, the Jews have become invisible—as white as the grand piano at which one of the black movers is seated in this image. From this perspective, "Nice Jewish Boys" thinks about the possible political and economic consequences of the Jews' "whitening" in light of the multicultural paradigm and its investment and affirmation in the markers of race, ethnicity, and subaltern status.

Much is provocative in an image in which African-Americans are identified with and represented under the symbol of "Nice Jewish Boy." Yet, this image of the moving company also addresses the issue of diaspora in general—the common trajectory of the becoming-exile of home that is shared by these divided subjects whether they are African/American, Latino/American, or Jewish/American. They all partake of what Jean-Luc Nancy calls "the togetherness of otherness." To cite Nancy: "All the selves are related through their otherness, which means that they are not 'related'; in any case, not in any determinable sense of relationship. They are together, but togetherness is otherness."[34]

In recent years, there has been a growing tendency for black cultural scholars to compare transnational African migrations with Jewish diaspora and to acknowledge the appropriation of this term from Jewish sources. In *The Black Atlantic,* Paul Gilroy speaks of "the Diaspora concept which was imported into Pan-African politics and black history from unacknowledged Jewish sources" and how Jewish thinkers "have been a rich resource for me in thinking about the problems of identity and difference in the black Atlantic Diaspora."[35] From this perspective, Brenner's loaded image might be viewed as an exploration of the limits and possibilities of something like comparative diaspora studies,[36] the "Diaspora concept," and the relations/nonrelations of all these selves related through their otherness.[37]

DIASPORA'S SLASH

Brenner's photographs have been framed repeatedly as the documentation of Jewish diaspora. However, this framing can interpret his account as too exclusively territorializing of belonging in between and of portable identity. Robin Cembalest's review in *Forward* is headlined this way: "Documenting the Diaspora with a Cast of Thousands: Brenner's Unconventional Portrait of American Jewry."[38] But this headline overlooks how the theatrical cast of Brenner's photographic constructions raises certain risks for diaspora's actual documentation. Meanwhile, the photo historian and

critic Vicki Goldberg frames the book in conventional narrative terms as "The American Chapter of the Jewish Saga." Losing track of the displacements of diaspora and of the photographic medium itself, she comments that "Brenner has tracked the Jewish Diaspora."[39] Even Brenner himself is not immune from this tendency, and he once referred to his project in a way that does not decenter diasporic representation and that asserts a totalizing comprehensiveness: "After a few years, I realized that I was piecing together the puzzle of the Jewish Diaspora."[40]

All of these accounts run the risk of forgetting how diaspora necessarily risks its own re-presentation and representation. In *Difference and Repetition,* the nomadic thinker Gilles Deleuze argues that representation is linked to an economy that would exclude difference. "Difference is not and cannot be thought in itself, so long as it is subject to the requirements of representation."[41] Deleuze goes on to sketch another economy that deploys repetition as its antidote. Utilizing such strategies as simulation and redoubling, this economy thinks about the dispersing rather than the representation of identity. Repetition exposes what Deleuze calls the *dispars,* the disparate. In etymological terms, this offers variations of slashing toward diaspora. "The ultimate element of repetition is the disparate (*dispars*) which stands opposed to the identity of representation. Crowned anarchies are substituted for the hierarchies of representations, nomadic distributions for the sedentary distributions of representation."[42] Keeping Deleuze's analysis in mind, we might find it possible to activate other dimensions in Brenner's slashing and risking of representation in *jews/america.* His photo-theatrical stagecraft substitutes the nomadic distributions of diaspora (such as actions of the Jewish fur trader Perry Green, who transits among the Inuit in Alaska) for the sedentary distributions of fixed representation. Meanwhile, his odd sociological permutations and combinations of Jewish/American groupings introduce anarchic possibilities (such as "Jewish Lesbian Daughters of Holocaust Survivors with Their Mothers" or "Jewish Mothers Who Have Had Their First Child after Age Forty") that challenge the hierarchies of conventional representation.

Thus, it is important to resist the temptation of territorializing appropriations of diaspora when examining Brenner's work and to recall the elliptical figures and symbols of diaspora that are on display or lurking in the background of *jews/america.* These are the stage props of mobility that register the nomadic distributions that are part and parcel of the "wandering Jew" and that make up the diasporic decor of Brenner's photo performances. For example, sails serve as backdrop for the portrait of the Goldman family of San Francisco, the descendants of Levi Strauss—the jeans manufacturer, not the structuralist anthropologist—recalling their mythical ancestor's voyage to the land of opportunity (or, as they say in Yiddish, the *goldeneh medinah*). On the other side of the continent, a flying carpet prop appears in the portrait of an upwardly mobile family residing in Montclair, New Jersey ("Aryeh Family," 1995). The family members are all smiles as they sit on their Arabian Nights conveyance that has transported them from their Sephardic Jewish roots in Iran to the assimilating suburbs of New Jersey.

The book also includes photographs of Jewish American diasporic communities that are self-consciously shot in the sand, recalling the biblical wanderings of the Jews in Sinai and elsewhere. For example, Brenner travels to the beach at Coney Island to shoot a caravan of Jewish taxi drivers who have emigrated from the former Soviet Union and are still on the move in their new homeland ("Taxi Drivers," 1994). In strapping the cabbies to the top of their conveyance, Brenner transposes the nomadic desert wandering of the ancient Hebrews on their camels to the carnival backdrop of this New York metropolitan beach and amusement park. He shows his meticulous attention for formal design as the taxis slash toward the ocean and then back again, outlining a pyramidal figure that recalls the wanderings of the Jews in the desert during their exodus from Egypt. Or Brenner exposes what is at stake in the desert room of the Brooklyn Botanic Garden greenhouse. Here, he has gathered gay and lesbian families who claim the right to hold Jewish family values and homosexual identities ("Gay and Lesbian Families," 1994). This image is a typical Brenner defiance of stereotype and another example of how his work raises the question of community. He underscores what is at stake for heterosexists in this attempt to reconfigure the Jewish family that has functioned as the core institution of diasporic continuity.

It is important to recall that Brenner's images portray Jewish/American diaspora in terms of the becoming-home of exile *and* the becoming-exile of home in a single stroke. For while these images always have a territorializing tendency to make diaspora feel "homey" (or, in Yiddish, *haymish*), they also recall that being-in-diaspora is never to be thought of as the reification of presence (not even the "here of elsewhere"). Diaspora slashes representation in its acknowledgment of dispersal and the breakdown of any unified field of peoplehood or of people in their proper places. In this way, Brenner's images recall Kafka's particularly Jewish diasporic dilemma reviewed by Maurice Blanchot in *The Space of Literature:* "The wanderer has the desert for a destination, and it is his approach to the desert which is now the true Promised Land. And in this land of error, one is never 'here,' but always 'far from here.'"[43] No matter how comfortable Jews may appear to be in America, this errant quotation lurks in the unconscious of the images in *jews/america*. The photographic spaces in Brenner's theatrical tableaux function in much the same way as Blanchot's and Kafka's literary spaces in their symbolic figuration of mediation, displacement, and errancy.

In staging these photographic gestures toward diaspora, Brenner is guided by the biblical injunction *Lekh Lecah*. At the beginning of chapter 12 of Genesis, the Lord said unto Abram: "Get thee out of thy country, and from thy kindred, and from thy father's house, unto a land that I will show thee." If there is a "foundational narrative" for the photography of Frédéric Brenner, it resides in this passage about the loss of foundations and the ongoing and contemporary relevance of that loss for modern and postmodern Jewish experience. Brenner echoes Blanchot's epigraph as follows:

And what is more modern than *Lekh Lecah?* Have you ever seen a people that is being asked to go, and without being told where to go, and the people go there? This

is so modern. Who can ever say that he left the house of his father? And I believe that historical circumstances have enabled the Jewish people to enact this injunction of God to Abram. And from this point of view, I never considered Diaspora as a curse, but truly a vocation, as a project. This is at the heart of what I do.[44]

In his resistance to the total Zionist fantasy of home and in his abiding in the promise, Brenner keeps to this same injunction in his photographs of Jews who have immigrated to the state of Israel as well. In this context, one recalls both the title and subject of this 1998 publication project as *Exile at Home* (Galut Bayit).[45] The figures of sail and flying carpet, of desert and sand are the markers of what moves or scatters the imaging of Jewish diaspora elsewhere and otherwise. Like Kafka's characters, Brenner's images stage this paradoxical "truth of exile." To return to Blanchot: "What he has to win is his own loss, the truth of exile and the way back to the very heart of dispersion."[46] For Brenner, the slash (as the marker of diaspora) registers the way back to the very heart of dispersion, or it is what marks the divided origin for this winning/losing proposition that is dubbed diaspora. Four ironic photographs in *jews/america* foreground the figure of the slash in their staging, and I would like to analyze them in terms of the diasporic questions that they invoke and provoke.

"Minyan of the Stars, Sukkah in the Sky" (1994) takes us to the roof of a New York apartment where a star-studded penthouse party appears to be already in progress (Figure 6.5). In this highly staged performance, the penguin suits and evening gowns make the sacred symbols seem more like theatrical props, and one has the feeling that the event might have more to do with glamour and smiling for the camera than with strict religious observance. Here the protective wall around the rooftop and the chorus line of Broadway notables can be read in terms of the slash. The wall leads the eye directly to the Empire State Building, which dominates the left-hand side of the image. It is juxtaposed with the Sukkah—the temporary dwelling constructed for the Jewish holiday Sukkot. This structure recalls the fall harvest festival during which the Jews are commanded to live in huts. In the middle of the frame, we see the Broadway stars who smile and hold aloft the symbols of the holiday. The imperial and statist symbol of the United States in all its phallic glory is juxtaposed with the symbol of the nomadic and of Jewish diaspora—the temporary dwelling of the Sukkah. What is at stake in this juxtaposition of structures and symbols? The risk is that the investment in the showy, self-satisfied materialism and the imperialist dynastics of American belonging will override the diasporic subjectivity of the wandering Jew. In this depiction of the becoming-home of Jewish American exile, Brenner's photograph speculates how this assimilation process risks the loss of slashing toward diaspora. But, for now, this Sukkah supplement still remains as architectural para-site perched on top of its hospitable host.

Brenner's photograph "Spiritual Gathering" (1994), of Navajos and Jews in Monument Valley, Arizona, brings together two spiritual traditions and imperiled ethnic groups who have had to deal with mass genocide in the West (Figure 6.6). This

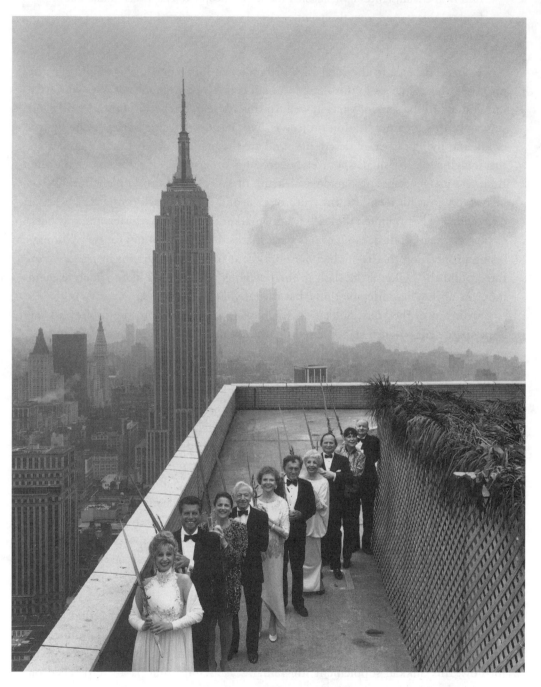

FIGURE 6.5. Frédéric Brenner, "Minyan of the Stars, Sukkah in the Sky," New York City, 1994. Copyright Frédéric Brenner. Courtesy of the Howard Greenberg Gallery, New York.

encounter also can serve as a symbol of so-called new age Judaism. In recent years, the Jewish renewal movement has looked to other mystical traditions to infuse new life into moribund modern orthodox convention. In this image, Brenner uses the rearview mirror of the automobile to produce a haunting reflection. In his meticulously symmetrical staging, the dividing line of the highway performs a photographic trick. The prayer shawls of the Jews bounce off the ceremonial garb of the Navajos. The slash marks two clans in the desert, separated yet sharing the same space in a reversible play of mirror reflections.[47] The viewer witnesses the moment of decision for the founding of spiritual community on both sides of the road. Similarly, Brenner illustrates how such a foundational gesture is risked by exposing it to its mirror image, to the presence of the other functioning as a blind spot for the constitution of self-same identity. In this elegant play of reflections, Brenner's "Spiritual Gathering" can be viewed in terms of both a splitting and a sharing—a mutual interpenetration of two tribes that exposes how identity is constituted and risked through the other.

Meanwhile, "The Hebrew Academy, Las Vegas" (1994) was taken at the inauguration of the Luxor Hotel in this city of simulation (Figure 6.7). Here, the slash takes the form of the sash that announces the formation of community and the name of this community formation. The Hebrew Academy sash/slash runs parallel to the right side of the group's pyramidal formation. The composition is balanced by the second pyramid, on the right. Clearly, Brenner's image parodically engages photo-colonialist photography of the Middle East in the mid-nineteenth century (e.g., the photography

FIGURE 6.6. Frédéric Brenner, "Spiritual Gathering," Monument Valley, Arizona, 1994. Copyright Frédéric Brenner. Courtesy of the Howard Greenberg Gallery, New York.

of Maxime du Camp and Francis Frith). Recalling the ancient Hebrews as slaves in Egypt who built the tombs of the pharaohs, this postmodern Hebrew Academy builds a pyramid of its own in a smaller-scale version of the living photographs and mass ornaments of Arthur Mole and Eugene Goldbeck. In this symbolic action of "becoming-pyramid," Brenner enlists the Hebrew Academy students to forge and embody the living symbol of their ancient oppression and of Jewish being-in-exile. In his elliptical manner, Brenner also makes us wonder if Las Vegas (or America in general) is itself an ersatz Egypt rather than a true Promised Land. The riddler Sphinx of Giza, who asked the question that yielded a universal humanist response, is ironically on hand to witness Brenner's questioning of Jewish community as it seeks to establish itself in the heart of this spiritual desert, renowned for its many vices. Brenner's liner notes to the image indicate the presence of a permeable border in this diasporic cut of community and its strategy of in-gathering. The academy's displaced director, Tamar Lubin (born in Mea Shearim, Jerusalem), states: "This is a community Hebrew day school, which gathers students from all walks of life; fifteen percent of the children are non-Jews."[48]

Brenner's self-consciousness of the history of Jewish photography is also apparent in his double shot of the International Jewish Arts Festival at the Suffolk County Jewish Community Center in Commack, Long Island ("International Jewish Arts Festival," 1995). One of the oldest genres in Jewish photography is the biblical image, the touristic view of sacred sites that serve as a keepsake of the Holy Land. The most popular image of this photographic genre is the Wailing Wall in Jerusalem, the holiest site of Judaism, the relic of the Second Temple, dating back to the days of Jewish sovereignty. In *jews/america,* Brenner shows us that the biblical image still lives, but now it is simulated in a carnival-like atmosphere in Long Island by means of a photo charade. In this "totally Surrealistic" image,[49] the secular father dresses up as pious Jew with black coat, hat, and prayer book. The diasporic Jewish family plays at being at home, but in their own backyard. Brenner's doubled perspective shows how photography stages and frames the illusion. Yet through all the masquerade and kitsch, an aspect of Jewish longing for belonging shines through the facade. Brenner's Jewish

FIGURE 6.7. Frédéric Brenner, "The Hebrew Academy, Las Vegas," the Luxor, Las Vegas, Nevada, 1994. Copyright Frédéric Brenner. Courtesy of the Howard Greenberg Gallery, New York.

American diasporic subjects enter into a photo-play with a pair of photographers to simulate a holy version of "home" and pay their respects to the elsewhere that inhabits their being here. It is the double framing of Jewish Community Center and Wailing Wall, of Long Island and Land of Israel, of secular and religious identification, American Jew and Zionist aspiration. The wall facade functions as a cut in the landscape that produces this elaborate series of slash marks. For what is at stake here in this simulation is nothing less than the mutually interdependent economy of Jewish diaspora and Jewish homeland.[50]

In this review of the figure of the slash in *jews/america,* it is also important to recall how the displacements of photography and its "transmission value" link it to the rhetoric of diaspora and the critique of national identity. In other words, the medium of photography itself functions as a facilitator of diaspora because of the way in which its mediated presence and its iterability (its capacity for reproduction and transmission) prompt "teletechnic dislocations." In other words, the displacements and dislocations of photography cause a disturbance in what Jacques Derrida calls *national ontopology,* or what links "the ontological value of present-being . . . to the stable and presentable determination of a locality, the *topos* of territory, [or] native soil."[51] Thus, the portable identity of modern photographic technologies, photography's "becoming-absent," and its dislocating critique of national ontopology move in synch with Brenner's Jewish diasporic project, *Homelands in Exile.*

"DIASPORIZED IDENTITY," OR SAYING OY TO THE BOYARINS

In "Diaspora: Generation and the Ground of Jewish Identity," two of the leading exponents of the new Jewish cultural studies, Jonathan and Daniel Boyarin, posit and privilege a Jewish subject formation that they call "diasporized identity."[52] What is striking about the title of this study is its one-sidedness. The Boyarins have no problem in casting diaspora as the ground of Jewish identity. But in so doing, they overlook those dispersive aspects of diaspora that would destabilize their foundational gesture. In this way, the Boyarins refuse to acknowledge diaspora as both the ground *and* limit of any possible conception of Jewish identity, and they do this in a rather prescriptive and programmatic manner. For the Boyarins, Jewish diaspora offers a critique of Zionist nationalism combined with an affirmation of cultural and religious identity. "We want to propose a privileging of Diaspora, a dissociation of ethnicities and political hegemonies as the only social structure that even begins to make possible a maintenance of cultural identity."[53] Unfortunately, this prescriptive privileging no longer holds itself open to the call of Jewish diaspora as a limit experience and an experience of limits. In this way, the Boyarins miss a more subversive and dispersive aspect of diaspora. In a chapter that takes "slashing toward diaspora" as its site of intervention, we need to review the Boyarins' diasporized identity and examine how Brenner's images might act as a foil for their speculations by means of photographs that attend to Jewish diaspora in terms that are closer to Jean-Luc Nancy's discussion

of a "community at loose ends"—a community that shares and divides its member-
ship—than to the Boyarins' dogmatic insistence of "holding on to cultural identity . . .
with a fierce tenacity."[54]

For the Boyarins, the dispersing of identity does not automatically mean dis-
pensing with identity. Instead, three distinct meanings for "diasporized identity" are
given in this study. First, we are told that diasporized identity brings different forma-
tions of identity into dynamic tension with one another because of the phenome-
non of "disaggregation." Diasporized identity signals the Jew's inability to be held to
just one register of identification—national, religious, or genealogical. To quote the
Boyarins: "In other words, diasporic identity is a disaggregated identity. Jewishness
disrupts the very categories of identity because it is not national, not genealogy, not
religious, but all of these in dialectical tension with one another."[55] Here, the Boyarins
seek refuge in dialectics as a means to escape the subversive and rupturing potential
indicated in the first part of this statement ("Jewishness disrupts the very categories
of identity"). This is a rhetorical strategy that uses dialectical tension as a means to
recoup diaspora's dispersions and the potential dissemination of the diasporized sub-
ject. For if Jewishness does disrupt the very categories of identity, then one wonders
how the Boyarins can take a concept like diasporized identity seriously.

In contrast, Brenner reframes the problem of "diasaggregated identity" in terms
of the question of split loyalties in his photograph of Jewish reenactors of the Civil
War who replay the 1864 Battle of Cedar Creek, Virginia, in the costumes of the
Union Army ("Reenactors," 1994) (Figure 6.8). Brenner focuses on this split as a rup-
ture rather than making any attempt at dialectical synthesis. In contrast to Mole and
Thomas, this consciously ironic image casts doubts and suspicions on the authenticity
of military service for Jews/Americans. "Reenactors" exposes how "Jewishness" disrupts
the very categories of national identity (what Homi Bhabha neologizes as "Dis-
semiNation"),[56] or rather how it raises the question of simulation for any staging of
nationality on the part of Jewish diasporic subjects. As in "International Jewish Arts
Festival," Brenner frames the image through a split scene of photographic reproduction.

FIGURE 6.8. Frédéric Brenner, "Reenactors," Battle of Cedar Creek, Virginia (1864), 1994. Copyright Frédéric
Brenner. Courtesy of the Howard Greenberg Gallery, New York.

Simulating the Civil War's mass production of soldiers' portraits, a reenactor assumes a patriotic stance. Brenner adds a comic touch on the right side of the frame with a popgun shooting out an American flag. Even as these Jewish soldiers perform their roles with all due respect and pledge allegiance to the flag, the symbol of American national community is represented as some kind of gag prop. One might compare Brenner's staging with the images of the flag and the critique of American patriotism found in the diasporic photography of the Jewish Swiss émigré Robert Frank in the mid-1950s. One sees in this comparison different emphases in diasporic photography—between the mannered stagecraft of the French photo-wit's theatrical tableaux slashing toward Jewish/American diaspora and the Jewish diasporic positioning of Frank's subjective documentary lens and wandering eye in the alienated and exilic vision that constitutes his classic photo road trip, *The Americans.*[57]

The second definition of "diasporized identity" for the Boyarins veers into a vision of hybridized identity. This involves the ability to maintain "partially Jewish, partially Greek bodies" rather than the disjunction that Western tradition offers, such as "Jewish/Greek bodies."[58] In this formulation, the Boyarins deploy the slash as the mark of division as it cuts up bodies into "Jewish" and "Greek," in opposition to the diasporized bodies to which they are partial. They seem to forget, however, that the dividing slash also exposes the one to and through the other. Theirs is a radically different vision from Brenner's images, in which Jewish identity is obtained through these cuts and slashes and the lure of any fusional model of Jewish community is resisted. Brenner's ambivalent image of hybridized identity is "Josephson Family" (1994), which he shot in New York City. When Brenner stages the family's daughters Yi-Ling/Livia and Yi-Pei/Rebekah as the subjects of *jews/chinese/america,* it is by means of a mirror image that founds and enacts their self-representation as a mode of *partage,* of sharing and splitting. As each daughter faces the camera (the so-called mirror with a memory), her image ricochets off another mirror in a Lacanian scene of misrecognition that constitutes identity in the split.

Finally, the Boyarins suggest that diasporized identity allows for a union of opposites and contradictions. In the case of the Arab Jew Rabbi Sa'adya, the suturing of identity appears to be miraculously healed. "Diasporized, that is, disaggregated, identity, allows the early medieval scholar Rabbi Sa'adya to be an Egyptian Arab who happens to be Jewish and also a Jew who happens to be an Egyptian Arab. Both of these contradictory propositions must be held together."[59] This statement recalls Brenner's photograph of the interfaith family, the Colans in Staten Island, who appear in front of their Christmas tree *and* their Chanukah menorah. According to the terms of the Boyarins, diasporized identity should allow them to be a Christian American who happens to be Jewish and a Jew who happens to be a Christian American. But Brenner entitles his image in a more problematic way. It is "The December Dilemma" (1993), indicating something for which there is no easy resolution. On the horns of this dilemma, diasporized identity holds together and holds apart in this image. Even more important, it holds open.

In the space of a single page, the meaning of "diasporized identity" shifts in the text of the brothers Boyarin to such an extent that one can only wonder if this is not somehow the revenge of diaspora as it refuses to be pinned down to any stable meaning, let alone to serve as the ground of Jewish identity. It takes off like the figure of the *Luftmensch,* the unrooted man of air, who was a staple in eastern European Jewish folklore and to whom Brenner alludes in the middle man of "Three Brothers Restaurants" (1993), shot in Charleston, South Carolina, as he "floats" upside down in the center of the image. The reader of the Boyarins' text moves from diasporized identity as a disaggregation of forces in dialectical tension, to a mixture of hybridized partial identities, to the unification of opposites that erases and effaces the cuts and slashes of identity. The errant movement of diasporized identity enacts the limit of its own conceptualization in the Boyarins' text. From this perspective, diaspora is not just the ground of Jewish identity; it is also its quicksand. But another aspect of diasporized identity is excised from the Boyarins' account. This excision has to do with their programmatic insistence that diaspora is to be read exclusively as the "becoming-exile of home" and with the positive valuation that this is accorded. Throughout their study, the Boyarins posit diaspora's dispossession as morally superior to Zionist nationalism. In his work "Scattered Seeds: A Dialogue of Diasporas," in the *Inside/Out* volume, Michael Galchinsky takes the Boyarins to task for such *triumphalism.* "The Boyarins' essay takes the triumphalism in a certain version of American Jewish thought and postcolonialism to an extreme. The Boyarins idealize the condition of Diaspora and seem to oppose the formation and continuing existence of Israel as a nation-state."[60] In other words, the Boyarins overlook that diaspora can also involve a longing for home (as witnessed in part in Brenner's "International Jewish Arts Festival") and that this was the ground for the Zionist nationalist movement in the first place. This point of view has not been expunged in contemporary diasporic life in groups ranging from the Zionist Organization of America to Kahane Chai. As John Dalberg-Acton said in an oft-quoted dictum, "Exile is the nursery of nationality."[61] While the Boyarins insist that diaspora is the ground of Jewish identity, they fail to note that it can also serve as the ground of Zionism and Jewish *national* identity.

The theme of diaspora perpetuating the longing and desire for home is at the root of Brenner's risky exposure titled "Kahane Chai Summer Camp" (1994), shot in upstate New York, which has the slash marks of interdiction written all over it (Figure 6.9). Rabbi Meir Kahane (1932–1990) was the leader of the militant JDL (Jewish Defense League), and he preached an actively aggressive stance against anti-Semitism in America and a hard-line Zionist position advocating that American Jews should exercise the right of return to Israel. While Simon Schama admits that this image is a "chilling exception to Brenner's soft-focus definition of Jewishness,"[62] he then makes light of it in an effort to minimize its slashing effects. For Schama seeks to maintain a moderate stance that re-forms Brenner's vision of American Jewish life into the mold of what he calls "fusion music."[63] But this overlooks the divisive issues raised by this image. It is as if every tree were a literal stake to remind us of what is at stake in

this militant and fundamentalist stance in an image that censors the faces of these not- so-nice Jewish boys who are in training at this summer camp. Unfortunately, the slash in this instance marks the violence of the exclusionist desire of Zionist nationalism that cuts itself off from the others, that will not heed the call of the Palestinians as others, and that refuses to recognize otherness on either side of the border. And yet, the irony is that this guerrilla action takes place on the soil of the United States. As in many contemporary examples, radical fundamentalists use diaspora not to disperse the idea of home but to foreground a longing for it. It is this reterritorializing aspect of diasporized identity that the Boyarins refuse to acknowledge in their one-sided accounting. From the extreme ultranationalist perspective of Kahane Chai, the diaspora outlined by the Boyarins might be equated with "defeatism"—with a mode of submission to colonialist thinking and a false consciousness that mistakenly sees exile as freedom rather than as a perpetuation of subjection to a foreign power.

Ceaselessly wandering between "triumphalism" and "defeatism" or shuttling between the slash that divides and the slash that shares (between the "becoming-home of exile" and the "becoming-exile of home"), diaspora moves through the photographs of Frédéric Brenner with all its paradoxes, ambivalence, and discontinuity as it awaits a decision regarding the "truth of exile."

CODA: SLASHING WIT

This chapter has reviewed Frédéric Brenner's ability to produce complex and ironic images that are, to use Vicki Goldberg's words, "outright funny."[64] In the context of this study, Brenner's style of wit must be dubbed "slashing," which is defined as "incisively satirical." It is this mode of slashing wit that enables Brenner to stage the interruption and deflation of Jewish myth and the confounding of easy stereotypes in *jews/america*.[65] In the modern period, Jewish humor has been a way of coping with diaspora and the tension that comes out of the simultaneous need to assimilate to the host culture and the desire to maintain a connection to tradition. This sociological

FIGURE 6.9. Frédéric Brenner, "Kahane Chai Summer Camp," upstate New York, 1994. Copyright Frédéric Brenner. Courtesy of the Howard Greenberg Gallery, New York.

analysis of the tension of being an acculturating people provides a way of explaining why so many comedians and humorists in the United States have been Jews. As Brenner sees it, his oxymoronic images provoke laughter because they arise out of a split. "Many images operate in this very tension, permanently within this fracture."[66] In this way, Brenner's photo witticisms fracture and split the sides of meaning.

I would like to conclude with an extended reading of Brenner's sophisticated homage to one of the most slashing wits of the Jewish/American diaspora in the twentieth century, Groucho Marx. Brenner's Marxist revisionism is a sly commentary on the paradoxes of Jewish belonging when it has been cast according to the anarchic script of brother Groucho and recorded in the medium of mechanical reproduction. "Marxists" (1994) stages Jewish community as a group portrait that consists of sixteen Groucho impersonators (Figure 6.10). They don the proper comic props (i.e., cigar, wire-frame glasses, bushy eyebrows, and mustache) that mark their masqueraded membership. It is clear that Brenner's punning and compressed title forces a direct confrontation with the communism of the German/half-Jewish Karl Marx and his band of followers. The desire for the fusional community of workers has been the utopian dream of many Jews in the diaspora over the course of the past century, and they became ardent converts to the Marxist vision of a communist society or some socialist variant. In some ways, Marxism transferred the old messianic hopes of orthodox Judaism to the modern secular sphere. But, from all appearances, this does not seem to be the brand of Marxism that Brenner has identified or represented. Instead, he is drawn to the antics and anarchics of the fast-talking comedian who shares and undermines the gravity of the same proper name. For Sidra Dekoven Ezrahi, this particular image is also emblematic of the pop cultural and historical conflation of Jews, America, and humor operating according to what she calls "the Purim principle" in contrast to Zionism and the Holocaust. She writes: "Even as Marxists, then, we knew we were only playacting. The province of American Jews was comedy, the comedy of make-believe, the detoxified Jewish story, unfolding while the epic and tragic dramas of our time were enacted on other stages, under other mustaches."[67]

A Groucho witticism haunts this photographic exposure of Jewish/American diasporic community and exposes the slash that propels the humor of Brenner's project. This joke has achieved such notoriety that it receives a full chapter of analysis in Richard Raskin's *Life Is Like a Glass of Tea: Studies of Classic Jewish Jokes*. Here, Raskin compiles over a dozen variants of "Groucho Marx's Resignation Joke"—a community of versions to rival the Marx variants in Brenner's photograph. "Groucho Marx sent the following wire to a Hollywood club he had joined: 'Please accept my resignation. I don't want to belong to any club that will accept me as a member.'"[68] Interestingly enough, this quip is also incorporated (interrogatively) in the artist R. B. Kitaj's "First Diasporist Manifesto": "But it is not my intention to drag all that expatriate weight across my present Diasporist musing and open up the membership. What did Groucho say? Something like he wouldn't want to join a club that would let people like him in?"[69]

FIGURE 6.10. Frédéric Brenner, "Marxists," New York, 1994. Copyright Frédéric Brenner. Courtesy of the Howard Greenberg Gallery, New York.

Raskin also refers to Groucho's joke as "an impossible figure"—one that contains an explanation that is "impregnable to logic."[70] While the story is purportedly about the Friar's Club in Hollywood, Marx's self-disparaging remarks also might be read as a comical Jewish parable for the problematics of belonging to a community in diaspora as well as representing it. This impossibility is enacted in Brenner's staging of a "becoming-Marxist" (Groucho style) in the gesturing (and jestering) of these mimes who have accepted membership in a club that sui generis demands self-exclusion. This impossible membership is emblematic of the playful and provocative representations at risk in *jews/america* as Frédéric Brenner marks and remarks their moves toward community in terms of their slashing toward diaspora.

7. Digital Chicanos

PEDRO MEYER, *Truths & Fictions*,
AND BORDER THEORY

But this *mestizaje* would not be one of races, that would only suggest a trope.
It would be, in people, peoples, histories, events of existence, the *mestizaje* of their
multiplicities that cannot be assigned to places of pure origins. It would be less a
question of mixed identity [*d'identité métissée*] than of the *mestizaje* of identity
itself, of any identity.

—JEAN-LUC NANCY, "Cut Throat Sun"

MIXING THINGS UP

For the past quarter of a century, the photographic work and advocacy of Pedro
Meyer has been a major force in contemporary photography. It should be recalled that
Meyer founded and served as the first president of the Consejo Mexicano de Foto-
grafía (Mexican Council on Photography), which was responsible for organizing the
First Colloquium on Latin American Photography in Mexico City in 1977 to draw
attention to this undervalued area of study.[1] Today he remains at the forefront of Latin
American and international photography but in an entirely new capacity, as the editor-
in-chief of what many photo savants consider the most important online photography
journal, gallery, and forum on the Internet, ZoneZero.[2] This recent role reflects the
powerful impact that the computer has had on Meyer's vision of photography over
the past decade. His digital self-portrait, "Pedro Meyer vs. the Death of Photography"
(1991/1994), is emblematic of this transformation (Figure 7.1).[3] The photographer
stages himself as breathing new life into the dead skeleton of documentary photogra-
phy through the power of the digital imagination. In a visual pun, Meyer gives the
nod to Apple as the preferred operating system that powers his mind's eye for both
digital photography and graphic design. The cross fertilization of the two technical
apparatuses is also referenced in Meyer's comical digital montage "Walking Billboard"
(1987/1993) (Figure 7.2). This image features a man who wears a combination camera-
computer on his head against the background of Central Park in New York City.[4]

FIGURE 7.1. Pedro Meyer, "Pedro Meyer vs. the Death of Photography," 1991/1994. Courtesy of Pedro Meyer.

In the course of a decade, Pedro Meyer has been transformed from a social documentary photographer who employed a straight-shooting aesthetic and made claims to realism and unadulterated truth into a digital photographer who uses artistic techniques (compositing, montage manipulation, and electrobricolage) that offer a direct challenge to such photographic truth claims. In taking up digital photography, Meyer has moved away from an indexical understanding of the photograph as the direct trace of the referent. It is exactly at this juncture—in the digital alteration of the index—that an expository approach to photography and community can intervene in order to adulterate the myth of the purity of photographic origins. Furthermore, in an ongoing series of editorials in ZoneZero, with provocative titles such as "'Hasta Luego' Darkroom" (April 2001), "Why the Future (of Imaging) Is Digital" (May 2001), and "Redefining Documentary Photography" (April 2000), Pedro Meyer has established himself as one of the foremost polemicists for the digital revolution in photography. In this editorial capacity, Meyer has been outspoken in denaturalizing the myth of photographic truth. "Only now with a heightened awareness brought on by the notions of what digital photography can accomplish, are we beginning to discover what photography was all along: the very act of deception."[5] In other words, the digitally wired Meyer now wants us to consider how manipulation and deception have been internal to photographic practice from its very origins, and thereby how the long history of photographic manipulation contaminates the binary opposition of an analog versus digital divide. As he asks rhetorically in one of these editorials: "Isn't it

FIGURE 7.2. Pedro Meyer, "Walking Billboard," New York City, 1987/1993. Courtesy of Pedro Meyer.

about time that we come to terms with the fact that photographs have never been THE truth about anything?"[6]

Meyer's trajectory and transformation is further evidenced in the subtitle of his 1995 book and CD-ROM *Truths & Fictions: A Journey from Documentary to Digital Photography* (*Verdades y ficciones: Un viaje de la fotografía documental a la digital*).[7] This publication contains many images from Meyer's intermittent border crossings and photographic forays north of the Mexican border in the United States.[8] In 1987, Meyer was granted a prestigious Guggenheim Fellowship to document social and cultural life in the United States. Like the Jewish Swiss émigré Robert Frank and his subjective documentary project *The Americans* in the mid-1950s, Meyer undertook a major road trip that put him on a journey of over fifteen thousand miles in search of his own critical and satirical vision of the United States. In an interview with Michael Sand in August 1994, Meyer comments on this legendary precedent and on the anxiety of its influence: "That now-legendary book by Robert Frank broke new ground for the presentation of content and the aesthetics of the photographic image. So when I started on my journey of picturing North America, Frank's book was a reference that no one would let me forget. . . . Maybe because of this omnipresent reference, I was clear that whatever I did, I had to make sure not to replicate what had been done so well thirty years earlier."[9]

The major markers of differentiation for Meyer revolve around two axes—new techniques and new subject matter. On the one hand, the avoidance of being just another Frankian replicant lies in the introduction of digital photography and other emerging technologies—of living and working in this uncommon era, which Meyer abbreviates as "A.C." (After Computers). As Meyer states: "I also felt the presence of new technologies emerging all over the place, which led me to the conclusion that such technologies would afford me the opportunity to express my ideas regarding photography and the United States in ways that would differ significantly from what had been done earlier." On the other hand, Meyer discovered that, in terms of its ethnic and racial composition, the United States was no longer just a matter of 1950s black and white. His analysis of contemporary American demographics casts the United States as a multicultural society tending toward heterogeneity. "I soon realized that the country that Frank had pictured was no longer the same one that I was encountering in my travels. I never found those Americans that would fit the description of being *The Americans;* the insinuated homogeneity of the 'The' had become a mosaic of different cultures."[10]

The emergence of the Chicano movement as a political and cultural force and the increased presence of Mexican-Americans in general have obviously played crucial roles in this demographic and perceptual shift of the United States to a "mosaic of different cultures." This point is underscored by another project that Meyer has supported, entitled "The New Americans." Writer Ruben Martinez (U.S. citizen of Mexican-Salvadoran origin) and photographer Joseph Rodriguez (U.S. citizen of Puerto Rican origin) undertook this documentary photographic project and the

ZoneZero Web site to gain a better perspective of the recent wave of Mexican immigration to the United States. The project is another example of recent border studies that take the Chicano together with the U.S.-Mexican borderlands as a privileged locus of visual cultural analysis. The Web site contains a discussion group that is particularly relevant to any analysis of "digital Chicanos." It begins: "Perhaps what we are seeing is, in the context of the history of the Americas, merely the ongoing process of *mestizaje,* which originally described the mingling of European and Indian blood and culture that created the mixed people (*mestizos*) that are the majority in Latin America today."[11] While this statement was written to contextualize "The New Americans" project, it can also serve as a guidepost for *Truths & Fictions,* in that the book and CD-ROM versions contain a number of Meyer's own digital photographs of the ongoing process of *mestizaje.* While many of these images were taken in the United States, the project also contains many vividly colored digital images of the syncretic religious life of the Mixtec people of the Oaxaca region in Mexico.

Thus, *Truths & Fictions* offers a double shot of new technologies (the digitalization of photography) and of new Americans (the representation of Chicanos in the Southwest and California and of mestizos in Oaxaca). The present chapter, under the title "Digital Chicanos," seeks to bring Meyer's digital compositing techniques—the result of the hybridization of the camera and the computer—and the photographic exposure of mestizo culture in the United States and Mexico into dialogue with each other in order to underscore how the rhetoric of digitality and Chicano hybridity insists on the alteration and even the subversion of traditional concepts of identity, as well as the undermining of the indexical theory of photography. In other words, it is important to consider how digital Chicanos reconfigure traditional notions of subjectivity and photographic truth claims. This argument draws on the ideas of Jean-Luc Nancy regarding the complexities (and multiplicities) of mestizo identity in his study "Cut Throat Sun." In addressing himself to an imaginary Chicano reader, Nancy insists, "Your identity is obtained through cuts. Through mestizajes." But rather than framing this in terms of a valorization of mestizo identity, Nancy suggests that the cuts that constitute Chicano community make for a "*mestizaje* of identity itself."[12] Meanwhile, Scott Michaelsen and David Johnson's *Border Theory: The Limits of Cultural Politics* asserts that the theorizing of the Chicanos as "border subjects" necessitates a refusal of binary oppositions that would locate them as self-identical subjects on either side of the line.[13] My goal is to use Nancy's "*mestizaje* of identity itself" and Michaelsen and Johnson's border theory to challenge those readings of Pedro Meyer's digital Chicanos that serve an unproblematic politics of identity along with the reassertion of photographic truth claims and indexical rationales. In other words, if the unstable border (*la frontera*) is to be affirmed as the site where digitality and Chicano/mestizo culture happen, then this space must be articulated and theorized as something that risks identity and that is constituted by cuts—what cuts into identity whether in terms of digital montage or in terms of "being mestizo" (or someone who is not one). That is why Nancy writes: "A *mestizo* is someone who is on the border, on the very border of meaning."[14]

If we use Meyer's work as a means to arrive at a new *digital truth* (which is the express goal of photography critic and curator Jonathan Green)[15] rather than to seed digital doubts and to map (out) the border of meaning, then we refuse the radical potential of the digital and mestizo subject to mark the limits of identity and the limits of any thinking of community that is grounded in an essentialist project of race and ethnicity. Instead of forging identity as an essence around the restrictive concept of race (*la raza*) along with the purity or superiority of bloodlines, the digital Chicanos exposed in the photographs of Pedro Meyer's *Truths & Fictions* are necessarily open and multiple in that they are constituted "from the cut and in the cuttings."[16]

Shifting Borders of Race:
Mexican/American Stereotypes and Interpellations

It is the visual stereotype that racializes, that refuses peculiarities and excesses. This stereotype is the means whereby multiplicity and singularity are reduced to group caricature and two-dimensional typecasting. What are we to make of those images in which Pedro Meyer confronts the negative stereotypes of Mexicans in the United States? What are we to make of an image where Meyer self-consciously plays with the positive-negative process of photography itself in order to achieve an ironic and provocative effect? "Mexican with a Positive Attitude in a Negative Environment," Malibu, California (1988/1992), was taken at the La Salsa restaurant in Southern California (Figure 7.3). It features a mustachioed Mexican wearing a sombrero and a serape who plays the role of a Ronald McDonald-like mascot for a fast-food restaurant. While this giant towers over the patrons of the restaurant, his servile pose—that of serving food and waiting on tables—reinforces the reigning power relationships. But Meyer stages the image in both positive and negative reversals, and, in this way, he manages to flip both tonal values and racial valuations in an image of dark-skinned Americans and a lightened Mexican in "whiteface." With this technical trick and this act of reverse discrimination, the digital photographer (as image maker and image breaker) is shown to be working at the wavering border of cultural values and national identities.

In *Truths & Fictions,* "Mexican with a Positive Attitude" is paired with another photograph that foregrounds the image of the Mexican in the United States in terms of a negative stereotype. This photograph is the "Mexican Serenade," in Yuma, Arizona (1985/1992) (Figure 7.4). With this image, Meyer uses caricature as an artful device to expose the inherent racism of this trailer park's white inhabitants who have reduced Mexicans to lawn ornaments. Meyer's own reading of this documentary image of a mini-mariachi band illustrates his identification and solidarity with the Mexican community and with the feeling of being powerless and oppressed. It begins with the invocation of the collective pronoun: "We were thus reduced to these ceramic mariachis in a very unpleasant way. And there was nothing much I could do with that image." However, his brandishing of the Apple computer and Adobe

FIGURE 7.3. Pedro Meyer, "Mexican with a Positive Attitude in a Negative Environment," Malibu, California, 1988/1992. Courtesy of Pedro Meyer.

Photoshop as symbolic weapons allows Meyer to fight back and to stage a counter-discursive practice of community. As he relates, "I brought a person from this community down to the scale of the little mariachi figures, and in the process addressed the issue of racism."[17] Yet, one wonders about the end result of this attempt at redress via digital means. What is the exact nature of this address in and to the borderlands of Arizona? Does this "photograph as a political cartoon" (as Meyer refers to it) and its scaling down of the Anglo woman merely result in an inversion of power relations that now turns Pedro Meyer into a satirist and critic of white trash American culture? Meyer's reductive recasting of the American woman allows us to see clearly the racist stereotype and its harmful effects. But perhaps we need to go further and ask if Meyer is still holding on to racial distinctions and dichotomies here that have been disabled by digitality and its mestizo-like character. For digital photography signals a space that follows the logic of the border, wherein identity is always on the verge of being contaminated by its other and where the permeability and alterability of identity is enacted. If "Mexican Serenade" is to be viewed in this light, then it exposes the limits of the nationally and racially identified subject. This digitally altered and malleable photograph questions the ability to enforce the type of subject positions (correction, stereotypes) on which xenophobia and racism depend.

While there are no images of illegal immigrants or of border skirmishes in Meyer's examination of *la frontera,* the contested border does enter into the political unconscious of "You're Dead . . ." (1988/1990) (Figure 7.5), which is as much about the

FIGURE 7.4. Pedro Meyer, "Mexican Serenade," Yuma, Arizona, 1985/1992. Courtesy of Pedro Meyer.

policing of the American border with Mexico as it is a critique of American gun culture and the prevalence of violence in the United States that begins in youth. In this image, Meyer presents four smiling Anglo boys who are taking aim at his camera—which means, necessarily, at him—the Mexican intruder who comes from the South. Situated at the border of nationality and racial difference, this act of interpellation of Meyer for dead (Mexican) is more than just child's play. This reading is compounded when one considers that this photograph was shot in the border metropolis of San Diego, California. Here, Meyer's digital alteration also involves an act of interdiction and censorship as he bars the eyes of most of the gun-toting boys, thus miming the convention of concealing the identity of minors and criminals. The youths of "You're Dead . . ." function as a mini–border patrol modeled in the tradition, say, of Eugene Goldbeck's sobering group portrait of the "Immigration Border Patrol," in Loredo, Texas (ca. 1936).

But while Pedro Meyer is hailed and interpellated as the Mexican or Chicano other (who is taken and mistaken for brown) in conjunction with this border image, the slippery positioning of race and racial categorization undergoes a drastic change when he visits Magdelena Peñazco in Oaxaca and meets an old woman there whom he mythologizes as Mother Earth in an image and in his accompanying narration. In contrast to "You're Dead . . . ," the furrowed and indigenous Earth Mother (according to Meyer) interprets the photographic intruder as the conquering white man and the exploiter. Inserting yet another wrinkle of racial identification, one has to consider

FIGURE 7.5. Pedro Meyer, "You're Dead . . . ," San Diego, California, 1988/1990. Courtesy of Pedro Meyer.

Meyer's own Jewish German ancestry in this context as well. Given that a number of Meyer's ancestors were exterminated in the Holocaust and given the positioning of the Jews of western Europe as the disposable other, the following passage becomes an even more complicated self-estimation.[18]

> Well, when she saw me and I put my camera up to my eye and photographed her, she actually had that attitude in looking upon me and [asking] who was I in relationship to her. I am actually the white man and the white man who came to her world in pre-Hispanic times who altered this entire region through all the ways in which it was exploited.[19]

This impression led Meyer to stage this (altering) digital image as "The Arrival of the White Man" (1991/1992), bemoaning Hispanic colonialism as the rape of "Mother Nature" (see Plate 7). One must mark how this narrative sets up a binary opposition between native nature (brown) and Hispanic culture (white). But even as he empathizes with the indigenously oppressed, Meyer personifies the white man (and therefore, in part, himself) by means of a giant Christian saint. The saint is the marker and symbol of Christian missionary zeal in the region. It symbolizes the colonialist imposition of Judeo-Christian beliefs and civilization on the indigenous peoples. "And I wanted to represent the way the white man had arrived. So the thing that came to my mind was to take one of the white saints that were in the local church and have him come up sort of like a giant over the hills with the children looking at this giant. And that is why I call the image 'The Arrival of the White Man.'"[20] Aligned with the altering logic of the mestizo, this comparison of "You're Dead . . ." and "The Arrival of the White Man" in relation to the photographer's own shifting subject position(s) illustrates how race becomes a construct whose borders are permeable, fluctuating between brown and white and something else again.

RELIGIOUS MOTIFS: VIRGIN OF GUADALUPE AND THE DAY OF THE DEAD

The Virgin of Guadalupe is one of the few icons that appears in both Meyer's Mixtec images of Oaxaca (e.g., "Housewarming," Magdelena Jaltepec, Oaxaca, Mexico [1992/1992]) and the Chicano images of Southern California. As a symbol of national and religious community, the Virgin is viewed as "the Mother" or "the Queen" of Mexico (as in "Reyna de México"). In fact, this is the very title of one of the images in Meyer's 1985 publication, *Tiempos de America* (American Times).[21] As Judy King writes, "Truly, the Virgin of Guadalupe is the rubber band that binds this disparate nation into a whole. She is the common denominator of this land, it is she giving Mexicans a sense of Nationalism and Patriotism."[22] In addition, the Virgin of Guadalupe is considered the original mestizo—the bridge between the Aztec and the Christian religious traditions, between the Indian and Spanish cultures.

Historical reasons also make the Virgin of Guadalupe an overdetermined choice

for Meyer in terms of her intimate relationship with the history of photography. In *Mexican Suite: A History of Mexican Photography,* Olivier Debroise discusses how the miraculous imprint that the Virgin left in the mantle of the cape of Juan Diego has been theorized as a photographic sign. "As a sign or proof of her apparitions, the Virgin produces an image of herself by using certain common properties of light: she prints herself photographically on the cloth."[23] The connection of the Virgin with radiating beams of light is another common trope of her representation. This can be seen in Meyer's photograph "Big Hazard," Los Angeles, California (1992/1992), in *Truths & Fictions.* This representation of a Chicano life as a risky business that turns to the divine for support and protection multiplies the iconic and devotional images (most of them photographic in nature). These include the Virgin, the pope, and Jesus Christ, as well as family members displayed on the mantelpiece.

The Virgin of Guadalupe is also featured in the photograph "From Conquest to Reconquest," a dynamic and visionary image of the back of a lime green car with red taillights (the national colors of Mexico) as it speeds away (see Plate 8). The matron saint of indigenous Mexican Christianity, well known for her mystical visitations and miraculous powers, appears to give her blessing to this speed racer. In Meyer's image, the Virgin has moved from sitting on the car's dashboard (the customary position of this icon) to floating or hovering over the taillights. Meyer uses his magic Photoshop tools most effectively to give the Virgin the radiating effect that accompanies the foundational narrative of her first appearance in luminous protophotographic form. She rises above this California vanity license plate as it proclaims an abbreviated message of Chicano national and ethnic pride—"MEXNPWR" (Mexican power).[24] This is a complicated and suggestive image at the intersection of popular culture, nationality, and religion. It alludes to both the Spanish conquest of Mexico and the American conquest of the Southwest and California in the mid-nineteenth century, even while it imagines contemporary Chicano culture in California as the reconquest of American territory. In selecting the subject of the Chicano low-rider, Meyer takes up a theme that goes back to the late Louis Carlos Bernal's Tijuana images that documented the maintenance of cultural traditions amid absorption into an "American way of life."[25]

Jonathan Green has interpreted "From Conquest to Reconquest" as a commentary on the production of a border subject:

> Caught between the two worlds of the United States, their birthplace, and Mexico, their mythical and ancestral homeland, the Chicano uses the automobile to synthesize Mexican nationalism and U.S. culture transforming American car culture into something potent and distinctively Chicano. This is an image not of Mexican immigrants, but of young Mexican-Americans seeking to find stature, power, and identity in an unrelentingly hostile environment.[26]

Green stumbles here on the paradox of positing the Mexican-American as a hybridized subject through an attempt at *synthesis* that overruns and overrides the problematic

of the border in both geopolitical and ethnic terms. In other words, he speaks in the name of a mestizo or of a hybridized "Mexican-American" subject whose individual elements could be enumerated and elucidated in terms of something that is "distinctively Chicano." But who speaks for the digital Chicano and the forging of a pixelated multitude of hybrid singularities whose individual elements cannot be isolated, summed up, or summarized? The digital Chicano—if it is truly to be marked as mestizo or hybrid—cannot be counted, distinguished, or founded.[27] In other words, this digital image depicts a perpetually unfinished journey of arrivals and departures for this Mexican-powered and American-driven low-rider, who remains anonymous.

Rather than interpreting this image in terms of a young Mexican-American finding his identity, we see that the invisible mestizo who bears the license plate branded "California MEXNPWR" follows the logic sketched by Jean-Luc Nancy's "Cut Throat Sun," in which the border subject "gets his/her identity from the cut, in the cuttings."[28] This is a counterintuitive idea, but it is the only way in which to understand *mestizaje* and its compositing of an ethnic or racial identity of unknowable origins forever incomplete and yet to come. The inattention to border theory in Green further illuminates his essentialist and romanticized reading of the cultural product as somehow "distinctively Chicano." But this again plays into the hands of a misconceived understanding of Chicano identity formation. For what could it mean to be distinctively Chicano if and when the Chicano as hybridized subject is "caught between the two worlds" and therefore always challenging the markers of distinction of what it means to be American, Mexican, or Mexican/American?

The Day of the Dead celebration is another instance of contemporary Mexican religious practice that has fascinated Meyer and his camera. In "Day of the Dead," Papantla, Veracruz (1989/1991), Meyer shows us a boy who is already in the shadows (cast by the photographer), with a family altar in the background arranged with flowers and food prepared especially for the dead on this occasion. In this image, the alterations of digital photography complement the *altarity* that is celebrated at the altar place—the becoming-other of life that is the leitmotif of the Day of the Dead.[29] Another Mexican/American border image in the same vein that engages religious and cultural hybridity is "The Night of the Day of the Dead in Hollywood" (Figure 7.6), Los Angeles, California (1990/1992). Meyer recalls the title of the image that cuts and pastes American All Hallows' Eve with the Mexican Day of the Dead.

> The name comes because Mexico, the festivity of the Day of the Dead, was in this case combined with Halloween in Hollywood Boulevard. And there were, I don't know, about thirty to forty thousand people of which the majority were from Mexico and speaking Spanish. And I found that absolutely astounding—this collision of the Halloween festivity with the Day of the Dead festivity.[30]

In this digital montage, we see principally three Chicano youths celebrating Halloween and interacting with a skeleton figure that represents the Day of the Dead.

The central figure is a girl in a carnivalesque costume who exposes a "plastic tit" (to quote Meyer) and flirts with the skeleton. It is a symbolic image that pits the forces of lust and death, of the carnal and the cadaverous, of Eros and Thanatos. But this image also stages an interruption of myth in that it refuses to identify with the totality of one or with the fusion of the two myths. In other words, the celebration of Halloween interrupts and undercuts the Mexican Day of the Dead and vice versa.

But Meyer's analysis risks polarization in his saying that the American Halloween is on the side of the secular, while the Mexican Day of the Dead is on the side of the religious rite. "In the Halloween representation, it's very secular, while in the Day of the Dead, it's very religious. So it's a collision of the secular with the religious, which I find comes together here where the super tanker and these kids with a plastic tit—they're part of the Halloween culture—[are] with the skeleton of the Day of the Dead."[31] In his rush to dichotomize for the sake of an easy photographic trope, Meyer forgets or fails to mention two things that complicate matters. First, the Aztec Day of the Dead ceremony was moved by the priests from the Gregorian month of July and the beginning of August, when it was celebrated before the conquest, to the first days of November to coincide with the Christian All Saints' Day (Día de Todos Santos) in pursuit of the doctrine of religious syncretism. Thus, the Day of the Dead is a holiday that combines pre-Hispanic (Aztec) and Roman Catholic rituals. Meanwhile, All Hallows' Eve, or the night before All Saints' Day, has its roots in sacred

FIGURE 7.6. Pedro Meyer, "The Night of the Day of the Dead in Hollywood," Los Angeles, California, 1990/1992. Courtesy of Pedro Meyer.

religious rites designed to pay respect to the dead saints. Its roots are in the Celtic tradition, in which it was believed that the souls of the dead, including ghosts and witches, return to mingle with the living. Later, Pope Gregory IV moved the celebration for all the martyrs to November 1. Therefore, it is important to remember the religious roots and syncretic aspects of Halloween that bear remarkable similarities to those of the Day of the Dead. In other words, amid its ghosts and its skeletons, Halloween still retains aspects and traces of a haunted religious past in spite of its current secular commercialization in the United States.

In the light of border theory and "the *mestizaje* of identity itself," it is perhaps better to say that Pedro Meyer has staged a digitally manipulated image of Mexican-American cultural exchange at the limit of community's communication that entertains a Halloween–Day of the Dead celebration, simultaneously "colliding," "combining," and "representing" in the same breath—and out of breath. As Meyer himself states in extolling the digital dimensions of this particular image, "These two contents combine, collide, and represent both the Halloween representation [and] the Day of the Dead representation in one single moment in time."[32]

CONCLUSION: IN DEFENSE OF THE DUBITATIVE

Whether it is read as a traditional hard copy photography book or browsed as an interactive CD-ROM, Pedro Meyer's *Truths & Fictions* is a project that forces a reconsideration of the truth value of the photographic image. As already remarked, the indexical linkage to the referent that is so crucial to the documentary tradition has been severed in Meyer's digital photographs. According to Jonathan Green, Meyer's images function as a new hybrid formation, or what he terms "documentary fictions." From this perspective, Meyer's images are artistic renderings that mime or simulate documentary discourse. But the problem with Green's reading is that he wants to have it both ways. He wants to read Meyer as a digital artist of the "post photographic era" *and* as the producer of images that are "essentially photographic" in nature and in a direct relationship with a traceable reality. This approach leads to hopeless contradictions. Given that digital alteration (always on the side of alterity) cuts into any attempt to secure an essential identity, this latter claim appears to be rather misconceived. Green's very use of scare quotes around the term *photographic reality* in the following extended passage already reveals that the attempt to salvage the referent with an indexical theory of photography in the age of digital media and computer simulation is quite problematic.

> Meyer's work from the United States and from Oaxaca would not have been possible without the computer's capacity for smooth alteration and amalgamation. Yet, in spite of the photographer's interventions, these images cannot be classified as synthetic media. They are not paintings or drawings. They remain essentially photographic. They draw their strength from a direct relationship to "photographic reality," that

surface world of reflected light that the camera has so precisely described through its history. Meyer's photographs usher in a new reality: a brave new world of *digital* rather than *visual* truth. Here, image makers will take us into the post photographic era, in which new forms of visual rendering will reveal extra photographic reality.[33]

Even while invoking a digital truth (what would deconstruct the photographic index), Green holds on to a privileged relationship to the real and does not let go of the truth claims of photography. That is why the German digital media theorist Florian Rötzer agonizes over "the irritations caused by such half-baked classifications [that] arise *en masse*" in Green's study.[34] It is at this juncture that a thinking of photography in terms of exposure—or as community-exposed photography—intervenes and shifts the way in which one thinks about these images. Rather than thinking about digital Chicanos in indexical terms, one focuses on their being posed in a relationship with exteriority and in terms of an exposure to being-in-common that occurs at the limits of meaning. As Nancy states, "A *mestizo* is someone who is on the border, on the very border of meaning. And we are all out there, exposed."[35] The exposure of the digital Chicano is not something that can be assimilated into an essentializing discourse, because it is always turned toward the other ("and we are all out there") or what cuts into and alters it.

Interestingly, Pedro Meyer's explication of the image "Retirement Community," taken in Yuma, Arizona (1985/1992) (Figure 7.7), reveals his own fear of framing his

FIGURE 7.7. Pedro Meyer, "Retirement Community," Yuma, Arizona, 1985/1992. Courtesy of Pedro Meyer.

work completely outside the documentary tradition and its humanist values. In this digital image, a one-armed and one-footed man relaxes in solitude in the shallow water of a swimming pool. However, Meyer relates that the man was missing only one of these limbs in the original image. This leads Meyer into an ethical dilemma and a self-critique in which he asks: "What right do I have to do that to a person?" Here, he shies away from the full embrace of the posthumanist consequences unleashed by this cyber-technology and the prosthetic devices of digital representation. Meyer does not appear to be fully satisfied with the disclaimer of artistic license, and, in a sense, he shows that for all his advocacy of the brave new digital world, he is not entirely willing to give up his own relationship with the indexical referent of this photograph ("a person"). Instead, he straddles the borderline, caught in "the dilemma" between the demands of documentary depiction and of digital manipulation. To recite Meyer, "A lot of the people who saw the image and whom I asked said, 'No, as an artist I have a right to make a representation.' I'm not sure of the issue. I'm not clear. I decided to . . . show it precisely to open the debate. I honestly don't have an answer to this except to explain my own unhappiness about the dilemma that this issue presents me with."[36]

In contrast, the introduction to *Truths & Fictions,* written by the Spanish photographer and historian Joan Fontcuberta and subtitled "Truths, Fictions, and Reasonable Doubts," unconditionally affirms the unsettled and unsettling border that advances both the technical implementation of the digital *and* the exposure of the mestizo. To quote Fontcuberta: "They are images that are situated in an ambiguous neutral space, as illusory as they are present: the *vrai-faux,* the space of uncertainty and invention— the most genuine category of contemporary sensibility. Today more than ever, the artist should reclaim the role of demiurge and seed doubt, destroy certainties, annihilate convictions, so that from the chaos that is generated, a new sensibility and awareness may be constructed."[37] From this perspective, Pedro Meyer's images of digital Chicanos provide a chance to destroy the certainties of fixed identity and identification. In disseminating the digital and the mestizo as twin demiurges, these images seed doubts regarding the documentary search for proper origins and indexical certainties. Fontcuberta's viewpoint is closely aligned with what new media theorist Peter Lunenfeld has called the "dubitative" processes of digital media. In other words, digital media are closely connected to painterly and iconic modes of rendering, even if they visually simulate the indexical signs of photographic media. Lunenfeld asks:

> What has happened to this class of signs, and to the semiotics of the image in general with the advent of digital photography? With electronic imaging, the digital photographic apparatus approaches what Hollis Frampton refers to as painting's "dubitative" processes: like the painter, the digital photographer "fiddles around with the picture till it looks right." Those who theorize this insertion into the realm of photography of the dubitative—which the OED defines as "inclined or given to doubt"—have a number of directions in which to go.[38]

It is the *dubitative* element that has guided this reading of Pedro Meyer's digital Chicanos in terms of both their technique and their subject matter. For the epistemological doubt cast upon the digital image is matched by the doubt cast on any hybridized type of knowledge of what it means to be Chicano or mestizo. In this light, the conclusion of Nancy's "Cut Throat Sun" is applicable, because it advances a concept of *mestizaje* that confirms the digital and hybridity all the way down: "Everything, everyone . . . who alters me, subjects me to *mestizaje*." The important thing here is to recognize that *mestizaje* requires and demands a level of nonknowledge in Georges Bataille's sense of the term—a *je-ne-sais-quoi* that attributes an unknown origin and destiny to the practice of digital manipulation as well as to the thinking of ethnic and racial hybridity. Given this chance, *mestizaje* must be thought of as and with the advent of the other who, according to Nancy, is "always arriving from elsewhere."[39] Such a relation (without relation) underscores the liminal existence of the expository approach to photography and community, of community-exposed photography.

Any investigation of the digital or of the Chicano that is not attuned to the liminal and the border from which the other arrives—and through which community is exposed—remains suspect. In acknowledging alterity or what arrives from elsewhere in Pedro Meyer's digital Chicanos (in terms of both their technics and their *topoi*), border theory resists the conversion of hybridity (what cuts and pastes identities) into a new fused identity or a new fusional community. In this manner, border theory resists the enunciation of a digital truth that is not always already a digital fiction.

8. Performing Community

Nikki S. Lee's
Photographic Rites of Passing

Simulating: An Introduction

As American photographic culture moved toward the twentieth century's end, a young Korean-born conceptual photographer and performance artist under the adopted name of Nikki S. Lee, born in 1970 and living in the United States for only a handful of years, took center stage with a body of work that addresses some of the most fascinating issues of photography and community. While still a graduate student at New York University, Lee began to undertake a series of performative "Projects" (a critical term that demands further reflection) and visual sociological experiments. In each of them, Lee has selected a subculture upon which to practice her artistic version of the anthropologist's "going-native." Whereas the anthropologist focuses on rites of passage that establish the bonds of community, Lee's Projects enact "rites of passing" that raise the question of belonging to community in the first place. She hangs out with these groups for a month or so, she mimes their semiotic codes of dress and appearance, she assumes their bodily gestures and postures, she learns the skill sets, and she partakes in the activities that are typical and often stereotypical of them. In these ways, Lee attempts to pass herself off as a member of these groups. All in all, Nikki S. Lee performs community. However, Lee's brand of camouflage is not to be equated with the covert operations of spies and secret agents, because here the infiltrator is quite open about the nature of her game as the taking of artistic license and liberties. Nevertheless, this disclosure does not change the nature of the cumulative viewing experience of the Projects, which makes these stage extras often appear as props that serve Lee's self-staging or, better phrased, that serve her own self-staging in the guise and disguise of these others.

None of these acts of subcultural drag would amount to very much without the visual proofs and the photographic records that document Lee's performances of community and that are commodified as objects of artistic value. It is important to stress that Nikki S. Lee never takes these photographs herself. Instead, they are shot by her friend Soo Hyun Ahn, by random passersby, or by other members of the group. This gives the production of these snapshots an anonymous aspect that challenges the cult of authorship to some extent. Lee also appears very aware of her perverse relationship with documentary discourse, referring to these images as "fake documentary."[1] Taking a term used in relation to Woody Allen's film *Zelig* (the story of a "human chameleon," which bears many striking resemblances to Lee's Projects), one can classify these narratives as "mockumentaries." Thus, Lee's is a parodic practice that mimes the snapshot conventions of the photographic document only to better serve the staging of duplicity and the production of simulated facts.[2] The conscious use of the date stamp on each photograph is one of the operational ruses that Lee deploys in her desire to mock documentary and to document life as simulation. Following the Baudrillardian logic of the precession of simulacra,[3] Lee says the following in her "Artistic Manifesto" as she engages the perverse logic of simulation: "To include the date on the photo is an affirmation of this use. There is irony in the partly traditional utilization of accurately documenting the record of someone's life, and instead to document a simulated life. The irony becomes more complex if one considers the role that photography has in determining our reality. A good documentation of our simulation, in fact, renders the simulation more true."[4]

In Nikki S. Lee's publication *Projects,* one has the opportunity to see the range of identities that she has performed or "tried on" over the past years and the ways in which these call attention to the decisions and divisions that constitute community across a number of the axes of contemporary identity politics, whether race and ethnicity (the Hispanic Project), nationality (the Young Japanese [East Village] Project), class (the Yuppie Project), sexuality (the Lesbian Project), age (the Schoolgirl Project), or other communities (e.g., the Tourist Project, the Swingers Project). Each of these series constitutes a photo essay that highlights Lee's specific stereotypical interactions with the group that she seeks to mime. These rites of passing illustrate identity as relational—posing how the one passes through the other—or rather, they articulate that there is no singularity but that which is exposed to being-in-common.

Given the emphasis placed on the performing subject, Lee's photographic practice relies on the snapshot aesthetic and its community access for its delivery. In the closing passage to her "Artistic Manifesto" that she issued in 1999, Nikki S. Lee discusses the egalitarian impulses of this teched-down approach to photography. "Different from the intimate authority of the more sophisticated lens and the consequent distance that is generally created from the performance of an artist, the humble Polaroid proposes an egalitarian perspective and a communal activity."[5] The term *Polaroid* is used in a generic sense here to mark the democratizing tendencies of popular photography. The "point-and-shoot" camera with its automatic settings is rhetorically framed

as the agent of democracy, the great leveler that is juxtaposed with the elitism and sophistication of the professional apparatus. In addition, Lee argues that her practice attempts to lessen (or to repress) the hierarchical distinctions that are generally created by performances with a more distanced audience. The everyday ritual of the snapshot—what functions as the living proof of her "rite of passing"—is seen as "a communal activity." However, when these images are later grouped together in the form of a book, they single out the role of "the performing artist," who is the repeated figure that unites the sequence of images and whom the viewer actively seeks out. In other words, the book format and the Project sequences reestablish hierarchies, and the result is the staging of Nikki S. Lee as the art star and the center of attention.

There are obvious photographic precedents for this type of theatrical engagement with identity and a concern for the social interpellation of the performing and embodied subject. Lee's exposure to the work of Cindy Sherman and the major degree of role playing that constitutes the groundbreaking black-and-white Film Stills series (1977–1980) in particular is a clear reference point that she and many critics have acknowledged.[6] Some points of comparison exist between the simulated strategies of Film Stills—these faux documentary images that cast Sherman in stereotypical female film roles with no indexical referent in reality or even in the celluloid world—and Lee's role-playing Projects. Interestingly enough, Lee downplays her level of indebtedness to Sherman in what might be seen as a clear case of the anxiety of influence: "I'd seen Cindy Sherman's work at school, but I didn't really pay attention at that time. I was just interested in commercial and fashion photography. I liked the film stills, but I was more into the people getting published in *Vogue*."[7] Lee shifts the focus of attention from the auteur Sherman to the mass medium and commercial consumption of fashion magazines, but in either case, one notices the shared interest in masquerade and the alteration of identity through clothing, makeup, and props. However, Lee's performances of community do not share Sherman's feminist-engaged focus regarding the social construction of female identity and mass media image. Instead, her Projects are forays into a range of subject positions, social constructions, and visual categories. While Sherman's photo parodies are studio-based and her solo self-portrait images (which deny the self) are staged under precisely controlled circumstances, Lee's work (and performance) in public is under much less controlled conditions and almost always occurs in conjunction with the members of the group that she mimes.[8]

This chapter reviews how Nikki S. Lee's images imagine the possibility of becoming a member of a group at the same time that the slippages in stagecraft and the elements of parody and self-reflexivity suggest the impossibility of fully joining or being included. The photographs of Nikki S. Lee and her performances of community give us pause to consider what it means to be both a part of (sharing) and apart from (splitting) community. Her rites of passing give us pause to consider community in terms of the question of belonging or not belonging, of being included or being excluded. In this way, her image projections return incessantly to posing and exposing the question of community: Who is one of us?

RELATING: COMMUNITY VALUES

> In Western culture, identity is always "me.". . . . In Eastern culture, the identity is "we." Identity is awareness of others.
>
> —NIKKI S. LEE

With the above citation and other statements to the same effect, Nikki S. Lee could be accused of broad stereotyping, of the very kind of gesture that she is often said to be making fun of in her photographs.[9] Here, that stereotyping is through a simple binary opposition contrasting identity formation in Western and Eastern cultures. The West is represented as putting the individual first in the first person singular ("me"), while the East stresses collective identity or the first personal plural ("we"). Given this formulation, one might think of Lee's performances as applying the Eastern model of identity as "awareness of others" to Western subcultures in order to expose the fallacies of Cartesian philosophy ("identity is always 'me'"). Lee alludes to Descartes's famous formula of "cogito, ergo sum" ("I think, therefore I am") in an interview with the *Japan Times* that asserts the same dichotomy in another way: "'In Western cultures, people tend to identify themselves in a certain way, with regards to how they think,' says Lee, 'while in the East I think people's identities are developed through their relationships with other people. The process is more group-based.'"[10] Interestingly enough, Lee inscribes the marker of Western identity ("I think") to frame the Eastern group-based concept of identity as developed through relationships with other people in a slippage or a reverse case of camouflage that has her communicating like a Westerner in an interview with an English-language Japanese newspaper.

This coverage in the *Japan Times* recalls one of her early performances of community. In the Young Japanese (East Village) Project (Figure 8.1), Nikki S. Lee projects herself into the milieu of a hipster subculture in New York City. In one respect, these youths mirror Lee's situation as hailing from an Asian culture and living in diaspora in the artistic center of New York. The project plays with the stereotype that both Koreans and Japanese look the same to Western eyes, who will be unable to discern any differences in appearance in these photographs. But from the perspective of Asian studies and the political history of nationalisms in that region, specifically the colonization of Korea by the Japanese at the beginning of the twentieth century, the difference between being-Japanese and being-Korean is a very complicated one. One of the implied ironies here is that Lee's simulation of herself in the guise of a young Japanese woman plays into the historical desire of imperialist Japan to co-opt Korea into its sphere of influence. Another, however, is that the Project's projection ("turning Japanese") may alternately be read as the unconscious desire in the Korean imagination to assimilate to the dominant culture. Thus, Lee's parody offers an ambivalent mixture of compensatory anger and resistance as well as admiration and desire for Japanese cultural and aesthetic power. However, the staging and the meeting ground for Lee and the young Japanese hipsters happen on another soil—the artistic subculture

of the East Village, where both the Koreans and the Japanese become exiles abroad in the artistic center of the imperial West. The community of the East Village lends itself to self-conscious posing and therefore is one that parallels Lee's own performative interests. It is a community of fashionable youth who act cool, exhibit their dyed hair color of the month, and wear flashy and funky clothing assembled from thrift stores. In each image of the series, Lee has the opportunity to make her case that "identity is awareness of others" in performances of community and rites of passing, which she does by crossing and confounding the lines of (national) identity. In parodying the posers, the green-haired Lee hangs out with them at their nightclubs, in their sushi bars, and at their happy-go-lucky birthday parties, where she smiles along with them and mimes their image and "commodity selfhood," to invoke Stewart Ewen's term for the construction of identity through the purchase and use of products that brand and interpellate their consumers.[11] As in all her simulations of community, Lee raises the question of whether the mere investment in and identification with the commodity signs of a group are enough to make one a bona fide member of that group.

In questioning Lee's binary opposition of East and West—what Nancy refers to as the "tirelessly dialecticized identity" of "individual/collective"[12]—my goal is not to advance a more inclusive concept of a "common being" or a hybrid in which East meets West. Instead, it is to insist that what Nancy calls "being-in-common" is crucial to any formation of Eastern or Western or any other exposure of community. For Nancy, being exposed to community means being in relation, and, moreover, this

FIGURE 8.1. Nikki S. Lee, image 15 of the Young Japanese (East Village) Project, 1997. Copyright Nikki S. Lee. Courtesy of Leslie Tonkonow Artworks + Projects, New York.

exposure "would designate being *insofar as it is relation*, identical to existence itself."[13] This idea must be thought beyond the developmental model of community relations posited by Lee when she insists that "people's identities are developed through their relationships with other people." For what Lee has located in her critique of Descartes and what her photography exposes over and over again is something that is "even more 'thoughtless' than the Cartesian experience of existence."[14] This nonegocentric praxis is the subversive experience of being-in-common that situates being insofar as it is relation and that is exposed at the limit where photographic communication (photography and community) takes place. In contrast to a developmental process of identity formation via group interaction, Nancy "presupposes that we are brought into the world, each and every one of us, according to a dimension of 'in-common' that is in no way 'added onto' the dimension of 'being-self,' that is rather co-originary and coextensive with it."[15] In another interview, Lee asserts, "The concept of identity forming in relation to a group is a very Asian one."[16] But rather than locating relationality as endemic to a specific place or a particular location of culture in what could be read as a new type of Orientalism, one must insist that being in and as relation is constitutive of any exposure of community that poses the limits of the concepts of identity and the self-identical being.

In her interview with Gilbert Vicario, Lee affirms the relational logic that guides a photographic practice of community in the following exchange:

> VICARIO: So what you're saying is that one's self is always understood in rela-
> tion to that which surrounds you?
> LEE: That's the underlying concept: other people make me a certain kind of
> person.[17]

While there is no argument with the insistence that the self is always understood *in* relation, both Lee and Vicario evade the more subversive consequences of community-exposed photography that posits being and the self *as* relation. Only this type of more nuanced analysis can resist the lure of essentialism or what bases itself on the grounds of the underlying concept. In other words, the positing of the self in and as relation can be foundational only to the extent that it is viewed as a foundation without foundation. Furthermore, the relationality of the self is not something produced by "other people," as if it were possible to identify or attribute the source of relation in identifiable beings. It is, rather, an effect of being-in-common—that which exposes our being as a being-with. Lee comes closer to the formulation of identity in terms of relation in a statement from my unpublished interview with her at the Colloquium for Visual Culture at University of Toronto. "That's why I always take pictures with other people, because I thought my identity is connected to other people's identities."[18] Or, as Nancy waxes philosophically, "that the mode of existence and appropriation of a 'self' (which is not necessarily, nor exclusively, an individual) is the mode of an exposition in common and to the in-common."[19] Applying Nancy's formulation to

the photographs of Nikki S. Lee, whether they represent her as hanging out with yuppies or with exotic dancers, one could say that her images illustrate this appropriation of a "self" as a mode of exposition in common and to the in-common.

SELF-DETERMINING: ON THE LIMITS OF VOLUNTARISM

Writing in the *New York Times,* Holland Cotter reviews some of the major ingredients of Nikki S. Lee's work. These include "humor, satire (including self-satire), a keen eye for social detail, a Method school histrionic flair, and a self-assured faith in the endless possibilities for self-alteration."[20] It is this last point that is particularly resonant with the rhetoric of self-determination that adheres to Lee's projects. If one were to accept this point at face value, then Nikki S. Lee appears at one with the American dream. She is the immigrant success story, a Korean Horatio Alger who is using performance art and photography to illustrate the endless possibilities for self-alteration. But such an estimate of naive optimism would conflict with Cotter's first characterization of Lee as a humorist and a satirist. The emphasis on the former qualities opens up the possibility that Lee, whoever she is, is actually showing us the limits of self-determination in staging these "fake documentaries." For instance, there is no assurance that the Seniors Project is really about a thirty-year-old becoming an old person before her time through the magic of self-alteration. If viewed as social satire, Lee's undercover infiltration and simulation of senior citizenship allow us to see and to reflect on the stereotypes of old-ageism in contemporary American society.

In a similar fashion, Russell Ferguson notes that Lee's "unshakeable belief that she can, almost by force of will, become part of virtually any group suggests an extraordinarily strong self-confidence."[21] In the Skateboarders Project, Lee's self-determining choice took her to San Francisco, where she became a member of the community of those who skateboard. Unlike some of her other series, this role required that this determined performance artist learn a new skill in order to pass and be accepted into this subcultural community. While most of the images show Lee on the sidelines, a couple of shots show her in action and exposed to the thrills and spills of the sport. All these images also reveal her as the only female depicted in a risk-taking activity dominated by males and male bonding. Therefore, Lee's Skateboarders Project is also about gender and sexuality and the usual exclusion of females from skateboarders' ranks. The Skateboarders series also illustrates the commodification of subcultural identities in contemporary American culture—the ways in which the acquisition of the appropriate props, fashionable gear, and stylish consumables brands the subject with group belonging. (As already mentioned, Lee foregrounds and capitalizes on the concept of the commodity self in all of her photographic performances of community.) In other words, the Skateboarders forges identity and community identification as a product of "consumer choice." Thus, it is quite fitting that the first image of the Project reproduced in the book (Figure 8.2) is shot in front of a building adorned with a Levi's logo, which advertises the brand that did the most to advertise youth culture

in the postwar era. Another shot shows Lee with a skateboard in hand, standing in front of a wall adorned with brand-name T-shirts of skateboard gear manufacturers.

Lee's voluntarism and its assertion of the power of artistic creation and control is also implicit in the opening paragraph of her "Manifesto":

> The subject of my work is my identity and the performances in which I create the characters that compose my identity. I don't consider my work to be schizophrenic in nature. A schizophrenic has distinctly different identities that come and go, while my characters have one prevailing identity that consciously controls the manifestations of these different characters. My identity doesn't change, but the characters of which it is composed change according to the situations.[22]

Here, Lee wards off the possibility of schizophrenia that would render problematic the controlling agency of an authorizing identity. Self-determination cannot be a party to the schizo, in whom distinctly different identities come and go. Thus, Lee insists on a restricted economy of personal transformation as she capitalizes on what simulates schizophrenia. She is determined to be whoever she wants to be, but only so long as her identity doesn't change. This is a very conservative appropriation that most critics have overlooked in their appraisal of Lee's performances. However, one could argue that—like a wipeout in skateboarding—these performances resist and risk Lee's own attempts to control them in becomings that blur the boundaries of identities.

FIGURE 8.2. Nikki S. Lee, image 29 of the Skateboarders Project, 2000. Copyright Nikki S. Lee. Courtesy of Leslie Tonkonow Artworks + Projects, New York.

But the paradoxes of Lee's self-determining stance do not stop here. For no matter how much it is "dressed up" or repressed, the myth of self-determination is always indebted to the other. As Werner Hamacher reviews, "The experience of *aporia* is the only possible experience of self-determination that does not deceive itself about the fact that a self, in order to be capable of determining itself, must already be given, and that, in order to be given, it must have been given by itself, but can never be a *given.*"[23] The rhetoric of self-determination stumbles and falls upon an aporetic experience that involves indebtedness to the other (a being-given) or what Hamacher refers to elsewhere as *heterautonomy*. In either case, one is returned to the question of community—that to which Lee's work is always indebted—and this moves the conversation to a level at which one comes up against the limits of any self-determined identity. The doubling demons of schizophrenia, or, in Jean-Luc Nancy's less psychoanalytically inflected terms, "being singular plural," undermine Lee's artist statement.

It is here that Nancy's concept of the singular intervenes, and it does so in a way that shifts the terms of the discussion from identities that are conceived as indivisible atoms to a space of singularities conceived in the Lucretian sense of the *clinamen* (or swerve) that inclines being toward being-with. The singular being maps out the approach toward a liminal space of sharing and splitting where nonidentity prevails and where communal fusion is resisted. The singular being incessantly approaches the border that shares and divides the relationship single/common or individual/collective. If one were to frame Lee's Projects in terms of singularities instead of identities, then it is possible to see her photographic performances of community not as the summary identity of many enumerated personas but rather as a singular voice, in common. This formulation relates directly to Nancy's definition of the artist: "The artist is this singular voice, this resolutely and irreducibly singular (mortal) voice, in common: just as one can never be 'a voice' ('a writing') but in common."[24] One can add photography to this list and assert "just as one can never be 'a voice' (a 'light writing') but in common." From this perspective, the photography of Nikki S. Lee projects a singular light writing that appropriates itself only as an exposure to the "in-common."

Nancy also insists on the relationship of the singular being with the ecstatic. "It is linked to ecstasy: one could not properly say that the singular being is the subject of ecstasy, for ecstasy has no subject—but one must say that ecstasy (community) happens to the singular being."[25] In taking up this question in relationship to Lee's performances of community, one notes how many of these subcultural roles potentially have an element of the ecstatic in them. (This is something often unnoticed in her work that parallels the photography of Nan Goldin, as discussed previously.) The Punk Project and the Swingers Project are roles in which dancing and nightclubbing take center stage in subcultural communities where ecstasy happens to the singular being as the partying being. Meanwhile, the Lesbian Project and the Exotic Dancer Project put into play the excesses of sexuality in more intimate and more public spaces, respectively. The latter project, of course, involves topless dancing as the always already "exotic" Lee becomes a stripper at the Gold Club Gentlemen's Cabaret

in Hartford, Connecticut, in one of her most controversial performances of community. This series plays into the voyeurism and exhibitionism inherent in the female stripper, who becomes the "exposed" photographic object of erotic desire and subject to the male gaze. While the Project may be read in a feminist manner as a moral indictment of the strip club and its degradation of women, this is not at all present in Lee's rhetoric of self-determination and the desire to capitalize on subcultural spectacle. But, in either case, this rite of passing exposes being-in-common in a voyeuristic/exhibitionist dance that articulates community as the impossibility of total individualism or communal fusion.

In other audacious projects, Lee's rites of passing turn to the miming of race and ethnicity in complex performances that point to the limits of self-determination. In *Writing Diaspora,* the cultural theorist Rey Chow discusses the limits of voluntarism in regard to the study of minority cultures in the United States. Unlike the view put across by Nathan Glazer, for whom ethnicity in America is "voluntary" in character, the consciousness of race and ethnicity for Asian and other nonwhite groups is inevitable—a matter of a history of discrimination and of social interpellation rather than of choice. Like Hispanics, African-Americans, and Native Americans, Asians focus attention on the problem of voluntarism and the rhetoric of assimilation, which, as Vine Deloria Jr. puts it, "relegates minority existence to an adjectival status within the homogeneity of American life."[26]

These comments speak directly to a number of Lee's subcultural Projects in which race and ethnicity take center stage and one comes up against the limits of voluntarism. In two of these cases, the Asian-American as impersonator attempts to pass herself off as a member of two of the other minority groups (African-Americans in the Hip Hop Project and Hispanics in the project of that name) for whom race and ethnicity pose the "involuntarist" dilemma of being discriminated against by the dominant white culture. Meanwhile, in the Ohio Project and the Yuppie Project, Lee reverses direction in her satirical attempt to perform whiteness. In a recent article in *Art Journal,* Maurice Berger analyzes the Yuppie Project, in which Lee interacts with Wall Street stockbrokers, traders, and investment bankers to expose and denaturalize this unmarked and invisible racial category of power and privilege. "While these photographs play on certain stereotypes—they depict a preppie, moneyed world peopled with fresh-faced, all-American WASPs—the clichés Lee tries to inhabit also make visible a racial category that has, for the most part, remained invisible in American culture: whiteness. It is rare for any work of art to represent whiteness per se, for we live in a culture in which whiteness is so much the norm that it does not have to be named."[27] In each of these cases, Lee's practice plays both sides of the border against each other. There is the utopian desire to look beyond what separates us as well as the foregrounding of those naturalizing and discriminating markers and forces that differentiate and impose categories of race and ethnicity.[28]

The Hispanic Project offers one of Lee's boldest gestures in the performance of ethnicity. One image from the series serves as the cover of the book *Projects.* This

image shows Lee with excessive lip liner sitting on the sidewalk on August 12, 1998, in a halter with the silver nameplate of an alter ego named Genie around her neck. In another image, this "Genie" joins in what appears to be the celebration of a Puerto Rican Day Parade in New York City (Figure 8.3). Here she is featured posing with her girlfriends amid the Puerto Rican flag waving. Lee simulates belonging to the community of those immigrants who share Puerto Rican pride and patriotism. There is something incredibly ambivalent about these drag images of race and ethnicity, and perhaps the possibility of reading them in two radically diametrically opposed ways is what offers a key both to Lee's photo-cultural significance and to an explanation of what has helped to catapult her to art stardom in such a short time. This explanation involves the way in which her photographs play out the lure of ethnic voluntarism at the same time that they hint at its impossibility. On the one hand, there is Jennifer Dalton's assessment (contra Rey Chow) that ethnicity is a permeable category—self-determining and self-subscribing: "Her [Lee's] work argues that even the subcultures one is apparently born into, such as ethnic groups, are more socially fluid and self-subscribing than conventionally believed."[29] On the other hand, there is Mark Godfrey's assertion that these images always maintain the parodic wink of mimicry that casts doubts on these rites of passing. Rather than enhancing group belonging, in the end they result in pitting the artist and the audience against the group with which the artist appears. "The comedy of the images works because Lee is not a chameleon, but an artist. A shared and secret understanding springs up between artist and viewer: we

FIGURE 8.3. Nikki S. Lee, image 1 of the Hispanic Project, 1998. Copyright Nikki S. Lee. Courtesy of Leslie Tonkonow Artworks + Projects, New York.

are not like the people with whom she appears and we can recognize the subtlety of the joke. But while flattering, this complicity lulls the viewer into a kind of snobbery."[30]

The Ohio Project is a good example of a series in which questions of race and ethnicity come to the surface. In going to live in a trailer park in Ohio, Lee dyes her hair blond and attempts to blend into this zone of whiteness. This Project is the economic flip side of the Yuppie Project, in which Lee goes upwardly mobile to blend into the corporate financial world of lower Manhattan. In the Ohio Project, Lee interacts with "white trash" in scenes that find her dressing down in jean cutoffs and farmer's overalls. In the *KoreAm Journal,* Paul Lee Cannon reports voyeuristically on Lee's crossing over into uncharted racial territory: "Lee's work has taken her to places most KAs [Korean Americans] have not tread. In *The Ohio Project,* Lee lounges in full-on trailer-trash glory, replete with rickety mobile home backdrop and peroxide-blond coif next to her bare-chested hick boyfriend."[31] Perhaps the most sensational and provocative image in the Ohio Project is the one in which Lee is sitting on the arm of an armchair (in a marginalized position) next to a bearded man who has a gun slung across his knees. On the wall to their right hangs a Confederate flag containing the caption "I Ain't Coming Down"[32] (see Plate 9). While the racial confrontation here is not something that is in black and white, the presence of the contraband flag that served as the emblem of the Confederacy in the Civil War marks a resistance to the equality of the races via the sordid history of slavery. This image calls attention to Nikki S. Lee's rites of passing for a subject who is socially interpellated in terms of "yellowface" and who projects herself into the heart of whiteness. If one were to read this documentary image as a truth-telling index and as standard photographic evidence, it would offer the proof of Lee's inclusion into the ranks of the rebels and (perversely) the living proof of the American dream of self-determination. If one were to question it as a logical contradiction and an impossible joke for a "KA" to be accepted by someone with all the earmarks of a card-carrying member of the KKK, then this "fake documentary" in its extra-indexical performance would underscore the difficulty of Lee's simulation turning into complete assimilation. Will this image be read in terms of self-determination and an affirmation of a politics of inclusion or as a damning indictment of a discriminating and discriminatory practice of exclusion? The decision lies with the viewer. Swerving in between, Nikki S. Lee's rites of passing again raise the question, Who is one of us?

In engaging in these rites of passing and in performing race and ethnicity, Lee's Projects hearken back to the writings and performances of Adrian Piper of the 1970s and 1980s. For example, Lee's passing for black in the Hip Hop Project can be compared with Piper's *Funk Lessons* of the early eighties, when she taught white people the dance moves necessary to pass for black. Called "paleface" by black people yet self-identified as an African-American woman not fitting into white society either, the author of "Passing for White, Passing for Black" has always found herself in a borderline position that has given her dual access and the ability to pose questions about racial and racist categories.[33] Like Lee's work, these documented performances were

very public in nature. However, some of Piper's performances were very confronta-
tional and aggressive and induced the opposite effects from Lee's self-camouflage
assimilations. In contrast with Lee, Piper posed as the other—as the embodiment of
"everything you most hate and fear."[34] In her early *Catalysis* works, Piper confronted
people in public spaces such as subway trains and buses and tested the limits of com-
munity and the potentialities of being-with (i.e., of standing to be with other people).
In the first *Catalysis* performance, she "saturated a set of clothing in a mixture of vine-
gar, eggs, milk, and cod liver oil for a week and then wore it on the D train during
rush hour, and while browsing in the Marlboro bookstore on Saturday night."[35]
About *Catalysis IV* (1970) she explains, "I dressed very conservatively but stuffed a
large white bath towel into the sides of my mouth until my cheeks bulged to about
twice their normal size, letting the rest of it hang down my front and riding the bus,
subway, and Empire State Building elevator."[36] As an alienated graduate student and
a self-identified black woman not at all at home in the hierarchal structures of the
Harvard philosophy department, Piper created the persona of the Mythic Being—"a
third-world, working-class, overtly hostile male"—as a vehicle to give vent to her
"sense of difference and alienation from others in the Harvard environment."[37] These
examples illustrate how questions of race, ethnicity, and community belonging can be
posed via performance art and its photographic exposure either by the staging of
extreme differences and "otherness," as in the case of Piper's Mythic Being, or by
slight slippages in mimicry, as in the case of Lee's Hispanic Project.

PASSING: KOREAN/AMERICAN RITES

Anticipating the lingo of visual cultural studies and the "academic" analysis of her
work as inevitably and inextricably tied to the Asian-American diaspora in the era of
multiculturalism, postcolonialism, and transnationalism, Nikki S. Lee states: "All the
critics want to . . . bring up the academic issues of post-colonialism or Asian cultural
studies. I understand that's the first level, so I just let it be."[38] Although she quickly
proceeds to another level of reading, the present critical analysis of Lee's Projects can-
not move so rapidly. Instead, we must tarry with this diasporic and dispersed Korean
immigrant living in New York City in order to consider if and how such a subject
position impacts a body of performance and photography whose mode of operation
involves the miming of specific subcultures. It is from the perspective of the immi-
grant who exposes contemporary prejudices against minority groups and the cultural
politics of a specific ethnic and racial identity that Mark Godfrey has analyzed the
photographs of Nikki S. Lee. Plain and simple, Godfrey insists "her position as 'the
Korean' is the subtext of all the images."[39] He makes this claim through a compara-
tive analysis of Woody Allen's Zelig character, who symbolizes the wandering Jew of
New York City between the world wars. This is a reading that seeks to locate a cen-
tral axis of ethnic and national identity (being "the Korean") at the basis (or "subtext")
of this artistic chameleon's rites of passing.

As in Woody Allen's film *Zelig*, Lee plays with ideas about the immigrant's fear and the newcomer's desire to blend into their environment. . . . For just as Allen's film highlights the conformity of Zelig's society, Lee's work suggests contemporary prejudices. If Allen was also critiquing the compromised situation of the American Jew in the 20's, similarly Lee is engaging with her own ethnic identity—her position as "the Korean" is the subtext of all the images, implying that if a viewer can laugh at "The Hispanic Project," then they could also laugh at "The Korean Project."[40]

Lee's status as an immigrant and the symbolism of Americanization are directly indexed in the Tourist Project (1997), in which she poses as a foreigner visiting the tourist traps of New York City, whether she is situated in Rockefeller Center or positioned next to a pair of binoculars to admire the New York skyline. The most pointed image in this series has to be that of a tourist who wears sunglasses and a tacky New York T-shirt and stands proudly in front of the Statue of Liberty on Ellis Island (see Plate 10). It is an unusual image for Lee, because her character is standing alone and not in relation to other members of the same community. Nevertheless, the Asian tourist is clearly in a parodic relationship with the American national icon. This image is also a direct photographic reference to the Chinese conceptualist photographer Tseng Kwong Chi and the image "Statue of Liberty, New York" (1979) that is part of his expeditionary series East Meets West (1979).[41] But while the "Man in the Mao suit" coolly poses with his hand on the remote control, Nikki S. Lee's posture, the viewer quickly notes, mimes Lady Liberty's upraised hand and torch. Part of the humor of the image lies in its cutting the head, the right arm, and the torch of the Statue of Liberty from the top of the image so that we do not see the original icon that Lee is copying. In terms of the Tourist Project, the Statue of Liberty is an obvious landmark for the sightseer, and the appropriating desire to claim the icon photographically and to put oneself in the picture is also stereotypical. The camera case draped over her neck in this image is another marker of the photographic tourist in action. However, this image can also be read as emblematic of the political status of Nikki S. Lee and her relationship to the United States. On the one hand, we see her affirmation of the liberty and the self-determination that allow her to try out many so different roles in this vaunted land of opportunity and to live out her American dreams. But on the underside of this arty and artificial smile, we see the insecurity and the fear of the immigrant who has not yet been fully included or politically enfranchised. Following Godfrey's approach, the subtext of Lee's Tourist Project is that of someone who desperately wants to fit in and who invents these rites of passing as a way to prove that she really belongs. In this respect, Nikki S. Lee's Tourist Project has something in common with the patriotic photographs of the British-born Arthur Mole. In both cases, the images are emblems of the naturalization process to which their makers aspire with their community-exposed photography.

However, there are a few problems with Godfrey's argument. For one, we might ask why it is that so many of Nikki S. Lee's Projects are aimed at miming marginal

groups. If she were feeling so insecure, she would want only to pass as a member of those groups that hold power or status. But Lee wants to be a punk as much as she wants to be a yuppie. Jennifer Dalton concurs with this analysis. "The artist brings a fresh and energetic spirit to what is often a deadly serious debate over assimilation and 'passing.' These terms usually describe the process by which immigrants and members of other marginalized groups strive to enter mainstream culture, but Lee assimilates into both mainstream and marginal cultures with zeal and success, highlighting both the intricate visual markings and broader social functions of our cultural bound-aries."[42] One could just as easily make the argument that her criterion of selection would be groups considered to be hip and cool.

Furthermore, Godfrey's analysis runs into difficulties when one confronts the final Project in the book. This is the Schoolgirls Project, and it presents us with Lee returning "home" to Korea at Christmastime in the millennial year 2000. In response to Godfrey's overarching subtext, which attempts to master the meaning of Nikki S. Lee's performances of community in terms of her Korean identity, this Project fea-tures the artist performing Korean identity by simulating the community of school-girls. One might say the Project shows us that "there is no place like home." This is the only Project in which Lee's ethnic identity and nationality are congruent with the community at large. But one has a sense that after all the other roles Lee has tried on in the United States, this one is not going to be somehow outside the performance of community. First of all, the thirty-year-old must act as if she were a teenager again, and our Kodak chameleon manages to meet the camera's gaze with a naïveté and innocence that befit the youths around her. Obviously, the school dress code, con-sisting of the official uniform of black stockings, sport jacket, and knee-high skirts, makes it much easier for Lee to blend in with this community. It is clear from the image of schoolgirl Nikki in the school auditorium/chapel (featuring a Korean national flag and a Crucifix below it) that this school is one where the dominant reli-gion of the West along with its brand of Christian communion has made its mark. All of these images position Lee as the outsider artist who needs to pass into her "own" culture and its milieu. One particularly self-reflexive shot features Lee and her two companions having their picture taken at a mall photo booth, where the girls stare intently at the lens inside as they are snapped by another companion from outside the booth (Figure 8.4). This representation suggests that even naive Korean schoolgirls are engaged in rites of passing—in posing and performing their identity.

However, this is not to suggest that nothing is related to the status of the alien or the immigrant in Lee's work that speaks directly to the issues of inclusion and exclu-sion. In the history of photography, the precedent of the post–World War II Jewish Swiss immigrant Robert Frank is certainly an example of someone who captured the Americans in the 1950s in a way that relied upon this specific outsider subject position. In other words, the photographer who represents the alien, alienation, and the alien nation marks the social place of those who are unrepresented or even unrepresenta-ble in democracy.[43] In his essay "One 2 Many Multiculturalisms," Werner Hamacher

discusses the status of immigrants, refugees, and asylum seekers as the "unrepresented or unrepresentable" that keep democracies vigilant and that point out how democracies are never democratic enough, how democratization necessarily demands the passage from exclusion to inclusion. "In keeping with the claim of the unrepresented or unrepresentable to democratic representation, the borders of democratic states must be open again and again, and ever wider: to refugees, asylum seekers, immigrants regardless of origin—what counts is only their future and the future of democratization."[44] From this perspective, the multiple faces of Nikki S. Lee serve as the means by which the unrepresented or unrepresentable immigrant artist and border denizen finds the means to pass through the other and to pose the future of democratization. This happens in images that expose community as a site of exchange and passage at the border of its inclusions and exclusions.

If one compares Nikki S. Lee's rites of passing with the strategies of fellow Korean-American artist Yong Soon Min, the contrast in terms of the negotiation of the politics of identity and of relating to the subject position of the alien could not be any more different. Born in Korea in 1953 at the end of the war and immigrating to the United States at the age of seven, Yong Soon Min has produced sobering and solemnizing work rooted in the political and cultural memory of Korea as a colonized and divided nation of the Cold War era. In a photo-based work such as the series Defining Moments, she inscribes and tattoos the cultural memory of oppression onto her body in the attempt to connect pivotal events in Korean history with her own

FIGURE 8.4. Nikki S. Lee, image 25 of the Schoolgirls Project, 2000. Copyright Nikki S. Lee. Courtesy of Leslie Tonkonow Artworks + Projects, New York.

personal life trajectory. Yong Soon Min's work seeks to assert Korean female identity as an independent and decolonized entity. Her work refuses to pass into the model American family. It stages a resistance to the attempt to colonize or assimilate both her body and her history. As an immigrant living in the United States, she writes, "We are like errant children disowned for bad behavior by their foster parents because we don't belong in the model American family."[45] Born into a later generation in postwar Korea and coming to the United States at the age of twenty-four, Nikki S. Lee's assimilatory Projects are the antithesis of Yong Soon Min's approach in certain respects. The gregarious Lee is not somebody who is about to be thrown out or disowned for bad behavior in these subcultural rites of passing. However, in her own sly way, Lee's communal mimicry is also asking whether and how she might belong to these model and not-so-model American families. If the immigrant images of Nikki S. Lee subvert, they do so by means of postmodern parody and pastiche rather than by means of the active resistance of a disowned identity.

PROJECTING: THE PARODICS OF PERFORMATIVITY

The concept of the project is recurrent and overdetermined for Nikki S. Lee. However, it is important to question the goal directedness of the project and the desire to have or to reach an end. Here it is appropriate to recall Nancy's reading of Georges Bataille's thinking of community as a refusal of the project in the assertion of play. "Of course, to not reach an end was one of the exigencies of Bataille's endeavor, and this went hand in hand with the refusal of project to which a thinking of community seems inexorably linked. But he himself knew that there is no pure non-project. ('One cannot say outright: this is a play, this is a project, but only: the play, the project dominates in a given activity.')"[46] In Lee's case, one can assert something similar. Her image projections foreclose the goal directedness of the project by inscribing the play and the parody of these performances of community.

But while the most obvious way to read the title of Lee's book is as a noun, there are a number of reasons to view it as an active verb and to explore how Nikki S. Lee *projects* herself. This is a term that cuts across many registers of meaning—photographic, cinematic, theatrical, psychoanalytic, and philosophical. From all appearances, Lee views these projections of herself in the same way that an actor views the assumption of a role. That is why it is not surprising to learn in interviews that Lee's childhood fantasy, when she was still Lee Seung-Hee, was to become a movie star. "When I went to university, I decided I wanted to be an actress and to be in film. But I realized I'm not pretty enough to be an actress in Korea. I looked in the mirror, looked at my face and said, 'Okay, I give up, but maybe I can make a movie.'"[47] This is an intriguing passage with Lacanian overtones. A young Lee Seung-Hee looks into the mirror and recognizes that her face is not of movie star quality. In a sense, she projects the prototypical Korean movie star face unto her own and finds no correspondence. At that moment, she imagines herself in the directorial chair as an alternative

career to the one made impossible by this presumed lack of movie actress looks. Furthermore, Lee discusses that she decided to go into photography as a "side door to film."[48] But in combining performance art with photography—and particularly the fashion end of photography, in which she started and which still fascinates her—Nikki S. Lee has managed to have the best of both worlds. She operates in the "directorial mode of photography" (to recall A. D. Coleman's phrase) while playing the model that enacts all of these varied roles. As she operates on both sides of the camera, Lee functions as an image projector. She discusses her chameleon-like capacities as a performer in the Vicario interview in a manner that stresses the logic of the fold that creases and doubles over identity.[49] In this way, the impersonator describes the twin process of projection onto and folding into. "I came to the US in 1994 and I was raised in Korea. But it's strange: I can put myself into all these different cultures here and fold them into myself. Maybe it's a very special ability."[50]

Using the terms of Lacanian psychoanalysis as filtered through the writings of Kaja Silverman and Marianne Hirsch, one could explain this very special ability as Lee's capacity to understand how the subject is constituted as an effect of a screening process and to stage her masquerades and mimicry as the means to actively intervene in this process along a number of parameters of subjectivity. While writing about the "familial gaze" and the staging of the familial subject, Hirsch's remarks are applicable to Nikki S. Lee's image projections and the imaginary relationships of community that they forge. Hirsch writes: "Subjects are constituted and differentiated in relation to a screen that is informed and shaped by a variety of parameters—class, race, gender, sexuality, age, nationality—that determines the ways we see and are seen. . . . If the gaze and the look cannot constitute subjectivity except through the grid of the screen then the screen becomes the place of the subject's active intervention—through mimicry and masquerade—in the imaginary relationship."[51]

One of Lee's first projections of herself into the world of subculture involved the punk community in a series of images taken in February 1997, while she was still in graduate school. The miming and doubling of punk style was a marvelous choice for Lee to access the necessary level of parody that adheres to such a performance of identity. It is not just that Lee mimed the semiotic codes in her adaptation of punk dress and attitude, from leather and chains to the look of wasted disgust (Figure 8.5). Her parody also forces a questioning of the authenticity of punk subculture in the first place. Or, better yet, it makes us recall the perverted clownishness and carnival aspects inhabiting punk subculture from the start. Consider Dick Hebdige's analysis of punk in which he focuses on this subculture's foregrounding of class issues via a spiked and barbed sense of humor. "We could go further and say that even if the poverty was being parodied, the wit was undeniably barbed; that beneath the clownish make-up there lurked the unaccepted and disfigured face of capitalism."[52] From this perspective, Lee's simulation of punk enacts Hebdige's own fear of the recuperation of punk into a commodity and a mere fashion statement or the move "from resistance to incorporation."[53]

But one also can read the attraction of Lee to the punk movement from a much more respectful position—one that forged an alliance between the young performance artist and an anarchic youth gang in their finding of commonalities around the staging of ploys to escape and transgress the principle of identity. In this regard, Lee can be said to be working in the same tradition of performance art that finds its roots in Dada and surrealism. "Through punk rituals, accents and objects . . . , the exact origins of individual punks were disguised," Hebdige proposes, "symbolically disfigured by the make-up, masks and aliases which seem to have been used, like Breton's art, as ploys 'to escape the principle of identity.'"[54] As Lee projects herself into this subcultural underground, the images of the Punk Project show a red-haired and leather-jacketed woman at home in this alias that licenses the "abjecting" of her subjectivity, as in the shot in which Lee appears ready to vomit while her rowdy punk pals cut up for the camera.

But even though Lee has claimed that her image projections mean just hanging out and that she needs to respect boundaries (as when she says, "I don't live with the people, I just hang out. I have to have borders"),[55] the Lesbian Project hints at a very different kind of relationship. First, it is one of the few projects in which most of the shots are taken indoors and in a private domestic space rather than in public. All except one of the snapshots reproduced in *Projects* focus on a specific couple, and these images bear similarities with and mime the style of Nan Goldin as they expose the intimacies of sexual relationships. This cool interracial lesbian couple features

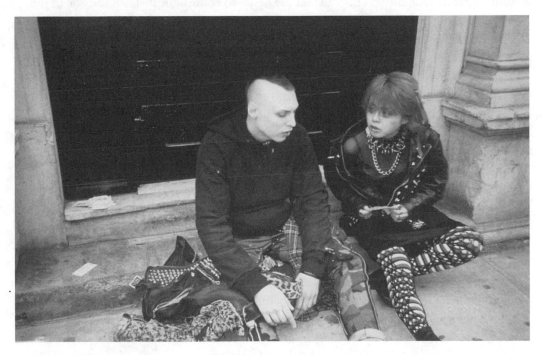

FIGURE 8.5. Nikki S. Lee, image 6 of the Punk Project, 1997. Copyright Nikki S. Lee. Courtesy of Leslie Tonkonow Artworks + Projects, New York.

Lee's persona sporting jet-black hair, sometimes glasses, and a tattoo on her right arm, along with her friend, a young white woman with blond hair. We witness five shots of the couple "at home" in interior spaces as they engage in romantic domestic activities—cooking in the kitchen, snuggling together while watching television, and making love. In one particularly voyeuristic image, the lovers are shown tongue-kissing each other (see Plate 11). In performing lesbian identity, it appears that Lee has gotten caught up in the action. This series raises some intriguing Baudrillardian questions of simulation: Was Lee having a real or a staged affair with this other woman? To what extent was either of them emotionally involved? To what extent was either of them faking it?

On the one hand, such a projection makes lesbianism appear to be a choice of lifestyles linked again to the rhetoric of self-determination. On the other hand, the Lesbian Project raises doubts that this actor can be considered an authentic lesbian without a level of activism or a history of commitment that goes beyond the "super-ficiality of surface appearance" (to deploy Abigail Solomon-Godeau's phrase) that is photographic representation.[56] Again, Lee's Projects raise the question of belong-ing, of what it means to be considered a member of the lesbian community. But if one moves the discussion from self-determining identities to singular beings who seek to touch their limits and who have a passion for community that is exposed only inasmuch as it is shared, then the Lesbian Project (whether staged or not) offers Nikki S. Lee's photography as a lover's discourse of image projections and transformations, photography that answers the call and the desire to communicate from the one to the other. Rather than affirming a lesbian identity, Lee's Lesbian Project and her other projections point to the sharing of everyone's nonidentity. As Nancy notes, "What is shared therefore is not the annulment of sharing, but sharing itself, and consequently everyone's nonidentity, each one's nonidentity to himself and to others."[57]

If we look at Lee's Lesbian Project only in terms of questions of authenticity, then we miss how its parodic mimicry is very much in dialogue with Judith Butler's ideas about gender and the performance of identity.[58] In *Gender Trouble: Feminism and the Subversion of Identity*, Butler argues for gender as a construction in the attempt to denaturalize any and all of its manifestations. She calls attention to drag, cross-dressing, and sexual stylization as parodic mechanisms that have the subversive power to expose gender as performance and to problematize the notion that there is any original whatsoever. "The notion of gender parody defended here does not assume that there is an original which such parodic identities imitate. Indeed, the parody is *of* the very notion of an original."[59] The deconstruction of gender via performances of parodic repetition becomes a mechanism by which to challenge heteronormativity and to affirm heterautonomy. Butler concludes her study in the final chapter, "Con-clusion: From Parody to Politics," with the following passage: "The parodic repetition of gender exposes as well the illusion of gender identity as an intractable depth and inner substance. As the effects of a subtle and politically enforced performativity, gen-der is an 'act,' as it were, that is open to splittings, self-parody, self-criticism, and those

hyperbolic exhibitions of 'the natural' that, in their very exaggeration, reveal its fundamentally phantasmatic status."[60] It is interesting to point out in this context that the Drag Queen Project was one of Lee's first projects, which involved the double take of her miming a man miming a woman. While not included in her book, it can be used as a template for the mode of drag performativity that governs her work.

One can argue that all of Nikki S. Lee's Projects operate in the manner sketched out by *Gender Trouble* and that the Lesbian Project is an especially apt one because it redoubles Butler's subversive logic in opening lesbianism to the "splittings" and self-parody always already contained within it. In doing lesbianism as a mode of gender performance, Lee's parodic repetition and hyperbolic exhibition expose "the natural" as an act. But one can argue that this questioning through parodic projection does not stop at gender and that Lee pushes it much further so that it encounters all the major axes of the politics of identity as the subversion of gender identity gives way to ethnicity, class, sexuality, and so forth. In each and every case of projection, parodic doubling and the consequent questioning of the norm contaminate the purity of the original or of doing what comes naturally.

It is at this juncture that laughter breaks out. As Judith Butler notes, "The loss of the sense of the 'normal,' however, can be its own occasion for laughter, especially when the 'normal,' the 'original' is revealed to be a copy, and an inevitably failed one, an ideal that no one can embody. In this sense, laughter emerges in the realization that all along the original was derived."[61] From this perspective, the photographs of Nikki S. Lee illustrate rites of passing that inevitably fail and cannot live up to their ideals. However, following Butler, if the net result of these parodic projections is a total questioning of all norms, originals, and ideal (stereo)types (whether yuppie, punk, or Hispanic) that reveals them to be constructions and phantasmatic structures, then these are rites of passing that pass at nothing. One might refer to this net result as the punch line of the parodic performances of Nikki S. Lee's Projects or their zero-sum game.

CODA: LET'S BE NIKKI/LET NIKKI BE US

In his introduction to *Projects,* Russell Ferguson relates how the twenty-four-year-old Lee Seung-Hee became Nikki S. Lee. It is an old story, yet another rite of passing. It is the standard assimilation narrative of changing or adapting one's name in order to become Americanized.

> When Lee Seung-Hee came to America in 1994, one of her first decisions was to get an "American" name. She asked a friend to send her some to choose from. On receipt of them, the choice was made, and Nikki S. Lee came into existence. Only later did Lee discover that her friend had compiled her list from names in that month's *Vogue.* Nikki Lee, it turns out, is named after the model Niki Taylor. She thus began her life in the United States by giving herself another identity, taking her new name from someone who herself is constantly photographed in different costumes.[62]

Ferguson sees it as something quite uncanny and quite fitting that the Niki who bore the name appropriated by Lee was a Vogue fashion model. One notices that this story of appropriation of the proper name (with the extra *k*) is again cast in the voluntaristic mode of a free choice (with names "to choose from") and self-determination ("giving herself another identity") that repress heterautonomy or the gift of the other.[63]

Ferguson then proceeds to inform the reader of another interesting anecdote that relates this name game to the question of community. "Today Lee wears a gold necklace with letters that spell out the phrase, 'Let's Be Nikki.' The implication is clear, but a little unsettling. If she can be you, then perhaps you could be her. All identities are potentially in play at any given moment, even those that we might assume are exempt. Even artist. As Lee herself says, "I'm doing The Artist Project. There aren't any pictures of it, but it exists."[64] While the Projects offer the picture of the Hispanic Nikki in the assumed identity of the persona named Genie with a gold chain around her neck to prove it, the book contains no images of the artist with the gold necklace that enjoins us to be Nikki. Ferguson makes a good point when he suggests that Lee's Projects put all identities in play at any given moment. In other words, Lee makes every community member think about his or her performances of community by asking him- or herself the question, Who is one of us? In the face of these doubles and decoys, something slips in between that forces such a self-interrogation and that implicates the viewer in the work. Ferguson refers to the phrasing "Let's Be Nikki" as unsettling, but he does not problematize the predicate nominative enough when he suggests that "you could be her" and then authoritatively turns to the artist and her self-possessive pronoun "as Lee herself says." In a sense, Ferguson settles here for something less than what is put into circulation and dissemination in the name Nikki S. Lee. As discussed previously, this is not to deny that Lee's artist statement also deploys the same maneuver of centering her in the attempt to control her personas from the perspective of a fixed identity and of an authorial and authorizing "I."[65] But this reading coexists with another—always another exposure and one that is necessarily posed in exteriority—that speaks to Nikki in the name of an other and that, in invoking us to become Nikki, gives us pause to wonder who in the world is the referent of the statement "you could be her."

The statement "Let's Be Nikki" (whoever she may be) can be seen as the flip side of the question of community addressed by the Projects, in which Lee seeks to become one of us. In other words, "Let Nikki Be Us." For these photographic exposures and rites of passing shot in the name of Nikki S. Lee repeatedly ask: Have I become one of them? Have I been able to pass and thereby become "one of us"? Have I been included, or am I still on the outside? But these questions that are perched at the border of inclusion and exclusion have no definitive answers. Instead, the intriguing snapshots of Nikki S. Lee are light-written riddles that offer no clear-cut proofs. As rites of passing, they ceaselessly return to and regenerate the question of community—of who is one of us. This is the question that our being-in-common, whether in the form of being-Nikki-in-common or Nikki-being-us-in-common, cannot get past.

NOTES

INTRODUCTION

1. Benedict Anderson, introduction, *Imagined Communities: Reflections on the Origin and Spread of Nationalism* (London: Verso, 1983), 15.

2. Neal Slavin, *When Two or More Are Gathered Together* (New York: Farrar, Straus and Giroux, 1976).

3. This "Memo" is dated June 5, 1973.

4. Jean-Luc Nancy, *Being Singular Plural,* trans. Robert D. Richardson and Anne E. O'Byrne (Stanford, CA: Stanford University Press, 2000), 61–62.

5. Martin Heidegger, *Sein und Zeit* (Tübingen: Max Niemeyer Verlag, 1993), 120; my translation.

6. As Heidegger puts it, "Being-with is an existential characteristic of Dasein even when factically no Other is present-at-hand or perceived. Even Dasein's Being-alone is Being-with in the world." See Martin Heidegger, *Being and Time,* trans. John Macquarrie and Edward Robinson (New York: Harper and Row, 1962), 156–57.

7. John S. Caputo, "Community without Community," *Deconstruction in a Nutshell: A Conversation with Jacques Derrida* (New York: Fordham University Press, 1997), 107–8.

8. See Miami Theory Collective, ed., *Community at Loose Ends* (Minneapolis: University of Minnesota Press, 1991). The volume begins with Jean-Luc Nancy's pivotal study "Of Being-in-Common" and goes on to include contributions from Peggy Kamuf, Christopher Fynsk, Chantal Mouffe, Verena Andermatt Conley, and the late Linda Singer (to whom the volume is dedicated).

9. Jean-Luc Nancy, *The Inoperative Community,* ed. Peter Connor, trans. Peter Connor, Lisa Garbus, Michael Holland, and Simona Sawhney (Minneapolis: University of Minnesota Press, 1991), 15. The book was originally published as *La communauté désoeuvrée* (Paris: Christian Bourgois Éditeur, 1986), and this quotation is found on page 43.

10. For Roland Barthes, the photograph induces "a micro-version of death (of parenthesis)," in which the exposed subject is "truly becoming a spectre" (14). See Roland Barthes, *Camera Lucida: Reflections on Photography,* trans. Richard Howard (New York:

Hill and Wang, 1981). For Eduardo Cadava's elegant and elegiac meditation crossing Walter Benjamin with deconstruction, photography "speaks to us of mortification," acknowledging "that it is always already touched (or retouched) by death" (12). See Eduardo Cadava, *Words of Light: Theses on the Photography of History* (Princeton, NJ: Princeton University Press, 1997).

11. Cadava, *Words of Light*, 13.

12. Maurice Blanchot, *The Unavowable Community*, trans. Pierre Joris (Barrytown, NY: Station Hill Press, 1988), 11.

13. Nancy, *The Inoperative Community*, 15.

14. "The Negative Community" is the title of the first part of Blanchot's *The Unavowable Community*. The photographic resonances of this term also should be kept in mind. For a further elaboration of a non-Hegelian negativity that cannot be put to use, see Ignaas Devisch, "Négativité sans emploi," *Symposium*, yearbook 4 (vol. 2, 2000): 167–87.

15. See Ignaas Devisch, "Jean-Luc Nancy," *The Internet Encyclopedia of Philosophy*, www.utm.edu/research/iep/n/JLNancy.htm#Community (accessed August 25, 2003).

16. In *The Unavowable Community*, Maurice Blanchot refers to "the principle of incompleteness" as the key to Bataille's understanding of community. "There exists a principle of insufficiency at the root of each being" (5).

17. Nancy, *The Inoperative Community*, xxxix.

18. Ibid., 66–67.

19. Ibid., xxxvii.

20. Ibid., 41.

21. The French reads: "en métamorphosant toute chose en une altérité d'autant plus altérée qu'elle nous est proche, qu'elle nous renvoie à notre immédiateté familière. Toujours par conséquent elle murmure un nous autres: nous autres les exposés, les irradiés du soleil, de la lune et des projecteurs." I thank Jean-Luc Nancy for sharing this text and the background to its publication. As he relates, "'Nous autres' was written for and published by Fotospaña, the photo festival of Madrid (Nosotros, Madrid, La Fabrica, 2003)— 'Nosotros' = we (the '*nous autres*' seems to me untranslatable . . .) was given as the theme of the festival, which presented mainly pictures of people (but my text has not been written toward any particular picture)." E-mail correspondence, Jean-Luc Nancy to Louis Kaplan, May 25, 2004. Thanks also to Heather Diack for her help with the nuanced translation of this passage.

22. Nancy, *The Inoperative Community*, xxxix.

23. The importance of semiotics to photography theory is already embedded in the pivotal volume of the early 1980s that was edited by Victor Burgin and is entitled *Thinking Photography* (London: Macmillan Education, 1982). While insisting on the nonexclusivity of semiotic theory, Burgin, in the introduction, points to its crucial importance: "To argue that the specificity of the object to be constituted in photography theory is semiotic is not to restrict the theory to the categories of 'classic' semiotics" (2).

24. Charles Sanders Peirce, "What Is a Sign?" (1894), *Collected Papers*, vol. 2, ed. Charles Hartshorne and Paul Weiss (Cambridge, MA: Belknap Press, 1965–1967), 297–302. See online at www.iupui.edu/~peirce/ep/ep2/ep2book/ch02/ch02.htm.

25. Geoffrey Batchen makes this astute point in *Burning with Desire: The Conception of Photography* (Cambridge, MA: MIT Press, 1999), 195. Batchen recalls: "As Sekula would have it, 'everything else, everything beyond the imprinting of a trace, is up for grabs.' . . . In coming to this conclusion, Sekula refers to Rosalind Krauss's influential writings about the index." See Rosalind Krauss, "Notes on the Index, Part 1," *The Originality of the*

Avant-Garde and Other Modernist Myths (Cambridge, MA: MIT Press, 1986), 196–209. Krauss's photographic formula reads: "Its power is as an index" (203). For Sekula, see "Dismantling Modernism, Reinventing Documentary (Notes on the Politics of Representation)" (1978), *Photography against the Grain and Photo Works 1973–1983* (Halifax: Press of the Nova Scotia College of Art and Design, 1984), 57.

26. Barthes, *Camera Lucida*, 80.

27. For an online version of Cadava's lecture, see the Slought Foundation, "New Futures for Contemporary Life," www.theorizing.org/content/11138 (accessed March 16, 2004). Cadava stresses the "refugee status" of Sheikh's photos of Afghani fathers as they offer their little snapshot memorials of dead relatives in the palms of their hands. "They also bear witness to the force of decontextualization that takes place in every photograph and that thereby enables us to suggest something about the nature of photography in general." I take up the same issues regarding photographic iterability and its application to the detached and anonymous hand (chapter 4) in my book *Laszlo Moholy-Nagy: Biographical Writings* (Durham, NC: Duke University Press, 1995).

28. Cadava, *Words of Light*, 61. Cadava then goes on to quote Nancy's study "Finite History" on history and the problem of representation. As Nancy puts it: "History is unrepresentable, not in the sense that it would be some presence hidden behind the representations, but because it is coming into presence as event."

29. Batchen, *Burning with Desire*, 198.

30. Nancy, *Being Singular Plural*, 93.

31. To reference the books that have not been already mentioned: Giorgio Agamben, *The Coming Community*, trans. Michael Hardt (Minneapolis: University of Minnesota Press, 1993); and Alphonso Lingis, *The Community of Those Who Have Nothing in Common* (Bloomington: Indiana University Press, 1994). For the case of Jacques Derrida, I single out *The Politics of Friendship*, trans. George Collins (London: Verso, 1997), among innumerable others that have marked this text.

32. Blanchot, *The Unavowable Community*, 1.

33. Nancy, *The Inoperative Community*, 16.

34. Interestingly enough, Nancy's photography studies have been quite recent projects, and all of them involve some aspect of community. In addition to "Nous autres" (We others), Nancy has published "Lumière étale" (Steady light) in the book *WIR* (the German word for "we"), with his text closely linked to the images of Anne Immelé (Paris: Filiganes Éditions, 2003). Nancy has also written an essay on photographs of the tram workers of Strasbourg. The images are by Nicolas Faure, and there is also a study by Philippe Lacoue-Labarthe. See Nicolas Faure, Philippe Lacoue-Labarthe, and Jean-Luc Nancy, *Portraits/Chantiers* (Geneva: MAMCO—Musée d'Art Moderne et Contemporain of Geneva, 2004). Jean-Luc Nancy, "Georges," *Le poids d'une pensée* (Sainte-Foy, Québec: Éditions le Griffon d'argile, 1991), 113–24.

35. Ibid., 116. The original text reads, "C'est comme si la réalité de ton regard sur ta propre image à venir—mais aussi sur moi, qui prends la photo—formait la surface même, étalée, brillante et nette de la photo."

36. Ibid., 122. The text reads, "La photographie montre la réalité de la pensée." This citation is also the epigraph to Cadava, *Words of Light*.

37. Hal Foster, "Death in America," *October* 75 (Winter 1996): 37–60.

38. Ibid., 42.

39. Blanchot, *The Unavowable Community*, 9.

40. Jacques Derrida, "A 'Madness' Must Watch Over Thinking," in *Points: Interviews, 1974–1994*, ed. Elizabeth Weber (Stanford, CA: Stanford University Press, 1995), 355.

41. For an interesting article that allies Warhol to Weegee, see Kristen Hope Bigelow, "Warhol's Weegee," *New Art Examiner* (October 1994): 21–25. One thinks in this context of Weegee's allegorical image "Their First Murder" (October 9, 1941). It shows a group of schoolchildren who forge community (for themselves and for the viewers of this image) around the corpse of a murder victim absent off-camera, at whom they are gazing and gaping.

42. "What Is Pop Art? Part I: Interviews by G. R. Swenson" (*Art News,* November 1963), reprinted in Steven Henry Madoff, ed., *Pop Art: A Critical History* (Berkeley: University of California Press, 1997), 104.

43. Quoted phrase is from Foster, "Death in America," 41.

44. Ibid., 43.

45. Nancy, *The Inoperative Community,* xxxvii.

46. Quoted in Madoff, ed., *Pop Art,* 105.

47. Susan Sontag, "America, Seen through Photographs Darkly," *On Photography* (New York: Farrar, Straus and Giroux, 1978), 44.

48. Jacques Derrida, "Freud and the Scene of Writing," *Writing and Difference,* trans. Alan Bass (Chicago: University of Chicago Press, 1978), 224.

49. In addition to Electric Chair, Warhol's *Thirteen Most Wanted Men* and its own scandalous exposure of community also must be read in this light. As his contribution to the pop art exposition at the New York State pavilion in the World's Fair, Warhol submitted a silk screen of the thirteen most wanted criminals of the FBI. This incurred the wrath of the authorities, who did not appreciate the in-operator's exposure of this fugitive cut that articulates community and divides "us" and "them." While they censored the work, this did not lead to a mere whitewashing. Instead, it produced a signature effect that allowed Warhol to paint over the mural in a wigged-out shade of silver. From the perspective of the in-operator, one might argue that these self-effaced works mark the violence of the decision that it takes to found the law of community and its other, inside and out. For a recent discussion of the gay subtext of the *Thirteen Most Wanted Men* and its double-coding between "official surveillance and illicit desire" (137), see Richard Meyer, "Most Wanted Men: Homoeroticism and the Secret of Censorship in Early Warhol," *Outlaw Representation* (London: Oxford University Press, 2002), especially 128–53.

50. Stephen Koch, *Stargazer: Andy Warhol and His Films* (New York: Praeger, 1973), 32.

51. Foster, "Death in America," 42.

52. Andy Warhol, *The Philosophy of Andy Warhol* (New York: Harcourt Brace Jovanovich, 1975), 80.

53. Ibid.

54. Ibid., 81.

55. The original text reads: "Das Ich verweigert es, sich durch die Veranlassungen aus der Realität kränken, zum Leiden nötigen zu lassen, es beharrt dabei, dass ihm die Traumen der Aussenwelt nicht nahe gehen können, ja es zeigt, dass sie ihm nur Anlässe zu Lustgewinn sind." Sigmund Freud, "Der Humor" (1928), *Werke aus den Jahren 1925–1931* (Frankfurt: S. Fischer Verlag, 1948), 385.

56. See Jennifer Doyle, Jonathan Flatley, and José Esteban Muñoz, *Pop Out: Queer Warhol* (Durham, NC: Duke University Press, 1996).

57. See Thierry de Duve, "Andy Warhol or the Machine Perfected," trans. Rosalind Krauss, *October* 48 (Spring 1989): 4.

58. David Antin's "Warhol: The Silver Tenement" is particularly appropriate here because he sees the Warholian mirror as a "cracked mirruh," and he overhears this crack

through the "deathlike voice" of Nico in her German-inflected refrain, "Let me be your mirruh!" See Madoff, ed., *Pop Art,* 290. The cracking of the mirror, or what Antin calls the "precisely pinpointed defectiveness" of Warhol's silk screens, locates the opening to his flawed vision of community.

59. These lyrics seem to cry out for an image from Nan Goldin's *Ballad of Sexual Dependency* (New York: Aperture, 1986). And let us not forget that *The Ballad* pays homage to this song as one of its chapter headings. Her "community at loose ends" will be the subject of chapter 4.

60. Agamben, *The Coming Community,* 10–11.

61. Anderson, *Imagined Communities,* 16.

62. Archibald MacLeish, *Land of the Free* (New York: Harcourt Brace, 1938), 88.

63. Jean-Luc Nancy, "Cut Throat Sun," in *An Other Tongue: Nation and Ethnicity in the Linguistic Borderlands,* ed. Alfred Arteaga (Durham, NC: Duke University Press, 1994), 123–33.

64. Jacques Derrida, "Loving in Friendship: Perhaps—the Noun and the Adverb," in *The Politics of Friendship,* 42.

65. Nancy, *Being Singular Plural,* 21.

66. Here I paraphrase Pierre Joris in his "translator's preface" to Blanchot's *The Unavowable Community.* "That death, disaster, absence are at the core of this possibility of community—making it always an impossible, absent community—is, in effect, the central thrust of *The Unavowable Community*" (xiii).

1. "LIVING PHOTOGRAPHS" AND THE FORMATION OF NATIONAL COMMUNITY

1. This loose cyber-network owes much to the efforts of Melissa Shook and Sally Stein for its foundation, and Margaret Wagner runs the Web site currently. The site also includes photographs by Karl Baden, Margaret Morton, and Marion Faller, among others. See www.umb.edu/flaggingspirits/.

2. Marshall McLuhan and Quentin Fiore, *War and Peace in the Global Village* (New York: Bantam Books, 1968), 97.

3. Examples of Mole's living insignia photographs of fraternal organizations are the Knights of Columbus and the YMCA (consisting of eight thousand officers and other men at Camp Wheeler in Georgia) as well as one stunning high school group shot on its football field for some extra teen spirit. This last image is one of Mole's final living photographs. It gathered fifteen hundred students and faculty of Phoenix Union High School, in Phoenix, Arizona, in the formation of a coyote (their school emblem) on November 17, 1933. For the most part, this portion of the chapter will focus on Mole's military insignia and those symbols exposing national community.

4. Max Kozloff, "Photographers at War," *The Privileged Eye: Essays on Photography* (Albuquerque: University of New Mexico Press, 1996), 213. There is no disagreement with this aspect of Kozloff's analysis of Mole, but his views regarding Mole's images and the question of community will be analyzed later in the chapter.

5. The commercial aspect of Mole's photographs is well known, and, most often, the consumers were those very servicemen who had posed in the picture and wanted it as a souvenir (even if they appear as a speck in the final image). This procedure was sometimes referred to as *kidnapping.* In her brief review "Arthur Mole's Living Portraiture," Maud Lavin notes that "the photographs are reported to have sold widely." See *Art Express* 2 (September–October 1981). Some of the images were made into postcards as well.

6. I thank Sally Stein for her astute comment here that one has to take into consideration the motivations of both the wartime and the postwar images that were shot by Mole.

7. See Jeffrey Schnapp's online exhibition Faces in the Crowd, which he curated at the Stanford Humanities Lab in 2001. The quotation and the reproduction of Mole's images can be found at http://shl.stanford.edu/Crowds/galleries/faces/faces9.htm (accessed July 1, 2003). Schnapp conceives of Mole's (and Goldbeck's) work in terms of "mass panoramas." Thus, Schnapp remarks that Mole "made use of panoramic photographic techniques both to portray entire battalions and to provide emblems of American national identity."

8. The most information is to be gleaned from the master's research of David L. Fisk, entitled "Arthur S. Mole: The Photographer from Zion and the Composer of the World's First 'Living Photographs,'" which was published in the History of Photography Monograph Series at Arizona State University in 1983. Meanwhile, the best collection of Mole and Thomas's images is located at the Chicago Historical Society. I am grateful to the Chicago Historical Society for its permission to reproduce the Mole and Thomas photographs in this chapter.

9. Jacques Lacan made this assertion in "Les formations de l'inconscient," *Bulletin de psychologie* 8 (1957–1958).

10. Judith Roof, *Reproductions of Reproduction: Imaging Symbolic Change* (New York: Routledge, 1996), 11.

11. Ibid.

12. Another undated Mole and Thomas photograph of a flag is complete with decorative tassels on its sides. The so-called "Living Service Flag" features ten thousand officers and other men on a polo field near Fort Riley, Kansas, in service to the flag of the U.S. armed services.

13. Martin Rubin, *Showstoppers: Busby Berkeley and the Tradition of Spectacle* (New York: Columbia University Press, 1993), 101.

14. Siegfried Kracauer, "The Mass Ornament," trans. Don Reneau, in *The Weimar Republic Sourcebook,* ed. Anton Kaes, Martin Jay, and Edward Dimendberg (Berkeley: University of California Press, 1994), 406. The text was first published in German as "Das Ornament der Masse," *Frankfurter Zeitung* 420 (June 9, 1927). Kracauer's article focuses on the visual spectacles of the Tiller Girls, whose geometric patterns and aesthetic gymnastics bear comparison to Busby Berkeley's stagecraft.

15. Tony Thomas and Jim Terry, with Busby Berkeley, *The Busby Berkeley Book* (Greenwich, CT: New York Graphic Society, 1973), 70.

16. Rubin, *Showstoppers,* 112.

17. For a general survey of the Farm Security Administration's work in the social documentary mode, see Roy E. Stryker and Nancy Wood, *In This Proud Land: America 1935–1943, as Seen in the FSA Photos* (Boston: New York Graphic Society, 1975).

18. Thomas and Terry, *The Busby Berkeley Book,* 19. The two sections that discuss Berkeley's military years are "Uncle Sam Wants You" and "His First 'Production Number,'" 18–19.

19. Ibid., 70.

20. This information can be found on the Web site of the Zion Genealogical Society at http://wkkhome.northstarnet.org/zion/ccc.html (accessed February 23, 2005). See the articles "Christian Catholic Church" and "History of the Founding of Zion."

21. Of course, a lot of preparations had to be made before the final snapping of each living photograph. Doug Stewart reviews the standard procedure in "How Many Sailors

Does It Take to Make an American Flag?" *Smithsonian Magazine* (January 1996): 58–63. "For each picture, Mole and Thomas would spend a week or more doing the groundwork, literally. Mole would place a tracing of his desired image on a ground-glass plate mounted on his 11-by-14 inch view camera. Then, using a megaphone, body language, and, for distant sections, a long pole with a white flag tied to the end, Mole would position his helpers as they nailed the pattern to the ground using miles of lace edging. He worked out in advance precisely how many troops would be needed and how they should dress—jackets or shirtsleeves, campaign hats or bare heads" (58–60).

22. Nancy, *The Inoperative Community*, 10.

23. This show was curated by Peter Galassi and Wendy Weitman, and it is part of the twenty-four MoMA exhibitions related to the sprawling topic of their title: Making Choices (1920–1960).

24. Before taking leave of Mole's military insignia, I should also mention another noteworthy example in this genre: a postwar celebration photo entitled "Living Insignia of the Twenty-seventh Division (New York's Own)," which assembles ten thousand officers and enlisted men on March 18, 1919, in the form of their own "NY" logo (which resembles the insignia on the New York Yankees baseball cap). This group portrait commemorates this military team on account of their feats as "breakers of the Hindenburg line."

25. As David Fisk notes, "The depiction of President Wilson's head and shoulders included 21,000 men and women and was assembled at Camp Sherman in Chillicothe, Ohio" ("Arthur S. Mole," 4).

26. This museum is located inside the pedestal of the statue. One can visit its Web site at www.nps.gov/stli (accessed June 16, 2001).

27. See Ellen Zweig, "The Missing Context: A Review of *The Panoramic Photography of Eugene O. Goldbeck*," *Exposure* 26, no. 2/3 (1988): 36. Zweig criticizes the move to make Goldbeck's vernacular images speak in the language of art history.

28. These three major works are: Clyde W. Burleson and E. Jessica Hickman, *The Panoramic Photography of Eugene O. Goldbeck* (Austin: University of Texas Press, 1986); Marguerite Davenport, *The Unpretentious Pose: E. O. Goldbeck, a People's Photographer* (San Antonio, TX: Trinity University Press, 1981); and, the most recent European catalog, Kitti Bolognesi and Jordi Bernado, *Goldbeck* (Barcelona, Spain: ACTAR, 1999).

29. For Goldbeck's accreditation of Mole, see Roy Flukinger, "'Only a Crazy Man Would Do What I Do': The Panoramic Career of E. O. Goldbeck," in Bolognesi and Bernado, *Goldbeck*, 81. Flukinger writes parenthetically, "(It is important to note that Goldbeck did not invent the concept of the 'living insignia'—he has always credited that to Arthur S. Mole (1889–1983) of Chicago—but he certainly recognized its aesthetic and, probably more especially, its economic possibilities.)"

30. Susan Sontag, "Fascinating Fascism," *Under the Sign of Saturn* (New York: Farrar, 1980), 316. According to Sontag, *Triumph of the Will* is "a film whose very conception negates the possibility of the filmmaker's having an aesthetic conception independent of propaganda."

31. Walter Benjamin, "The Work of Art in the Age of Mechanical Reproduction," trans. Harry Zohn, *Illuminations* (New York: Schocken Books, 1969), 241.

32. Ibid.

33. Ibid., 251.

34. Kozloff, "Photographers at War," 213.

35. Ibid.

36. Nancy, *The Inoperative Community*, 13.

37. Molly Billings, "The Influenza Pandemic of 1918" (June 1997), online at www.stanford.edu/group/virus/uda (accessed August 10, 2004). Billings also notes the climate of sacrifice of the individual to the collective will, which also helps to contextualize Mole's wartime images. "People allowed for strict measures and loss of freedom during the war as they submitted to the needs of the nation ahead of their personal needs." I thank Sally Stein for sharing this historical thesis.

38. Nancy puts it this way: "We are condemned, or rather reduced, to search for this meaning beyond the meaning of death elsewhere than in community. But the enterprise is absurd (it is the absurdity of a thought derived from the individual)." See Nancy, *The Inoperative Community,* 14.

39. Tristan Tzara, "Monsieur Antipyrine's Manifesto" (1916), *Seven Dada Manifestos and Lampisteries* (London: John Calder, 1977), 1. The martial spirit that revolts and disgusts Dada is reinforced when Tzara goes on to speak of Dada's balcony from where "you can hear all the military marches," and, in response, he imagines jumping off the balcony to make a big Dada splash, "like a seraph landing in a public bath to piss."

40. One should also recall that the expatriate Francis Picabia was based in New York when he made these nonsense machines. For a discussion of this milieu, see Armin Zweite, Michael Petzet, and Gotz Adriani, eds., *New York Dada: Duchamp, Man Ray, Picabia* (Munich: Prestel, 1973).

41. Kozloff, "Photographers at War," 213.

42. Benjamin, "The Work of Art in the Age of Mechanical Reproduction," 238.

43. Robert Silvers, *Photomosaics* (New York: Henry Holt, 1997).

44. Angela Hickman, Carol Levin, et al., "Photomosaic Art," *PC Magazine* (January 6, 1998): 9.

45. In *Photomosaics,* Robert Silvers provides this commentary: "Abraham Lincoln, sixteenth president of the United States, was the first American leader to be frequently photographed, just as the American Civil War was the first large-scale military conflict to be extensively documented with photographs." He discusses the composition of this image as follows: "Along with portraits of hopeful recruits and resolute officers are images of carnage, suffering, and below Lincoln's left eye, an assassin-to-be" (12).

46. The language is taken from the Web site advertising these jigsaw puzzles: www.buffalogames.com/HTML%20pages/Photomosaics500.html (accessed May 13, 2001). I thank Scott Michaelsen for this electronic piece of detection.

47. S. Paige Baty, *American Monroe: The Making of a Body Politic* (Berkeley: University of California Press, 1995), 31. Most of the discussion of community occurs in chapter 1, entitled "In Media Res," which reviews how "mass-mediated representative characters incorporate citizens into a representational nation" (45) and how this is achieved by the figure of Marilyn Monroe specifically.

2. "WE DON'T KNOW"

1. MacLeish, *Land of the Free,* 1.

2. In terms of administrative history and organization, the Farm Security Administration was first instituted as the Resettlement Administration by executive order on April 30, 1935, with Roy E. Stryker becoming the chief of the Historical Section of the Division of Information in July. In 1937, the RA was incorporated into the Department of Agriculture, and the Farm Security Administration took over most RA activities by September of that year.

Other of the image-text collaborative projects include James Agee and Walker Evans,

Let Us Now Praise Famous Men (Boston: Houghton Mifflin, 1941); Sherwood Anderson, *Home Town: The Face of America* (New York: 1940); Dorothea Lange and Paul Taylor, *An American Exodus: A Record of Human Erosion* (New York: Reynal and Hitchcock, 1939); and Richard Wright and Edwin Rosskam, *12 Million Black Voices* (New York: Viking Press, 1941).

3. Archibald MacLeish, *Archibald MacLeish: Reflections,* ed. Bernard A. Drabeck and Helen E. Ellis (Amherst: University of Massachusetts Press, 1986), 95. The transfer of FSA images to MacLeish's purview took place at the beginning of his last year of service as the librarian of Congress in 1944. The transfer was implemented by Elmer Davis, director of the Office of War Information (OWI), on January 14, 1944.

4. As MacLeish said: "Those photographs do go together. They make a marvelous sequence. The poem is an illustration of them: a theme, a running, continuing sort of choral voice." See MacLeish, *Archibald MacLeish: Reflections,* 95.

5. MacLeish, *Land of the Free,* 89. MacLeish does not completely tell the truth when he claims that all the photographs existed before the poem was written. Correspondence shows exceptions to this, with Stryker asking both Russell Lee and Dorothea Lange to find particular images that had been requested for the MacLeish project. For example, Stryker's letter to Lee dated October 12, 1937, offers a shopping list of seven "pictures yet to look for on the MacLeish book." In Roy Stryker Letters, University of Louisville Library, Photographic Archives, Louisville, Kentucky.

6. John Holmes, *Boston Transcript,* April 16, 1938, 2.

7. For the classic formulation of iterability as the principle of graphic modes of communication, see Jacques Derrida, "Signature Event Context," *Margins of Philosophy,* trans. Alan Bass (Chicago: University of Chicago Press, 1984), 307–30.

8. "Books," *Time,* April 28, 1938, 70.

9. Letter, Roy Stryker to Dorothea Lange, March 27, 1937, in Roy Stryker Letters, University of Louisville Library, Photographic Archives.

10. Letter, Roy Stryker to Russell Lee, August 10, 1937, ibid.

11. This theme would become central to the poem that MacLeish wrote after *Land of the Free. America Was Promises* takes as its target "the Aristocracy of politic selfishness" who "bought the land up." See Archibald MacLeish, *America Was Promises* (New York: Duell, Sloan and Pearce, 1939), 13.

12. Letter, Roy Stryker to Russell Lee, April 16, 1937, in Roy Stryker Letters, University of Louisville Library, Photographic Archives.

13. Richard Doud, "The Politics of Media: Interview with Ben Shahn," in *Ben Shahn's New York: The Photography of Modern Times,* ed. Deborah Martin Kao, Laura Katzman, and Jenna Webster (New Haven, CT: Yale University Press, 2000), 307.

14. Archibald MacLeish, *Land of the Free,* ed. A. D. Coleman (New York: Da Capo Press, 1977).

15. I take this neologism combining the two media from the *Time* magazine review that refers to MacLeish as a "poetographer." See *Time,* April 25, 1938, 70.

16. Nancy, *The Inoperative Community,* 41.

17. See Georges Van Den Abbeele, introduction, in *Community at Loose Ends,* ed. Miami Theory Collective, xvii.

18. The concept of general economy is derived from Jacques Derrida's study of Georges Bataille. See Jacques Derrida, "A Hegelianism without Reserve," *Writing and Difference,* 251–77.

19. Letter, Roy Stryker to Grace Falke, August 13, 1937, in Roy Stryker Letters, University of Louisville Library, Photographic Archives.

20. Letter, Roy E. Stryker to Ben Shahn, March 25, 1938, in FSA Historical Section Textual Records, Department of Prints and Photographs, Library of Congress, Washington, DC, Box 2, General Correspondence 1938, Reel 2, Frame 987. Shahn replies to Stryker in an undated letter: "Your enthusiasm for it makes me very anxious to see it" (ibid., Frame 990). On April 7, Stryker composed a letter to Eleanor Fish in the editorial department at Harcourt, Brace and Company in which he praises the book. "We are very glad that we could be of help in supplying illustrations for an excellent book of this sort" (ibid., Frame 993).

21. F. Jack Hurley, *Portrait of a Decade: Roy Stryker and the Development of Documentary Photography in the Thirties* (Baton Rouge: Louisiana State University Press, 1972), 138.

22. Robert E. Girvin, "Photography as Social Documentation," *Journalism Quarterly* 24, no. 3 (September 1947): 215.

23. Jean-Luc Nancy, "Being-in-Common," in *Community at Loose Ends,* ed. Miami Theory Collective, 9.

24. Gayatri Chakravorty Spivak, "Deconstruction and Cultural Studies: Arguments for a Deconstructive Cultural Studies," in *Deconstructions: A User's Guide,* ed. Nicholas Royle (New York: Palgrave, 2000), 23.

25. Nancy, "Being-in-Common," 8.

26. MacLeish, *Archibald MacLeish: Reflections,* 95.

27. Ibid., 85. MacLeish goes on to say later: "I don't feel much hope in *Land of the Free.* It was pretty hard to feel any hope about those people. They felt very little about themselves" (96).

28. Giorgio Agamben, "From Limbo," *The Coming Community,* trans. Michael A. Hardt (Minneapolis: University of Minnesota Press, 1993), 4.

29. A. D. Coleman, introduction, in MacLeish, *Land of the Free,* ed. Coleman. This and the following quotations are taken from this unpaginated essay.

30. Jacques Derrida, *The Other Heading: Reflections on Today's Europe,* trans. Pascale-Anne Brault and Michael Naas (Bloomington: Indiana University Press, 1995), 9.

31. Jean-Luc Nancy, *The Experience of Freedom,* trans. Bridget McDonald (Stanford, CA: Stanford University Press, 1993), 95.

32. Nancy, *The Inoperative Community,* xxxviii–xxxix.

33. Maurice Blanchot, "Community and the Unworking," *The Unavowable Community,* trans. Pierre Joris (Barrytown, NY: Station Hill Press, 1983), 11.

34. Nancy, *The Inoperative Community,* 25.

35. Ibid., 31.

36. Pare Lorentz, "We Don't Know . . . ," *Saturday Review of Literature* 17 (April 2, 1938): 6.

37. Ibid. Lorentz was not alone in feeling let down by the repetition compulsion of the poem to settle for nothing less than collective self-doubt. The anonymous reviewer in *Time* magazine saw the ending as a letdown, quashing both its "poetical" and "revolutionary" (in the political sense) potential. "But, next page, 'poetographer' MacLeish drops that potential like a hot potato: 'We wonder—We don't know—We're asking.' Beside its case-hardened picture, this soft-boiled conclusion seems not only limp but incompatible." See *Time,* April 25, 1938, 70.

38. Nancy, *The Inoperative Community,* 15.

39. *Land of the Free* is mentioned in the semimonthly report for the first half of August under the category "Other activities." It reads: "Worked on photographs for book being prepared by Archibald MacLeish, Harcourt Brace." (See FSA Historical Section, Textual Records, Box 4, "Monthly Reports 1937–8," Reel 4, Frame 380.) Meanwhile, *The*

River is mentioned in the report for the first half of October 1937. "Working on stills for the new picture, *The River*" (Reel 4, Frame 382).

40. Ruth Lechlitner, "Now the Land Is Gone: Magnificent Pictures of America Matched with a Rhythmic Text," *New York Herald Tribune Books,* April 10, 1938, section 9, 6.

41. Eda Lou Walton, "Poetry as Sound Track," *Nation* 146, April 2, 1938, 390.

42. It is interesting to point out in this context that Sandburg wrote a letter of praise to MacLeish on March 17, 1938, after MacLeish sent him an advance copy of *Land of the Free*. Sandburg's reading is decidedly humanistic, even as it alludes to the encroaching apparatus of technological reproduction. "And now, lowlifer, you come with this *Land of the Free*. I hesitate about letting go of all the superlatives that come to me about this folio so true in forms to the best of our precision-instrument era. The synchronization between text and photographs equals any of Bach's contrapuntals. The words are first rate and God help those not moved nor interested. As a book of photographs alone, as a chosen gallery, it is superb. The accompanying poem would stand alone as profound and musical, even without the amazing pictorial equivalents." See "Correspondence with Carl Sandburg" (Box 20), Archibald MacLeish Papers, Library of Congress, Washington, DC.

43. T. K. Whipple, "Freedom's Land," *New Republic* 94 (April 13, 1938): 312.

44. By invoking *Mitsein*, one puts MacLeish in communication with the philosophy of Martin Heidegger. The following is documentary evidence that MacLeish was not a complete stranger to Heidegger. In one of MacLeish's undated notebooks (in Folder 1) on page 61, we find the following entry: "Read Heidegger Existence and Being. Essay on Holderlin and the Essence of Poetry." In "Notebooks" (Box 60), Archibald MacLeish Papers, Library of Congress, Washington, DC. The original English publication of this volume, introduced by Werner Brock, was Martin Heidegger, *Existence and Being* (Chicago: H. Regnery Co., 1949), so this encounter took place well after *Land of the Free*.

45. Peter Monro Jack, "Archibald MacLeish's Poem for Our Day," *New York Times Book Review,* May 8, 1938, 2.

46. This Lange image achieved great contemporary notoriety when the cropped central figure appeared in *Life* magazine on June 21, 1937, with the caption "Dust Bowl Farmer Is New Pioneer." MacLeish's words of doubt became words of hope for the anonymous pioneer. "I heerd about this here irrigation [in California]. I figured that in a place where some people can make a good livin' I can make me a livin'." See FSA Historical Section, Textual Records, Reel 22, Newspaper and Magazine Clippings, January–June 1937, Department of Prints and Photographs, Library of Congress, Washington, DC.

47. This Lee image is also cropped in the book in a close-up that provides more dramatic effect. The original photograph by Russell Lee shows H. F. Walling standing with a pipe in a field with a farmhouse in the background. He is identified in the FSA caption as the "drought chairman." The image is cataloged as LC-USF33-011142-M3 in the FSA Photograph Collection, Library of Congress, Prints and Photographs Division, Washington, DC.

48. This Shahn image is captioned as "Strawberry picker's child, Louisiana, 1935" in Roy Emerson Stryker and Nancy Wood's *In This Proud Land: America 1935–1943 as Seen in the FSA Photographs* (Greenwich, CT: New York Graphic Society, 1973), 53. The child was a member of the Fortuna family in Hammond, Louisiana.

49. For the many uses of "Migrant Mother," see Derrick Price and Liz Wells, "Thinking about Photography: Debates, Historically and Now," in *Photography: A Critical Introduction,* ed. Liz Wells (London: Routledge, 2000), 35–45. For the photographer's own

reflections on the image, see Dorothea Lange, "The Assignment I'll Never Forget," *Popular Photography*, February 1960, 42–43, 128.

50. See *Survey Graphic* (September 1936): 526–29, 537, in FSA Historical Section, Textual Material, Oversized Box 4, July–December 1936, Reel 22, Department of Prints and Photographs, Library of Congress, Washington, DC.

51. The process of effacement is taken up in Martha Rosler, "In, Around and Afterthoughts (on Documentary Photography)," in *The Contest of Meaning: Critical Histories of Photography*, ed. Richard Bolton (Cambridge, MA: MIT Press, 1989), 303–43. Meanwhile, Sally Stein has exposed the Native American origins of Florence Thompson in a recent illuminating text. In Stein's analysis of this migrant mother's "passing for white," the repressed issue of racial and ethnic difference returns to the forging of *the* American icon. See Stein, "Passing Likeness: Dorothea Lange's Migrant Mother and the Paradox of Iconicity," in *Only Skin Deep: Changing Visions of the American Self*, ed. Coco Fusco and Brian Wallis (New York: International Center for Photography, 2003), 345–55.

52. See Stryker and Wood, *In This Proud Land*, 19.

53. The caption in *Land of the Free* leaves out a second sentence found in the FSA archives, which furthers the dislocation: "Living in the American River Camp near Sacramento, California." The photograph is cataloged as LC-USF34-009909-E, Prints and Photographs Division, Library of Congress, Washington, DC.

54. This one-paragraph review is found in "Briefer Mention," *Commonweal* 29 (April 8, 1938): 416.

55. This image appeared in the *Indianapolis Times* on April 23, 1937, as part of the series President Roosevelt's Farm Tenancy Committee. The caption reads: "The old couple's land in Brown County has been optioned by the Government."

56. MacLeish's text reads: "We wonder whether the American dream / Was the singing of locusts out of the grass to the west and the / West is behind us now: / The west wind's away from us" (verse 83).

57. Alan Trachtenberg, "From Image to Story: Reading the File," in *Documenting America 1935–1943*, ed. Carl Fleischhauer and Beverly W. Brannan (Berkeley: University of California Press, 1988), 46.

58. MacLeish, *Land of the Free*, verses 84–87.

59. As Derrida discusses, "The experience of mourning and promise that institutes the community but also forbids it from collecting itself, this experience stores in itself the reserve of another community that will sign, otherwise, completely other contracts." See Derrida, "A 'Madness' Must Watch Over Thinking," 355.

60. For another example of MacLeish's steadfast and foundational humanism as a "fundamental proposition" (76) that man has worth and value in "his essential quality as man," see his essay, "Humanism and the Belief in Man," *Atlantic Monthly* (Boston), November 1944, 72–78.

61. Nancy, *The Experience of Freedom*, 73.

62. Or just a little later: "Maybe we were endowed by our creator / With certain inalienable rights including / The right to assemble in peace and petition. Maybe." MacLeish, *Land of the Free*, 10.

63. For the embedded aspect of the enemy within, see Derrida, *The Politics of Friendship*.

64. Dorothea Lange and Paul Schuster Taylor, *An American Exodus: A Record of Human Erosion in the Thirties* (New Haven, CT: Yale University Press, 1969), 66. This north Texas image bears the date of June 1937, or around the same time that MacLeish began to select images from the Resettlement Administration files.

65. Nancy, *The Experience of Freedom*, 3.

66. Ibid., 57.

67. Ibid., 13–14.

68. Quoted phrase, ibid., 59.

69. See Hurley, *Portrait of a Decade*, 88. Robert Hirsch also recalls the incident: "Roosevelt's opponents latched onto the image as proof that the RA program tricked people into accepting socialist experiments." Robert Hirsch, *Seizing the Light: A History of Photography* (New York: McGraw Hill Higher Education, 2000), 290.

70. This was originally published in the *Dispatch Herald* in Erie, Pennsylvania, on September 7, 1936. See Microfilm NDA 8, Frame 101, in the Roy Emerson Stryker Papers, Archives of American Art, Smithsonian Institution, Washington, DC.

71. Stryker recalls, "Was it sociology? I'm sure it was more than a little bit sociology. Ansel Adams, in fact, once told me, 'What you've got are not photographers. They're a bunch of sociologists with cameras.'" Stryker, "The FSA Collection of Photographs," *In This Proud Land*, 8. It is important to point out that MacLeish specifically distanced *Land of the Free* from the death knell of sociology: "If it turns into a sociological tract, it's dead." See MacLeish, *Archibald MacLeish: Reflections*, 85.

72. See comment numbers 94 and 340, respectively, in Microfilm NDA 8, Frames 1050–73, Roy Emerson Stryker Papers, Archives of American Art, Washington, DC, for these "Farm Security Administration Picture Comments" at the First International Photographic Exposition, Grand Central Palace, April 18–24, 1938.

73. Walton, "Poetry as Sound Track," 390.

74. Blanchot, *The Unavowable Community*, 20.

75. Nancy, *The Inoperative Community*, 80.

76. See Scott Donaldson, *Archibald MacLeish: An American Life* (Boston: Houghton Mifflin, 1992), 226.

77. These political complexities are discussed in Eleanor M. Sickels's excellent analysis in "Archibald MacLeish and American Democracy," *American Literature* 15, no. 3 (November 1943): 223–37. On the one hand, "He would not espouse communism because of its economic materialism and its anti-individualism, but he never called on artists actively to oppose it" (233). On the other hand, "MacLeish saw the peril in Spain so clearly that to combat it he was even willing to co-operate with the Communists—at the time, of course, in one of their periodical anti-Fascist phases. He was promptly dubbed a Communist for his pains" (n. 38). For MacLeish's critique of the Marxist position on art, see his "The Poetry of Karl Marx" published in *A Time to Speak: Selected Prose* (Boston: Houghton Mifflin, 1941).

78. Nancy introduces the term as follows: "'Literary communism' is named thus only as a provocative gesture—although at the same time the name cannot fail to be a necessary homage to what communism and the communists, on the one hand, and literature and writers on the other have meant for an epoch of our history." Nancy, *The Inoperative Community*, 80.

79. Ibid.

80. Georges Bataille's (inter)dictum is the epigraph to Maurice Blanchot, *The Unavowable Community*, 1.

3. PHOTO GLOBE

1. This phrase was the subtitle of the exhibition catalog, self-promoting and self-praising on the front cover. The full verbiage reads: "The Family of Man. The greatest

photographic exhibition of all time—503 pictures from 68 countries—created by Edward Steichen for the Museum of Modern Art. Prologue by Carl Sandburg." See Edward Steichen, *The Family of Man* (New York: Maco Magazine Corporation, 1955). Minor White also noted the spectacular aspects of the show, comparing its production values to the blockbuster film *The Ten Commandments* (1956). "These were productions in the tradition of Max Reinhardt or Cecil B. De Mille." See Minor White, "Exhibition Review," *Aperture* 9 (1961): 41. In challenging the universal humanism of the Family of Man, White also employed a Yinglish term to mock its maudlin sentimentality, suggesting that it was dripping in chicken fat, "How quickly the milk of human kindness turns to schmaltz." This is quoted in Jonathan Green, *American Photography: A Critical History 1945 to the Present* (New York: Abrams, 1984), 70.

2. Carl Sandburg, prologue, in Steichen, *The Family of Man*, 2.

3. See Roland Barthes, "The Great Family of Man," *Mythologies*, trans. Annette Lavers (New York: Hill and Wang, 1972), 100–102; and Hilton Kramer, "On the Horizon: Exhibiting the Family of Man," *Commentary* 20, no. 4 (October 1955): 365–67.

4. The conference was organized by the Department of Art History, University of Trier, and the Centre national de l'audiovisuel (CNA), in Luxembourg (Steichen's birthplace). It took place October 12–14, 2000. Some information related to the conference appears at www.uni-trier.de/uni/fb3/kunstgeschichte/2000/ws/symp.html (accessed February 23, 2005). The introduction includes the following photo-global statement: "Even today the main themes of Edward Steichen's photographic construction of a global family of mankind keep the whole world in suspense."

5. Edward Steichen, "The U.S.A.," *Travel and Camera: The International Magazine of Travel and Photography* 32, no. 2 (February 1969): 54.

6. "Memo on Family of Man Panel Version, 1956–57," Department of Circulating Exhibitions II.1, Exhibitions, 1931–1958, "Family of Man," Box 58, File 4/12, Museum of Modern Art (MoMA) Archives, New York.

7. Edward Steichen, "Photography: Witness and Recorder of Humanity," *Wisconsin Magazine of History* 41 (Spring 1958): 160.

8. Roland Barthes, *Camera Lucida: Reflections on Photography,* trans. Richard Howard (New York: Hill and Wang, 1981), 5.

9. Steichen, introduction, *The Family of Man*, 4.

10. Nancy, *The Inoperative Community,* 2.

11. Steichen, "Photography: Witness and Recorder of Humanity," 164.

12. Margaret R. Weiss, "Interview with Mr. Steichen," March 29, 1966, 26, in "Films and TV Films relating to Mr. Steichen" file, 1966–1967, Edward Steichen Archives, Department of Photography, Museum of Modern Art, New York.

13. Barthes, "The Great Family of Man," 100.

14. Nancy, *The Inoperative Community,* 12.

15. Museum of Modern Art press release, No. 4, January 26, 1955, 2, in an exhibition binder on the Family of Man, in MoMA Archives.

16. The quoted phrase is Susan Sontag's. See Sontag, "The Imagination of Disaster," *Against Interpretation* (New York: Dell, 1964), 209–25.

17. Museum of Modern Art press release, 2–3.

18. Steichen, "Photography: Witness and Recorder of Humanity," 166.

19. Ibid., 166–67.

20. Museum of Modern Art press release, 2.

21. While Eric Sandeen's *Picturing an Exhibition* offers a somewhat sympathetic treatment of the Family of Man, he does have some reservations about the "confused

anthropology" that guides this part of the installation and the collapsing of cultural dif-
ferences by means of formal similarities. "The ring-around-the rosie sequence, a circle of
photographs of rings of children, had not explored the similarities and differences among
ring games and dances. Each relatively small picture viewed its subjects from a distance,
so that a reiterated form would overwhelm any particular cultural practice." Sandeen's
cogent analysis defends the particularity of each game against the hegemonic desire to
appropriate it as another instance of the universality of ring-around-the-rosy. See Eric
Sandeen, *Picturing an Exhibition: The Family of Man and 1950s America* (Albuquerque:
University of New Mexico Press, 1995), 53.

22. John Szarkowski reports that Steichen insisted on this point at a staff meeting
with the United States Information Agency. One notes the return of photo-global think-
ing in Szarkowski's stress on circulation: "Steichen tried to explain the exhibition that they
had decided to circulate." See John Szarkowski, "The Family of Man," in *The Museum
of Modern Art at Mid-century at Home and Abroad* (New York: Museum of Modern
Art, 1994), 35. He quotes Steichen as follows: "I spent a good thirty-five years and all the
money I made in the photographic business in financing a plant breeding experiment—
breeding delphinium—a study of genetics. That backed me up in my observation of
people—that essentially we were all alike, and if we could see that alikeness in each other,
we might become friends." See "Transcript of U.S.I.A. Seminar with Steichen," April 27,
1955, 4, Steichen Archives, MoMA.

23. Steichen, "Photography: Witness and Recorder of Humanity," 161.

24. Ibid., 163.

25. Ibid., 162.

26. Barthes, "The Great Family of Man," 101.

27. Steichen clearly had this comparison in mind, because the two images are repro-
duced on pages 162 and 163 of the original publication of "Photography: Witness and
Recorder of Humanity."

28. Both statements are taken from Steichen, "Photography: Witness and Recorder
of Humanity," 162. In the sound recording of the original address that Steichen made to
the State Historical Society of Wisconsin at Green Lake in June 1957, the phrasing is
slightly altered, but the controversy is by no means clarified. In the first case, Steichen
speaks of "a family from Bechuanaland in Africa, said to be just like cave people today."
In the second case, he speaks of "a savage—a so-called savage let me say very plain, very
firmly—in Africa teaching his boy how to shoot a poisoned arrow for food." In this case,
the first word (*savage*) slips out as a racist remark, but then Steichen quickly corrects
himself with the reversion to *so-called*. My thanks to Sarah Hermanson and Eva Respini,
curators of the Steichen Archives at the Museum of Modern Art, for providing me with
access to these original tape recordings.

29. Ibid., 162, 164. The phrasing in the lecture is slightly different—"an American
family photographed in Nebraska—a wonderful picture of good, salty, earthy farmers sit-
ting around an old kitchen stove and in the center of the picture is a grandmother in a
rocking-chair with silver hair and a halo around her of her children and her grandchildren
and on the wall a row of crayoned portraits—all grim looking ancestors." At this point,
the audience laughs.

30. "'The Family of Man' Photographic Exhibition at Johannesburg, Union of South
Africa," *Coca-Cola Overseas* 11, no. 6, December 1958, 12.

31. Ibid., 15.

32. Allan Sekula, "The Traffic in Photographs," *Art Journal* 41 (Spring 1981): 21.

33. With Jameson's "global harmony," one recalls the jingle of one of Coke's ad

campaigns and its missionary zeal regarding consumption: "I'd like to teach the world to sing in perfect harmony."

34. Fredric Jameson, "Reification and Utopia in Mass Culture," *Social Text* 1, no. 1 (Winter 1979): 144.

35. The images depicting the voters of diverse nations are from Steichen, *The Family of Man,* 176–77.

36. Steichen, "Photography: Witness and Recorder of Humanity," 165.

37. Nancy, *The Inoperative Community,* 60.

38. Steichen, "Photography: Witness and Recorder of Humanity," 161. In the original sound recording of the address, Steichen's racial epithet is stronger in its denunciation— "You dirty little kike!"

39. One recalls that there is an image of this prime mover in the exhibition. Photographed by Steichen on her back porch, she beckons him by holding out a homemade pie. (What could be more American?) Steichen recalls a personal anecdote in relation to this image in the Wisconsin address: "Then there was bread—food. On a field of wheat, I placed the smallest picture in the exhibition; a tiny picture that I made years ago of my mother. The family was living in Elmhurst, Illinois at the time, and I was visiting. I had the camera out in the yard, photographing the house and the porch. I was all set to make a picture of the porch, with grape vines growing over it and shrubs on either side. My mother opened the screen door, came out, and held forward a big cake she had just baked, saying, 'Now here's something worth photographing.' And I did. With the photograph I used an old Russian proverb: 'Eat bread and salt and speak the truth.' My mother didn't happen to know that proverb, but it sounded like her, and that's the reason I associated it with her picture" (ibid., 163–64).

40. This argument is made in Viktoria Schmidt-Linsenhoff, "Die Banalität des· Guten: Zur fotografischen Re-konstruktion der Menschlichkeit in der Ausstellung 'The Family of Man,'" *Wiener Jahrbuch für jüdische Geschichte, Kultur und Museumswesen* 3 (1997/1998): 59–74. Playing off the title of Hannah Arendt's reading of the Eichmann trial as "the banality of evil," the title translates as "The Banality of Good: On the Photographic Reconstruction of Humanity in 'The Family of Man' Exhibition." However, for all of its investigation into how the Holocaust figures in the exhibition, Schmidt-Linsenhoff does not refer to the primal scene of this anti-Semitic racial slur at its source.

41. Steichen visited the show, which the records indicate that forty-five thousand people attended. The exhibition would return to Germany in 1958 under the auspices of the United States Information Agency. These records can be found in the list of "Itineraries" for the Family of Man, International Council/International Program Exhibition Records, *The Family of Man* (SP-ICE-10-55): VII.145.1, the Museum of Modern Art Archives, New York.

42. Leo Rosten, *The Joys of Yiddish* (New York: Pocket Books, 1968), 181–82.

43. Jean White, "Sandburg, Steichen to Explain Man's Universality to Russians," *Washington Post,* February 15, 1959.

44. AP report published in the *New York Times,* August 25, 1959, 3.

45. "Empty Bowl, Empty Head," *Hartford Courant.* This undated editorial comment, published in the summer of 1959, is in a group of press clippings related to the visit of the Family of Man to the American National Exhibition in Moscow. See "Family of Man," General Y, Reel MF 43, 2, Frame 100, Archives of American Art, Smithsonian Institution, Washington, DC.

46. "Meet the Press," program transcript, NBC Television, September 13, 1959, 7, Steichen Archives, MoMA.

47. This was part of the very first public statement that Steichen issued "explaining the aims and purposes of the exhibition." The press release is entitled "Museum of Modern Art Plans International Photography Exhibition," and it was issued on January 31, 1954. In Steichen Archives, MoMA.

48. Nancy, *The Inoperative Community*, 61.

49. Ibid.

50. Published by the Associated Press on August 7, 1959, this report is found in International Council/International Program Exhibition Records, *The Family of Man* (SP-ICE-10-55): VII.146.10, MoMA Archives, New York.

51. Ibid.

52. This was reported in *Afro-American* (Washington, DC), August 22, 1959. See Sandeen, *Picturing an Exhibition*, 155.

53. Walter Benjamin, "Theses on the Philosophy of History" (1940), trans. Harry Zohn, *Illuminations*, 256.

54. It is also interesting to think about how Neokonkwo would have reacted to the removal of the lynching photograph "Death Slump at Mississippi Lynching" (1937) from the section of the exhibition entitled "Man's Inhumanity to Man" shortly after its opening in New York. According to Lili Corbus Bezner, "By removing the lynching image, Steichen also removed the most specific repulsive image of oppression and the dehumanizing aspects of white supremacy." See Lili Corbus Bezner, "Subtle Subterfuge: The Flawed Nobility of Edward Steichen's Family of Man," in *Photography and Politics in America: From the New Deal to the Cold War* (Baltimore: Johns Hopkins University Press, 1999), 163. The excision and suppression of the image (as well as what it represents) point to a major trouble spot for photo-global thinking and its universal claims.

55. Sekula, "The Traffic in Photographs," 20.

56. Ibid., 19.

57. Ibid., 21. One is reminded in this context of a photograph by David Wojnarowicz that provides a visual illustration of the hegemonic basis of this American visioning of the globe, in which imagining global community occurs through the imaging of America alone.

58. Ibid., 20.

59. Quoted phrase, ibid., 15.

60. Allan Sekula, "Between the Net and the Deep Blue Sea: Rethinking the Traffic in Photographs," *October* 102 (Fall 2002): 19–20.

61. Nancy, *The Inoperative Community*, xxxviii.

4. PHOTOGRAPHY AND THE EXPOSURE OF COMMUNITY

1. The term *compearance* (*com-parution*) is used by Nancy to express our shared relation to finitude. This term provides a means to critique any theory of the social founded in the sovereignty of the individual. As Nancy states, "We would need to be able to say that finitude *co-appears* or *compears* (*com-paraît*) and can only *compear*: in this formulation we would need to hear that finite being always presents itself 'together,' hence severally; for finitude always presents itself in being-in-common." Nancy, *The Inoperative Community*, 28.

2. Ibid., xxxvii.

3. Ibid., 41. I am also indebted to Dana Broadbent's unpublished essay entitled "Exposure," which provided me with further insights into the dynamics of the singular being of community-exposed photography: "This being is not indivisible (not individual),

but divided and hence it can be put in communication (relation) with others in various ways" (14).

4. Goldin, *The Ballad*, 6.

5. It is interesting to note that this underground classic has been reprinted by the Grove Press (New York, 2000) after a number of years out of print.

6. Goldin made these remarks in "On Acceptance: A Conversation" with David Armstrong and Walter Keller, in Nan Goldin, *I'll Be Your Mirror*, ed. Nan Goldin, David Armstrong, and Hans Werner Holzwarth (New York: Scalo, 1996), 448.

7. Abigail Solomon-Godeau, "Inside/Out," in *Public Information: Desire, Disaster, Document* (New York: Distributed Art Publishers, 1994), 49–61.

8. John Gray, *Men Are from Mars, Women Are from Venus: A Practical Guide for Improving Communication and Getting What You Want in Your Relationships* (San Francisco: HarperCollins, 1992). Despite the dramatic title, Gray's instrumentalist book (as its subtitle indicates) is a lot more optimistic in its view of communication than Goldin's bleaker *Ballad*.

9. Goldin, *The Ballad*, 7.

10. Nancy, *The Inoperative Community*, 38.

11. Goldin, *The Ballad*, 7.

12. Nancy, *The Inoperative Community*, 93.

13. Goldin, "On Acceptance: A Conversation," 452.

14. Nancy, *The Inoperative Community*, 96.

15. Ibid., 99.

16. Ibid., 98.

17. Or, as D. Diane Davis puts it, "Community in a post-humanist world, as Nancy says, is an exposition of finitude and not a bond/age." See D. Diane Davis, "Laughter, or, Chortling into the Storm," in the online journal, PRE/TEXT (1997), www.utdallas.edu/pretext/PT1.1/Elect1/html (accessed November 15, 2000).

18. See "My Number One Medium All My Life: Nan Goldin Talking with J. Hoberman," in Goldin, *I'll Be Your Mirror*, 196.

19. Marcel Duchamp, in *Salt-Seller: The Essential Writings of Marcel Duchamp*, ed. Michel de Sanouillet and Elmer Peterson (London: Thames, 1972), 32.

20. Krauss, "Notes to the Index: Part 1," 205.

21. To cite Duchamp in his talk entitled "Apropos of 'Readymades'" at the Museum of Modern Art on October 19, 1961: "This choice was based on a reaction of visual indifference with at the same time a total absence of good or bad taste . . . in fact a complete anesthesia." In *Salt-Seller*, ed. de Sanouillet and Peterson, 141.

22. Roland Barthes, *A Lover's Discourse*, trans. Richard Howard (New York: Hill and Wang, 1978).

23. Goldin, "On Acceptance: A Conversation," 452.

24. *October* 1 (Spring 1976).

25. Nancy, *The Inoperative Community*, 39.

26. For a discussion of this haptic dimension in the work of Cameron, see Carol Mavor, "To Make Mary: Julia Margaret Cameron's Photographs of Altered Madonnas," *Pleasures Taken: Performances of Sexuality and Loss in Victorian Photographs* (Durham, NC: Duke University Press, 1995), 43–70.

27. Goldin, "On Acceptance: A Conversation," 452.

28. This is the argument that guides Susan Sontag's classic account of Diane Arbus in "America, Seen through Photographs, Darkly," *On Photography* (New York: Anchor Books, 1989). Interestingly enough, Nan Goldin has always shown great admiration for

Arbus's achievement. For example, see her review of Arbus's posthumous book on the mentally insane, *Untitled*. The review begins in a space that is far removed from the interruption of myth. "Diane Arbus is one of our legends." In Nan Goldin, "Art of Darkness," *Artforum* (November 1995): 14.

29. Max Kozloff, "The Family of Nan," *Lone Visions, Crowded Frames: Essays on Photography* (Albuquerque: University of New Mexico Press, 1994), 104.

30. Goldin, *I'll Be Your Mirror*, 136. This and the following two quotations come from pages 136 and 137.

31. Ibid., 137.

32. Goldin, *The Ballad*, 145.

33. The exhibition was further disseminated through the book publication of *The Family of Man* (New York: Maco Magazine Corporation, 1955). For the best formulation of Steichen's universal humanism, see his "Photography: Witness and Recorder of Humanity," 159–67. To cite Steichen directly from the last page of the article: "This is irrefutable proof that photography is a universal language; that it speaks to all people; that they are hungry for that kind of language."

34. See Barthes, "The Great Family of Man," 100–102; Sekula, "The Traffic in Photographs," 15–25; and Fredric Jameson, "Reification and Utopia in Mass Culture," *Social Text* 1 (1979): 130–48.

35. While Nan Goldin has always framed her work in the context of a community-exposed photography, she has rarely discussed it in the context of a discourse about the imaging and imagining of America. One exception is a comparison of her reception in Europe in contrast to the United States. She says, "[In Europe] it was not reduced to an investigation of subculture. In America, with its puritanical nature, the work was more compartmentalized." The contrast foregrounds the politics of the moral majority and its "family values" called into question by "The Family of Nan." See Goldin, "On Acceptance: A Conversation," 448.

36. Goldin, *Ballad*, 6.

37. Goldin quoted in Mark Holborn, "Nan Goldin's *Ballad of Sexual Dependency*," *Aperture* 103 (Summer 1986): 42.

38. Ibid., 43 and 38, respectively.

39. Judith Butler, Ernesto Laclau, and Slavoj Žižek, *Contingency, Hegemony, Universality: Contemporary Dialogues on the Left* (London: Verso, 2000).

40. For Laclau's concept of hegemony, see also Ernesto Laclau and Chantal Mouffe, *Hegemony and Socialist Strategy: Towards a Radical Democratic Politics* (London: Verso, 1985). For another explication of these issues in the context of "The Identity in Question," see Ernesto Laclau, "Universalism, Particularism, and the Question of Identity," *October* 61 (Summer 1992): 83–90.

41. Laclau, "Structure, History, and the Political," in Butler, Laclau, and Žižek, *Contingency, Hegemony, Universality*, 189.

42. Laclau, "Identity and Hegemony: The Role of Universality in the Constitution of Political Logics," in Butler, Laclau, and Žižek, *Contingency, Hegemony, Universality*, 56.

43. Laclau, "Structure, History, and the Political," 194.

44. Butler, "Restaging the Universal: Hegemony and the Limits of Formalism," in Butler, Laclau, and Žižek, *Contingency, Hegemony, Universality*, 32.

45. With the turn of phrase "gender troublemakers," I allude to Judith Butler's most important work on the performance of gender and the problematizing of identity: *Gender Trouble: Feminism and the Subversion of Identity* (New York: Routledge, 1990). Nan Goldin, *The Other Side* (Zürich: Scalo, 1993), will be discussed extensively in the section

of this chapter entitled "The Community of the 'Other Side': Of Drag Queens and AIDS Victims."

46. Butler, "Restaging the Universal," 24.

47. Laclau, "Identity and Hegemony," 51.

48. For this critique of Laclau, which has bearing on this differential treatment of the Hegelian dialectic and proceeds from a Nietzschean perspective that affirms singularity as repetition with a difference, see Nathan Widder, "What's Lacking in the Lack: A Comment on the Virtual," *Angelaki* 5, no. 1 (Fall 2000): 117–38. In his analysis of Laclau, Widder writes, "For the possibility of treating these dispersed elements not as particularities but instead as singularities which break with the logic of universal and particular, has been foreclosed. . . . This foreclosure is necessary for the theory of hegemony to operate" (123).

49. Jean-Luc Nancy, "Of Being Singular Plural," *Being Singular Plural*, 29.

50. Nancy, *The Inoperative Community*, xl.

51. As Nancy writes in *The Inoperative Community*, "It undoes the absoluteness of the absolute. The relation (the community) is, if it *is*, nothing other than what undoes, in its very principle—and at its closure or on its limit—the autarchy of absolute 'immanence'" (4).

52. Elizabeth Sussman, "In/Of Her Time: Nan Goldin's Photographs," in Goldin, *I'll Be Your Mirror*, 44.

53. See Raymond Carney, *American Dreaming* (Berkeley: University of California Press, 1985), 3.

54. Nancy, *The Inoperative Community*, 25–26.

55. Holborn, "Nan Goldin's *Ballad of Sexual Dependency*," 42.

56. For a discussion of this specific idea, see section 348 in Heidegger, *Being and Time*, 399.

57. This festive economy is toned down in the fictionalized film based loosely on the life of Nan Goldin, *High Art* (1998), directed by Lisa Cholodenko and starring Ally Sheedy as subcultural photographer Lucy Berliner. For example, the film reduces the thrownness of the partying being into a lesbian triangulation.

58. Nancy, *The Experience of Freedom*, 56–57.

59. Ibid., 70.

60. Ibid., 70.

61. Ibid., 57.

62. Holborn, "Nan Goldin's *Ballad of Sexual Dependency*," 42.

63. Christopher Wood, "Postmodernism and the Art of Identity," in *Concepts of Modern Art: From Fauvism to Postmodernism,* ed. Nikos Stangos (New York: Thames and Hudson, 1994), 285.

64. Goldin, *The Ballad*, 145.

65. Goldin, *The Other Side*, 5. While Goldin attributes this quotation to Oscar Wilde and while it certainly sounds like one of his sayings, I can find no direct evidence. I have found a similar saying in Kurt Vonnegut Jr.'s *Mother Night* (New York: Harper, 1966): "You must be careful what you pretend to be because you are what you pretend to be."

66. Goldin, *The Other Side*, 5.

67. Unfortunately, Elisabeth Bronfen also does not see the contradiction between asserting and affirming a "third sex" while claiming that the inhabitants of the other side act "in defiance of all categorization." See her study of Araki, Arbus, and Goldin, "Wounds of Wonder," in *Nobuyoshi Araki, Diane Arbus, Nan Goldin* (Munich: Sammlung Goetz, 1997), 42–43.

68. Goldin, *The Other Side,* 7.

69. For the quoted phrase, see ibid., 6. For the insistence that they are normal, see the videotape interview of Nan Goldin, *In My Life,* directed by Paul Tschinkel for the series ART/new york (no. 47), produced by Inner-Tube Video in 1997. As she states, "To me they're totally normal and some of the most beautiful people I've met."

70. "Interview with Nan Goldin," in *Life Sentences: Writers, Artists and AIDS,* ed. Thomas Avena (San Francisco: Mercury House, 1994), 149.

71. Ibid.

72. Nicholas and Bebe Nixon, *People with AIDS* (Boston: Godine, 1991).

73. One classic critique is Simon Watney, "Photography and AIDS," in *The Critical Image: Essays on Contemporary Photography,* ed. Carol Squiers (Seattle, WA: Bay Press, 1990), 173–92. Meanwhile, Douglas Crimp's original negative review of Nicholas Nixon's "victim photography" and other of his essays dealing with problems related to the photographic representation of AIDS have been compiled in *Melancholia and Moralism: Essays on AIDS and Queer Politics* (Cambridge, MA: MIT Press, 2002).

74. Goldin, *The Ballad,* 145.

75. Goldin quoted in the video interview *In My Life.*

76. See Avital Ronell, *Finitude's Score: Essays for the End of the Millennium* (Lincoln: University of Nebraska Press, 1998).

77. Nancy, *The Inoperative Community,* 12.

78. Alphonso Lingis, *The Community of Those Who Have Nothing in Common* (Bloomington: Indiana University Press, 1994). To quote Lingis, "Community forms when one exposes oneself to the naked one, the destitute one, the outcast, the dying one. One enters into community not by affirming oneself and one's forces but by exposing oneself and one's forces to expenditure at a loss, to sacrifice. Community forms in a movement by which one exposes oneself to the other, to forces and powers outside oneself, to death and to the others who die" (12).

79. Nancy, *The Inoperative Community,* 15.

80. If Nancy quotes the French outsider poet Arthur Rimbaud and his famous dictum here, then it is also important to remember that one of David Wojnarowicz's earliest photo projects was entitled "Arthur Rimbaud in New York" (1978–1979), in which he overlays gay subcultural pursuits in 1970s New York with those of 1870s Paris. Putting on the mask of Rimbaud, Wojnarowicz had himself photographed going through the paces of a variety of everyday life activities that range from riding in the subway car to masturbating to eating in the local diner. This project is analyzed in Mysoon Rizk, "Constructing Historics: David Wojnarowicz's Arthur Rimbaud in New York," in *The Passionate Camera: Photography and Bodies of Desire,* ed. Deborah Bright (London: Routledge, 1998), 178–94.

81. Goldin quoted in the video interview *In My Life.*

82. Goldin, *The Ballad,* 145.

83. Alexander García Düttmann, *At Odds with AIDS: Thinking and Talking about a Virus* (Stanford, CA: Stanford University Press, 1996), 41.

84. Ibid., 23.

85. Ibid., 65.

86. Ibid., 77.

87. For example, Barthes writes of the Winter Garden photograph of his recently deceased mother as a young girl: "I read at the same time: This will be and this has been, I observe with horror an anterior future of which death is the stake." See Barthes, *Camera Lucida,* 96.

88. Düttmann, *At Odds with AIDS,* 30, quoting Barthes from his preface to Renaud Camus, *Tricks* (New York: St. Martin's Press, 1981).

89. Düttmann, *At Odds with AIDS,* 104.

90. Goldin quoted in the video interview *In My Life.*

91. Nancy, *The Inoperative Community,* 41.

92. Goldin, *The Ballad,* 146.

93. Goldin, "On Acceptance: A Conversation," 452.

94. Quoted phrase, ibid.

95. Nancy, *The Inoperative Community,* 40.

5. Community in Fragments

1. Mary Schmidt Campbell, "Romare Bearden: A Creative Mythology" (Ann Arbor, MI: University Microfilms International, 1982), 251.

2. Nancy, *The Inoperative Community,* 62.

3. See Lee Stephens Glazer, "'Signifying Identity': Art and Race in Romare Bearden's Projections," *Art Bulletin* 76, no. 1 (March 1994): 411–26; and Kobena Mercer, "Romare Bearden: African American Modernism at Mid-century," in *Art History Aesthetics Visual Studies,* ed. Michael Ann Holly and Keith Moxey (New Haven, CT: Yale University Press, 2002), 29–46.

4. Ruth Fine, *The Art of Romare Bearden* (New York: Abrams, 2003). This book contains the most comprehensive bibliography on Bearden to date.

5. Ralph Ellison, "Romare Bearden: Paintings and Projections," *Crisis* 77, no. 3 (March 1970): 80–86; Dore Ashton, "Romare Bearden: Projections," *Quadrum* 17 (1964): 99–110; Charles Childs, "Bearden: Identification and Identity," *Art News* 63 (October 1964): 24–25, 54, 61.

6. Nancy, *The Inoperative Community,* 10.

7. "Romare Howard Bearden," interview by Henri Ghent, New York, June 29, 1968, Microfilm Reel 3196, Archives of American Art, Smithsonian Institution, Washington, DC, 11. The transcribed interview is paginated in the collection of the Archives of American Art.

8. As Bearden tells Ghent, "But I'm not myself [what] you'd call a churchgoing man, although I still have membership in St. Martin's" (5). Therefore, Bearden maintained the status of a nominal belonging to the church.

9. Glazer, "'Signifying Identity,'" 417.

10. Campbell, *Romare Bearden,* 222 n. 47.

11. Gail Gelburd, "Romare Bearden in Black-and-White: The Photomontage Projections of 1964," in Gail Gelburd and Thelma Golden, *Romare Bearden in Black and White: The Photomontage Projections of 1964* (New York: Whitney Museum of Art, 1997), 29.

12. Thelma Golden, "Projecting Blackness," ibid., 49.

13. Nancy, *The Inoperative Community,* 62.

14. "Bearden," interview with Ghent, 11.

15. Nancy, *The Inoperative Community,* 66.

16. "Bearden," interview with Ghent, 12.

17. Ibid., 9.

18. Ibid., 10–11.

19. Ibid., 10.

20. Ellison, "Romare Bearden: Paintings and Projections," 86.

21. Ashton, "Romare Bearden: Projections," 100.

22. "Bearden," interview with Ghent, 11.

23. I am indebted to Sarah Miller for this comparative analysis of Bearden and Warhol from her unpublished manuscript "Popping Pop's 'Neutral Screen': Projecting Race, Media, and Consumer Culture."

24. Here I invoke W. E. B. Du Bois's articulation of diasporic subjectivity as a double-consciousness. "It is a peculiar sensation, this double-consciousness, this sense of looking at one's self through the eyes of others." See W. E. B. Du Bois, *The Souls of Black Folk* (New York: Penguin Books, 1989), 3.

25. Romare Bearden, "American Myths," *Art and Man* (1976): 5, Box 2, Romare Bearden Papers, Archives of American Art, Smithsonian Institution, Washington, DC.

26. Ellison, "Romare Bearden: Paintings and Projections," 83, 85.

27. Ellison, quoted in Mary Schmidt Campbell, "History and Art of Romare Bearden," *Memory and Metaphor: The Art of Romare Bearden 1940–1987* (New York: Studio Museum in Harlem, 1991), 9.

28. See *Romare Bearden: The Prevalence of Ritual* (New York: Museum of Modern Art, 1971), with texts by Carroll Greene, Judy Goldman, and April Kingsley.

29. Campbell, "History and the Art of Romare Bearden," 8.

30. Nancy, *The Inoperative Community,* 56.

31. Joseph Campbell, *The Masks of the Gods: Creative Mythology* (New York: Viking Press, 1968). The mythologist introduces the individualistic concept as follows: "Creative mythology . . . springs not, like theology, from the dicta of authority, but from the insights, sentiments, thought, and vision of an adequate individual, loyal to his own experience of value" (7).

32. Campbell, *Romare Bearden,* 241.

33. Ibid., 197.

34. Ibid., 197–98.

35. Bataille, quoted in Nancy, *The Inoperative Community,* 58.

36. See the section "Downtown Art: George Grosz and the Art Students League" in Campbell, *Romare Bearden,* 63–66.

37. Campbell, *Romare Bearden,* 223.

38. Nancy, *The Inoperative Community,* 58.

39. Romare Bearden, "Rectangular Structure in My Montage Paintings," *Leonardo* 2 (1969): 17.

40. Campbell, *Romare Bearden,* 239.

41. Nancy, *The Inoperative Community,* 52.

42. Campbell, *Romare Bearden,* 252.

43. Nancy, *The Inoperative Community,* 12.

44. Campbell, *Romare Bearden,* 252–53.

45. Bearden quoted in Childs, "Bearden: Identity and Identification," 25.

46. Ashton, "Romare Bearden: Projections," 100.

47. Dore Ashton, "Romare Bearden" (unpublished typescript), in Catalogs and Announcements Folder, Box 1, Romare Bearden Papers, Archives of American Art, Smithsonian Institution, Washington, DC.

48. Ashton, "Romare Bearden: Projections," 100.

49. Bearden quoted in Childs, "Bearden: Identity and Identification," 25.

50. Bill Readings, "Pagans, Perverts, or Primitives? Experimental Justice in the Empire of Capital," in *Posthumanism,* ed. Neil Badmington (New York: Palgrave, 2000), 128.

51. Ashton, "Romare Bearden" (unpublished typescript), 3–4.

52. "Bearden," interview with Ghent, 21.

53. Bearden quoted in Childs, "Bearden: Identity and Identification," 25.

54. Ibid., 54.

55. Quoted phrase, ibid., 25.

56. Golden, "Projecting Blackness," 41, 44.

57. "The only image in *Projections* to employ a markedly vertical format, *The Funeral* bears a striking formal and thematic resemblance to a photograph of mourners outside the Sixth Avenue Baptist Church (Figure 16) that was reproduced to accompany *Newsweek*'s cover story on September 30, 1963, 'Bombing in Birmingham.'" See Glazer, "Signifying Identity," 424. The image is reproduced on the following page under the title "'A Phantasmagoria of Grief,' Sixth Avenue Baptist Church, Birmingham, Ala. September 18, 1963."

58. Nancy, *The Inoperative Community*, 15.

59. Mercer, "Romare Bearden: African American Modernist at Mid-century," 30.

60. Mikhail Bakhtin, "Discourse in the Novel," *The Dialogical Imagination: Four Essays by M. M. Bakhtin,* ed. Michael Holquist, trans. Caryl Emerson and Michael Holquist (Austin: University of Texas Press, 1981), 314.

61. Mercer, "Romare Bearden: African American Modernist at Mid-century," 30.

62. Ibid., 39.

63. Ibid., 38.

64. Ibid., 43.

65. Jacques Derrida, "From Restricted to General Economy: A Hegelianism without Reserve," *Writing and Difference,* 259.

66. Mercer, "Romare Bearden: African American Modernist at Mid-century," 42.

67. It is interesting to note that the old Negro spiritual was also adapted in February and March 1965 during the civil rights protest led by Dr. Martin Luther King Jr. from Selma to Montgomery, Alabama, and given the new title "Marching 'round Selma Like Jericho." The lyrics included the invocation "segregation's wall must fall."

68. Campbell, *Romare Bearden,* 216.

69. Nancy, *The Inoperative Community,* 13.

70. Mercer, "Romare Bearden: African American Modernist at Mid-century," 42.

6. Slashing toward Diaspora

1. Nicholas Mirzoeff, ed., *Diaspora and Visual Culture: Representing Africans and Jews* (New York: Routledge, 2000). In the allied field of cinema studies, see Hamid Naficy's *An Accented Cinema: Exilic and Diasporic Filmmaking* (Princeton, NJ: Princeton University Press, 2001).

2. For a comparative discussion of Jews, Africans, and Armenians as "victim diasporas," see chapters 1 and 2 of Robin Cohen, *Global Diasporas: An Introduction* (Seattle: University of Washington Press, 1997).

3. Nicholas Mirzoeff, introduction, in *Diaspora and Visual Culture,* ed. Mirzoeff, 2.

4. Stuart Hall's study appears in *Diaspora and Visual Culture,* ed. Mirzoeff, 21–33. It was originally published in J. Rutherford, ed., *Identity: Community, Culture, Difference* (London: Lawrence and Wishart, 1990), 222–37.

5. Alexander García Düttmann, *Between Cultures: Tensions in the Struggle for Recognition* (London: Verso, 2000), 74, 88.

6. Frédéric Brenner, *Diaspora: Homelands in Exile* (New York: HarperCollins Publishers, 2003). Volume 1, entitled *Photographs,* features 264 photographs, including many of the images of communities in the American project. Volume 2, entitled *Voices,* is

structured like a photographic Talmud that selects sixty images for close reading. Within that book, these become the subject of diverse interpretations by leading writers, scholars, and religious commentators.

7. This transformation is reviewed in Jeffrey Shandler, "Photoethnography as a Performance Art: The Recent Work of Frederic Brenner," in a conference paper presented at the Association for Jewish Studies Annual Meeting in Boston in December 1996. I would like to thank Jeffrey Shandler and Barbara Kirshenblatt-Gimblett for insightful interviews focused on Brenner's American project, for which they both served as consultants.

8. Frédéric Brenner, *jews/america/a representation* (New York: Abrams, 1996). Most of the images of communities in Brenner's project that are reviewed in this chapter can also be viewed online at www.photoarts.com/greenberg/brenner1.html (accessed on February 24, 2005).

9. Julie Gray, "Frédéric Brenner on American Jewry," *PDN* (*Photo District News*) (March 1997): 55.

10. This is also the image that serves as the starting point for Leon Wieseltier's scathing critique of Brenner's book published in the column "Washington Diarist: Shooting Jews" in *New Republic* 215, no. 24 (December 9, 1996): 46. Wieseltier argues that these subjects are "being exploited in a cheap culture game" in "this inane image from the American bacchanal of identity." In refusing to get beyond sensationalism, Wieseltier overlooks the express goal of Brenner's project, which is to pose the question of community or the representation of what is at stake.

11. This difficult question follows Jacques Derrida's reading of this photograph in *Voices*. Derrida (like Nancy) insists on a language of exposure to discuss this highly theatrical and "impossible" image that identifies with Judaism—and that crosses feminism with Judaism—to the limits of identification. "In front of the camera, these young women are posing, they are exposing themselves, they exhibit themselves in a row. Theater of the *impossible*, farce or provocation, limit of the identification: I have never seen women wearing tallitot and tefillin. I am immediately awakened here to an endless meditation on sexual difference, on the sexual hierarchy in Judaism, on the necessary revolutions and transactions under way. They are right to make their demands, but, as always when feminism begins, they seem to want to resemble. They mime, they identify with patriarchal authority." Derrida, commentary, in Brenner, *Diaspora*, 2:63.

12. Louis Kaplan, "'What Is Represented Is What Is at Stake': Frédéric Brenner on *jews/america/a representation*," *CR: The New Centennial Review* 4, no. 1 (Michigan State University Press) (Spring 2004): 98–99. My interview with Frédéric Brenner took place in New York City on February 3, 2002.

13. Egon Mayer, "Representing American-Jewish Acculturation: Reflections on the Photography of Frederic Brenner," *Reconstructionist: A Journal of Contemporary Jewish Thought and Practice* 62, no. 1 (Spring/Fall 1997). See www.rrc.edu/journal/recon62_1/brenner-photographs.htm (accessed September 10, 1998).

14. A number of sections regarding "the technique of jokes" illustrate these connections in Sigmund Freud's classic study *Jokes and Their Relation to the Unconscious* (1905). See the translation by James Strachey (New York: Norton, 1960).

15. For a discussion of these two models and their articulation by Jewish intellectuals such as Israel Zangwill and Horace Kallen, see David Biale, "The Melting Pot and Beyond: Jews and the Politics of American Identity," in David Biale, Michael Galchinsky, and Susannah Heschel, *Insider/Outsider: American Jews and Multiculturalism* (Berkeley: University of California Press, 1998), 17–33.

16. Nancy, "Cut Throat Sun," 117.

17. Brenner quoted in Kaplan, "'What Is Represented Is What Is at Stake,'" 105.

18. Barbara Kirshenblatt-Gimblett makes this exact point and frames Brenner as an antidote. She writes: "Jewish continuity was a preoccupation of the organized Jewish community in the United States during the 1990's." Quoted in Brenner, *Diaspora*, 2:84.

19. Nancy, "Cut Throat Sun," 116.

20. One recalls in this context the title of the most famous compendium of Roman Vishniac's images: *A Vanished World* (New York: Noonday Press, 1986).

21. The posthumous project *To Give Them Light: The Legacy of Roman Vishniac* (New York: Simon and Schuster, 1992) relies on the rhetoric of illumination. Both "God's light" and the photographer's light ("he illuminates all that came before him") are invoked in Elie Wiesel's preface. Thus the photographic creator mimes God in separating light from darkness.

22. Brenner quoted in Kaplan, "'What Is Represented Is What Is at Stake,'" 100.

23. Simon Schama, "Looking Jewish," in Brenner, *jews/america/a representation*, v.

24. Jacques Derrida, commentary, in Brenner, *Diaspora*, 2:91.

25. Interestingly enough, Brenner's is not a one-of-a-kind image. The interesting photograph "The First Motorcycle Team of the Warsaw Maccabee," from November 17, 1929, is included in Lucjan Dobroszycki and Barbara Kirshenblatt-Gimblett, *Image before My Eyes: A Photographic History of Jewish Life in Poland, 1864–1939* (New York: Schocken Books, 1977), 193.

26. For a valuable discussion of the pedagogical and broadcast uses of mass media and electronic communication by the Lubavitch sect, see Jeffrey Shandler, "The Virtual Rebbe," in J. Hoberman and Jeffrey Shandler, *Entertaining America: Jews, Movies, and Broadcasting* (Princeton, NJ: Princeton University Press, 2003), 264–67. Shandler references the fundraising Chabad Chanukah Telethon as a media event related to the one that is the focus of Brenner's photograph. It seeks to "realize Chabad's spiritual agenda within the conventions of American entertainment" (264). It should also be noted that Brenner's photograph "Marxists" (1984) serves as the cover of *Entertaining America*.

27. While Wieseltier, in "Washington Diarist: Shooting Jews," accuses Brenner of a "Baudrillardian program," utilizing the motto "there is no American Jewish life, there is only a spectacle of American Jewish life" (46), Brenner's analysis of the Hasidim would seem to support this line of argument. Brenner acknowledged the importance of Baudrillard's vision of America to the conception of his project in my interview with him. See Jean Baudrillard, *America,* trans. Chris Turner (London: Verso Books, 1988). I take up these specific points of mediation, simulation, and spectacle in my video lecture *L'Chaim, Las Vegas,* which was coproduced with video artist and filmmaker Melissa Shiff. It was first presented at the SPE National Meeting "Photography and Mediated Experience," in Las Vegas, March 2002.

28. Biale, Galchinsky, and Heschel, *Insider/Outsider.*

29. Derrida, commentary, in Brenner, *Diaspora*, 2:103.

30. Ibid.

31. For a richly illustrated review of this history's alliances and conflicts, see Jack Salzman, ed., *Bridges and Boundaries: African Americans and American Jews* (New York: George Braziller, 1992).

32. Brenner states, "You know that, first of all, the company is not owned by a Jew. And there is not a single Jew in this photograph. Even the owner is not a Jew." Brenner quoted in Kaplan, "'What Is Represented Is What Is at Stake,'" 103.

33. One recalls in this context the recent sociological study by Karen Brodkin, *How*

the Jews Became White Folks: And What That Says about Race in America (New Brunswick, NJ: Rutgers University Press, 1998).

34. Jean-Luc Nancy, "Finite History" in *The Birth to Presence* (Stanford, CA: Stanford University Press, 1993), 155. Brenner expressed his agreement with Nancy's idea in the following way: "Yes I believe that the true togetherness is otherness. There is this beautiful *Midrash* (interpretation of the Bible) we tell that when the Bnai Israel [children of Israel] had to cross the Red Sea, it is said that each tribe crossed according to its own path, and each tribe was separated from the other by a wall of water. And wherever you were, you could see the other tribe because the walls were transparent, and there's not a better image of unity through the respect of the specificity of the other." Brenner quoted in Kaplan, "'What Is Represented Is What Is at Stake,'" 106.

35. Paul Gilroy, *The Black Atlantic: Modernity and Double Consciousness* (Cambridge, MA: Harvard University Press, 1993), xi, 205.

36. In my immediate intellectual context, I refer to the efforts of the African literary scholar Ato Quayson to launch a comparative diaspora undergraduate degree program and research center at the University of Toronto.

37. "Nice Jewish Boys" is reviewed by Julius Lester, who is himself a black Jew. Lester begins by anticipating the inflammatory reaction to this politically incorrect image. "Many would accuse the author of poor taste. Others would go into paroxysms of political correctness and excoriate the author for demeaning both Jews and blacks." However, he concludes along the lines of the "togetherness of otherness": "Blacks and Jews. The image subtly combines images of the suffering twins of history" (Lester, commentary, in Brenner, *Diaspora*, 2:86).

38. Robin Cembalest, "Documenting the Diaspora with a Cast of Thousands: Brenner's Unconventional Portrait of American Jewry," *Forward* (September 13, 1996): 15–16.

39. Vicki Goldberg, "The American Chapter of the Jewish Saga," *New York Times*, September 22, 1996, Arts & Leisure section, 1.

40. See "An Interview with Frédéric Brenner" at the Kodak Web site: www.kodak.com/ppiHome/kodakProfessional/features/jewsAmerica/interviewFred.shtml (accessed May 25, 1998).

41. Gilles Deleuze, *Difference and Repetition*, trans. Paul Patton (New York: Columbia University Press, 1994), 262–63.

42. Ibid., 278.

43. Maurice Blanchot, *The Space of Literature*, trans. Ann Smock (Lincoln: University of Nebraska Press, 1982), 77. As the epigraph to this chapter would indicate, Brenner has been inspired by the texts of Blanchot as well as those of Edmond Jabes.

44. Brenner quoted in Kaplan, "'What Is Represented Is What Is at Stake,'" 100.

45. Frédéric Brenner, *Exile at Home* (New York: Abrams, 1998).

46. Blanchot, *The Space of Literature*, 70.

47. Derrida responds to this image in terms of *partage:* "In a different but shareable manner (and this is sharing itself, at once sharing out or partitioning, and placing in common), Navajos and Jews feel themselves expropriated." Derrida, commentary, in Brenner, *Diaspora*, 2:101.

48. Tamar Lubin is quoted in Brenner, *jews/america/a representation*, 16.

49. Brenner quoted in Kaplan, "'What Is Represented Is What Is at Stake,'" 112.

50. In other words, Brenner counterbalances the longing for the Jewish homeland ("Next year in Jerusalem") with the simulation of homeland in exile ("Jerusalem, it is here").

51. Jacques Derrida, *Specters of Marx: The State of the Debt, the Work of Mourning, and the New International*, trans. Peggy Kamuf (New York: Routledge, 1994), 82.

52. Daniel Boyarin and Jonathan Boyarin, "Diaspora: Generation and the Ground of Jewish Identity," *Critical Inquiry* 19 (Summer 1993): 693–725. For their more recent foray into these issues, see Jonathan Boyarin and Daniel Boyarin, *Powers of Diaspora: Two Essays on the Relevance of Jewish Culture* (Minneapolis: University of Minnesota Press, 2002).

53. Boyarin and Boyarin, "Diaspora," 723.

54. Ibid.

55. Ibid., 721.

56. I refer here to Homi K. Bhabha's study "DissemiNation: Time, Narrative and the Margins of the Modern Nation," *The Location of Culture* (London: Routledge, 1994), 139–70.

57. Robert Frank, *The Americans,* introduction by Jack Kerouac (New York: Grove Press, 1959).

58. Boyarin and Boyarin, "Diaspora," 721.

59. Ibid.

60. Michael Galchinsky, "Scattered Seeds: A Dialogue for Diasporas," in Biale, Galchinsky, and Heschel, *Insider/Outsider,* 202.

61. John Dalberg-Acton, *Essays in the Liberal Interpretation of History,* ed. William H. McNeill (Chicago: University of Chicago Press, 1967), 146, quoted in Benedict Anderson, "Exodus," *Critical Inquiry* 20 (Winter 1994): 315.

62. Schama, "Looking Jewish," vii.

63. Ibid., xiii. The term *fusion music* is introduced in the context of "The Josephson Family" photograph, which I have already interpreted as a Lacanian scene of misrecognition and as riddled with a lot more epistemological dissonance than what Schama wants us to believe.

64. Goldberg, "The America Chapter of the Jewish Saga," 1.

65. Here, I take issue with Laura Levitt's analysis of Brenner in her work "Photographing American Jews: Identifying American Jewish Life" and her claim that Brenner "does not offer a critical re-evaluation of the stereotypes he reproduces" (77). However, if Brenner's humor is based on paradox, ambivalence, and oxymoron, then it becomes difficult for the stereotype to maintain itself. See Levitt in *Mapping Jewish Identities,* ed. Laurence J. Silberstein (New York: New York University Press, 2000), 65–98.

66. Brenner quoted in Kaplan, "'What Is Represented Is What Is at Stake,'" 118.

67. Sidra Dekoven Ezrahi, commentary, in Brenner, *Diaspora,* 2:99.

68. Richard Raskin, "The Original Function of Groucho Marx's Resignation Joke," *Life Is Like a Glass of Tea: Studies of Classic Jewish Jokes* (Philadelphia, PA: Jewish Publication Society, 1992), 121.

69. R. B. Kitaj, "First Diasporist Manifesto," in *Diaspora and Visual Culture,* ed. Mirzoeff, 39.

70. Raskin, *Life Is Like a Glass of Tea,* 128.

7. Digital Chicanos

1. The specific details of the founding of the Consejo Mexicano de Fotografía and Meyer's influential role in this enterprise are provided in Olivier Debroise, *Mexican Suite: A History of Photography in Mexico* (Austin: University of Texas Press, 2001), 7. The theme of the first colloquium ("What is and could be Latin American social photography?") demonstrates Meyer's major documentary interests in the 1970s.

2. For *ZoneZero,* see www.zonezero.com. Debroise reviews Pedro Meyer's personality

and his photographic career in *Mexican Suite* on pages 153–55: "Recently, Meyer has moved to digital technology, extensively using image manipulation software, special printers, and CD-ROMs to create sophisticated works: in particular, an extremely 'classical' series of images on CD-ROM about his mother's death. In reusing some of his more 'classic' and celebrated images of the 1970s, Meyer seems to have lost some of his aggressiveness. Blending modern and ancient technologies, he also employs traditional *amate* (a bark paper used in prehispanic times in Mexico) with modern ink-jet printers. In addition, he administers an important photographic Web site: www.zonezero.com" (155).

3. In showing the two years with a photograph title, I am following what Pedro Meyer does. Presumably, the first year indicates when the photo was originally shot, and the second indicates when it was digitally altered.

4. In his introduction to *Truths & Fictions,* Joan Fontcuberta discusses this image in a way that marks digital photography as the hybridization of the camera and the computer. "In *Walking Billboard,* Meyer comically illustrates this concept: a character whose head is crowned with a grotesque accessory of a camera and a computer, a clear allusion to the hybridization of the new visual thought." See Fontcuberta, "Pedro Meyer: Truths, Fictions, and Reasonable Doubts," in Pedro Meyer, *Truths & Fictions: A Journey from Documentary to Digital Photography* (New York: Aperture, 1995), 10.

5. Pedro Meyer, "The Renaissance of Photography," keynote address at the SPE Conference, Los Angeles, California, October 1, 1995. The lecture can be found online at www.zonezero.com/magazine/articles/meyer/03.html (accessed February 24, 2005).

6. Pedro Meyer, "Editorial 7," ZoneZero, April 1997. This editorial can be found online at www.zonezero.com/editorial/editorial.html (accessed February 24, 2005).

7. Pedro Meyer, *Verdades y ficciones: Un viaje de la fotografía documental a la digital* (Mexico: Casa de las Imágenes, 1995).

8. The rhetoric that situates Pedro Meyer as a "border subject" crossing and bridging peoples, regions, and techniques is quite common. Fred Ritchin's promotional blurb on the back cover of *Truths & Fictions* is indicative. "Not only has this Mexican photographer been a bridge between the photographic communities of North and South, but also between those of the analog and digital ages."

9. Meyer, *Truths & Fictions,* 110.

10. Ibid.

11. See "The New Americans: A Dialogue" online at www.zonezero.com/foros/forums.html (accessed March 10, 2002). The text goes on to make a distinction between *mestizaje* and the American model of acculturation prior to the birth of Chicano consciousness, or what it terms the "U.S. assimilationist term 'melting pot.'" It concludes that "*mestizaje* is a journey that has no end; the cultural version of perpetual motion not in theory but in practice." The present chapter seeks to broaden this point with the insistence that *mestizaje* is also a journey that has no beginnings or origins and that this must be acknowledged in viewing the digital Chicanos of Pedro Meyer's photography.

12. Nancy, "Cut Throat Sun," 117, 121.

13. See David E. Johnson and Scott Michaelsen, "Border Secrets: An Introduction," in *Border Theory: The Limits of Cultural Politics,* ed. Michaelsen and Johnson (Minneapolis: University of Minnesota Press, 1997). "Such an other way of thinking produces defamiliarizing border readouts without the possibility of laying it on the line" (15). My contribution to Michaelsen and Johnson's collection, "On the Border with *The Pilgrim:* Zigzags across a Chapl(a)in's Signature" (97–128), also takes up the issue of the straddling of the border.

14. Nancy, "Cut Throat Sun," 123.

15. Jonathan Green, "Pedro Meyer's Documentary Fictions," *Metamorphoses: Photography in the Electronic Age* (New York: Aperture, 1994), 33–35. This study was adapted from Green's oral "Narration" in the CD-ROM version of *Truths & Fictions* (Voyager Company, 1994).

16. In "Cut Throat Sun," Nancy phrases the cut as integral to Chicano identity and community this way: "And yet what we will hear in your word, as well as besides the word, is that the *gente chicana* [Chicano people] does not propose the purity of a bloodline nor a superiority. It gets its identity from the cut, in the cuttings. It is no less an identity for it, but it is not an identity in terms of blood or essence" (117).

17. Meyer, *Truths & Fictions*, 120.

18. Meyer takes up the rather personal issues of familial and cultural memory in his first CD-ROM, *I Photograph to Remember* (Voyager Company, 1991). This is a visual diary that records the later lives and deaths of his parents. Here, he openly acknowledges his parents as Jewish refugees who escaped the Nazi terror, fleeing first to Madrid (where Pedro was born) and then to Mexico City.

19. Transcribed from Pedro Meyer, "Digital Studio Commentaries," *Truths & Fictions* (CD-ROM), no. 4.

20. Ibid.

21. The catalog *Tiempos de America* features many documentary images of Mexican religious festivals. The catalog is rather difficult to find in North America. It was published in Italy by the Premio Internazionale di Cultura Citta di Anghiari in April 1985.

22. See Judy King, "*La Virgen de Guadalupe:* Mother of All Mexico," in her online article on the Web site Mexico Connect, www.mexconnect.com/mex_/travel/jking/jkgudalupe. html (accessed May 18, 2002).

23. See Debroise, "Of the Miraculous 'Imprint' and Other Illuminations," *Mexican Suite,* 18.

24. This image bears comparison with another of Meyer's digital Chicano photographs, entitled "Eagles" (1980/1995), which features a Mexican flag with its symbolic eagle draped on the backseat of another green and white automobile driven by a Chicano youth who is cruising around the American eagle territory of Oxnard, California.

25. Olivier Debroise recalls: "The late Louis Carlos Bernal meticulously documented 'Latin interiors' and aspects of the daily life of the Chicanos and Cholos, with their 'low-riders,' and of the Mexicans who had arrived relatively recently in the border areas of New Mexico, Arizona, and California. Bernal, who suffered a serious accident in 1989 that eventually took his life, had begun to delineate the cultural confluences, the absorption of the 'American way of life' by groups that, nevertheless, still retained their Latin traditions." See Debroise, *Mexican Suite,* 158.

26. Jonathan Green, "Stereotypes of Mexicans in United States," in his "Narration," Meyer, *Truths & Fictions* (CD-ROM), no. 7.

27. Scott Michaelsen touches upon this crucial point through a reading of Edgar Allan Poe's "Descent into the Maelstrom," in his review of José David Saldivar's *Border Matters* (Berkeley: University of California Press, 1997). He recalls Poe: "Poe's brief text, perhaps, should serve as a warning to certain forms of post-colonial criticism concerned with hybridization. The warning takes this complex form: hybridity cannot really be hybridity—cannot really be a mixture and confusion of categories, types, bodies—if it is still possible, in the end, to identify the individual elements that compose the hybrid. If the hybrid were truly a hybrid, it would subvert the possibility of locating its individual parts, of producing an analytic which might chart the contributions of origin."

See Michaelsen, "Hybrid Bound," *Postmodern Culture* 8, no. 3 (1998). The review can be found online at http://muse.jhu.edu/postmodern_culture/v008/8.3r_michaelsen.html.

28. Nancy, "Cut Throat Sun," 117.

29. Here I invoke the neologism that guides Mark C. Taylor in *Altarity* (Chicago: University of Chicago Press, 1987) and its meditation on religion and the site of otherness.

30. Pedro Meyer, "Digital Commentaries," *Truths & Fictions* (CD ROM), no. 19.

31. Ibid.

32. Ibid.

33. Green, "Pedro Meyer's Documentary Fictions," 34.

34. See Florian Rötzer, "Re: Photography," in *Photography after Photography: Memory and Representation in the Digital Age,* ed. Hubertus von Amelunxen, Stefan Iglhaut, and Florian Rötzer (Amsterdam: G+B Arts, 1996), 13. This study offers a stinging critique of Green and mocks his transference of truth "from one technique to another." In other words, "What was formerly (wrongly) understood as documentation is now fiction, and what was fiction has now become a documentation (implying truth) of a 'digital truth,' as he later puts it." All in all, Rötzer wants to sever the digital image from serving the truth in any way. "Why cannot the artist simply play with his instrument, the computer, which is indeed a toy, without necessarily having to arrive at a digital truth?" (14).

35. Nancy, "Cut Throat Sun," 123.

36. Meyer, "Digital Commentaries," *Truths & Fictions* (CD-ROM), no. 18.

37. Fontcuberta, "Pedro Meyer: Truths, Fictions, and Reasonable Doubts," 13.

38. Peter Lunenfeld, "Art Post-History: Digital Photography and Electronic Semiotics," in *Photography after Photography,* ed. von Amelunxen, Iglhaut, and Rötzer, 95.

39. Nancy, "Cut Throat Sun," 123.

8. PERFORMING COMMUNITY

1. To reiterate the full context of Lee's statement, "I don't live with the people. I just hang out. I have to have boundaries. What I do is fake documentary." See Jessica Kerwin, "Faking It," *W Magazine* (September 2001): 416–18.

2. Lee's photographic practice of "false documentary" might be compared with Eleanor Antin's images in which one is given access to the duplicity through another medium, the motion-based reproductive technology of video. "Caught in the act, the companion videotape to the photograph however tells a different story. Ostensibly, the tape documents the shooting of the 'choreography' photograph, but it reveals the ballerina to be a *klutz.* Despite her *elan,* she can't dance. She can't move like a dancer; she can't even hold a pose for more than the 1/125 of a second that it takes to snap a photo." Howard N. Fox, "Waiting in the Wings: Desire and Destiny in the Art of Eleanor Antin," *Eleanor Antin* (Los Angeles: Los Angeles County Museum of Art, 1999), 76.

3. Lee's practice recalls the ideas of Jean Baudrillard in "The Precession of Simulacra," *Simulations* (New York: Semiotext(e), 1984). As Baudrillard famously proclaims, "Simulation threatens the difference between 'true' and 'false,' between 'real' and 'imaginary'" (5). In contrast to documentary photography and its claims to truth telling, Lee's photographic rites of passing occupy this more ambiguous space that substitutes "signs of the real for the real itself" (4).

4. Nikki S. Lee, "Il mio manifesto artistico" (My artistic manifesto), in *Guarene Arte 99* (Turin, Italy: Fondazione Sandretto Re Rebaudengo per l'Arte, 1999), 35. I thank Shannon Petrello for the translation of Lee's artist statement.

5. Ibid.

6. This view is the basis of Jennifer Dalton's essay "LOOK AT ME: Self-Portrait Photography after Cindy Sherman," which reviews the work of Nikki S. Lee, Anthony Goicolea, and David Henry Brown Jr., in *PAJ: A Journal of Performance and Art* 66, no. 3 (September 2000): 47–56. See also Jerry Saltz, "Decoy and Daydreamer," *Village Voice* 44, no. 38 (September 28, 1999), 61. Saltz comments that Lee "splices the dressing-up of Cindy Sherman with the snapshootiness of Nan Goldin."

7. Gilbert Vicario, "Conversation with Nikki S. Lee," in Nikki S. Lee, *Projects,* (Ostfildern-Ruit, Germany: Hatje Cantz Publishers, 2001), 98.

8. As Lee stated in my unpublished interview with her, "I love Cindy Sherman's work, but I always see a big difference because she views identity as all herself." Louis Kaplan, "Nikki S. Lee in Conversation with Louis Kaplan," Colloquium on Visual Culture, University of Toronto Art Centre, November 24, 2003. I thank my colleagues at the University of Toronto, Alexander Nagel and Lisa Steele, for their help in sponsoring this event.

9. The citation is Nikki S. Lee quoted in William L. Hamilton, "Dressing the Part Is Her Art," *New York Times,* Sunday Styles section, December 2, 2001, 8.

10. Nikki S. Lee quoted in Monty DiPietro, "Identity Found among Shifting Personas," *Japan Times,* October 28, 2000, 24.

11. Stewart Ewen, *All Consuming Images: The Politics of Style in Contemporary Culture* (New York: Basic Books, 1988).

12. Nancy, "Of Being-in-Common," 9.

13. Ibid., 10.

14. Ibid., 2.

15. Nancy, *The Inoperative Community,* xxxvii.

16. Nikki S. Lee quoted in Rebecca Sonkin, "The 13 Faces of Nikki Lee," *ELLE* 16, no. 12, August 2001, 63.

17. Vicario, "Conversation with Nikki S. Lee," 100–101.

18. This comment is taken from Kaplan, "Nikki S. Lee in Conversation with Louis Kaplan."

19. Nancy, *The Inoperative Community,* xxxvii.

20. Holland Cotter, "Nikki S. Lee at Leslie Tonkonow Artworks and Projects," *New York Times,* September 10, 1999, E.2, 36.

21. Russell Ferguson, "Let's Be Nikki," in Nikki S. Lee, *Projects,* 15.

22. Lee, "Il mio manifesto artistico," 35.

23. Werner Hamacher, "One 2 Many Multiculturalisms," in *Violence, Identity, and Self-Determination,* ed. Hent de Vries and Samuel Weber (Stanford, CA: Stanford University Press, 1997), 314.

24. Nancy, *The Inoperative Community,* 70.

25. Ibid., 7.

26. Quoted in Rey Chow, *Writing Diaspora: Tactics of Intervention in Contemporary Cultural Studies* (Bloomington: Indiana University Press, 1993), 139.

27. Maurice Berger, "Picturing Whiteness: Nikki S. Lee's Yuppie Project," *Art Journal* 60, no. 4 (Winter 2001): 55.

28. This point is also made by Jennifer Dalton in "LOOK AT ME," 49. Dalton states: "The performative aspect of her work requires her to look beyond the surface markings that define us to one another and keep us separated—while simultaneously riffing on those very markings."

29. Ibid., 49. See also the following statement by Russell Ferguson: "Nevertheless, the cumulative effect of Lee's own mutating presence in series after series does in the end

succeed in disrupting any possible confidence in social classification systems of whatever kind. They are all permeable." Ferguson, "Let's Be Nikki," 13.

30. Mark Godfrey, "Nikki S. Lee: Stephen Friedman Gallery, London," *Frieze* 52 (May 2000): 109.

31. Paul Lee Cannon, "Identity Crises," *KoreAm Journal* 12, no. 9 (September 2001): 26–27.

32. This image was the only Lee photograph selected for inclusion in the comprehensive exhibition at the International Center of Photography in New York devoted to the construction of race in American photographic history. In the catalog, the image has been placed as the frontispiece to Howard Winant's study, "The Theoretical Status of the Concept of Race." See Coco Fusco and Brian Wallis, *Only Skin Deep: Changing Visions of the American Self* (New York: ICP and Abrams, 2003), 50.

33. Adrian Piper, "Passing for White, Passing for Black," *Transition* 58 (1992): 4–32.

34. "I Embody Everything You Most Hate and Fear" is the wording of one of the thought bubbles of Piper's *Mythic Being* (to be discussed below). The poster can be found in *Adrian Piper: A Retrospective,* ed. Maurice Berger (Baltimore: Fine Arts Gallery, University of Maryland, Baltimore County, 1999), 142. It is also interesting to point out that Maurice Berger has written about race in the work of both Piper and Lee. In the same volume, see his "Styles of Radical Will: Adrian Piper and the Indexical Present," 12–33.

35. Adrian Piper, "Concretized Ideas I've Been Working Around" (January 1971), in *Out of Order, Out of Sight,* vol. 1: *Selected Writings in Meta-Art 1968–1992* (Cambridge, MA: MIT Press, 1996), 42.

36. Ibid., 43.

37. Adrian Piper, "The Mythic Being: Getting Back" (1975/1980), *Out of Order, Out of Sight,* 147. (According to Piper's notation, this piece was created in July 1975, written up in 1980, and was previously unpublished until inclusion in the cited volume.)

38. Vicario, "Conversation with Nikki S. Lee," 100.

39. Godfrey, "Nikki S. Lee," 109.

40. Ibid.

41. The comparison of Lee's work with Tseng Kwong Chi is taken up by Russell Ferguson, "Let's Be Nikki," 15.

42. Dalton, "LOOK AT ME," 47.

43. Robert Frank, *The Americans* (Paris: Robert Delpire, 1958; and New York: Grove Press, 1959).

44. Hamacher, "One 2 Many Multiculturalisms," 313.

45. Yong Soon Min quoted in Elaine Kim, "'Bad Women': Asian American Visual Artists Hanh Thi Pham, Hung Liu, and Yong Soon Min," *Feminist Studies* 22, no. 3 (Fall 1996): 598.

46. Nancy, *The Inoperative Community,* 21.

47. Vicario, "Conversation with Nikki S. Lee," 97–98.

48. Ibid., 98.

49. For a discussion of the postmodern figure of the fold, see Gilles Deleuze, *The Fold: Leibniz and the Baroque,* trans. Tom Conley (Minneapolis: University of Minnesota Press, 1992).

50. Vicario, "Conversation with Nikki S. Lee," 105.

51. Marianne Hirsch, "Masking the Subject," *Family Frames: Photography, Narrative, and Postmemory* (Cambridge, MA: Harvard University Press, 1997), 103.

52. Dick Hebdige, "Subculture: The Meaning of Style" (1979), in *The Subcultures Reader,* ed. Ken Gelder and Sarah Thornton (London: Routledge, 1997), 138.

53. Ibid., 134.

54. Ibid., 140.

55. Quoted in Jessica Kerwin, "Faking It: From Trompe l'Oeil Fashion to Faux Documentaries; the New Reality Is Completely Twisted," *W Magazine* (September 2001): 418.

56. Solomon-Godeau, "Inside/Out," 51.

57. Nancy, *The Inoperative Community*, 66.

58. Kathryn Rosenfield also discusses the link with Butler. Unlike my analysis, which stresses the shared interest in the parodics of performance, Rosenfield concludes that Lee's is a superficial reading of Butler. "The theorist Judith Butler, whose work on performative identity would seem to be an inevitable subtext here, has argued that identity is not simply a closet full of different outfits from which we can choose each day. While Lee appears to dive enthusiastically into just such a fallacy, is she really claiming that subculture and social affinity are essentially a question of looking the part?" See Kathryn Rosenfield, "Nikki S. Lee," *New Art Examiner* (November/December 2001): 92.

59. Butler, *Gender Trouble*, 138.

60. Ibid., 146–47.

61. Ibid., 138–39.

62. Ferguson, "Let's Be Nikki," 17.

63. The initial "S." stands for the remainder of her given Korean name, Seung-Hee. This initial also helps to distinguish the photographer from another Nikki Lee who has made a name for herself in the world of adult movies.

64. Ferguson, "Let's Be Nikki," 17.

65. One recalls this specific statement from the "Manifesto": "Ultimately I control this fragmentation and manipulate the versatility of my identity."

INDEX

LOUIS KAPLAN is associate professor of history and theory of photography and new media in the Graduate Department of History of Art at the University of Toronto; he also coordinates the program in Visual Culture and Communication at the University of Toronto at Mississauga. He is the author of *Laszlo Moholy-Nagy: Biographical Writings*.